A Dance of Assassins

African Expressive Cultures

Patrick McNaughton, editor

Associate editors
Catherine M. Cole
Barbara G. Hoffman
Eileen Julien
Kassim Koné
D. A. Masolo
Elisha Renne
Zoë Strother

A Dance of Assassins

Performing Early Colonial Hegemony in the Congo

Allen F. Roberts

Indiana University Press · Bloomington & Indianapolis

This book is a publication of

Indiana University Press
601 North Morton Street
Bloomington, Indiana 47404-3797 USA

iupress.indiana.edu

Telephone orders 800-842-6796
Fax orders 812-855-7931

Manufactured in the United States of
America

Library of Congress Cataloging-in-
Publication Data

Roberts, Allen F., [date]
 A dance of assassins : performing early
colonial hegemony in the Congo /
Allen F. Roberts.
 p. cm. — (African expressive cultures)
 Includes bibliographical references and
index.
 ISBN 978-0-253-00743-8 (cl : alk. paper)
— ISBN 978-0-253-00750-6 (pb : alk.
paper) — ISBN 978-0-253-00759-9 (eb)
1. Congo (Democratic Republic)—
Colonization. 2. Congo (Democratic
Republic)—History—To 1908. 3. Storms,
Émile Pierre Joseph, 1846–1918. 4. Lusinga,
ca. 1840–1884. 5. Belgians—Congo
(Democratic Republic)—History—19th
century. 6. Hegemony—Congo
(Democratic Republic)—History—19th
century. 7. Ethnological museums and
collections—Belgium. I. Title. II. Series:
African expressive cultures.
 DT654.R63 2013
 325.3493096751—dc23

 2012030702

1 2 3 4 5 18 17 16 15 14 13

For Polly

Contents

Acknowledgments

Because this study has extended over more than forty years, I hold no hope of being able to thank all of my friends in the Democratic Republic of the Congo (known as the Republic of Zaïre during my research of the mid-1970s), Belgium, the Vatican, the United States, and the several other countries where I have consulted relevant museum and archival collections or conferred with colleagues about this project. So many have been so generous with their time and intellect and so warmly hospitable that I can only express my deepest gratitude for all they have offered so freely and cheerfully.

Inspiring mentors have set me on my path, from Donald Pitkin at Amherst College to Victor and Edith Turner at the University of Chicago, with many more along the way. Wonderful teachers in Zaïre included Sultani Mpala Kaloko, Kizumina Kabulo, and Louis Mulilo, whose wisdom and guidance will be obvious in the pages to come. My forty-five months in Lubanda and other Congolese communities were fruitful, pleasant, and often hilarious thanks to these and a host of others, including Belgian and American friends in Lubumbashi. The late Geneviève Nagant put her decades of humanistic research among Tabwa at my disposition, and she opened her home in Kalemie as did the family of Kalunga Twite Dodo for the several months needed to perfect my local Swahili before moving to Lubanda. My former spouse, Christopher O. Davis (then Davis-Roberts), and I pursued complementary dissertation projects in Zaïre, and her study of Tabwa medicine informs the present book. I am

most grateful for her amiable companionship through the thick and thin of such long fieldwork.

Financial support for my doctoral research was provided by the National Institute of Mental Health, the Society of the Sigma Xi, and the Committee on African Studies and Edson-Keith Fund of the University of Chicago. Later sponsorship by the National Endowment for the Humanities, a postdoc with the Michigan Society of Fellows, and faculty grants from Albion College, the University of Iowa, and UCLA have contributed mightily to the present project. I greatly appreciate the research affiliation I was afforded by the Center for Political Study of Central Africa at the National University of Zaïre in Lubumbashi, 1974–1977.

Colleagues at the Royal Museum of Central Africa (RMCA) have been very supportive of this and my other projects over the years, especially and most recently curators Anne-Marie Bouttiaux, Sabine Cornelis, Maarten Couttenier, and Boris Wastiau. Thanks, too, to the Clendennings for weeks of hospitality in Brussels as I worked in RMCA archives in late 1977. Evan M. Maurer was a wonderful partner for the NEH-sponsored traveling exhibition and book in 1985 that was based upon my doctoral research in Zaïre. Again, many more faculty and student friends have offered thoughtful assistance than can be mentioned here. Nonetheless, particular thanks must go to Lucian Gomol, Prita Sandy Meier, and David Delgado Shorter for their cogent editing and suggestions about my manuscript, and especially to Johannes Fabian and Polly Nooter Roberts for their close and thoughtful reading. Thanks, too, to Kathleen Louw and Christian Ost for their remarkable scholarly investigations in Belgium on my behalf. Despite such brilliant support from so many, all responsibility for the present volume remains my own.

This book is dedicated to the memory of my parents, Ruth Fraleigh Roberts and Sidney Hubbard Roberts, and to my late spouse, Mary Kujawski Roberts. It is also dedicated with all my love to my spouse, Mary "Polly" Nooter Roberts; our children, Avery, Seth, and Sid; and to son-in-law James and grandson Gus. Writing a book is always an obsessive engagement, and Polly and the kids' tolerance for my mountains of books and papers, endless hours of lost-in-laptop concentration, and my other book-related preoccupations and idiosyncrasies has made this project not just possible, but profoundly fulfilling.

A Dance of Assassins

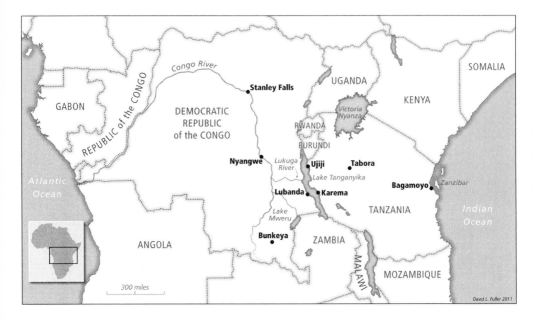

Figure 0.1. Map of central Africa. David L. Fuller, 2011, by commission for this book.

Introduction

This book is about a beheading. The event occurred in December 1884 and has been articulated ever since through competing Congolese and Belgian histories attuned to particular audiences and political goals. Two protagonists engaged in a deadly pas de deux driven by immense ambition, each violently striving to establish hegemony along the southwestern shores of Lake Tanganyika in what is now the Democratic Republic of the Congo (DRC): Lusinga lwa Ng'ombe, deemed a "sanguinary potentate" by the British explorer Joseph Thomson, who visited the chief in 1879, because of his ruthless slaving for the east African trade; and Émile Storms, belligerent commander of the fourth International African Association (IAA) caravan and founder of an outpost at Mpala-Lubanda near Lusinga's redoubt (fig. o.1).[1] The IAA's overt mandate was to promote scientific knowledge while helping suppress slavery. Lusinga and Storms were bound for confrontation, and Lusinga lost his head.

In the mid-1970s I spent most of my forty-five consecutive months of Congolese research among Tabwa people in and around the large lakeside village of

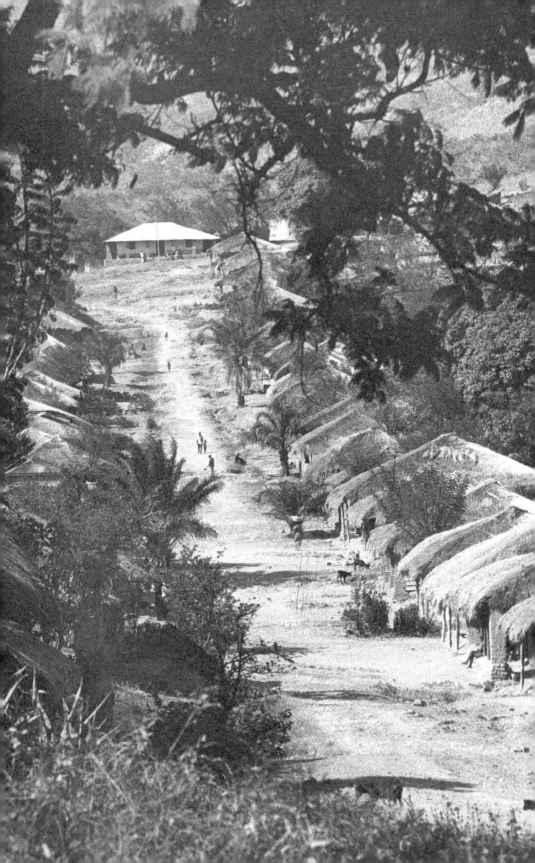

Lubanda, studying local-level politics and cosmology for a doctorate in anthropology at the University of Chicago (fig. 0.2). I was offered accounts of Lusinga's rise and demise by several elderly men. One named Kizumina told me that when Storms sent his warriors to execute Lusinga, they sang a ribald refrain as they climbed the steep mountain path to his palisade. The men accompanied their engaging song with three days of vivid dance, lulling Lusinga to lower his guard, and then they shot him dead and took his head. The assassins' choreography was an essential device of battle, and one can surmise from Kizumina's narrative that it mystically and magically empowered their reversal of Lusinga's fate, yet neither singing nor dance was featured in Storms's arid account of the incident left to us in his diary and letters. Whether or not the performance happened is irrelevant, for Kizumina's emphasis was derived from the embodied logic through which Congolese at Lubanda understood the lethal encounter and its far-reaching consequences ninety years after the fact.

Storms did develop IAA scientific aims, and as he scheduled, mapped, traded, and collected, he broached Belgian colonization of time, place, value, and Nature itself. He also initiated changes in social organization that were still perceptible at Lubanda in the 1970s. All was not orderly during Storms's brief stay along the shores of Lake Tanganyika, however, as ramifications of the bizarre behavior of a French explorer and the madness of Storms's own adjutant make abundantly clear. The "theatrical enterprise" that typified late nineteenth-century central African exploration and in which Storms so willingly participated must also be understood if one is to grasp the oddities of meaning-making during early encounter.

Despite its lofty public goals, the IAA was a front for the imperialist maneuvering of Léopold II, King of the Belgians. Storms had a covert directive to strike off westward from Lubanda and join Henry Morton Stanley coming up the Congo River from the Atlantic coast. Together they would inscribe a "White Line across the Dark Continent," as a tract referred to it in 1883, and in so doing they would substantiate Léopold's audacious claim to the Congo at the much-anticipated Berlin Conference of 1885, when Africa was partitioned among European colonial powers.[2] Had the plan been realized, Storms could have expected to share some portion of the enormous celebrity accorded to Stanley. As it was, the seasoned Stanley proved so swiftly successful

Figure 0.2 (opposite). The main street of Lubanda (DRC) in the mid-1970s, looking south to Sultani Mpala's residence. Photo from the research of Christopher Davis-Roberts and Allen F. Roberts, 1976.

that Storms's further services were reckoned unnecessary, and he was summoned back to Belgium to disgruntled anonymity.

"Émile Storms" is by no means a household name in Belgium today. In part this is because of what Ann Laura Stoler might term "a stubborn colonial aphasia" that—from a distance, anyway—seems to characterize contemporary attentions more readily directed to political frictions between Flemish and Walloons than to problematic collective histories. And in part it is because Storms's central African career did not result in wide or enduring recognition. Furthermore, as Auden once reflected, "another time has other lives to live," and persons once significant may not be after their fleeting moments have passed.[3] Still, Storms *did* establish the rudiments of Belgian control of southeastern Congo, in large measure through his brutal defeat of Lusinga. And even if the man is all but forgotten, how many Stormses does it take to produce a single iconic figure like Stanley? Are Storms and countless others like him to be lost in time, or is recalling their strengths and shortcomings necessary to any understanding of the complexities of early colonial hegemony? The same can be said of Lusinga lwa Ng'ombe, of course, although he—or at least parts of him—would live on in certain ways.

Twists and turns continued as Storms returned to Europe. He bore Lusinga's skull in his luggage and presented it to the eminent physical anthropologist Émile Houzé, who made it the subject of a sinister treatise. As "one of the fathers of Belgian anthropology," Houzé "systematically analyzed the ethnic characteristics of Belgian populations." Through proto-eugenic discourse, he drew analogies to the "degeneracy" he perceived in Lusinga's cranium as he sought to determine essential differences between Flemish and Walloon communities to the distinct advantage of the latter.[4] Storms also brought home booty seized from Lusinga, including a magnificent ancestral figure now considered a treasure of the Royal Museum of Central Africa. Unpublished photos taken in 1929 as the Widow Storms prepared to donate her husband's African collections to the Royal Museum show the sculpture standing before an overmantel mirror that reflected phantasmagorical displays in the Stormses' drawing room. Discussion of the "Africa" so created permits further thoughts about how Belgians understood Lusinga and other central Africans at the turn of the century.

What might have become of Lusinga's sculpture or skull had these objects remained in the Congo? In the late 1800s Lusinga and a few of his kinsmen seeking to exploit the explosive potentialities of the east African ivory

and slave trade adapted symbols of self-aggrandizement in emulation of the fabled Luba kingdom that was so influential throughout southern Congo and adjacent lands. Lusinga commissioned the unusually large ancestral figure mentioned above as the locus of matrilineal ancestors who would support and validate his emerging authority. The sculpture would have been central to Lusinga's attempts to create a perduring dynasty, for its spiritual investments extended the chief's person through the object's efficacies. Very few works from late nineteenth-century central Africa have received the ethnographic and historical elaboration that Lusinga's figure does in these pages.

Burial practices for Lusinga and those close to him were also borrowed from Luba models of kingship. Through arcane procedures mentioned in the Mpala-Lubanda Mission diaries of the 1880s and explained by my Tabwa interlocutors in the 1970s, Lusinga's skull would have been conserved for veneration, while his body was interred with the cranium of his predecessor beneath the course of a diverted stream. Such enchainment of one man's body with the skull of another further articulated through positional succession—one Lusinga was all Lusingas—defied death and time as a chief lived on in his successor. Unless, that is, his skull should be consigned to the drawer of a museum in Brussels.

And what *of* such museums? How are memories and artifacts of Lusinga and Storms presented to today's visitors to the Royal Museum of Central Africa at Tervuren, on the outskirts of Brussels?[5] Here, too, unexpectedly sinuous tales are to be told—or as often, whispered by the ghosts of Lusinga and his peers—with linear logic left behind. And yet, as our epigraph from Wallace Stevens suggests, relation *does* appear, however elusively, like a shadow on sand.[6]

The Present Book

The beheading of Lusinga was a signal *event*. By focusing upon the moment and its two protagonists, I hope to avoid "the reifying and dulling effects of generalization" and the spurious sense of cultural coherence that have characterized so many studies of African communities. As the humanistic ethnographer Michael Jackson asserts, "It is possible . . . to produce edifying descriptions . . . when we are afforded glimpses into what is at stake for the actors" of a particular event "and how they experience the social field in which they find themselves." Yet, as he continues, "rarely is an event described so fully or entirely that we, the readers, may see for ourselves the wealth of meanings it contains." A goal of the present study is to provide just such an opportunity to

ponder "the ways an event gradually or dramatically illuminates what is at stake for those involved, and . . . the ways it carries ethical and practical implications that far outrun specific individual intentions and awareness." Indeed, as Victor Turner demonstrated through his own processual studies elsewhere in central Africa, such a focus can reveal the workings of society itself. This will be, then, an "ethnography of the particular," following Lila Abu-Lughod, for such specificities "are always crucial to the constitution of experience" with all the fits and starts, regretted decisions, dismal failures, initiatives to cope and thrive, and blinding successes so implied.[7] After all, colonialism was introduced and implemented event by event, soul by soul.

Despite obvious dissimilarities of means and purpose, European accounts from "the colonial library" and Congolese oral narratives from the 1970s reveal intriguing entanglements of purpose. We shall consider interdependent histories of (would-be) colonizers and (soon-to-be) colonized that require a "contrapuntal perspective . . . to think through and interpret *together* experiences that are discrepant, each with its particular agenda and pace of development, its own internal formations." As Edward Said further suggested, either interpreted without the other permits only a pale view of the peculiarities of early encounter; and although as a "regime of truth" the colonial archive could and can be overpowering, the Congolese narratives we shall consider strongly suggest that subaltern agency has been maintained from proto-colonial times to the present day.[8] How *can* one approach circumstances other than "contrapuntally" when Lusinga and Storms vied to establish authority and, at least for the first months that the latter occupied his fortress at Lubanda, it was by no means clear which of the two would prevail? Inspiration will be drawn from Talal Asad's largely unanswered urging to investigate "the cultural character of hegemony" and from Marie-Louise Pratt's call to consider how central Africans who received early European visitors interpreted "the historical processes they were living" as "coded in ceremony, sculpture and painting, dance, parody, philosophy and history."[9]

Several aspects of this project should be clarified. While I am trained as a sociocultural anthropologist, my studies and teaching have long been resolutely interdisciplinary. In following the fraught relations between Lusinga and Storms and their odd aftermaths, I shall bring to bear literatures that rarely meet in a single work, occasioning a longer-than-usual bibliography. Exegeses and ethnographic data from many months of research at Lubanda will receive equal play with documentation from long archival study in Zaïre

(now the DRC), Belgium, and the Vatican. My own points of view will be evident, among the many other perspectives presented in this study. In this regard I readily acknowledge V. Y. Mudimbe's assertion that it is impossible "to imagine any anthropology without a Western epistemological link," and I also accept James Clifford's sense that "ethnographic representations are always 'partial truths'" and political in various ways, sometimes unwittingly so. In mitigation I seek multiple accountability to the Congolese and Belgians under discussion in the pages to follow. Luise White's reflection on her own work is apposite here: "If this study has any authority at all—indeed, if I can use the term with a straight face—it is . . . because I am writing about the colonial world with [and through] the images and idioms produced by the colonial subjects."[10] Scholarship should be open-ended and no one given last words, including the present author.

From the accounts to follow, a sense will emerge of how social life wanders, detours, and flips over upon itself as often as it follows any so straight a course as has been described in most social-science accounts over the years. As John Comaroff holds, we should "broaden our analytic compass to take in [colonialism's] moments of incoherence and inchoateness, its internal contortions and complexities" so as to "treat as problematic the *making* of both colonizers and colonized." Colonial memories will be investigated as well, through the diaries of Émile Storms and especially through conversations with a most remarkable Tabwa raconteur named Kizumina, in order to grasp the dynamics of meaning-making in very particular, eventful circumstances.[11]

What-ifs and might-have-beens will not be avoided, for I would rather deduce from incomplete data than restrict my presentation to evident record. Intellectual risks should be taken rather than acquiescing to the seeming silences of the past. I also hope that some sense of the *absurdity* of proto-colonial encounter will be imparted in the pages to follow, with emphasis upon that word's Latin reference to deafness: Lusinga, Storms, and those who would follow them simply could not seem to "hear" one another—or as often, they chose not to listen. In somewhat similar regard, "colonialism . . . exercises its authority through the figures of farce," and we shall see that Storms and his European peers were by no means immune to such devices, but in significant ways, nor were Lusinga and his supporters. Grasping any such intra- and inter-cultural dissonance poses literary challenge, and I gladly pick up the writerly gauntlet in hopes that both information and sensibility will be conveyed.[12]

My goal is to offer multiple and sometimes competing perspectives from within the cultures implicated by these stories, and to examine them according to the perspectives of complementary academic fields. This will not be a positivist History, in other words, and to the extent possible, I shall seek insights from indigenous historiology as manifested in the Tabwa narrative form called *milandu* that is the subject of this book's second chapter. Through milandu, histories—always plural—are made by orators to serve particular political purposes, using collective memories that are arranged and emphasized differently by adversaries much as opposing trial lawyers in the United States compose their cases for litigation. Any given *mulandu* is vulnerable to other, more convincing and expedient constructions, even as it retains its verities for some. One is reminded of Akira Kurasawa's brilliant film *Rashomon,* as it carries "the ethical burden . . . not just that the truth of any event is relative to our vantage point and interests, but that the outcome of any event hinges on how successfully we claim final truth for our own view, and how we relate our own interests to others." As Jan Vansina has noted with specific regard to Luba peoples, "historical consciousness continuously re-creates its contents with the changing of times" through interpretive *processes,* often articulated by multivocal symbols. Significantly, the making of histories in central Africa is often instigated and facilitated by performance and related visual arts, as Mary Nooter Roberts and I have explored through museum exhibitions and writings on Luba and Tabwa peoples. The tensions between memory and history that we have studied, especially as understood through and adapted from the writings of Pierre Nora, are of specific pertinence to the present work.[13]

A second source of epistemological inspiration is *bulozi,* a set of concepts and practices that share the logic and often provide circumstances for the production of milandu. As Michael Jackson reflects, "Human wellbeing . . . involves endless experimentation in how the given world can be lived *decisively,* on one's own terms," and bulozi, as an "occult search for capacity," is a primary means to assert such agency. "Bulozi" is usually translated—and reductively so—as "sorcery" or "witchcraft," and virtually every study of central African society features discussion of its means and ramifications.[14] Too often lost are the ambiguous potentialities of bulozi that are always subject to interpretation. That is, one observer's sense that the bulozi associated with some action is nefarious will invariably be countered by another's that the very same attitudes and accomplishments are morally justified and astonishingly clever, since they have led to a welcome outcome. Thus, bulozi is necessary to social life as Tabwa know it,

and its local-level analysis is always *situational,* changing over time as people seek to know the etiology of misfortune through divination even as events inexorably develop. The indeterminacies of bulozi and the problem solving it occasions have everyday significance, and although such indeterminacies will not be discussed often in the pages to follow, they inform every one of them. Of particular interest will be how the bulozi paradigm undoubtedly influenced local understanding of Émile Storms's various actions to the favor of some and to the distinct disadvantage of others like Lusinga.

Geography and Social Identity in Southeastern DRC

Lake Tanganyika is a feature of the Western Rift that begins in Djibouti on the Red Sea coast and curves far inland to find the ocean again in Mozambique. As a geographer has quipped, "Africa comes unzipped" along this great tectonic tear, and Tanganyika is one of the longest, largest, and deepest freshwater lakes in the world.[15] Terrific tropical storms rush "up" from the north, as people at Lubanda define cardinal directions, bringing assaults of lightning and towering waterspouts. Great waves crashing on rocky shores, treacherous currents, and the occasional whirlpool can make travel on, and especially across, the lake very perilous indeed. Lands southwest of Tanganyika are marked by jutting peaks, exfoliating granitic domes, ancient volcanism, ongoing seismic activity, and striking rock formations; by swift rivers emptying into the lake, with the Lukuga River the only outlet leading to the mighty Congo; and by swamps and moors extending from the Marungu Massif toward the grassy savannahs of northeastern Zambia (fig. 0.3). Big game used to abound throughout the region but have been hunted out in most places. Nowadays fishing on the lake and in its lagoons and estuaries is far more important to food and trade than whatever hunting remains.

The carrying capacity of land is generally poor throughout present-day southeastern DRC, the terrain exceedingly rugged, and population density relatively low. A demographic map from the 1960s shows significant settlement around Lubanda but vast, virtually empty expanses along the lake as mountains drop to water's edge and inland across steep flanks and deep valleys. Lubanda is located where the Lufuko River empties into Lake Tanganyika, and the village's name refers to the two annual crops of millet and maize harvested from its rich alluvial soil, as is rarely found elsewhere in the region. Astounding numbers of a small catfish called *jagali* (*Chrysichthys sianenna*)

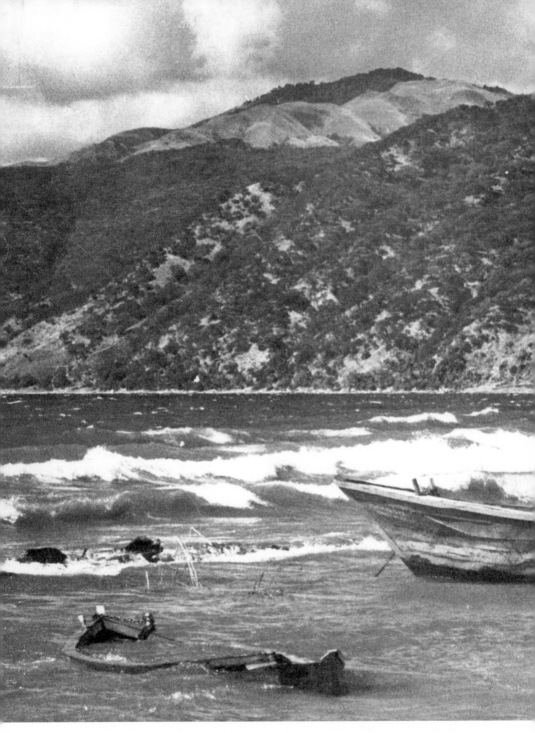

Figure 0.3. Stormy weather on Lake Tanganyika and the flanks of Mount Nzawa, looking south from Lubanda. Photo from the research of Christopher Davis-Roberts and Allen F. Roberts, 1976.

spawn in the Lufuko's meanders every year and are caught in elaborate weirs to be smoked and traded throughout the region. Such unusual resources have contributed to Lubanda's size and historical prominence. In contrast, Lusinga's hamlet remains a remote little settlement high in the mountains southwest of Lubanda, lost in a boggy meadow that is otherwise virtually uninhabited. How present-day population in the region might reflect demographics in the 1880s is difficult to determine, but Émile Storms found lands around Lubanda to be "bestrewn with . . . countless small villages, each nearly independent from the others, and without political cohesion," while Father Pierre Colle estimated that most villages in the area were composed of "five to fifteen houses, for which the chiefs are independent, so to speak." Little seems to have changed, except a fair distance to the south where Moba-Kirungu and satellite towns were created by missionary and colonial efforts in the early decades of the twentieth century. Several of these have been abandoned during recent years as people have fled civil strife, and resettlement efforts organized by the United Nations are creating small towns and villages as Congolese refugees who have spent twenty or more years in Zambian camps have been repatriated in 2010 and 2011.[16]

Obvious questions arise about ethnicity. Who lived and lives at Lubanda? Social identities throughout southeastern DRC are situationally determined and very complex. People have a range of identities to which they may refer depending upon needs of the moment, from sweeping "tribal" terms reinforced and sometimes invented in the colonial period to clan affiliations, lineages, and names derived from chiefdoms, regions, professions, social movements, and dialects.[17] Any of these points of reference and others still could be turned to when useful, much to the befuddlement of colonial administrators seeking to sort individuals and communities into political hierarchies for easy policing, taxation, and labor recruitment. At Lubanda, clan was the first-order, everyday social reference in the 1970s. By then, though, "Tabwa" had become an umbrella term accepted as the primary ethnic identity extending from Lubanda to communities some ways north of the Lukuga River, blending into Luba-related peoples to the west, and continuing southward to chiefdoms well into northeastern Zambia. Tabwa also maintain political and ritual associations with communities across Lake Tanganyika in southwestern Tanzania. And although this book cannot be the place for extensive theorizing about the nature of ethnic identity in central Africa, Tabwa culture will be understood as collective "processes of differing," to borrow an

apt phrase from the social theorist Tony Bennett, rather than any beliefs and practices neatly bounded by time or territory.[18]

Tabwa lands are roughly the size of Colorado, and people living in remote areas speak dialects of Kitabwa that are closely associated with and merge into Luba and Bemba languages to the west and south, respectively. Along the southwestern shores of Lake Tanganyika, Swahili has been the first language of several generations, and in the 1970s Kitabwa was spoken as a first language only by those far from the lake or by the very elderly. At Lubanda, people are proud of the "excellent" (*bora kabisa*) quality of their Swahili as opposed to the "so-so" way (*hivi-hivi tu*) they understand it to be spoken elsewhere in the DRC, and especially in Copperbelt cities like Lubumbashi. My own ethnographic research was conducted in Swahili, while my French has proven crucial for archival work and literature studies; I have turned to others to assist me with a few texts in Flemish. All translations from Swahili or French to English in the present text are my own.

A final point: lands southwest of Lake Tanganyika, including Lubanda and other places that are important to the pages that follow, have been swept up in the bloody conflicts of the DRC for many years now. The First Shaba War broke out in 1977 while I was completing my Congolese research, and in the 1990s Lubanda was attacked, occupied, pillaged, and much of it razed several times by different factions. Conflict-exacerbated epidemics and famine killed a great many at Lubanda, and a significant number of survivors made the long trek southward to refugee camps organized in northeastern Zambia by the United Nations. After more than a generation, a fragile peace has been restored to much of southern DRC, and refugees have begun returning to Lubanda and surrounding areas. One can only hope that stability will continue and fulfillment be found for years to come. As of this writing in 2012, with millions dead and many more grievously wounded in body and soul through a genocide still raging in northeastern DRC, we must further pray that all such conflict will be resolved and reconciliation achieved throughout the Democratic Republic of the Congo in the very near future.[19]

Part 1 · The "Emperor" Strikes Back

Les lettres du blanc sur les bandes du vieux pillard.
"The white man's letters on the hordes of the old plunderer."

Les lettres du blanc sur les bandes du vieux billard.
"The white man's letters on the cushions of the old billiard table."

—RAYMOND ROUSSEL, "IMPRESSIONS OF AFRICA"

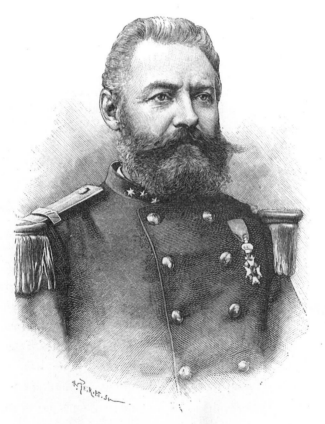

Le capitaine Storms.

Figure 1.1. Émile Storms in an engraving of 1886.
Artist's signature illegible, Giraud 1890, 451; public domain.

1 · Invitation to a Beheading

The colonizer constructs himself as he constructs the colony.
The relationship is intimate, an open secret
that cannot be part of official knowledge.

—GAYATRI SPIVAK, *A CRITIQUE OF POSTCOLONIAL REASON*

In the mid-1970s, people living in the large village of Lubanda in what is now the Democratic Republic of the Congo (DRC), readily recalled the name and a few of the exploits of Bwana Boma, despite his having lived there for a mere two years nearly a century before. Bwana Boma is the local sobriquet for Émile Pierre Joseph Storms (1846–1918), Belgian leader of the fourth caravan of the International African Association from Zanzibar to Lake Tanganyika that arrived deep in the heart of Africa in late September 1882 (fig. 1.1). The name Bwana Boma means "Mister Fortress," and it was chosen during Storms's days at Lubanda because of the formidable stronghold Storms constructed there in 1883.[1] Storms was an assertive young man who sought to leave his mark on European conquest of the Congo. With acuity and irony, a Belgian journalist noticed Storms's unmitigated ambition and heralded him as "Émile the First, Emperor of Tanganyika."[2]

Of Bwana Boma's many adventures, the one that proved pivotal to his proto-colonial project was a punitive expedition he mounted (but did not himself lead) in early December 1884. The goal was to sack the mountain fastness

of Lusinga, a most "sanguinary potentate," in the estimation of Joseph Thomson, the Scottish explorer who visited the chief in 1879.[3] Lusinga commanded men engaged in ruthless pillaging and slave raiding in a wide area north of Lubanda, and such activities seemed justification enough for Storms's attack. Yet as we shall see, he had more deep-seated reasons as well.

Setting the Scene

The mid to late 1800s were turbulent years in what is now known as southeasternmost DRC. Beginning around 1830, Swahili adventurers from coastal east Africa circumambulated or crossed Lake Tanganyika to hunt elephants and take slaves in the Marungu Massif and adjacent lands. The term "Swahili" and the related designation *wangwana* referred to "free-born" coastal men, as such social references were understood as far inland as Lake Tanganyika. These were expansive as well as prestigious identities, and non-coastal people could "reinvent themselves as *waungwana* by appropriating coastal culture, [and] by dressing and living a *waungwana* lifestyle" that included rich displays of consumer items and related material culture.[4] Storms noted that persons who presented themselves as "free-born" might remain enslaved in Zanzibar but possess significant autonomy in the interior. As one scholar has reflected, "The slave who had simply spent time in Zanzibar, even for a short while, was called an Ngwana 'free man' thereafter; . . . every *askari,* by the sole act of having taken part in a military escort, became an Ngwana; . . . [and] far from Zanzibar, the Arab, the free Swahili person, the slave of the coast, all were labeled *wangwana.*" Such a fluid sense of what constituted "free-born" challenges what being "enslaved" must have meant in the same circumstances, as understood across different languages and social practices as well as through individual cases. Indeed, Stephen Rockel argues that wangwana "were at the cutting edge of African engagement with international capitalism, that they were the prime movers in the economic, social and cultural network building of the period, and that they expressed an alternative East African modernity."[5]

Swahili and wangwana were soon seconded by or competing with mercenary brigands known as *rugaruga,* who hailed from what is now north-central Tanzania. In the words of historian Aylward Shorter, rugaruga were "wild young men, a heterogeneous collection of war captives, deserters from caravans, runaway slaves and others. They were without roots or family ties, and they owed no allegiance other than to their chief or leader."[6] Rugaruga often acted as

highwaymen, harrying straggling caravans. As Storms noted, "When a caravan crosses the land, it is considered a great godsend [*aubaine*], a favorable wind that has brought resources and circumstances that chiefs exploit as much as possible." No wonder that a few years later, a European stalwart found rugaruga to be "real vultures" preying upon the weak and robbing the dead.[7] Storms's phrase "a favorable wind" may have been a common expression in French, but it resonated with how local people would have understood such "good fortune": a *pepo*, or spirit—literally a "wind"—would be the agent leading the caravan into rugaruga clutches. Tabwa would comprehend the European metaphor of rugaruga as "vultures" in their own way as well, for like these remarkable birds, the brigands benefited from an extraordinary ability to locate caravan "carrion" over great distances. Indeed, vultures are deemed to possess a supernaturally extended ken that Tabwa call *malosi* as an attribute shared with hyenas and a few other predators and scavengers.

Ivory and slaves that rugaruga obtained to the west of Lake Tanganyika by commerce, force, and wile were sold to Swahili or Omani (collectively called "Arab") traders based at Ujiji as of the 1840s, and at several less significant entrepôts along the eastern shores and to the south of Lake Tanganyika. Some of the enslaved were settled around Ujiji and adjacent areas, but most were taken to the trading town of Tabora in what is now north-central Tanzania as a place that served as "the veritable knot of communications to which caravans converged and from which they left in all directions," to paraphrase Jérôme Becker.[8] Émile Storms commented on how in mid century, "Arabs" at Tabora and elsewhere were almost exclusively engaged in plantation agriculture, for which enslaved people provided the labor, but that after 1873 when slavery was abolished in Zanzibar, labor availability changed and the same Arabs became agents for Indian merchants in Zanzibar who were largely responsible for the burgeoning international trade in ivory. Those not put to work around Tabora itself were forced on to coastal cities or offshore islands for dispersal into the Indian Ocean world and beyond. Storms also noted that an enslaved person purchased for five piasters along the southwestern shores of Lake Tanganyika would be worth fifty to one hundred or more in Zanzibar, thereby suggesting relative market values despite how prices fluctuated from place to place and moment to moment. And for every enslaved central African who survived to reach coastal ports, a great many died in raids upon their communities or in harrowing transit from the interior.[9]

In the 1870s Lubanda was "a place of much importance as the principal starting-point of the caravan route adopted by Arab traders from Ujiji to Lake

Mweru and Katanga."[10] Saïd Barghash, the Omani sultan of Zanzibar, may have stationed a representative at Lubanda for some years to take advantage of "one of the richest mines of slaves" that the hinterland presented at the time. According to one account, the famed trader Sheikh Saïd bin Habib lived at Lubanda in the 1870s, and then a few years later, the even more renowned Juma Merikani, whom Verney Lovett Cameron met south of Lubanda and who would befriend several European explorers, was there as well, but whether they were resident at Saïd Barghash's behest is not clear.[11]

The prominence of Lubanda was undoubtedly why David Livingstone was brought there in mid-February 1869, following his visit to King Kazembe and exploration of what is now northeastern Zambia. He remained in Lubanda for about two weeks, too close to death from pneumonia to leave diary entries describing his stay.[12] Livingstone did write that Saïd bin Habib was in "Parra"— that is, Lubanda as the village of Chief Mpala ("Parra")—and maintained two or three large pirogues there. When the explorer was finally strong enough, he was conveyed northward by these vessels, arriving at Ujiji, where he could recover his health with the help of resident coastal traders. Livingstone would remain in the area, taking a long trip northwest of Lake Tanganyika before returning to Ujiji to be "discovered" so presumptuously by Henry Morton Stanley in late 1871.[13] A century later, people in Lubanda showed me where they believed the boat taken by Livingstone had been moored.

Lubanda was only of fleeting importance as a point from which to cross Lake Tanganyika, for rugaruga soon blocked the route inland as they sought to dominate ivory and slave trading. Thereafter, Lubanda resumed its status as an especially large and prosperous cluster of lakeside hamlets known not only for unusual agricultural productivity and lake and river fishing but also as a place vulnerable to pillaging because of just such abundance.[14]

In late 1879 an affable young Scotsman named Joseph Thomson—a tender twenty-one at the time—hiked along the rugged southwestern shores of Lake Tanganyika, visiting small villages wherever a cove or scrap of flat land permitted settlement in otherwise steeply mountainous terrain. Thomson headed the Royal Geographical Society's East African Expedition of 1878–1880 after the death of the original leader, Keith Johnston. As opposed to the era's shoot-first-ask-questions-later ethic of European explorers riding about in their *tipoy* portable hammocks and accompanied by lavish caravans, Thomson personally led his modest party unarmed and on foot. And although he was sometimes confronted by defensive parties who feared he

might be leading a slave raid or other attack, in each instance Thomson was able to prove his peaceful purposes without further incident, "his youth and high spirits" getting him through all such scrapes.[15]

In 1881 an anonymous reporter for the *New York Times* found that "it was indeed a singular fact that a mere boy . . . should make so rapid a march as he, so long a journey, and one through so many different tribes of all degrees of semi-civilization, without the loss of a single porter, and, what is infinitely more to his credit, without the sacrifice of a single life among the tribes he passed."[16] One must be cautious with regard to any so heroic a portrait, however, for as Johannes Fabian suggests and we shall discuss in chapter 4, Thomson's "youthful impetuousness and Scots radicalism" call for skepticism concerning some of his pronouncements.[17] Despite the *Times* reporter's hyperbole, the young man did stand out as an exceptional Victorian visitor, however. As Robert Rotberg has suggested, "Thomson, virtually alone of the leading explorers of Africa, professed to have *liked* Africans and to have attempted to treat them as equals—and not in accord with some abstract principle, but in an unaffected, natural way."[18]

Moving northward toward Lubanda, Thomson was impressed with the lot of local people: "Seldom or never making war, they live in the utmost comfort, in possession of an extremely fertile region, which yields food in great variety and abundance." He also admired the "cleared and cultivated fields of indescribable richness, producing wonderful crops of Indian corn, millet, ground-nuts, sweet potatoes, voandzia ['Congo goobers'], beans, and numerous other kinds of vegetable food." Indeed, he surmised that local people "have not a want which they themselves cannot supply."[19]

Thomson was well received at Lubanda by Sultani Mpala, who insisted that he and his retinue enjoy the chief's hospitality and spend the night. Continuing north along the shore, Thomson traversed another "charming piece of country" to arrive at Cape Tembwe, a promontory extending a good ways eastward into Lake Tanganyika. The scene then changed radically, from Thomson's Edenic pastoral to one of bleak devastation, for the large village at Tembwe was "packed with refugees" from surrounding areas laid waste by slave raiding. Despite such turmoil, local chief Fungo and the Scotsman "soon became the best of friends," suggesting reasonable behavior on both sides. Until two or three years before Thomson's visit, Fungo "had had a considerable number of villages under him," but now only Tembwe remained, the others having been destroyed by a chief "known as Kambèlèmbèlè, or 'Swift-of-Foot,' though his proper name is Lusinga" (fig. 1.2).[20]

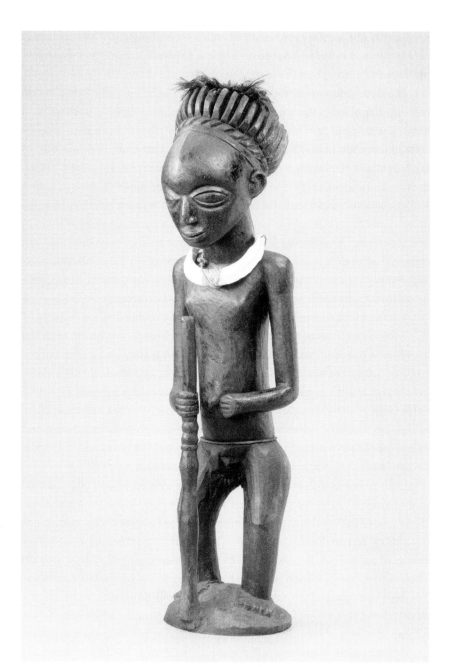

Figure 1.2. Ancestral figure of Lusinga and his matrilineage. H. 70 cm.; wood, bushpig tusks, feathers, reptile skin, fiber cord; unknown artist. EO.o.o.31660, collection RMCA Tervuren; photo R. Asselberghs, RMCA Tervuren © with permission.

In the 1860s and 1870s, Lusinga and a few other local chiefs began con-
solidating and legitimizing their authority through emulation of eastern Luba
models of dynastic political economy while gaining ever greater power by
taking advantage of turmoil caused by intrusive slave raiders.[21] Some of these
latter visited the southwestern shores of Lake Tanganyika, but population
density was generally too thin and the terrain too rugged to encourage any of
them to stay for long. While the economic stakes did not attract settlement
by those with the means to seek greater profits elsewhere in the region, Swift-
of-Foot did establish himself but followed the slave traders' ruthless modes
for increasing his wealth and power at the expense of local people. Further-
more, by locating his base of operations in a remote location *between* slave
routes and entrepôts, Lusinga was able to participate in the trans-regional
political economy while remaining sufficiently "local" to enjoy the advan-
tages of lineage and clan affiliations.

Great power could be had quickly by marshaling even a small force of
heavily armed rugaruga as Lusinga did to engage in small-scale trade in ivory
and slaves. Storms would write that "every native chief possesses *ruga-
ruga*. . . . If he makes war all men take up arms, but the *rugaruga* constitute the
principal core. In peaceful times, the *rugaruga* have as their profession brig-
andage for the chief." The lieutenant further noted that "war is imposed upon
chiefs, for if they do not wage it, they will lose their *rugaruga* who will go and
place themselves at the disposition of a neighboring chief who is more belli-
cose." Storms failed to mention his own force of rugaruga and other African
warriors in this passage, yet he was playing much the same game by many of
the same rules. Indeed, late in his stay he would ruefully note that were he to
prohibit his men from pillaging and taking slaves, he might as well take his
own life on the spot, for no one would follow or support him thereafter.[22]

Lusinga played the bandit's game very effectively in Thomson's estima-
tion. "From being an insignificant Uguha chief, . . . [Swift-of-Foot] suddenly
emerged from his obscurity in the west, descended like an avalanche upon
the more peaceably disposed inhabitants near the lake [Tanganyika], and
swept off the entire population of thirty or forty thriving villages, turning the
country into a perfect desert." At some point it seems that Lusinga visited
Unyanyembe near the important caravan town of Tabora in what is now
north-central Tanzania, where he began "to appreciate the marketability of
slaves and ivory." He may have acquired muskets there, or, more probably, he
hired armed rugaruga. Mid-century Arab traders sought to maintain a

monopoly on guns and powder, so that when Richard Burton visited Ujiji in 1859, even the most powerful local chiefs had at most two or three "fire-locks" at their disposal, if any at all.[23] According to Storms, Lusinga was the first to deploy such weapons against people west of the lake, who still defended themselves with arrows and spears, and it was such superior armament that proved "the origin of his glory," as Lusinga quickly vanquished Bondo and the other chiefs living around Cape Tembwe whom Thomson later visited. It should be noted that Lusinga and Bondo were closely related through lineage and clan, as are their descendants. Storms wrote with derision that Lusinga had been outnumbered by Bondo's men, who included fierce "Warua" or eastern Luba warriors, but that he alone possessed a firearm, and when he shot a man dead, great panic ensued from what was deemed a magical event.[24]

For a while, Lusinga settled at Cape Tembwe to control trade at this important point for crossing Lake Tanganyika, which was still used by smugglers in the 1970s, and he established a "large stockaded village there called Baliolima" or "There Where They Farmed." The lyricism of such an Arcadian name was belied by Lusinga's ruthless pursuits, however, as "he [had] made an onslaught on the surrounding villages, killed the useless old men and women, and made slaves of the others, thus establishing a lucrative 'business' without much trouble, though the consequence was the depopulation of 200 square miles of the most fertile land of the interior."[25] Lusinga soon came into contest with east African strongmen and their rugaruga mercenaries also operating around Cape Tembwe, and the chief and his followers retreated to a new position on the Muswe, a tributary of the Lufuko River high up in the craggy Mugandja Mountains.

Lusinga's village is a two-day hike west-southwest of Lubanda and located near a significant and still exploited salt spring at Kakonto. Exceptionally high grade iron ore was surface-gathered or obtained from shallow pits thereabouts as well, and through the deeply sophisticated technology of open-draft furnaces, "a soft steel comparable to that of Sweden" was smelted in the late nineteenth century that, when "polished, . . . has the gleam of silver and rusts less quickly than that of Europe." Accomplished regional blacksmiths forged a huge array of tools, weapons, gongs, jewelry, and ingots.[26] In earlier times, management of resources like salt, iron, copper, and fish proved essential to those who would consolidate and hold political power, as Thomas Reefe has demonstrated with regard to kingdoms of the Luba heartland.[27] Lusinga's reasons for settling along the Muswe clearly included more than its strategic position high in the mountains but within striking distance of the lake.

The most famous of the east African warlords competing in this fraught arena was Msiri, who established an important polity in the 1850s at Bunkeya, several hundred kilometers to the southwest of Lake Tanganyika. Neither Lusinga nor Storms is known to have had contact with Msiri, but nonetheless, he would become indirectly significant to them. Although originally from north-central Tanzania and of the "Sumbwa" congeries of peoples, Msiri and those who migrated westward with or like him came to be known as "Yeke," a new, situationally defined ethnicity after a Sumbwa term said to refer to elephant hunters.[28] Msiri established startling dominance of trade athwart the flow of commerce from ocean to ocean and among the most powerful kingdoms of central Africa. His military actions were feared and his attentions coveted, and European delegations sought Msiri's favor as an entrée to what was already known and wildly imagined of the natural and human resources of Katanga. With Msiri's assistance or toleration, Portuguese ivory and slave traders also undertook raids in southeastern Congo during the latter half of the nineteenth century, sweeping many Luba and other local people to what is now Angola and on into the Black Atlantic world.[29] As we shall see, important cultural activities were carried westward and back in the course of such frightful travails.

A far less well known Yeke chief named Ukala settled in the mountains west of Lubanda, not far from Lusinga's fortified village on the Muswe. There, "by ruse and audacity, he was able to create a little kingdom," Storms explained.[30] Lusinga called upon a chief named Kilembi of the Zimba or "Serval" clan to join in attacking Ukala to drive him away as a pestiferous competitor, and when Kilembi's men defeated Ukala and brought his head to Lusinga, the latter had nothing to give them in return other than his permission to settle in a portion of the lands that he himself had received from Sultani Mpala. Kilembi's rights to this territory have been contested ever since, but more to the point, Ukala's successor joined Storms in his armed conquest of Lusinga in December 1884.[31]

In the meantime, European powers and the United States had growing designs on the astounding mineral wealth of the Congo River Basin. European exploration might be publicized in different ways, stressing the need to promote scientific and humanitarian goals while suppressing the east African slave trade, but just beneath the surface of any such grand claims lay rank conniving for politico-economic advantage.[32] So it was with the creation by Léopold II, King of the Belgians, of an International Association for the Civilization of Africa during the Geographical Conference of 1876, followed by a Brussels-based International Association of the Congo (IAC) in 1878 and

then the International African Association (IAA) in 1882. These organizations were deliberately confusing, for Léopold wrote that "care must be taken not to let it be obvious that the Association of the Congo and the African Association are two different things." Distinctions were to be blurred between a purportedly international body (the IAA) and the organization through which the king's personal interests were pursued (the IAC), that is, and it was the claims of the latter that were recognized at the Berlin Conference of 1885 and led to the creation of the Congo Free State under Léopold's auspices.[33] Émile Storms was sent to central Africa by the IAA but in many ways served the less evident schemes of the IAC, as he himself attested with some frustration in a letter to the IAA.[34]

In opening the Geographical Conference of 1876, Léopold famously blustered that "until now, all attempts to reach the interior of Africa have been isolated. Each nation, each scholarly society, each individual has acted according to its own views. To open to civilization the only part of our globe where it has yet to penetrate, to pierce the darkness that envelops entire, vast populations, would be, if I dare say so, a Crusade worthy of this Century of Progress."[35] Some decades later, these last phrases would become an encomium to the king and his Congolese enterprises still emblazoned upon the walls of the Royal Museum of Central Africa, even as Léopold was held accountable by some for "the ten million murders on his soul" resulting from his years plundering the Congo, according to none other than Mark Twain.[36]

Belgium itself was less than fifty years old when Léopold proclaimed his vision of "civilization" in 1876. While the stated aims of the IAA's "Crusade" were to assist scientific, missionary, and commercial endeavors and to encourage suppression of the east African slave trade, Léopold's personal goals were far less lofty. As the king quipped "with astonishing frankness and cynicism" in an 1877 letter to his ambassador in London, he fully intended "to obtain a part of this magnificent African cake," and, not coincidentally, in so doing he would become wealthy beyond measure.[37] More generally, in launching his colonial project, the king would give collective purpose to his young nation, and "in a way, Belgium would be a creation of the Congo as [much as] this latter would become Belgium's creation," as the Congolese historian Isidore Ndaywel è Nziem holds.[38] The mimesis so implied will inform our understanding of the fateful conflict between Storms and Lusinga as discussed throughout the remainder of this book.

Swift-of-Foot and Bwana Boma

The abilities and qualities of Émile Storms were noticed by his superior officers through achievements of which there are next to no hints in the barebones documentation of his Belgian army career.[39] In 1882 he was commissioned to lead the IAA's fourth expedition to Karema on the southeastern shores of Lake Tanganyika. Storms would relieve Captain Jules Ramaeckers and then cross the lake to establish a fortress somewhere on the southwestern shore as a "bead in the rosary" of IAA stations extending from the east African coast to the Congo Basin.[40] The lieutenant would strike out westward from the lake to create several outposts along the Lualaba River and meet Henry Morton Stanley's expedition moving up the Congo River from the Atlantic coast. In this way, a "White Line across the Dark Continent" would be traced, in the words of a contemporary tract.[41] If all went well, Stanley and Storms could achieve this end by 1885, and Storms would then return to Europe via the Congo River, thus retracing Stanley's riveting transcontinental trek of 1874–1877.[42] Establishment of such a strong and evident presence would lend legitimacy to Léopold's eventual claim at the Berlin Conference of 1884–1885 that the immense Congo Free State should become his personal domain, and Storms's renown would be assured by such an epic deed.

Storms left Europe for eastern Africa in the spring of 1882 and set forth for Lake Tanganyika from Bagamoyo that same June, leading a relatively small caravan of 126 men. He was to have been seconded by Camille Constant, a grenadier from an elite Belgian regiment, but the latter took ill with fever in Zanzibar and immediately returned to Europe without setting foot on the continent.[43]

During a prolonged stop at Tabora in mid-August, Storms met with the famed coastal trader Tippo Tip (Hamed ben Mohammad el-Murjebi) and sought to create a pact through which the lieutenant would found an outpost at Nyangwe on the Lualaba (Upper Congo) River. Tippo Tip would further acknowledge that Stanley Falls would "belong" to the Belgians. Although no further explanation is offered, such an accomplishment would be an essential establishment in the chain of those that Stanley and his men had created. According to a Belgian account, "Tippo Tip presented several schemes but all were so onerous that he [Storms] was obliged to decline his offers," although in a letter to Storms, the IAA general secretary urged him to pursue the matter

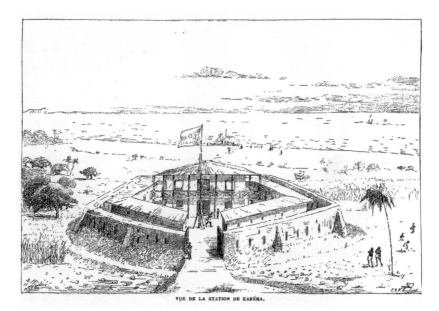

VUE DE LA STATION DE KARÉMA.

Figure 1.3. The fortress at Karema as Storms first found it.
Artist's signature illegible, Burdo 1886, 463; public domain.

should he encounter the man again. In his own diary, Tippo Tip gave the story a different spin, asserting that Storms told him he would provide guns and powder in exchange for porters to carry goods to Nyangwe. Any profits—presumably from use of the guns and powder—would be divided between the two. Tippo Tip told Storms he could conclude no such arrangement without authorization from Saïd Barghash, sultan of Zanzibar, but the lieutenant would hear of no such higher-level involvement. However this may have been, Tippo Tip allegedly told his contacts in Zanzibar that Storms had offered to purchase ivory from him that would be evacuated to Europe via the Congo River, and the rumor caused an ill-humored buzz among local ivory and slave traders, who assumed the monopoly to be their own.[44] The merchants' resentment would have consequences later in Storms's stay in central Africa.

It took the lieutenant a relatively brief three and a half months to travel from the coast of eastern Africa to Karema on the southeastern shores of Lake Tanganyika. The latter was where Ernest Cambier, leader of the first IAA expedition, had founded an outpost in 1878. With the death of Karema's commander, Jules Ramaeckers, Jérôme Becker was holding the fort when Storms arrived, and he stayed on for six weeks while the lieutenant situated himself.

As a first order of business, Storms vastly enlarged and strengthened the station at Karema, named Fort Léopold in the king's honor. The French explorer Victor Giraud visited Karema in late 1883 and reported that in laying eyes upon Storms's new design, local people were so astonished that they felt only the Supreme Being could have created anything so colossal (fig. 1.3).[45]

A German east African scientific expedition visited Karema during the early days of Storms's residency, and its leaders, Paul Reichard and Richard Böhm, soon became fast friends with the lieutenant. Reichard was ill, but Böhm joined Storms in response to an incident concerning Chata, a chief who lived an eight-hour hike north of Karema. Chata had attacked a village where many rugaruga were encamped, but was driven back, losing several men and the flag Storms had entrusted to him. The lieutenant felt he had no choice but to seek revenge through armed intervention, for, as he stated, by bearing his banner, Chata had "made war in my favor." Böhm was severely wounded in the thigh by a musket ball but recovered after several painful months, only to die of malaria some while later.[46] The skirmish on Chata's behalf seems to have been the last time that Storms would lead his own men into battle.

In May 1883 Storms left Böhm in charge of Fort Léopold and crossed Lake Tanganyika to establish a station along the southwestern shores. He traveled with two dozen men from the caravan that had brought him to Karema, as well as Reichard and some of his forces, who would soon be rejoined by Böhm and strike off for the fabled stronghold of Msiri.[47] The lieutenant traveled northward along the lakeshore, and when he came to a point of land just south of the Lufuko River, he recognized the place's special merits as a small, fertile delta supporting an unusually substantial population in several hamlets collectively known as Lubanda.

Whereas mountains rise abruptly from most of the southwestern shores of Lake Tanganyika, at Lubanda fairly flat land surrounds a promontory rising 30-some meters above the lake and with a clear view northward. Storms was struck by the strategic qualities of the location and its partially protected cove at the foot of the point, where he could build a fortress. Furthermore, local people were "mild" (*doux*), and Storms seemed impressed when, early in the first day of his visit, Chief Mpala Kakonto came to greet him accompanied by one of his wives (fig. 1.4). "This is the first time I have seen such a thing," the lieutenant wrote, quite incidentally taking note of the unusual egalitarianism between the sexes that still characterized Tabwa society at Lubanda in the 1970s. No sooner had he used the word "mild," however, than

Figure 1.4. Storms arrives in Mpala-Lubanda in 1883.
Alfred Ronner, Burdo 1886, 517; public domain.

Storms qualified his observation by asserting that local people were "pusil-lanimous," "lazy, and very talkative," almost as though he could not bring himself to offer any hint of a compliment.[48]

That same afternoon, Storms had a second meeting with Sultani Mpala, who was accompanied by an unnamed chief and two of the latter's wives. The lieutenant told Mpala that he wished to establish himself at Lubanda. The guns carried by Storms's retinue were worrisome to the chief, however. As Storms wrote, Mpala "told me that his people are peaceful, endowed with good character, and he hoped that the peace would not be troubled by my presence. I declared my good intentions and professed to them that I wanted to make friends

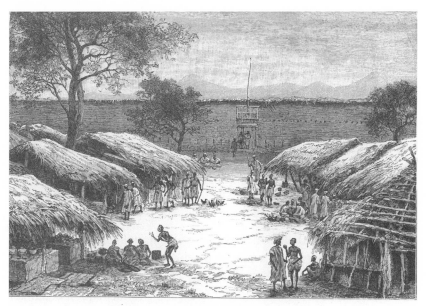

Rue et tembé de Mpala.

Figure 1.5. The only known depiction of the main street and vast *boma* (fortress) constructed by Storms at Lubanda. Artist's signature not evident, Giraud 1890, 505; public domain.

with all the inhabitants; and that, far from disquieting them, I would defend them should the need arise if they were attacked." These words were met with applause, and Storms "managed to render the two sultans sympathetic" to his propositions by giving them sumptuous gifts of cloth, including eight lengths of "*satini,* with which they were enchanted." Mpala sent a man to ask if Storms would be his "blood brother." The lieutenant responded that they could see to the ritual later, and he candidly ended the passage in his diary (in lines omitted when published in the metropolitan journal *Mouvement géographique*) by noting that "so ended the day. I obtained what I wanted."[49]

Following a plan executed at Fort Léopold, Storms commanded his men to cut "five thousand" trees to create a stockade that would be 30 meters square. The work required seven months of intense labor, and the resulting structure possessed walls of sun-dried earthen brick 60 centimeters thick (fig. 1.5). Its seventeen rooms surrounding a covered courtyard provided a "very agreeable habitation," in Storms's estimation.[50] The construction was undoubtedly influenced by the design of *tembe* defensive dwellings that Storms had seen along the east African coast and in towns to the interior like Tabora, and the layout

supported surveillance of his own premises as well as his perimeter. One is reminded of Michel Foucault's assertion that "in the Panopticon, there is used a form close to that of the castle—a keep surrounded by walls—to paradoxically create a space of exact legibility looking outward as well as into the protected central space."[51]

Having realized such an imposing achievement, it is little wonder that local people would call—and recall—Émile Storms as Bwana Boma, "Mister Fortress." One can further imagine what a dramatic stage such a place must have been as Storms and his men performed their play for power.

A Blood Covenant

Storms was "a clever diplomatist," the Leopoldian apologist Henry Wellington Wack surmised, and he set about making blood covenants and signing treaties with local chiefs as did other early European visitors to central Africa.[52] His first such act was achieved in acceding to the request of Sultani Mpala. As Storms recollected:

> Ever since my arrival in the Marungu, Mpala, chief of the lands that carry his name, had never ceased manifesting the most vivid desire to make himself my blood brother. For my side, I was pressed to respond to his solicitations, for my presence in the environs of his village was beginning to inspire such a panic among his subjects that several small hamlets had already deserted the country. To make an exchange of blood was the only way to revive confidence in their spirits, and so I waited impatiently to proceed to the ceremony until my boat could return from Karema, where I had sent for the several sorts of object one is expected to offer in such moments of fraternization.[53]

Storms's vessel returned in late June (about six weeks after his arrival at Lubanda), and he hurried to Mpala's compound, bringing Paul Reichard and two hundred of their combined forces with him. The sound of their drums and trumpets brought people running from all around. "Lusinga, chief of a vast district two days' march to the west, and who had come to Mpala to greet me, stayed on to preside over the ceremony." Sultani Mpala was "seized by agonizing fear" when he saw Storms's throng of wangwana mercenaries and rugaruga brigands, for he assumed that the lieutenant was coming to capture him and take his village—with the possibility of enslavement surely on everyone's mind. Lusinga, being "more intelligent" than Mpala, laughed and suggested that Storms

L'ÉCHANGE DU SANG.

Figure 1.6. Blood covenant as imagined for European readers.
A. Lynen in Burdo 1886, 31; public domain.

hold the event outside of Mpala's compound to allay any such trepidations. As Storms commented elsewhere, Lusinga "may not be the most important chief of the Marungu [Massif], but he is certainly the most feared. It will be good to be on my guard."[54]

However intelligent Lusinga may have struck Bwana Boma in their first encounter, "What an ugly mug!" he exclaimed soon thereafter. Thomson was similarly unimpressed by Lusinga, finding him "a tall lubberly-looking native . . . who suggested more the idea of a cowardly overgrown boy, than . . . a military leader who had depopulated the whole surrounding country with a very insignificant band of men."[55] "Lubberly-looking" refers to someone "coarse of figure and dull of intellect" and was a Dickensian epithet for an inexperienced seaman or other clumsy lout, "especially one who lives in idleness." The term once referred to drudges, scullions, and other "inferior servants," and as it has long passed from common usage, it is difficult to know its connotations of social class and ethnicity as addressed by Thomson.[56] We are left to reflect upon the differences between such descriptions and the implications of Lusinga's nickname "Swift-of-Foot," also as reported by Thomson, for Lusinga seems to have been anything *but* "dull," "idle," or "inexperienced" in his ravages. Later we shall see

how such pejorative descriptions of the chief played into sinister proto-colonial scenarios in the Belgian metropole.

The ritual of blood exchange, which Tabwa call *lusale*, began after Lusinga had seated the two parties on a large mat, facing each other and surrounded by their entourage. Two chickens were slaughtered and their livers grilled in the presence of both parties, presumably to avoid any suspicion of poisoning. Small incisions were cut into the chests of the protagonists using spear points, the chicken livers were soaked in the men's blood, and then each man placed his bit in the mouth of his counterpart while spears were clacked together in percussive rhythm above the men's heads (fig. 1.6).

Storms's wry comment was that "this little *lunch*"—he used the English word here—"was not especially pleasant." Oaths were to be taken, and Lusinga warned Sultani Mpala that he would forfeit his life and the lives of those close to him to supernatural wrath should he make war upon or otherwise injure his new blood brother. Lusinga then declaimed: "Whiteman, the oath of friendship through which you bind yourselves today should be sincere. You come amongst us [and] you must not hold us in contempt. If you harm Mpala or one of his people, you will die. If you make war on him, you will die, all of your people will die, and your powers will be finished."[57] The ironies of Lusinga being the one to make such a statement would soon become painfully apparent—especially to him.

Once the speeches were completed and the sign given that lusale had been "eaten," as Tabwa say, Bwana Boma's two hundred men fired a volley that "filled the native audience with wonder, who had never witnessed so grandiose a spectacle." Then, "in delirious joy," Storms and Reichard's throng began "leaping about, gamboling, gesticulating, and shouting as loud as they could. One would have thought that hell had unchained some of its pensioners." Storms commented that Sultani Mpala was joyful to witness this demonstration, but had it been produced when they first arrived at the chief's compound, the old man would have died of fright.[58]

More can be made of this event, the terms through which it was offered to metropolitan readers of *Mouvement géographique* in 1885 and *Le Congo illustré* a decade later, and its lasting ramifications.[59] Suffice it to say that in contrast to Storms's fairly anodyne presentation, the lieutenant expressed different views in boastful letters and in his more personal writings, through which he revealed profound ambivalence—if not outright contempt—for any such agreements with Africans.

> These engagements make me laugh. . . . The nigger [*nègre*] is a child, and to take treaties made with such children seriously is the height of ridiculousness. A nigger will make a treaty with you today and tomorrow with someone else without the least ill intention. If we want to have supremacy over a country we must occupy it effectively, there is no other way . . . for the general rule in Africa [is]: you must be feared, [for] friendship is a farce.[60]

Yet while Storms and his peers might seek pacts and written engagements with African leaders so as to provide a legalistic basis for land claims and a foundation for hegemonic enterprise, "Africans saw them as rituals requiring, as most rituals do, repetition or at least maintenance in the form of repeated proofs and enactments."[61] Rather than scorning such relationships as Bwana Boma did, Lusinga's pronouncements suggest that local people must have expected the European to live up to his commitments—at least in these earliest days of colonial encounter.

Conflict Ahead

Within the next few months, Storms came to a very different opinion of Lusinga. A conflict arose when Storms refused to give the chief some gunpowder he requested, and Lusinga hotly threatened to behead the first man from Storms's station whom he might encounter. With horrific prescience, Storms wrote in a letter that "if he [Lusinga] has the misfortune of executing this project, his head may one day arrive in Brussels with a label on it, for it would be warmly welcomed [*faire bonne figure*] in a museum."[62] Perhaps the lieutenant had an inkling of a letter from Secretary General Maximilien Strauch of the IAC written at about that time but that he would not receive for some months, reminding Storms that he "should not miss the opportunity to collect a few skulls of indigenous niggers [*nègres*] if you can do so without offending the superstitious sentiments of your people. As much as possible, choose skulls of people belonging to a well-defined race [*une race bien tranchée*], and whose character has not sustained physical modifications as a result of interbreeding [*croisements*]." Strauch further urged Storms to take "anthropological measurements" of local people using instruments and instructions for their use available at Karema, but there is no evidence of the lieutenant accomplishing any such task.[63] We shall return to these matters that must be understood with regard to racialist ideologies of their day.

Storms's sense of Lusinga's authority changed as well, for rather than a "great chief of the region," he soon held him to be "an intruder in this country, he is not of royal origin, he has obtained everything by force; he is a veritable chief of *rugarugas* and a rotten rascal [*mauvais gueux*] if there ever was one, although this did not keep him from being the godfather of the famous ceremony of my exchange of blood with Mpala."[64] What Storms did not mention as he grumbled about Lusinga here or elsewhere is that while he himself was of diminutive stature, standing a bit more than 160 centimeters tall (that is, around 5 feet 2 inches), Lusinga must have towered over him at some 180 centimeters, or about 6 feet. For someone so cocksure of himself, such a difference in height may have added to Storms's being so evidently vexed with Lusinga's behavior.

The lieutenant summed up his sense of Lusinga when he wrote that "all of the Marungu recognizes, if not Lusinga's authority, at least his force and his perfidy." There was more to the chief than might meet the eye, however, for Storms suggested that Lusinga had "the reputation in all these lands of being invulnerable. He can change himself into a lion . . . and if need be, he can make himself invisible. This strength of Lusinga is not contested, and gives him unbelievable power."[65] Similarly, Victor Giraud, then staying at Karema Station, heard that Lusinga could change himself into a flighty drift of termites or a partridge-like francolin that so readily disappears into stands of grass. Storms did not reveal what he thought of such local notions, and simply concluded that "to subjugate [*réduire*] this chief or make him disappear would certainly be of the greatest benefit to all the Marungu."[66] Such lionizing—both figuratively and literally—must have been critically important to Lusinga's political ambitions.

Before long, Storms revealed that he had "long dreamed" of attacking Lusinga, but he offered no more particular reasons in his own writings. An attack on Lusinga's well-fortified village would require more manpower than Storms felt he had at his disposition, since the chief had "many warriors" of diverse ethnicity, including "Rua" (eastern Luba or Luba-ized people), "Rungu" (people from the massif south of Storms's territories), and "Nyamwezi" from north-central Tanzania. Storms made no mention of how large the noncombatant population of Lusinga's village must have been, but in a later diary entry he noted that the chief had "sixty wives."[67] Whether or not such an assertion reflected conjugal realities or an imagined "harem," many more women, children, and elderly people must have resided with the chief and would have been at risk if battle were engaged. At any rate, the lieutenant

waited until Paul Reichard and his German East African Expedition returned to Lubanda from visiting Msiri at Bunkeya.

After the frustration of his every stratagem as he sought trade advantages for his German sponsors, Reichard left Bunkeya in a fury because of the disrespectful way he felt he had been treated, despite becoming "blood brothers" with Msiri. During the two months it took him to trek back to Lubanda, Reichard had violent encounters along the way. As Johannes Fabian suggests, "no sharp line separated exploration from military action" for early visitors such as he, and "Reichard conducted part of his travel as a hostile campaign." He considered people of the Marungu to be "literally 'wild' or feral," and "without seeming to feel the slightest compunction, ... Reichard regaled his readers with an account of the looting and killing binge" that, among other ends, led to building a significant ethnographic collection of objects sometimes seized when people fled their villages rather than risk his wrath. At one point, however, when the German felt overpowered and was forced to flee, he burned "'3 loads of beautiful ethnographic collections, a lot of drums, 3 loads of war trophies, lead, trunks, and clothes, so as to reduce the porters' burden.'"[68] Not all was lost, for Reichard's still significant collection was eventually acquired by the Museum für Völkerkunde of Berlin.[69]

Reichard's only justification for his bellicosity was that "'we, in contrast to other travelers, realized that the only correct procedure is to respond immediately to hostilities on the side of the natives, because all ill-timed leniency ... will be interpreted as weakness or fear so that the situation really gets dangerous.'" It must have been difficult for local people to differentiate between Reichard's depredations and those of east African and more local slave raiders. The constant skirmishing took its toll on the traveler as well, and Reichard was beside himself by the time he reached Lubanda on November 30. As he conveyed his rage to his old friend Émile Storms, he undoubtedly added to the latter's resolve.[70] Indeed, the lieutenant wasted no time in assembling an expeditionary force of his own men bolstered by Reichard's for the long-awaited assault of Lusinga's palisade on the Muswe.

On December 3, 1884, more than a hundred men climbed the mountain trail from Lubanda to Lusinga's fortress, their ranks increased by fighters from loyal chiefs like Ukala. The men camped for the night and attacked early the next morning. According to Storms, the chief was felled with the very first volley and decapitated before his last gasp. Lusinga's head was hoisted on a spear as his and three adjacent villages were razed amidst "an indescribable

pell-mell." While only one of the lieutenant's men was even slightly wounded, 50 or 60 of Lusinga's were slaughtered and 125 prisoners seized. Because no further mention is made of them, they were presumably enslaved by Storms and Reichard's warriors following contemporary conventions of battle. Everything that was not destroyed became booty for Bwana Boma's forces, including a large quantity of food prepared as a great battlefield feast "to affirm their victory."[71] Those who escaped must have been hard-pressed to survive their subsequent hunger.

Because the lieutenant did not participate in the skirmish, or perhaps because Lusinga's violent demise was of an idiom too ordinary to merit commentary, especially with Reichard's violence so fresh in mind, no further details of the massacre are offered in Storms's known writings. He did record that his men joyfully returned to Lubanda and feigned battle before throwing themselves at his feet "as a sign of submission," although as we shall see, such deft moves may have had distinctly different meaning. Sultani Mpala offered a moving oration in which he praised his "brother," Bwana Boma. "No one in this land could defeat Lusinga, because he was the strongest," Mpala said, but now "you have defeated him and so you are the greatest chief and we are your children." In response, Storms brought forth the bloody head of Lusinga and cried, "Here is the man whom you feared yesterday. This man is dead because he sought to destroy this country and because he lied to the white man." The "country" to which Storms alluded was the "empire" that Bwana Boma was building around Lubanda. The lieutenant was aware that some in Belgium might consider his attack to have been precipitate, but his response was that one must strike swiftly, especially when operating in lands so little visited by Europeans and hence so little under their control. Days later, Storms concluded somewhat defensively that "a great blow has been struck in the Marungu that will bear its fruit. Little by little, people will see that I only wished to deliver the country from an individual who caused all imaginable harm."[72]

Hostilities did not end, however. Chief Kansabala, whose lineage is related to Lusinga's through a mother's-brother/sister's-son relationship (with relative seniority a matter of debate), moved to extend his own authority after Lusinga's overthrow, but Storms sent men to confront him and he readily capitulated. Three months after these triumphs, however, Lusinga's people named a successor to the title without Storms's participation or approval. This infuriated the lieutenant, who felt that "to allow this to pass unnoticed would

be to discredit my authority." Lusinga's immediate successor assembled his people at the village of Kansabala, and it was there that Bwana Boma launched his next attack. By then Reichard had left for Europe, and so to mount the expedition, Storms completed his large force of over a hundred rugaruga and wangwana with men provided by local allies. The lieutenant's forces were again victorious, although not as clearly so as it seemed in Lusinga's assassination, and he could crow that "the country of the Marungu is ours."[73]

Following these momentous events, Storms's reputation did seem to soar. Every time a chief visited him, Bwana Boma's praises would be sung to drummed accompaniment. "It is principally Lusinga who is the butt of such songs. 'Well Lusinga, where is your power now that the European has put you in his trunk?' [they would sing]. People know that I have taken a few chiefs' heads in my collection, which inspires bloody horror. They say I want the heads of all the kings of this land." Lusinga's execution proved a political watershed, because those the chief had raided and robbed were now free of his menace. Storms wrote with satisfaction that there was "great joy throughout the region [and] all the territorial chiefs hasten to pay tribute to the post of Mpala," but political winds in Europe were shifting in ways that would alter the lieutenant's plans for his station at Lubanda.[74]

An Abrupt and Angry Departure

Storms hoped to strike out from Lubanda to meet Stanley and thereby establish the "White Line across the Dark Continent" as the goal that had brought both men to central Africa. A letter from Secretary General Strauch in March 1883 made the plainest of statements: "I still hope that your expedition and that of Stanley will be able to make their junction in 1885 and that you will return to Europe via the Congo" River. A year later Strauch wrote that he was happy to convey Léopold's "extreme satisfaction" with the lieutenant's achievements at Karema and Lubanda and to send the king's "high approbation. It is with great pleasure that we see the ardor that animates you and that thrusts you forward. Nonetheless, we urgently pray you to suspend execution of your projects" at Lubanda and Karema. Strauch stressed that he agreed with Storms that "the surest and most rational plan" would be for the lieutenant to proceed to Nyangwe and found an outpost on the Upper Lualaba (Congo) River, and added that he intended to dispatch Jérôme Becker and two other agents to manage Karema and Lubanda so that Storms might set out westward.[75]

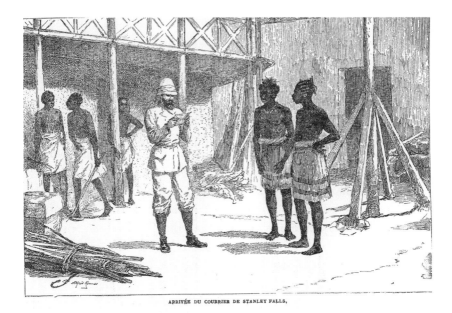

ARRIVÉE DU COURRIER DE STANLEY FALLS,

Figure 1.7. Storms reads Stanley's fateful letter. Alfred Ronner
in Burdo 1886, 535; public domain.

In May 1884 Storms received a letter from Stanley sent overland by a
circuitous route, announcing that he had founded an outpost at Stanley Falls
on the Congo (Lualaba) River and was returning to Europe (fig. 1.7).[76] Storms's
reception of Stanley's brief note was reported in the IAA magazine *Mouvement
géographique,* and in Adolphe Burdo's propagandistic *Les Belges dans l'Afrique
centrale* the moment was greeted as "an event of greatest importance for the
future [word effaced] to consecrate the project undertaken by the International
African Association."[77] Communication was thus established—in however
roundabout a manner—between outposts at Stanley Falls and Lubanda, and so
for all intents and purposes, receipt of Stanley's letter proved that a "White line"
had been established across central Africa. No mention is made of Storms's
sentiments, but a full-page engraving in the Burdo volume by the illustrator
Alfred Ronner imagined how Storms looked while soberly reading Stanley's
letter.[78] Storms's pose in the drawing conveyed the solemn significance of the
moment to Burdo's metropolitan audiences, yet, ironically, it also captured
Storms's fury.

Bwana Boma was bitter that the original goal of his mission had become
superfluous and his further usefulness seemed dismissed by his superiors.

When he had assumed responsibility for the IAA's operations, he had been instructed to use great discretion with regard to the relationship between overt IAA purposes and those of King Léopold's self-serving International Association of the Congo, which were to be kept far less evident. Storms noted that Stanley was working for the IAA but had established a station on the Lualaba on behalf of the IAC, and he pointedly stated in a letter to the IAA that he did not think Stanley was demonstrating his own initiative in so doing. Rather, the lieutenant concluded, "Mr. Stanley could not have undermined my authority without receiving the order to do so." As the head of operations for the IAA around Lake Tanganyika, Storms continued, he should have been the first to be informed of any such plan, and if he had been so informed, he would have resigned his commission rather than suffer the humiliation he now felt. And *were* his superiors so displeased with his service? He might be criticized for his lack of correspondence with them, but his calls for support from other European personnel had gone unanswered, and unless he had cut himself in two, he would not have been able to manage the posts of Karema and Mpala any better than he had. Stanley had "usurped" his prerogatives, Storms angrily concluded.[79]

For his part, Stanley may have been more actively involved in the decision making about these matters than Storms could have known. Tim Jeal notes that "when Leopold spoke of wanting to establish a series of posts linking East Africa with the Upper Congo, Stanley countered that it was much more important to build trading stations on the Congo and a railway." He also seems to have opined that the IAA expeditions across eastern Africa, "all inspired by the king, had resulted in the foundation of a single small station on Lake Tanganyika [that is, at Karema] at the cost of many lives." The urgency of Stanley's push eastward up the Congo was due to his competition with Pierre Savorgnan de Brazza, who was trying to establish colonial claim to some of the same lands for his French superiors, but it would seem that in advancing such a self-serving argument with Léopold and his advisors, Stanley did indeed undermine Storms's mission. For his own account, Stanley felt deceived by the promises Léopold made to the French that he would never return to the Congo, despite having been told he would be named first governor general once the colony was secured.[80] In other words, ambitions were thwarted and egos bruised on both sides.

Storms's grasp of Congolese current events as well as of Stanley's motives and activities could only have been very limited, given the sketchy knowledge and difficult communications of his time. The small outpost that Stanley

founded at Stanley Falls was a great distance from Lubanda, and Nyangwe and other strongholds of east African slave raiders and the furious communities they were victimizing lay in between.[81] Stanley's letter to Storms was accompanied by rumors of turmoil, as the Swahili traders Tippo Tip and Juma Merikani were said to be enraged that Stanley should purchase a great deal of ivory in the region west of Lake Tanganyika known as the Maniema that they felt should have been at their disposition instead. The French explorer Victor Giraud, staying with Storms at the time, had hoped to follow the very path that Storms was planning to take, either catching up with Stanley or following his footsteps back to the Atlantic coast. The rumor that the Swahili of Nyangwe would attack Stanley with "three thousand guns" so frightened Giraud's Zanzibari caravan crew that they refused to accompany him westward, mutinied, and returned to Zanzibar, abandoning Giraud at Karema.[82] In such fraught circumstances, it seems unlikely that Storms could have joined Stanley even if he had tried.

Storms now realized that there were "maneuvers" under way to which he was not a party, and he was deeply resentful.[83] One of his misperceptions may have been in assuming that the king's plans for establishing the "White Line" were more carefully thought through than they were. As the historian Guy Vanthemsche makes abundantly clear, this was not the case, and instead Léopold's decisions were frequently made in highly idiosyncratic—and even impromptu—ways. Bolstering the point, Vanthemsche cites an undated, confidential, and startlingly impertinent letter written by General Strauch himself, asserting that in his project to possess the Congo, "'the king was very ignorant. He was dominated by an unceasing imagination whose excessive activity suggested the most chimerical projects to him.... In this way this oeuvre [the Congo] was not the object of any preliminary study. He adopted it straight away, without reflection, without any goal determined and without tracing a plan.'"[84] Furthermore, rapid yet momentous changes of strategy were afoot, as instigated by Portuguese, British, and French politicians vying for advantage in central Africa. Within a few short weeks in spring 1884, the king and his counselors conceived of a brilliant move to outfox these competitors by proposing the rudiments of what would become the Congo Free State—"free" and so attractive to these same rivals plus others like the Americans, yet dominated by Léopold's own economic interests.[85]

Through the five-hundred-some treaties with Congolese chiefs that Stanley established, and because of his achievements in establishing outposts along the

Congo River, enough of Léopold's "White Line" was established to thwart French pretenses to lands south of the Congo River. The king would be able to negotiate possession of the Congo Free State at the Berlin Conference in late 1884—however preposterous his claims and catastrophic his rule would prove. Furthermore, Strauch wrote glowingly to Storms that the United States government had recognized the IAC as "the dominant power in the Congo Basin."[86] Clearly, the lieutenant was caught up in politics of a scale he could neither fully fathom nor effectively influence, especially from the far remove of his *boma* at Lubanda.

With the partition of Africa at the Berlin Conference, Léopold ceded the IAA outpost at Karema to the Germans who would occupy Tanganyika Territory in exchange for acceptance of Lake Tanganyika as the border between the two colonies. Control of Karema and its sister station at Lubanda would be assumed by Roman Catholic missionaries, and Storms was to return to Belgium forthwith.[87] Bwana Boma was beside himself and railed against those "who make a lie out of a royal promise." He further complained about being obliged to leave his post "just as our efforts have been crowned with full success," and he worried that those with whom he had created alliances and who had willingly joined his various battles would be slaughtered as soon as he departed. "In twenty or thirty years, the wars that we have fomented will not have ended. . . . If we abandon our operations there will be enough blood spilled to drown all the members of the [International African] Association." The degree to which Storms was hurt as well as angry is evident as his diary entry continues: "For three years I have made superhuman efforts to give stability to a shaky [*chancelante*] endeavor. After sweating blood and tears I have achieved a result that they certainly could not have hoped for, and yet they tell me, 'All your work is worthless, get lost!' I certainly have no great confidence in the word of the Association, but just the same, it is difficult to believe there are so many iniquities of the sort."[88] It was in this context that a Belgian journalist noticed Storms's pique—however poignant and prescient it may have been—and derisorily dubbed him "Émile the First, Emperor of Tanganyika."[89]

The journalist's joke took on a life of its own, perhaps, as a subsequent, exculpatory article in *Mouvement géographique* suggested, "not *although* hard to believe, but *because* hard to believe."[90] Soon after he assumed leadership of the boma at Lubanda, Father Isaac Moinet jovially wrote of the piece to Storms, quipping that given his "elevation to the throne and the crown of Tanganyika," he was not sure what title he should take to replace "His

Majesty Émile I." The missionary also took pains to assure the lieutenant that in "our kingdom of Mpala and Tanganyika, everything is working smoothly, [and] I still have the complete domination that you had in your time, nothing has been lost, and if you ever return you will find everything as it was in the past."[91] However, half a world away, an anonymous piece in the *New Zealand Herald* as picked up by the *Star* (also of New Zealand) provided a new twist to the jest from *Mouvement géographique:*

> Lieutenant Storms, formerly of the Belgian army, has conceived the proud idea of appointing himself an Emperor, and of establishing a new empire in the heart of the Dark Continent. Emperor Émile I, as he styles himself, has made his way to the west shores of Lake Tanganyika, and is surrounding himself with a Native Court. He announces that he is perfectly willing to be on good terms with the [Congo] Free States [*sic*], only he cannot allow that its limits include the Tanganyika region, which he claims as his own. That is to say, the young potentate is asserting himself in defiance of the fourteen Powers which traced the limits of the Free State at Berlin. It is a hardy thing to brook the European concert. But no Dulcigno demonstration seems possible in Lake Tanganyika, and while Emperor Émile's supply of rum holds out he will probably maintain his shadowy sovereignty undisturbed.[92]

This may have been nothing more than mockery, with its blatant nationalist overtones couched in worldly allusions. Yet the original article in *Mouvement géographique* seemed to reveal "tensions of Empire" as different Belgian factions took positions on the colonial enterprise, and the fact of the matter was, as self-proclaimed "chief of chiefs" Storms *had* created a de facto empire at and around Lubanda, the autonomy of which is contested to this very day.[93]

Burning the Boma

Tensions rose as Storms prepared to turn over his station at Lubanda to the White Fathers, whom the lieutenant had helped establish a small mission at Chanza, south of Lubanda and near the present-day lakeside town of Moba.[94] The several Europeans in the area were on edge because of threats by increasingly aggressive slavers. One of these latter menaced London Missionary Society personnel at Mtoa, saying he would soon come and seize their place. If they resisted, they would be dispatched with impunity, for no revenge had been taken when Carter, Cadenhead, and Penrose were murdered by ruga-ruga east of Lake Tanganyika.[95]

The anxieties of Storms's African protégés increased as well. Without overt attack, those most loyal to Bwana Boma were subject to months of *vipondo*—little random attacks, "here an arrow, there a fire," and more than enough to make everyone fearful. In such fraught circumstances, Storms thought someone was being complimentary when he held that "I was a man of Lusinga, who was so strong; but you, you were stronger still, and I was like a tongue between two jaws."[96] Yet such a statement was overtly ambiguous in a manner typical of Tabwa narrative devices—and especially dilemma tales—for in effect, it placed Storms and Lusinga in the mimesis of an odd dialectic. And indeed, such "tongues" would soon wag again, for at midnight on May 19, 1885, Bwana Boma's boma was burned to the ground.

Fire was set to the dried thatch of the boma's roofs and enclosures. Homes and neighborhoods of Lubanda are still at risk from accidents of the sort caused by errant cooking fires or other blunders of everyday life. Once the blaze was raging, there would be no putting it out with whatever meager means the lieutenant may have prepared in anticipation of any such disaster, and indeed the conflagration spread so quickly that the lieutenant could do little more than flee the flames and take up a strategic position in case the aggressors attacked. "Savage men" did mount two brief forays, as they thought Bwana Boma would be preoccupied and might have succumbed, but they were repulsed. Storms was able to save his gunpowder from the blaze, but much else was lost, including large portions of his precious natural history and ethnographic collections, 150 glass-plate photographic negatives, and many of his journals and other papers: "In a word, everything, everything, everything. All that is left to me is a rock to sit upon," he wrote glumly.[97]

In the aftermath of arson, Storms directed his anger at Sultani Mpala for his slow response to the crisis and for not marshaling enough men to extinguish the blaze. Storms wrote in his diary that the chief "was in despair," for the Warua perpetrators dispatched by Lusinga's people had stopped at his village the night before their attack, telling the chief that they had come in friendship. He had shown them warm welcome, but in duplicitous reversal of his hospitality, they must have secreted a bit of the food prepared for them by his wives so that they could use it to make medicines to thwart the chief's best intentions. Then the Warua deployed arcane science to send the boma's guards into a stupor, thus allowing the terrible task to be undertaken unhindered. Had they not resorted to such trickery, Mpala continued, he and his people would not have been taken by surprise, for in these times of worrisome

insecurity, he posted sentinels to guard the pathways to Lubanda. A bundle of soporiferous magic was soon discovered buried near the charred ruins of the fortress in the form of "an axe handle" bound about with several pieces of "special wood" and glass trade beads, and the chief was afraid that a similar device would be used by the same aggressors against his own sentinels.[98]

People at Lubanda with whom I discussed esoterica in the 1970s told me that such a thing of thieves must have been a *kabwalala*, literally "the little dog sleeps," suggesting that even the most vigilant beast—or even a man as panoptically powerful as Bwana Boma—will be overcome by this potent means. Malevolent individuals still employ the magic around Lubanda, and their victims are plunged into such profound sleep that they will be oblivious to being robbed or otherwise violated. The thief will stand before the home of even the most powerful or wealthy individual, shouting out the resident's name in a brutally insulting manner and instructing him to arise, though remaining deeply asleep, to open the door and allow entrance. Not until later will the person awaken and find his house ransacked, but he will not be aware of who perpetrated the crime.[99]

Such devices were reported elsewhere in the region over the years, suggesting a trans-ethnic technology. For example, in the 1920s a British official in Northern Rhodesia complained to his Belgian counterpart that Greek-owned fishing boats plying the waters of Lake Mweru and the Luapula River were being robbed by Congolese ne'er-do-wells using kabwalala.[100] Twenty years later, the Belgian community of Albertville (now Kalemie, DRC) was aghast that the remains of Father Auguste van Acker—author of the Kitabwa–French dictionary—had been violated by local grave robbers, and that the venerable priest's digit bones were removed for use in kabwalala. Similar magical tactics account for why the corpses of mercenaries killed in battle were sometimes secretly exhumed, for activating agents (*vizimba*) derived from them could be incorporated into powerful concoctions to protect people from depredations by Storms's men or other aggressors.[101] Given what we know of other clandestine resistance to colonial interests, and especially *visanguka* (lion-man) attacks directed against missionaries at Lubanda and other European concerns, these fragments of intelligence permit one to surmise that kabwalala was not destined for theft alone, or even primarily so.[102] Most colonial fears of open insurrection proved overblown, but more subtle subversion was ever present; and in deploying kabwalala, occult warfare was being undertaken by those opposed to Bwana Boma.

"Architecture is an eminently political phenomenon," Dominique Malaquais reminds us, and this was certainly true of the building of Bwana Boma's boma and of its destruction. From a Tabwa perspective, burning the fortress might be understood as a courageous act of incendiary revenge. Such a counterattack signaled that Lusinga and his survivors were by no means cowed, and indeed, because he was the first European to settle among them, they may have understood Storms to be more of a commercial and political competitor among other intrusive agents like the Yeke traders Ukala and Chura, with whom he was closely aligned, than a proto-colonial conqueror.[103] Some months later, the conflagration was more specifically attributed to men sent by Lusinga's mother, Kaomba, who was an important political figure in her own right.[104]

In a sense, however, to commit arson was to assault Bwana Boma himself, as the lieutenant's sobriquet suggests. The imposing boma was an evident monument to the lieutenant's personal ambitions, even as it served practical and ideological purposes in staging the pretenses of early colonial hegemony. We are left to surmise that the powerlessness that Storms felt in seeing his fortress burned to the ground must have added profound personal insult to the injury of his being summoned home, his hopes dashed for Stanley-like fame and glory. Storms had been bested by those he sought to dominate, whether or not he was prepared to admit as much. Such existential thoughts are not reflected in the pages of his diary and letters, however; instead, he portrayed the incident as simple aggression on the part of Lusinga's people—a skirmish in an ongoing battle that he was sure he could win if only given the chance.

Sultani Mpala was left fearful by the conflagration. The next day he sent a patrol on reconnaissance into the mountains surrounding Lubanda, and one man returned wounded, struck by the arrow of a hidden assailant. The chief urged Bwana Boma to rebuild his fortress as quickly as possible and said that once he had done so, he and his people would take shelter there and fight to the death or until their enemies had been vanquished. Such a statement must be understood with regard to a more general anxiety as reported by Victor Giraud, who visited Lubanda some months before the arson.[105] Because his predecessors had been murdered by Lusinga, according to Giraud, Mpala told the Frenchman that if Storms were to return to Europe, he was certain that he and his people would be slaughtered. The arson must have deepened the chief's distress, for it made Bwana Boma's vulnerability painfully clear and Mpala's own even more so.

Three weeks after the fire, Mpala Kakonto died of the smallpox epidemic ravaging the local population. Storms commented in his journal that the chief's death constituted "a true contretemps and especially now when I need people I can count on during my absence." He also noted that "I must admit that I have never encountered a savage more devoted to me" than Mpala.[106] Bwana Boma's otherwise soldierly façade cracked a tiny bit in the draft of a personal letter in which he held that "Mpala . . . is the most likable nigger that I have encountered in Africa"—with *nègre* an alternative to "savage" (*sauvage*) as he first described the chief in his diary. Despite such sentiments, however, Storms's writings about Sultani Mpala suggest a relationship valued for its strategic utility and little else. In the same letter, the lieutenant returned to the practicalities of the relationship, admitting that he could communicate directly with Sultani Mpala (as though this were very unusual) and that the chief often served as his interpreter, helping to "dissipate the distrust of new allies."[107]

Mpala's succession was organized by Bwana Boma, and he chose Kikonde from three candidates, who included Mumbwe, a close kinsman of Kizumina—a very elderly "man of memory," who will be introduced more fully in the next chapter. Storms claimed Mpala's "harem" (*sérail*) as his own, since the chief had submitted to his authority and was his "blood brother" to boot, and he distributed the eight wives and two enslaved people held by the late *sultani*. Three of the wives were free to do as they chose, and three were given to Kikonde; one of the enslaved was presented to Mumbwe and the other to Mpala's sister, as were Mpala's two remaining wives. The logic of the decision and terms of how Mpala's sister would assume responsibility for two of his widows are not clear, and it seems that Bwana Boma was inventing traditions rather than following them. At any rate, "this distribution pleased no one very much," Storms admitted ruefully.[108] Nonetheless, in later years it was asserted in pro-Léopoldian writings that this very moment when Bwana Boma appointed Sultani Mpala's successor "was the beginning of the political influence of the Belgian officers on the west coast of [Lake] Tanganyika, where it has endured ever since, and is now firmly established."[109] The hegemonic implications of Storms's actions could not be stated more clearly.

A Tempestuous Farewell

On the eve of leaving Lubanda, Bwana Boma declared that the Yeke warlords Ukala and Chura would remain his "principal *sous-chefs*." Storms and Ukala had

become blood partners through lusale, and the lieutenant wrote, "I now have some paramount chiefs [*grands chefs*] who are people created by me and who pay me annual tribute [*hongo*]." Like colonial officials of later years, Storms possessed a sense of feudal "tribute" from medieval European history that would obtain among chiefs whom he "created" in development of his political strategies. In the same breath, however, he expressed his more accurate understanding that among Tabwa chiefs following their own political culture, "the value of tribute is minimal" and "an entirely voluntary fee" that demonstrated deference rather than submission. "Tribute" was being redefined quite consciously, in other words. Ukala and Chura swore that the day he returned to Lubanda from Europe, Bwana Boma would find "his country" intact.[110]

As Storms was leaving for Belgium in late July 1885, Ukala requested that he be granted the lands of Kansabala, who had been defeated by the lieutenant's men days after their conquest of Lusinga. Storms refused because Ukala was "a foreigner from the other side of the lake" and because he knew that any such concession would occasion troubled responses from local people. Oddly enough, according to Father Moinet, Bwana Boma did cede Kansabala's lands to Ukala and Chura, but perhaps the priests were unaware of Storms's refusal and Ukala told a different story once the lieutenant had left Lubanda.[111]

Kansabala's people immediately contested the legitimacy of Ukala's claims. Through outright attack and clandestine terrorism in the form of random attacks by lion-men, they killed women and children and disguised the murders with iron claws. Someone also tried to burn Ukala's village, and just three weeks after Storms ceded his station to the White Fathers, Ukala asked Father Moinet's permission "to massacre all these devils in the Marungu. Give us beautiful cloth and we'll bring you heads, lots of heads that you can send to Europe." The missionary rebuffed Ukala's offer, but nevertheless when rugaruga from Lubanda joined Ukala in an attack on what remained of Lusinga's community, they brought a severed head to the Father, much to his dismay and anger. Moinet was equally displeased when he visited Ukala's mountain redoubt some time later and discovered a dozen skulls impaled on pikes at the entrance. Storms's wangwana also offered to venture into the mountains to kill a chief and take his head so that the priests could send it to Europe, just as Bwana Boma had carried off Lusinga's. The missionaries were furious with what they interpreted as the men's effrontery and demanded that they hand over their guns and settle away from the mission. Soon afterward, the priests dispatched the wangwana back to Zanzibar in order to establish peace.[112]

Figure 1.8. Mpala Mission, seat of a de facto "Christian Kingdom." Photo from the research of Christopher Davis-Roberts and Allen F. Roberts, 1976.

Several authors associated with the White Fathers have suggested that Fathers Isaac Moinet and Auguste Moncet took over from Bwana Boma "without enthusiasm," but such an assertion is belied by the cautious exuberance that the two missionaries demonstrated in their many letters. Within months, they converted Bwana Boma's "empire" into a "Christian Kingdom," as they called it, that would have all attributes of a de facto state (fig. 1.8). Such a polity would realize the fond dreams of their order's founder, Cardinal Charles Lavigerie, and although formal recognition was never granted by the Congo Free State or later Belgian authorities, informal aspects of the kingdom persisted well into post-Independence times.[113] More specifically, Bwana Boma's beheading of Lusinga served the missionaries' political purposes for years to come. As Father Guillemé wrote to Storms seven years after the lieutenant's departure, "Now if a chief is recalcitrant regarding the directions imposed upon him or if he makes some foolish blunder [*sottise*], people quickly tell him 'Pay attention, watch out, and remember that the head of Lusinga, the first to revolt [against a European], has gone to Europe and yours could easily follow!' With this, the chief in question is given to reflect and meditate upon the caducity of human heads, and he returns to good order."[114]

Storms had hoped to return to Lubanda but he never did. His central African experience was called upon in 1888 when he served as technical director of a Belgian antislavery expedition to Lake Tanganyika, and for a while it did seem that he would lead the expedition he planned with such diligence. That same year, though, he met Henriette Dessaint, a young woman "of the good bourgeoisie of Brussels," who was fifteen his years his junior. Storms abandoned any plan to revisit central Africa, married Henriette the next year, and settled into domestic life and Belgium-based military service. In his place, the antislavery mission was led by Jacques de Dixmude, whose accomplishments would become much celebrated.[115] Storms retired from the army in 1909 as a lieutenant general. He served as director of the Fund for Army Widows and Orphans for a few years thereafter and died in Brussels in 1918 at the age of seventy-two.[116]

2 · A Conflict of Memories

One cannot do good history, not even contemporary history, without regard for ideas, actions, and ontologies that are not and never were our own.

MARSHALL SAHLINS, *HOW "NATIVES" THINK*

Storms's account of Lusinga's demise will be left here in order to turn to Tabwa narration of the same events. Such alternative histories can move our understanding of fraught political relations beyond nineteenth-century European "idiom[s] of doubt" that would deny agency to soon-to-be-colonized Africans. To the degree possible all these years later, we need to consider what Tabwa thought and think of these same events via tropes and historiologies of their own making. "Concept[s] of agency as embedded in narrative possibility" can result, as Premesh Lalu notes of somewhat similar circumstances in nineteenth-century southern Africa. Indeed, an approach sensitive to metaphors and esoteric references embedded in narratives "may yield a story unimagined and unanticipated by the perpetrators" of proto-colonial violence like Bwana Boma.[1]

While many people in and around Lubanda knew something of Storms's epic confrontation with Lusinga when I discussed such matters with them in the mid-1970s, two elderly gentlemen offered far richer detail than anyone else I came to know. One was Louis Mulilo, a World War I veteran who wore remnants of his Belgian colonial army uniform on exceptional occasions in an almost talismanic manner.[2] People at Lubanda always used first and last

names when referring to Louis Mulilo, almost as though the names were hyphenated. He was in his eighties when I knew him, yet he was remarkably youthful in mind and body. He fished by himself very early most mornings, paddling his heavy hardwood pirogue a kilometer or more "up onto" Lake Tanganyika, as people at Lubanda say, and he and his equally spry spouse maintained a very prim and proper home on the street in Lubanda where I also lived. Several afternoons a week, Louis Mulilo would climb the hill from his house to mine to drink tea and tell stories, fulfilling two of his—and my—greatest passions. Sadly, Louis Mulilo died during the cholera epidemic of 1978, which was exacerbated by the "Shaba Wars" that brought collapse to what little was left of national health care in rural southeastern Zaïre.[3]

The other gentleman, Kizumina Kabulo, was reputed to be the oldest person in the area. He claimed that he was already "running around" as a toddler when Bwana Boma arrived in Lubanda in 1883, and he was surely well into his nineties when we met. He had long been blind and no longer left his home, which stood in some disrepair on a narrow cobblestone beach of Lake Tanganyika, beneath the rapid rise of Mount Nzawa. Because Kizumina's village of Nkuba is more than a half day's pirogue paddling from Lubanda, I was able to visit him only a half dozen times. On each of these occasions I was stunned by his acumen, for as a recognized "man of memory" Kizumina knew more details of important events and practices than anyone else in the region.[4] I was informed in a letter that the old man perished in 1978 when a Zaïrian air force plane strafed and napalmed Nkuba, killing everyone as the soldiers sought "rebels" in the early phases of the wars that have plagued the "failed state" of Zaïre and the subsequent Democratic Republic of the Congo ever since.[5]

Whenever I conversed with Kizumina, a cluster of villagers would press tightly around us to hear his compelling tales and, undoubtedly, to observe me as the anomaly I most obviously was in so remote a place. In the course of a long conversation that led to Kizumina's recounting the fateful encounter between Bwana Boma and Swift-of-Foot, a young man complained that a lasting sin of the colonial period was that such knowledge was lost to all but this one very old man who would share such precious information with an evident outsider more readily than with his own family. As Lowell Lewis has reflected, such encounters may provide opportunities to—and even oblige—anthropologists and their hosts "to rediscover themselves while they create a new discourse to bridge the gulf of strangeness. This discourse becomes known as 'culture' when it is reformulated for public consumption by the anthropologist upon [her or] his

return, but the hosts may well call it something else."[6] *What* else, we shall now consider.

The conversation began with my asking Kizumina about an early entry I had found in the White Fathers' Mpala Mission diary. The priests had ordered that a huge old tree be cut down in the hamlet of Kapyapya near Lubanda because it was said to harbor a *muzimu,* or Earth spirit.[7] Kizumina said he did not know of this spirit tree, but as he made this passing admission, the same young man snapped that this was typical of "you elders of the past. You liked to hide many things from us, and you would say, 'If I show this to this child here' [pause], ah-ah, so the old ones have taken [such information] away [with them in death]. Isn't that why we are lacking many medicines [*madawa*] now? The old ones have died" and taken their secrets with them.

Kizumina answered this cheeky challenge with petulance. The elders "were badly deceived [*wamedanganikwa vibaya*]" he conceded, "but if you want to tell of something you must only tell about things you yourself have seen or that were explained to you by the person who saw them, for if it [the information] is received from three or four different people, it is utterly worthless." The young man was not ready to drop the issue but did soften his approach. "Now in Lubanda," he continued, "who is there who would know about that tree in Kapyapya? Who would be the senior man to know this? There is no one older than you [Kizumina,] and still you don't know about it."

Kizumina responded, "When they built that church in Kapyapya because of the sleeping-sickness, I was there.[8] That was a place of mosquitoes and no one lived there, and anyway, when those people were in their churches we never knew what they were doing, all we heard was hoo-haa-ho-haaa, hoo-haa-ho-haaa [everyone laughed] and there was the sound of people kneeling but we didn't know what they were doing. Well, they were stealing our spirits [*mizimu*], they were taking the strength of our mizimu for their own mizimu." Recognizing Kizumina's gesture, the young man added in a conciliatory tone, "Yes, they took away all of our mizimu and filled their place with them, and even when the old people went to make offerings there [to the mizimu] they [the missionaries] had led the mizimu astray. They would make people pay money [tithes] and do whatever else, and they bought them [the elders who became engaged in such reciprocity]. People answered to them [the priests] after that . . . and the mizimu moved away." "Yes," Kizumina further lamented, "if the priests [*mapadiri*] heard that someone was making offerings [to the mizimu], ye-ye-ye-ye, you would be insulted and locked up right there, and this is now [the source of] our wretched lameness [*kilema kya ubovu*]."[9]

The discussion continued with Kizumina asserting that Catholic missionaries had given people the crucifix and replaced their *minkisi* wooden figures with "Mary and all," so implying their categorical similarity. In bringing attention to such matters, he had masterfully shifted attention from the frustrating and politically fraught loss of knowledge for which he might be held accountable in the eyes of young people like the one who had confronted him. As opposed to implications of the sort, Kizumina's purposes bring to mind Alessandro Portelli's insight that "to tell a story is to take arms against the threat of time. . . . The telling of a story preserves the teller from oblivion." Yet, if such accounts are *not* handed down—even as secret knowledge to be shared with a select few—one must assume that such matters have become "vitiated abstractions" that are no longer relevant to today's audiences. Such an assertion should be qualified, however, for while the historical content of stories may lose importance and inexorably change to meet current narrative needs, the communicative practices through which their content is organized, presented, and contemplated, undoubtedly persist.[10]

Kizumina's assertions about how the strength of mizimu was "stolen" by Catholic missionaries are apposite to our later consideration of the consequences of Storms's having seized the belongings of Lusinga, which, most significantly, included a remarkable wooden figure in which the chief's ancestors dwelt, as will be explained in chapter 8. A last reflection is nonetheless in order here. Kizumina was referring to the Latin Mass, and probably more specifically to performance of the Eucharist. His "hoo-haa-ho-haaa" recalls the English phrase "hocus pocus," now suggesting "nonsense words or phrases used as a formula by conjurers" but attributed by many to a derisory deformation of the Latin phrase *hoc est corpus meum* of the Eucharist. If Kizumina's humorous "hoo-haa-ho-haaa" referred to "the trick of Transubstantiation" through Holy Communion, to borrow a phrase from an acerbic seventeenth-century archbishop of Canterbury, then the instrumentality of such "hocus pocus" that could "take the strength of our mizimu" becomes even more pertinent.[11] So, too, in Kizumina's narrative to follow, efficacious knowledge will lie just beneath or beyond any superficial reckoning.

Let the Stories Begin

Louis Mulilo began his account of the encounter between Lusinga and Bwana Boma by explaining that "Lusinga lwa Ng'ombe and his mother's brother Kansabala Kisuyu came from Buluba," a generic term for Land of the Luba

and indicating a great swath of land west of Lubanda and the many polities established there.[12] Both hailed from around Kiombe near the confluence of the Niemba and Lukuga Rivers west of Lake Tanganyika, and both were Kalanga. Louis Mulilo continued, "There had been some sort of dire trouble at Kiombe, and Lusinga and Kansabala had been driven away like animals"— *balikuwa banamuswaga,* referring to how panicked prey are driven into hunting nets by beaters. "After that they wandered aimlessly about [*kutangatanga*] for some time. Kansabala arrived upon the [southwestern] shores of Lake Tanganyika first, followed by Lusinga a year later; and although Mpala Kakonto did not know why they had been forced from their own lands, he allowed them to settle near a saline spring along the Muswe creek in the Mugandja Mountains west of Mpala's own lakeside village. Lusinga built a *lilinga* on the Muswe"—that is, a tall palisade of poles for defense against his many adversaries.

"Mpala Kakonto received Bwana Boma when he first visited Mpala's village," Louis Mulilo continued. "Mpala told Bwana Boma that there was one person causing a lot of difficulties for him, and that person was a troublemaker [*muguruguru*] named Lusinga. Bwana Boma could not get the man's name right, and always called him Kasinga rather than Lusinga." Louis Mulilo thought this detail was quite significant and very funny, and he enjoyed repeating and chuckling about the mispronounced name. One is reminded of Bwana Boma's own comment many years earlier that "there is nothing so amusing [to people around Lubanda] than an individual who mimics another: his gestures, his tics, his way of speaking are seized in a lively way and reproduced with comic exaggeration."[13] The prefix *ka-* in the Tabwa language is a diminutive, further emphasizing the insult of Storms's ignoring Lusinga's proper name. "Kasinga" may also mean "little catfish," adding the humor of malapropism to Bwana Boma's awkward command of local language as well as to Louis Mulilo's subtle put-down of Lusinga and his lineage.

"Bwana Boma built a huge fort near Karema Point, on land now incorporated into Mpala's village of Lubanda. Lusinga came to see Bwana Boma and his fortress for himself. Bwana Boma asked, 'You, Kasinga, have you come to make war on me, *me,* the *muzungu* [referring to a person of European heritage] Bwana Boma?' But Lusinga did not answer. Bwana Boma asked again, and again received no answer. Finally, Bwana Boma had a volley of ten pistol shots fired out over the water of Lake Tanganyika." As an early lexicographer reported, a Tabwa term for "pistol" is *kapata makolo,* "the stifler of chiefs," perhaps in

particular reference to assassinations like that of Lusinga. This same phrase was used to refer to the astoundingly brilliant but gravely portentous Sungrazer comets of the 1880s in Tabwa millenarian narratives, thus adding a subtle element of tension to Louis Mulilo's account of the period.[14]

> Lusinga left Lubanda without ever answering Bwana Boma's question, but he set fire to several houses on the outskirts of town, and Mpala told Bwana Boma that now he had seen for himself what Lusinga was like. Bwana Boma sent his soldiers [*askari*] to Lusinga's and when they got there they began dancing to make Lusinga happy.[15] In reality they were hunting him, however, and they suddenly shot him and cut off his head to bring back to Bwana Boma.

Kizumina offered a far more detailed account than Louis Mulilo's succinct tale, yet his narrative shared much the same structure.[16] "Bwana Boma was not the first *muzungu* to visit Mpala, no, there had been another called Sakala. He came northward through the Marungu Massif, killing people, killing people, killing people, chiefs and others, ah-ah. Everyone ran from him and slept in the bush. Sakala was the first *muzungu* and Bwana Boma the second. Some called him Bwana Boma Sakala because he was like that first *muzungu*." Storms is called "Sakala" in several early European documents, but the first to have been given this nickname may have been one of the Zanzibari slave traders who began crossing Lake Tanganyika and adjacent lands in the 1830s.[17]

> When Bwana Boma arrived, people sang a song of welcome: "Let's go to Mpala's, let's go to Mpala's, the people of Bwana [Boma] begin to arrive, they meet the people of [Mpala] Kakonto." Bwana Boma said "You, Mpala, you are a *sultani* ten times over. There is no one who can touch you [*kugusa*]. When I leave here I will take your name with me, Mpala, because really, you are a man ten times over." That was how they became fond of each other [*wamependana*]. After about a week, Bwana Boma and Mpala made *lusale* [a blood covenant], they "ate" lusale together, each swallowing some of the other's blood to show they would forever be friends. It was Bwana Boma who begged [*kuomba*] Mpala to "eat" lusale. Neither Mpala nor Bwana Boma performed lusale with anyone else, and those who say they did are liars.

Chief Mpala Kaloko also insisted that neither his predecessor nor Bwana Boma "ate" lusale with anyone else, although European historical records

suggest otherwise.[18] Such selective memory characterizes the historiology of *milandu,* to be elucidated shortly.

> It was the time of the maize harvest when Bwana Boma arrived at Mpala's [in early May 1883], and Kansabala and Lusinga were already living along the Muswe. Kansabala told Lusinga about the stranger at Mpala's and that he had red skin that was amazing to see. Lusinga said he would go to Mpala's to see this for himself, and he took six of his men with him. When he got there he went to Chief Mpala and asked what that thing was over there. Mpala replied that it was the tent where Bwana Boma lived. Lusinga said that Bwana Boma must be an evil spirit [*shetani*]. "No," said Mpala, "he has a head, two eyes, two ears, two hands, two feet, yes, really, he is a man." [Blind Kizumina turned to a very distinguished elderly man sitting next to him on the porch, humorously gripping his body parts as he named them, much to the man's discomfort and the audience's hilarity.] Lusinga answered that he could not believe that a man could be as red as this one was.
>
> Lusinga went to look at Bwana Boma for himself. He still did not know what sort of thing this could be, this Bwana Boma. Mpala's people had become accustomed to seeing him, but Lusinga had not. Lusinga told Mpala that if Bwana Boma had come to his place instead of Mpala's, he would have had his men capture him, bind him, and throw him into the river to drown. Mpala said no, this is a man. Lusinga replied that he just could not get used to the man's red color. He went to look at Bwana Boma and moved up very close to him, seizing Bwana Boma by the ear. He tugged on the ear and said to his men, "This man is a *kabege*" [or, as Kizumina explained in an aside, someone who has no hair on his head or body, or who has shaved it all off for some reason]. "He is like a *kamushulwe*" [a baby born "red," before its time, that does not mature and is a *kaonde* that soon perishes]. "He is a *kasuke*, a reddish person" [just as you can say that this man is very black and that one is redder]. Bwana Boma heard all these words and wrote them in a little book which he then put back into his breast pocket.
>
> Lusinga saw a stand of rifles and asked what they were. Mpala explained that they were *manfuti* as they are called in Kitabwa, or *bunduki* as one says in Swahili.[19] Mpala asked Bwana Boma to show Lusinga what these were so that Lusinga could hear the sound they make. Now at that time Bwana Boma had soldiers with him of two ethnicities [*kabila*], the Batuta Kyalo and the Manjori. Bwana Boma asked two of the Batuta to take guns down to the Lufuko River and show Lusinga what they did. The soldiers fired into the water pah-pah-pah-pah, and Lusinga was very frightened. Soon after, Lusinga left to return to the Muswe.

At about this time, Kansabala and Lusinga decided they could no longer live in the same village. Lusinga stayed at the Muswe, where he still lives today [that is, in the person of the descendant bearing his dynastic name], while Kansabala moved on to Mount Kipungwe, where he [his descendant] lived until 1975 when he moved to the town of Kala because all his people at Kipungwe left him. Lusinga had not been back at the Muswe many days after meeting Bwana Boma when he decided to send two men down the mountain to Lubanda to ask Sultani Mpala to ask Bwana Boma to give him eight soldiers with guns. Lusinga told his own people that with only eight men bearing weapons like Bwana Boma's, he would be able to do astonishing [*ajabu*] things. They would see, he would go to [his neighbor] Kalabe's and quickly capture the place and reduce it to ruins.

The next morning the two men went down to Chief Mpala and explained what Lusinga wanted. Mpala went to Bwana Boma and told him in turn. Bwana Boma asked who this was that wanted him to send eight soldiers armed with rifles. "Lusinga," said Mpala. "Was he the one who pulled my ear and who called me a kabege and a kamushulwe and a kasuke?" he asked, reading these words from his little book. "Yes." "Ah-ah! Mpala, tell twenty of your men to come to me, ready to go to Lusinga's." [Kizumina added in an aside that these twenty included Kizumina's own kinsmen.] Bwana Boma went into his tent and called out a name, "So-and-so?" "Present!" "Here is your gun." He told his eight soldiers with guns to go with the twenty men of Sultani Mpala and to sleep at Lusinga's one day, two days, and on the third to come back, bringing Lusinga to him.

The men climbed Mount Laba and went through the village of Busongo on their way to Lusinga's. It took two days to get there. The eight soldiers of Bwana Boma killed five antelope along the way, and the men of Mpala carried the meat as food. When they got near Lusinga's they all started singing, and the soldiers held their guns in the crooks of their elbows, across their chests and not over their shoulders as hunters carry guns nowadays. They approached the village of Lusinga in this way, dancing and singing, "Penis, Penis, Penis sees the *bwali*, Penis sees the women, Penis stands itself up, Penis sees the *bwali*." The men danced so much that they shat![20]

Lusinga saw the men coming and thought they were the soldiers he had asked Bwana Boma to send to him. He felt great joy, and his women ululated [*kupiga vigelegele*] in welcome to the approaching soldiers. Mats were quickly spread out, houses were cleaned so the soldiers could stay in them, and goats and chickens were killed and prepared for food. That day until the sun set in the hills to the west, everyone watched the soldiers dance and sing, dance and sing, dance and sing, and everyone was very happy. The

soldiers were great dancers, and they sang, "Penis, Penis, Penis sees the *bwali,* Penis sees the women, Penis stands itself up, Penis sees the *bwali.*"

The next day was just the same, dancing and singing and feasting. The third day just the same, but now as Bwana Boma had told them to do, each soldier kept dancing but moved off a bit so that finally each was singing and dancing in a different part of Lusinga's village.[21] Then the *kaparali* [corporal], dancing with his gun in the crook of his elbow and singing all the while, slowly danced up to where Lusinga was sitting in a chair that had four legs like this one [in which Kizumina was seated as he told the story]. Lusinga felt great joy to see these soldiers. The kaparali threw himself down on his back [in an agile acrobatic move] and danced and sang, "The little thing, the little thing, the little thing sees the *bwali,* it sees the women, it stands itself up, it sees the *bwali,*" while Lusinga's women ululated. The kaparali sang and danced, sang and danced, sang and danced; and then suddenly, pah! "Ah-ah! Yo yo yo! Lusinga is dead! Lusinga is dead!" Pububububu, pububububu [the sound of pandemonium].

People fled in all directions. Bwana Boma's soldiers and the men of Mpala caught the women, insulting and killing the ugly ones by shooting some here, some there, some in the buttocks, and making the beautiful ones stand off to one side. They raped these beautiful women until they shat! The soldiers then went and the kaparali cut off Lusinga's head and on the neck of the head he put *manukato* medicine from a little bottle that Bwana Boma had given them to stop the bleeding. Only the headless body [*kiwiliwili*] of Lusinga remained. The soldiers stood the kiwiliwili up and danced around it. The *rugaruga* took so many goats, so many goats, so many goats, and chickens and cattle.[22] It was astonishing [*ajabu*] how many they took, and then they left for Mpala's, singing and dancing all the way home, "Penis, Penis, Penis sees the *bwali,* Penis sees the women, Penis stands itself up, Penis sees the *bwali.*"

The soldiers went to where Bwana Boma was and he asked them if they had brought him Lusinga. The men produced the head and said, "Here is Lusinga!" Bwana Boma called Sultani Mpala and asked him if he had seen Lusinga. Mpala said no, and Bwana Boma took out the head to show him. He held the head up and asked it, "Are you the one who pulled my ear and called me a kabege and a kamushulwe and a kasuke?" The head only grinned and said nothing [Kizumina's gruesome rictus brought hilarity to his audience]. Bwana Boma told Mpala not to be sorry for that guest of his, that Lusinga. Mpala was very frightened, but Bwana Boma told him not to worry for he and Mpala were friends.

Not long afterwards, Bwana Boma returned to Europe [Ulaya]. The head of Lusinga lwa Ng'ombe went to Europe too, in all his arrogance [*kiburi*].

Before Bwana Boma left, he gave Mpala two bales of cloth [*mitumba*], plates, buckets—really, everything that a muzungu uses. He said these were for Mpala, and Mpala put them in his house so that it looked just like the house of a muzungu. Mpala in turn gave Bwana Boma twelve elephant tusks, eight lion skins, six leopard skins, and copper, as well as two people.[23] Bwana Boma asked what he was supposed to do with these two. Mpala told him he could take them with him on his way back to Europe and sell them on the other side of Lake Tanganyika. They would be Bwana Boma's *matabishi*.[24] Bwana Boma thanked Mpala fourteen times. He then called out, "You, Batuta!" "Yah?" "Do you hear? So we will go this way, people will want these two people, they are our matabishi."

Mpala called his kinsmen Mwindi, Kakwa, Kabemba, and Katwebe to come and see the things that Bwana Boma had given to him. The bales of cloth were bound with iron straps, and Bwana Boma called to his kaparali, "Cut these open." [Kizumina used a comically nasal "European" voice to imitate Bwana Boma]. They measured the cloth and measured the cloth, and Mpala gave much of it to his kinsmen and kept the rest for himself. Then as Bwana Boma was leaving, he said to Mpala, "Ah, my friend, listen, if our place were not so far away I would send you a letter, but our place is so far away and no Tabwa person has ever gone to Europe." Ya, people understood it was very far away. "So, here, what will I do now?" Mpala asked, and then continued, "You will take my name with you and your name will remain here. That is all, good-bye!" "Good-bye." This was Mpala Kakonto who did this. So, wasn't that the end of it? There was no other chief who received Bwana Boma, no, no, no.

And when Bwana Boma died [in 1918], didn't a letter come to inform us, carried by Katampa Kinga, that muzungu?[25] And we said, "Ah-ah, Bwana Boma has died, Mpala's namesake has died, Mpala himself has died."[26] We gave a goat to Katampa Kinga because he had brought us the news, and we said, "Who will go there [to the funeral in Ulaya]? Who will go there?" We don't know the path to go there so we just remained here, we were saddened but we remained here. They sang, "The friend of Mpala has died, the friend of Mpala has died." That was it. Those others [Europeans], yah! *Wapi!* [What were they ever worth?]

Kizumina's Political Subtleties

The narratives of Louis Mulilo and Kizumina exemplify a Tabwa oral genre called *milandu* (singular: *mulandu*) that is specifically political in nature. I was told that such accounts "have yet to be 'opened'"—clarified, that is—and

their negotiation and arbitration are inevitably ongoing. The root of the word *milandu* refers to speech and memory in Tabwa and Luba dialects, and such histories are composed during debates and litigation over land, succession, and other important rights and obligations.[27] That is, milandu imply performance techniques and events and exemplify what Jan Vansina calls "oral tradition as *process*": they do things and get things done. As Wyatt MacGaffey writes of similar discursive forms among Kongo, milandu are above all purposeful, as "forensic instruments in unending disputes" and of critical importance to their resolution.[28]

All sides know most details of any such contest, but each will create a historical argument that proves its points while dismissing those of adversaries. Power politics can be very much at the fore when deciding who has "won" any such debate. Yet milandu are both predictable and open-ended, for they depend upon complex logical structures that are shared with other clans and ethnicities, sometimes over very broad areas of Bantuphone central Africa and undoubtedly through the course of many centuries. Still, the paradigms within these tales accommodate new data when times change and needs present themselves.[29] Narrators insert characters or incidents into established frameworks as they seek to make a convincing case and therefore achieve the goals of a particular telling. Metaphor, analogy, and other tropes play significant roles in such performances, as does cosmology; and the overall narrative form of milandu is related to the "retrospective determinism" of divination, through which the cause of present-day misfortune is tracked back to a seminal incident so that "what actually happened looks as if it somehow *had* to happen."[30] Whether or not it *did* happen as proposed is decided through further prognostication, and in particular, by whether or not whatever has been going wrong can be turned around, as when, for example, a protracted, worrisome illness is brought to remission.

The early lines of Kizumina's story illustrate how milandu narratives work, for Kizumina portrays Bwana Boma as being very deferential to Sultani Mpala, praising him, noting when and how they began "liking each other" as friends, and specifying that it was Bwana Boma who begged Mpala to join him in the lusale ritual of blood covenant. There is poignancy to a story like this, for it can be understood as a retort to the denial of dignity that characterized European disdain for colonial "subjects." Kizumina's assertions also reflect how anxious Storms was to dramatize the ritual with a great show of largesse matched by a frightening spectacle of excessive force, even if the

lieutenant's more private thoughts about these same events suggest that he only grudgingly condescended to exchange blood with the chief, since he derided the oaths, procedures, and contractual expectations of any such worthless transactions with childish Africans. Despite Storms's swagger, which can be understood as an early contribution to "the political economy of colonial sarcasm," as Janet Hoskins might dub it, "eating" lusale meant as much and perhaps more to the lieutenant than it did to the chief.[31]

Blood covenants are "a very widespread variety of communion," Arthur Hocart noted many years ago, and in the turbulent days of late nineteenth-century east-central Africa, security established through such a bond that extended beyond kith and kin could be a real boon to trade in and travel through contested territories.[32] Tabwa understand blood to be the essence of life itself and hold that it brings heat (*moto*) and therefore vital energy to heart and soul (*mutima*). Furthermore, "human being is abstracted and essentialized" in blood, and a mere drop can stand in for a person in objects and procedures of magic.[33] For people at Lubanda, a sense of the partitive person was put in play by lusale as a most intimate communion. Although lusale was not practiced for many years, people told me that in the old days, spouses established such a covenant to cement their enduring love, while persons otherwise unrelated through the expansive relationships of matrilineal descent or the interdependencies of clan alliance might exchange blood to confirm a special friendship, especially for the purposes of trade. Perhaps, as Luise White has found in eastern Africa, the blood of covenant "was thought of as a sexual fluid, more akin to breast milk or semen than to the blood of wounds and injuries." Should this have been the case for Tabwa of Bwana Boma's day, then lusale would have borne even greater intimacy than one might think.[34] The dark side of the same idiom was and is achieved through *bulozi,* when victims' blood is secretly consumed in the course of soul theft, as discussed in chapter 8. One wonders if there might be a correlation between lusale during late precolonial years and the *mitumbula* "blood-suckers" of the colonial period who were as notorious among Tabwa as they were other Congolese peoples.[35] In a related vein, power and wealth are also "eaten" following local expressions that suggest ambiguity as to whether such actions are appropriate. In effect, then, Sultani Mpala and his people must have expected more from—and been anxious about—"eating" lusale with Bwana Boma than Storms could have known.

Lest any such notions seem distinctly "African"—as they most assuredly were understood to be by Storms and his contemporaries—it is instructive

to consider an unsigned introduction to the lieutenant's description of ex-changing blood with Chief Mpala as reprised in *Le Congo illustré* a dozen years after the fact. Advice was offered to future "expeditionary commanders" who might consider establishing blood covenants with Africans as had the lieutenant.[36] While it might "sometimes [be] a good idea . . . to agree to this," under no circumstances should a superior (read European) exchange blood with an inferior (African); instead, a subaltern European or African adjutant should perform the ritual instead of the commander himself. The author recognized the egalitarian threat to colonial hierarchy that a ritual like lusale might signify, in other words. Mimicry carries menace, as Homi Bhabha re-minds us.[37] Through the emphases of his mulandu narrative, Kizumina seemed to suggest that Mpala pursued just such a transactional tactic in seek-ing to "eat lusale" with Bwana Boma and was looking to what he could expect from such a sharing of vital essence.

Further challenge to colonial hierarchy was evident in Kizumina's nar-rative when Bwana Boma made ready to leave for Europe and gave Sultani Mpala gifts that suggested "everything that a muzungu uses." When Mpala put these things in his own home, "it looked just like the house of a muzungu." Storms's generosity suggests far more than a transfer of material goods, then, for Kizumina posited an exchange of social identities: Mpala became "Euro-pean." In return, Bwana Boma was presented with ivory tusks, prestigious animal pelts, and copper—probably in the form of the cross-shaped ingots so famously produced in Katanga.[38] Symbols of wealth were reciprocated, in other words. Yet other aspects of the account make clear that such mimesis would not be enduring, as Storms's departure for Belgium left Mpala and his people far behind.

That two enslaved persons were offered to Bwana Boma as a matabishi complicates Kizumina's story, however. The term, referring to a gratuity or a bribe, can be quite demeaning in its assertion of differential status and largesse as the "dash" of a "big man" of means; yet in Kizumina's telling, Bwana Boma was not sure what to do at first but then felt naïve pride and joy as he told his rough-and-readies that Mpala had offered him two people as a matabishi. That the gift should be in the form of chattel is telling, for Kizumina revealed both his knowledge of the times and suggested Storms's complicity in the very ex-ploitative system he was supposed to stand against. Even as his mercenaries took and traded slaves, so did Bwana Boma himself, Kizumina implied—and quite correctly so, judging from written records to be considered in chapter 5.

Yet when Mpala died of smallpox, all Storms could bring himself to note was how loyal Mpala had been to him. And if Kizumina's narrative was an assertion of fragile agency—for in his telling, Mpala might be a more significant figure than Bwana Boma—the weight of colonial realities was also very apparent to the old man. For a brief moment, Mpala's residence might have been decked out with the material attributes of a muzungu, but no one among colonizers and colonized would be fooled by such fleeting appearances.

That Lusinga refused to answer when Bwana Boma spoke to him according to Louis Mulilo's story, tugged on Bwana Boma's ear as he insulted him in Kizumina's telling, or that he went so far as to slap Storms across the face, as Sultani Mpala once recounted to me, can be understood in more than one way as well. Lusinga was arrogant and from a certain perspective, brave enough to show defiance of the European; yet in so doing, he proved himself the perfect fool. To refuse to acknowledge Bwana Boma or to strike or seize him by the ear suggests that Lusinga thought the European was both child-like and powerless. That the warlord soon got his comeuppance underscores Kizumina's assertion that whatever claims to seniority over Mpala that Lusinga might himself have made or that later Belgian and Zaïrian administrators asserted on his behalf, the man had no idea what he was doing, and by extension, his descendants are equally worthless (*bure kabisa*). Kizumina's mulandu may have had other political motivations as well, including the fact that in choosing a successor to Sultani Mpala, Bwana Boma passed over Kizumina's own ancestor, Mumbwe.

Kizumina could be so vitriolic in his assertions concerning the relative seniority of chiefs Mpala, Lusinga, and Kansabala that he was jailed for some days in the late 1950s for having insulted Paramount Chief Kansabala to his face during a discussion of such matters as convened by a colonial officer. The story was a celebrated one recounted to me a number of times, always in praise of Kizumina's defiance of established authority. A judge of Sultani Mpala's court told me that he had been present at the meeting and that even though Kansabala admitted that Mpala was his senior, the colonial officer did nothing about it. The gendarmes accompanying the officer teased Mpala thereafter, saying that while Kansabala had won the paramountcy through his *bwerevu* (the craftiness of bulozi), Mpala had received the cross—an allusion to his loss of status because of the overwhelming influence of the White Fathers at Mpala Mission. More "hoo-haa-ho-haaa" hocus-pocus, in other words. Clearly, Kizumina's account of Lusinga's demise reflects the stakes of

just such local-level politics, and when Tabwa tell milandu, there are always motives other than entertainment, despite how engaging the narrations may be in the hands of masterful orators like Louis Mulilo and Kizumina.

Given the purposeful biases of the milandu genre, it would have been instructive to hear versions of these same incidents as told by Lusinga or those close to him, quite obviously. This did not prove possible during my research in the mid-1970s, however, for I was never able to meet the man despite several attempts. On one occasion friends from Lubanda and I hiked two days into the mountains with the expressed purpose of visiting Lusinga Ng'alala at his village on the Muswe, as we had been told he was there at the time. On the path during our second day, we happened upon Lusinga's younger brother Mufwaya, who told us that the chief was on a moonshine (*rutuku*) binge in a village some ways beyond the Muswe. I asked if Mufwaya knew the story of Bwana Boma's battle with Lusinga, but he replied that it would be inappropriate for him or anyone else to tell the tales of his older brother, thus reflecting the Tabwa sense of personal rights to narratives and esoteric information of other sorts alluded to by the young man who challenged Kizumina.[39] Lusinga was reputed to be very aggressive when inebriated, and asking about the humiliation of his ancestor would be dangerously imprudent, the friends with me warned. Other, increasingly daunting political matters were in mind, including the tense lead-up to the First Shaba War, which would break out in spring 1977.[40] We returned to Lubanda, however disappointed.

Lusinga's "mother's brother," Paramount Chief Kansabala, did agree to speak with me several times, but he, too, was widely acknowledged as an alcoholic so cantankerous that he was eventually removed from office by Zaïrian regional officials because his drunken behavior had caused their embarrassment in a particularly public moment.[41] As a consequence, I did not think it wise to ask Kansabala to recount anything as esoteric as his version of his ancestors' parts in the conflict between Bwana Boma and Lusinga in 1884. Such alcohol-inflected exchanges—or the lack thereof—may be more common in the "spirited ethnography" and "ecstasies of encounter" of which Fabian has written than is generally acknowledged, of course, but as my lack of direct contact with Lusinga suggests, resulting studies are specifically affected by the fact that the chief has not spoken for himself.[42]

One is left to assume that Lusinga's narrative would have cast his ancestor in a far more favorable light than Kizumina's Mpala-centric account did, thus justifying the official recognition of seniority over Mpala's lineage that colonial

administrators bestowed upon Lusinga for years to come. Indeed, a mulandu composed to further Lusinga's interests would have dealt with Mpala and others chafing under Lusinga's rule in anything but generous terms. Such an account might have reflected what David Henige has called the "'amnemonic' process by which 'embarrassing' interludes of foreign conquest are elided, or greatly played down, in a local ruling-line's official account of its past."[43] And in all likelihood, what Lusinga Ng'alala would have said about Bwana Boma and what he did to and with the Lusinga of the early 1880s would have been very different from what I learned from Kizumina and Louis Mulilo.

For an idea of how Lusinga might be portrayed by his successors nowadays, one can look to the ongoing interpretation of the career of the Yeke chief Msiri introduced in the first pages of chapter 1. Msiri was far more successful a warlord than Lusinga, insofar as he created a "new African supra-regional (proto-) state," and as opposed to Lusinga's contemporary obscurity, Msiri's descendants remain prominent in Congolese and Zambian politics. As he is now recalled on his dynasty's website, "Msiri was fearless in battle and magnanimous in time of peace. His generosity and loyalty to the Yeke people made him a beloved monarch, whose legend was passed down in the oral tradition of story-telling, later kept alive through written accounts and Yeke traditional songs."[44] Were they given the opportunity, Lusinga's descendants would laud him in similar ways, one must assume.

Aside from contributing to local-level politics, Kizumina's tales can be understood as something more provocative with regard to Occidental debates and discourses: in certain ways, Kizumina presented a Tabwa cultural history as an ethnographer might. That is, he fulfilled aspects of my own role as an author insofar as he tried to tell a consistent and engaging tale while making allusions that would be appreciated by his audience, although not— and perhaps *specifically* not—by the protagonists. Duplicity is not suggested on either Kizumina's or my side; instead, narration often has purposes that elude or are irrelevant to certain parties. Still, Kizumina's deeply coded references provoke examination because of the information they add to the narrative, and because they reveal the brilliance of the storyteller and his cultural milieu. Here one may recall V. Y. Mudimbe's reflection that Africanist anthropologists like Meyer Fortes, John Middleton, Marcel Griaule, and Luc de Heusch "taught us that an account of, and attention to, each group's cultural arbitrariness and specific history enable us to understand that the less visible aspect[s] of cultural transformations might perhaps be the most

important from a historical perspective."[45] I would add Kizumina to such a list of savants.

That these *were* Kizumina's rather than Lusinga's words must be emphasized, for it is impossible to know what portions of the story—what "facts," metaphors, ironies, or other tropes—Kizumina learned when others told him about Lusinga's demise, and what are his own embellishments and inventions. Following the logic of milandu, other orators would have chosen different devices even if seeking similar results. Nor can we know what details Kizumina might have forgotten or deemed inappropriate to the particular narrative events to which I was a party. In other words, this is a tale of the mid-1970s, not the mid-1880s. It illustrates the *making* of history rather than any positivist sense of what really happened on that fateful day in early December 1884—if, indeed, we can ever know what did. Nonetheless, I hope to demonstrate—through ethnographic detail and the deductive reasoning I recorded and in which I joined in nearly four years of intellectually stimulating conversations with Tabwa friends—that the accounts of Louis Mulilo and Kizumina do lend a sense of the ongoing significance of the "dance" of our two protagonists, at least in the mid-1970s during my research in Zaïre.

A further political dimension of Kizumina's narrative must be mentioned before broaching his esoteric allusions. Whereas in Émile Storms's accounts, it was he who was the intrepid explorer seeking to advance the purposes of science even as he established a bastion of European hegemony, Kizumina reversed the roles. In Kizumina's telling, Lusinga was the one who sought to determine the most apposite idiom within his own epistemology and so explain the anomalous "red" being standing before him. As Luise White might put it, Lusinga deployed "a powerful way to talk about ideas and relationships that begged description." He possessed and demonstrated agency through the intellectual processes available to him, in other words. He explored Bwana Boma rather like a scientist, asking questions and testing hypotheses within his own system of knowledge and according to his own political purposes. While Kizumina used his tale to indicate the follies of the chief, hence his inferiority in contests of status between Lusinga's lineage and Kizumina's own, the old man nevertheless permitted the chief's dramatic character certain triumphs of intellect. In so doing, to some small extent Kizumina turned the tables on Bwana Boma—the would-be "emperor-of-all-he-surveyed," to paraphrase Marie Louise Pratt—by defying the imperialist pretenses Storms personified by the 1970s, at least for the few like Kizumina who still knew and could elaborate his stories.[46]

Code "Red"

Now let us consider the particular metaphors at Lusinga's disposal as Kizumina deployed them. Early on, Lusinga told Mpala that Bwana Boma must be a *shetani,* a Swahili word from the same Semitic root that gives us "Satan" in English and that has long been used by Christian missionaries to Africa with reference to the Antichrist. Tabwa do not usually describe maleficent spirits as shetani, for there are much more precise terms in Kitabwa and their dialect of Swahili that differentiate among the nefarious persons, spirits, and forces with whom and with which "good" people must contend on a daily basis.[47] Rather, Kizumina's choice of words is church-inflected and implies a source of evil from outside—and perhaps far outside—the Tabwa community that he was defining as his audience.

Somewhat similar reference to "distance"—social or temporal—was made in Kizumina's description of Bwana Boma's men as Batuta and Manjori. Batuta Kyalo, "the ones who break the country," were Zulu-related Ngoni people and those swept up with or pushed ahead of them in a vast movement northward from what is now South Africa. In the late 1840s small bands of Ngoni raided lands west of Lake Tanganyika, including those of Tabwa living in the Marungu Massif, while most directed their energies into what is now southwestern Tanzania. Batuta also figured among early rugaruga, and "in a real sense the Ngoni . . . set the scene for the Arab penetration that was to follow."[48] No one I consulted could explain who the Manjori were, nor have I been able to find the name in written or Internet sources: might they have been Moujoua or Monjava people of present-day Malawi and Mozambique (usually called Yao), who were long-distance traders throughout the region in the early nineteenth century?[49] Neither Batuta nor Manjori appears in Storms's own descriptions of his men, and it would seem that Kizumina's anachronistic reference may have been nothing other than just that. Yet given the way he called Storms the "second Sakala," thereby linking him to a violent predecessor, the narrator's collapsing of time may have been to create a more purposeful analogy than may have met most eyes in the 1970s, but that could have been a logical association in the 1880s.

And then there is the matter of "red." At a first level, that Lusinga should describe Bwana Boma as "red" must refer to the Belgian's skin pigmentation. Nowadays, Tabwa at Lubanda may say that people of European heritage are "white," using the French term *blancs,* and they may occasionally use the similar Swahili word *weupe.* But these are European racial terms, and whether

or not they were of imperialist introduction, they were certainly greatly reinforced during the colonial moment. More commonly in the 1970s as in Bwana Boma's days, Tabwa referred to Europeans by the Swahili term *wazungu* (singular: *muzungu*), and they used the referent "red" far more frequently when describing the skin of people of European heritage than any terms for white.

Muzungu is not a strictly racial term (although it is also that), for it bears the prefix of sentient being (*mu-/wa-*) for a noun that otherwise means "something wonderful, startling, surprising, ingenuity, cleverness, a feat, a trick, a wonderful device," or any ploy or expedient for getting out of difficulty. The stative form *uzungu* refers to "strangeness" and "novelty," while the verb, *zungua* or *zunguka*, is "to cause to go around" or spin, and a muzungu startles and turns the head.[50] My sense is that such an explanation is far too benign, however, for in Tabwa reckoning, any cleverness sufficiently startling to turn the head would be associated with the illicit advantages derived from bulozi—"witchcraft," that is. As we have seen, this latter is the ambivalent "art of exercising unusual powers" for both the best and worst of purposes, helping and harming people for personal or collective gain as situationally determined and interminably debated.[51]

Needless to say, Tabwa and other Bantuphone Africans do not construct race as people do in the United States or in European countries. In the late nineteenth century, Afro-Arabs from the Swahili coast were considered wazungu and may or may not have had "red" skin according to Tabwa. And nowadays Tabwa themselves may be considered wazungu if they act as thoughtlessly and with the unmitigated self-interest that people of European heritage do, following conventional wisdom at Lubanda as influenced by the ambivalences of mission history. Through the term *wazungu*, then, economic class, political perquisites, nationality, and race may be merged.[52]

The reason why Tabwa might consider "red" skin startling is not just a commentary by people who have seen few people of European heritage, although that is undoubtedly an aspect of their choice of words. Nor is it simply a reflection on earlier and contemporary power dynamics that continue to privilege people of European heritage in contemporary Africa, although, again, it is also that. Instead, as Chief Mpala Kaloko stated, in the days when Bwana Boma was the first European many had seen, it was felt that he could only be so "red" because he had risen from the dead (*kufufuka*). That such an assertion is not unusual in the history of early encounters between central Africans and people of European heritage should not obscure the fear that

such an oddity surely produced among late nineteenth-century Tabwa—matched, one must quickly add, by the panic of many early European visitors in finding themselves among Africans.[53] Associations with the worst sorts of *bulozi* would have come to many Tabwa minds as well, for the dead can be raised and directed toward evil ends.

In a more general way, Kizumina's account of the confrontation between Lusinga and Bwana Boma deploys elements of deep philosophy recalling Marshall Sahlins's assertion that "politics appears as the continuation of cosmogonic war by other means." Sahlins was writing of the tragic encounter in 1779 between Captain Cook and people of what is now Hawaii. Cook's appearance was understood as the return of the god Lono, and the Englishman was put to death and revered according to ritual practices associated with ghosts.[54] I did not hear any stories that integrated Bwana Boma into cosmogony as explicitly as this, yet as a "red" being, Storms was understood through deeply symbolic idioms begging for narrative exposition. Furthermore, we shall see that there are other ways in which Sahlins's insights concerning the "apotheosis of Captain Cook" prove apposite to an understanding of "the dance of assassins" to be considered in the next chapter.

In Kizumina's account, Lusinga makes more specific allusions beyond the generally "red" appearance of Bwana Boma's skin, for he calls him a *kabege*, a *kamushulwe*, and a *kasuke*. Storms recognized these terms as deliberately insulting—with his ear pulled by Lusinga to make sure he got the point. The lieutenant wrote the words in his little breast-pocket diary, thereby exercising the archetypal power of Europeans to capture knowledge through literacy in order to use it for their own ends, often to the detriment of seemingly illiterate Africans. Tabwa, Luba, and other regional peoples were by no means "illiterate," strictly speaking, although their performance of oft-embodied, ever-so-subtle systems of inscription eluded their European observers in Storms's day as they did throughout the colonial period.[55]

Formal education was central to the purposes of Mpala Mission, and the first seminary in the Congo was established there, lending Lubanda a significance that was sustained for many years. Given how important literacy skills were to the many who attended mission schools, Kizumina's emphasis of Bwana Boma's writing alluded to colonial pretensions achieved through frightening "signifying practices" of colonial and postcolonial authority.[56] Administrators often exchanged written messages carried by local people who were not permitted to read them; written codes and laws were applied

without explanation and in ways that reversed the "natural" order of things that Tabwa might expect through their own epistemologies; lists of local people's names were brandished as taxes were levied and corvée labor imposed; and deliberate mystification and arrogance were empowered by the written word. Indeed, those close to Sultani Mpala in the 1970s held that the seniority of rival chiefs Lusinga and Kansabala was established by *writing*, as though it were a powerful process extending beyond the practicalities of communication. As I was told, literacy was the device of "Europeanness" (*kizungu*) through which Mpala was "brought down" (*wamemupunguza*) by colonial administrators as a consequence of his adversaries' bulozi-inflected trickery. In this regard as well, Catholic missionary use of the Bible as both Truth and talisman informed Kizumina's narrative, and as Patrick Harries suggests for some southeastern Africans of the late nineteenth century, writing and reading were performances in their own right and were "not a skill to be acquired, but rather a ritual to be harnessed."[57]

The three "red" terms cited by Lusinga (as Kizumina told the tale) refer to anomalies of human being or practice that Tabwa feel to be threatening. In each case, a particular sort of marginality is considered dangerously "red," "hot," and "powerful," and Kizumina alluded to them to nuance his description of Bwana Boma in a way that reinforced the humor of such insider knowledge. Through what James Fernandez has termed "edification by puzzlement"—that is, the proposition of metaphors and other images that "send us elsewhere to obtain our answers"—Kizumina's audiences were afforded opportunities to reflect upon how *their* world works.[58] Whether or not particular listeners were able or willing to do so was quite another matter and might well lead to the impatience manifest in Kizumina's discussion of mission-related esoterica mentioned above.

Symbolic senses of these terms come from the red-white-black triad of primary colors that is as much a "mode of thought" for Tabwa as it is for Kongo, Ndembu, and other central African peoples. "Red" stands for violent and bloody transformation and is always ambiguous, for it may be perilously destructive, but it can also be wholesomely creative and lead toward a "white" state of grace and harmony. According to the same key metaphors, however, "red" can also lead to the third basal point of the color triangle occupied by the deep secrecy and arcane potential of "black."[59] Above all, "red" is associated with rupture and change as much as it is considered something unto itself.

A *kabege* is someone without hair on head or body, either "unnaturally" or by removal for some perverse—rather than cosmetic—reason. Such a person lacks

or eschews a primary index of personal and group identity. Receding hairlines and thinning hair are as familiar to Tabwa as anyone else, of course, yet understanding the phenomenon is as much through cultural construction as in the West, where baldness is considered unfortunate and to be reversed through medication or elective surgery or hidden by aerosol coloring agents. According to Tabwa epistemology, anything as noticeable as sudden hair loss would initiate divination to discover its etiology, which could be the result of an attack by a human adversary or a malevolent spirit seeking to divest the victim of hair as a most obvious vehicle of self and group identity.

Along the southwestern shores of Lake Tanganyika in the late nineteenth century, "monumental" coiffures, as Storms described them, constituted a signal art reflected in ancestral sculptures.[60] The LMS missionary Edward Coode Hore was similarly struck by "the headdress people" he encountered in western lakeshore communities, noting that "men and women alike are got up in the most elaborate style. The hair is encouraged to grow long by every possible aid of combing and stretching over rolls and puffs, which are built up into shapes resembling crowns or turbans, and ornamented with iron and copper ornaments, bands of cowries and beads and terminal points and cones, forming a structure requiring great care to preserve from damage." Hore's spouse, Annie, was equally eloquent: "Both men and women have the most elaborate *coiffures*, padded and pomatumed to an extraordinary extent, and ornamented with coronets of cowries, with iron and wooden bodkins stuck artistically about, in the huge cushion formed by the hair."[61] Some Tabwa men wore dreadlocks braided into patterns whose names communicated important information to viewers, as depicted in rare period photographs and ancestral sculpture. And a variety of picks, pins, beads, mirrors of polished iron, and medicinally powerful accoutrements added to the visual and ideational impact.[62]

Rugaruga are also said to have worn their hair "plaited in long hanks," and Aylward Shorter has speculated that this suggestively "phallic" style may have given rise to their generic name *"rugaruga,"* based upon the Nyamwezi term *muluga*, or "penis." An early description of rugaruga underscores Shorter's assertion, for they "actually wore the penises of their enemies as trophies in their headdress, and it is certain that they did this with other parts of their victims' bodies."[63] Storms wrote that rugaruga in his employ wore their hair "braided in fine locks [*mèches*] that fall to their shoulders," sometimes wound about grasses to produce "a singular effect of contrast between their light

color and the black hair"; and they attached "all sorts of things, especially talismans such as little pieces of root, certain fruits, the teeth of humans or wild animals, little bones, [and] peanuts with three seeds that have the same significance in Africa as do our four-leafed clovers." The same men donned multiple bracelets and heavy anklets made from ivory, but other than their use of human teeth and unidentified "little bones," Storms made no mention of his men adorning themselves with relics of the vanquished. If some ruga-ruga did engage in such ghastly practice, they did so as "warrior theater" meant to terrify adversaries while emphasizing and perhaps magically re-inforcing the young men's own violent virility.[64] Similar preoccupations in-spired the ribald lyrics sung by Bwana Boma's hardies as they marched to and from Lusinga's redoubt and as they entertained the chief prior to his assassi-nation, according to Kizumina's telling of the tale.

To be "red," "hot," and hairless like a kabege, then, was to lose or deny participation in an essential personal aesthetic associated with masculine sexuality and strength, as enhanced by magic and medicine. Other Europe-ans visiting the area in the 1870s and 1880s were also addressed with this de-risory term, it seems, for the LMS missionary Walter Hutley reported that area "natives call us *kabejwe,* not men."[65] Judging from photographs and the engravings derived from them, Storms was quite hirsute (see figures 1.1 and 10.2), and a lack of hair could not be the reason for calling him a kabege. It is more likely that Lusinga's mockery of Bwana Boma as being "'red' like a *ka-bege*" is a reference to his being strangely uncommunicative according to Tabwa symbolic idioms, and so marginal to humanity itself as Kizumina and esoterically inclined members of his audiences might understand that definition.

More Ear-Tugging Taunts

A *kamushulwe* is an infant born prematurely and so literally red, as are all tiny babies in this perilous state, no matter whether they are of African or some other heritage. A kamushulwe is figuratively red as well, for it may perish and become a *kaonde,* as Kizumina explained. Tabwa do not consider such tragic beings to be human, as they are "'just blood' (*damu tu*), 'life' itself but lacking the boundaries that would have made them persons."[66] Since a kaonde is not a person (*mutu*), it is not to be mourned and will be buried in a midden rather than an ordinary grave. Shamanistic practitioners called Tulunga are said to

disinter the remains of a kaonde from such a place for use as a medicine when they steel themselves to confront and protect their clients from the most heinous agents of evil. Because a kaonde relic can be used to counter and even "terminate" an adversary, it is of great menace if it falls into the "wrong" hands, with this latter term politically determined by the side of a dire contest from which one is talking.[67] In calling Bwana Boma a kamushulwe, then, Lusinga (as voiced by Kizumina) was making reference—however ironically—to an esoteric complex of ideas and practices all pointing toward the European's dangerous lack of humanity.

Lusinga's third taunt, when he called Bwana Boma a *kasuke,* refers to an African with reddish skin compared to others whose skin is darker and considered by Tabwa to be more handsome. This might seem another straightforward reference to race, but because the term is one of comparison among local Africans themselves, a more profound cosmogonic allusion may have been at play. In the origin myths of Luba, Tabwa, and culturally related peoples, the dark "black" culture hero Mbidi Kiluwe (or his structural equivalent) confronts Nkongolo Mwamba, the "drunken king" and avatar of all excess, who kills his own mother during a bout of volcanic fury. According to one account, Nkongolo's father was a spotted hyena—itself a preposterous beast for its apparent lack of sexual dimorphism and other odd traits—while Nkongolo himself was "'a red or clear skinned man who was a monstrosity'... so ugly that no one resembled him before or since."[68] Nkongolo Mwamba would be considered a kasuke following such logic, in other words, thus compounding the insult when the term was extended to Bwana Boma.

As the Luba saga has it as couched in the profundities of color symbolism, the order and expectations of culture depend upon the conquest of "red" by "black." Mindless violence and primordial chaos must be overcome and transcended by profound reserve and secret strength—positive qualities personified by Luba leaders and those like Lusinga who would emulate them. By dubbing Bwana Boma a kasuke, Lusinga—again, as Kizumina would have it—implied that sooner or later the European would be overcome as had the "red" antagonist of cosmogonic lore. Distinct ambiguity was also achieved by the allusion, however, for "red" can never be completely defeated, as the incessant transitions and transformations it implies and instigates are necessary to existence.[69]

A final reference to color occurs in Kizumina's narrative when Lusinga commented on how peculiarly "red" Bwana Boma was and suggested that if

Storms had visited him instead of Sultani Mpala, he would have had him captured, bound, and thrown in the river to drown. In response, Mpala assured Lusinga that Bwana Boma was a man like any other, implying that Lusinga must have thought the opposite—that the lieutenant was anything *but* a human being. Given the prevalence of weapons and other more obvious ways that Lusinga surely knew how to do someone in, his suggestion that drowning the Belgian would be the appropriate way to dispatch such a "red" being deserves interrogation: why *this* murderous method, and when else was it employed with regard to those deemed dangerously red?

Several Tabwa told me that in precolonial times, infants with certain anomalies were drowned in just such a manner. Like the kaonde premature baby who dies shortly after birth, such abnormal children defied the cultural definition of what it meant to be "human." The archetypical case was those rare little ones whose first teeth emerged from the top rather than the bottom jaw, as is the biological norm. Such unfortunate toddlers are still known as *vinkula* (singular: *kinkula*), and they are considered so hugely dangerous that I heard in the 1970s that they ought to be destroyed to protect those to whom they are born as well as their birth community more broadly. The etymology of the word *kinkula* provides clues as to why Lusinga considered the drowning of Bwana Boma to be such a necessity.

Nkula is the bright-red to deep-crimson substance that Tabwa, Luba, and other central African peoples make from camwood bark (*Pterocarpus tinctorius*) or, more rarely, from ferruginous minerals. Tabwa still occasionally use nkula as body paint, as a preparation of divination equipment, and in other contexts when, as the noted Tulunga healer Nzwiba told me, a person wishes to show that "he is fierce, he has no friendship with anyone, now he is someone else, another person. He is like a policeman, he has no father or mother or mother's brother. He is blood!"[70] Here again, "red" refers to aggression, alienation, violence, frightening transition, transformation, discontinuity, and liminality. A kinkula as "a *thing* of redness" rather than a person, is a killer without conscience possessing power without limit: he or she can maim and destroy through thought or verbal menace alone. No wonder, then, that earlier Tabwa sought to eliminate those they felt to be of such danger to them; no wonder that Lusinga should wish he could dispatch the terrifyingly "red" Bwana Boma in the same efficient—and specifically "cooling"—manner by having him bound and thrown into a river to drown.[71]

We now know some of the nuances of "red," as well as other subtleties that Kizumina brought to his narratives about Bwana Boma. Did Lusinga really say any of the things that the old man ascribed to him? In other words, did these references to Tabwa esoterica inform the ways that Lusinga understood Bwana Boma when he met him in 1883, or are they the sedimentation of different narrators' inspirations as the tale has been told over the ninety-some years between Lusinga's fateful encounter and Kizumina's recounting the story to me in the mid-1970s? Although we cannot know the answer to the first question, we must assume that the second is affirmative and that, as Johannes Fabian might say, Kizumina engaged in "memory work" as he explained to his audiences how and why the conflict between Bwana Boma and Swift-of-Foot was still significant, nearly a century after the fact.[72]

3 · Histories Made by Bodies

We must be prepared to experience the figure, severed and whole,
in its severing and its dance: to inhabit it, rigid and fleeting,
violent and happy, blood and spirit, horror and promise.

—JULIA KRISTEVA, *THE SEVERED HEAD*

Because of the strength of Lusinga's forces, Storms felt obliged to wait until his troops could be bolstered by those of Paul Reichard before attacking the chief's mountain fastness in early December 1884. He then added men from local chiefs who were loyal to him so that he could deploy over a hundred warriors for the expedition. Kizumina offered a different description of Bwana Boma's force, saying that only eight "soldiers" (*askari* in Swahili, presumably *wangwana* and *rugaruga*) bearing carbines were joined by twenty men mustered by Sultani Mpala, including Kizumina's own older brother. Kizumina emphasized wiles rather than numbers, and, as we shall see, arcana and spiritual agency seem to have been very much on the old man's mind when he stressed the men's singing, and—especially—the dance that accompanied the foray, as important technologies of warfare.

As Kizumina had it, Lusinga and his people were pleased to receive Bwana Boma's men, most obviously because the chief assumed they were bringing him the repeater rifles he had requested. Flintlocks are notoriously inaccurate, and as Storms put it scathingly and perhaps with racist sarcasm,

such "firearms that possess terrible powers are soon discredited . . . for they are generally wielded by people who only manage to make noise with them." Again in Kizumina's reckoning, Lusinga would have seen the breakthrough of carbines as a potential "means of *destruction*" as he sought to establish local hegemony while participating more fully in the growing industries of ivory hunting and slave trading.[1] One only needs to recall Joseph Thomson's vivid description of how Lusinga had laid waste to lakeside communities north of Lubanda to imagine the heinous adventures he might have entertained using Bwana Boma's high-powered weapons.

There was no resistance to the soldiers' entry into Lusinga's fortress, and indeed women hastened to offer warm hospitality of food and lodging for the heavily armed yet greatly outnumbered men. The plot as both Louis Mulilo and Kizumina told their tales hinges on this point: Lusinga was entertained, flattered, and distracted by the singing and dancing, and thereby lulled into lowering his guard. Yet the nature of the soldiers' performance suggests that Lusinga was so easily tricked for other, more deeply esoteric reasons that Kizumina had in mind as he composed and presented his narrative concerning the chief's reversal of fortune.

Songs that "Rollick with Raw Humanity"

Storms admired the varied and harmonious vocalizations of his rugaruga. There was nothing melodious about the music of Kizumina's telling, however, for the "roaring coarseness" of the soldiers' song could not be a more obvious demonstration of machismo.[2] Kizumina's audience found its absurdity very funny, laughing uproariously every time he sang the words in his creaky voice, clearly playing to his crowd. Peripatetic Penis has a life of its own in Kizumina's lyrics, recalling Nicolai Gogol's surreal short story "The Nose," in which a disembodied proboscis struts about, hails horse-drawn carriages, and haughtily refuses to obey the commands and entreaties of the person occupying the rest of its body.[3] In Kizumina's telling, Penis hungrily looks upon the starchy *bwali* polenta made from manioc, sorghum, or maize that is the basic dish of Tabwa meals. It sees women and "stands itself up." Penis, Penis, Penis—the old man's mirth was mesmerizing.

Might these words have suggested another purpose to the men in Bwana Boma's service? The relationship between praise singing and honor among brazen Zulu warriors in the time of Shaka may provide an analogy, for insatiable

sexual appetite was among the qualities they most avidly flaunted. Among their songs was one with the following words, the more potent for their understated analogy of "eating" and forceful sexual conquest: "He who while devouring some devoured others / And as he devoured others he devoured some more."[4] Although lacking any such subtlety, Kizumina's song was meant to elicit laughter and yet surely referred to the same sorts of harsh gender politics in times of dire turmoil that one can assume motivated the Zulu lyrics. The insulting treatment, physical brutality, and forced, long-term concubinage of Lusinga's women—who had just been so warmly hospitable—say as much of Storms's warriors.

Ribaldry also has its place in contemporary Tabwa culture, as it long has from what little direct evidence one can find and as one can surmise from outraged missionary accounts of early ritual and related collective activities.[5] In particular, lascivious songs and dancing are the province of the parents of twins, whose fertility is deemed remarkable. Crude humor demonstrates the parents' release from the niceties of ordinary etiquette, and lyrics often refer to genitalia of Pantagruelian extravagance. Furthermore, to Tabwa reckoning, twins communicate secretly between themselves and possess the power to harm others through thought alone. People may find aspects of twins' ambivalence to be auspicious, yet as not-quite-human beings, twins can be distinctly alarming. In this regard, analogies are drawn between twins and chiefs, and the ambiguities of lunar symbolism are addressed to both. Twin songs accompany possession rituals and other events that seem to have no explicit relationship to twinship itself through bawdiness beyond risqué.[6] The purpose of such expression is reversal of expectation, and so it was with the rude song of Bwana Boma's men in Kizumina's account.

Much Tabwa song possesses call-and-response structure, and Kizumina's audience could assume that Bwana Boma's soldiers' priapic ditty elicited participation beyond the ululating women of Lusinga's entourage.[7] Aural dialectic undoubtedly accompanied and reinforced the mimetic moves implied by Kizumina's allusions to dance, to which we now turn.

Both Louis Mulilo and Kizumina emphasized the choreography of Storms's men as they attacked Lusinga. Although details are frustratingly spare, the two narrators contributed a sense of how such performance was significant to the purposes of the tales, in contrast to the deliberate aridity of the lieutenant's written accounts. How, then, we want to know, have people at Lubanda "danced their truths"?[8]

As a young man, Kizumina enjoyed dancing and was given the nickname Matofari, an Arabic word borrowed into Swahili and Kitabwa that refers to sun-dried bricks. In all likelihood, Kizumina was "solid" in his steps.[9] Although no further information has been found, one can surmise that as a dancer himself, old Bricks was well aware of the complex phrasings, subtle references, and distinct efficacies borne by the dances of his day that extended to those known to Lusinga. Unfortunately, though, Edward Evan Evans-Pritchard's declaration made so long ago still holds true for Tabwa and related central African peoples: "In ethnological accounts the dance is usually given a place quite unworthy of its social importance."[10] A long-standing social-science bias against studying embodied experience cannot be denied, but it is also true that writing about movement practices presents its own challenges. As Susan Foster asserts, "The sense of presence conveyed by a body in motion, the idiosyncrasies of a given physique, the smallest inclination of the head or gesture of the hand—all form part of a corporeal discourse whose power and intelligibility elude translation into words." As a result, she and fellow dance theorists call for "bodily engagement" by those writing and reading about performance.[11] To the extent possible, we are to experience the dance, even in historical reconstruction.

If we know so very little of earlier choreographies, we know even less of particular performance events, nor can we readily perceive the sense of "presence" to which Foster alludes. We can only speculate about conventions and codes informing Kizumina's account and how and why dances were presented on any given occasion.

An Archaeology of Tabwa Dance

An exception to Evans-Pritchard's rule is Robert Schmidt's tantalizing description of the *sompo* dance among Tabwa living near the Lukuga River's egress from Lake Tanganyika, about a hundred kilometers north of Lubanda. In sompo a line of men and another of women faced and flirted with each other in creative tension, singing a call-and-response while a pair moved forward to dance between the serried ranks. To the words *butanda nkonge, yo-lo-lo*—"a bed [soft like the pelt of] an otter, *yo-lo-lo*"—a man proved himself "an extraordinary mime and she also; their movements were of a rare litheness; a couple of panthers would not be more gracious. At a bound they are at the end of the dancing place, they slide, they turn over, they are going to fall . . . no! With the right hand they push up from the ground and here they

are upright again, vibrant, their arms open and with love on their lips. But she refuses and they return sadly to their places."[12]

Yo-lo-lo is a euphonic term of rhythm and emphasis, and the song's reference to the bed of an otter is a risqué double entendre. The word *nkonge*, designating the spotted-necked otter (*Lutra maculicollis*), is very close to *nkongwe*, a term for a woman's pudendum, hence the ready pun. Otters (but more specifically the Cape clawless, *Aonyx capensis*) are important as a Tabwa clan emblem.[13] Rather than to "panthers"—melanistic leopards, that is—as Schmidt had it in racialist allusion, the song compared the dancers' lithe movements with the playful agility of these aquatic animals. *Sompo* as a noun refers to the stringing of minnows on a long blade of grass as little boys do when they fish along the rocky shores of Lake Tanganyika. A related verb, *kusompola*, is to swoop down on prey as a raptor might, or to snatch something that someone else is about to seize. Such a sense of contingency and closely coordinated movement is realized in the dance, for allusion to fish strung together may be a poetic reference to feigned union, and the frisson of eagle-like swooping and snatching a partner's passions before someone else can do so is reflected by the term as well. Sultry sompo with its *milonga* lines of men and women focusing their rapt attention upon a swooning couple "in the bed of the otter" further recalls performance idioms of the Black Atlantic that find resonance in central Africa, and indeed, in Argentina, the milonga was an early form of tango.[14]

One can guess that Robert Schmidt was a no-nonsense colonial administrator in ordinary circumstances. That he was so evocative in his passage about sompo suggests that he was swept up in what he understood to be an engrossingly erotic moment. Furthermore, his writing here is so florid that one suspects he may have penned it in antagonism to Catholic missionary accounts that reflected a late nineteenth-century sense of African dance as the essence of primitivity.[15] However the goal of sompo may have been entertainment of a very sexy sort, its virtuosic mimetic phrases reflected deeper significance, which will be discussed shortly.

Bwana Boma's men were not performing anything so alluring as sompo, but the embodied logic of their movements was similar. Elements of their "warrior theater" may have originated with expatriate rugaruga who, as Storms reported, had "special dances for which they are the only actors." Such performances "always" had "a warlike character" and took the form of mock battle between two groups of young men. Dressed in their finest clothing, they danced around a central drummer and would suddenly break into rival

companies alternatively rushing at each other in a competition to see which side could knock the "bonnets" from the others' heads.[16] Central African war dances of the sort might "exhibit polish and power" to impress and intimidate audiences and allow leaders to gauge their men's preparedness for engagement, or they might reenact particular battlefield triumphs to educate and entertain those who had not been present and build unity in the process.[17] One way or the other, the point was to get "pumped."

Parenthetically, I have found no evidence that Bwana Boma ever joined in local dances of this or other sorts. Perhaps such a "refusal of ecstatic experiences" was "a form of abstinence based on the rules of hygiene and scientific method," as Johannes Fabian finds true of most of Storms's fellow explorers who proved similarly reticent.[18] Perhaps, however, the lieutenant was simply shy, physically awkward, afraid to lose face, or rigid and aloof in soldierly composure around the "niggers" (*nègres*) he sought to control through his own disciplined example, as discussed in the next chapter.

As stuffy as this may make him seem, a fragment of Storms's writing adds a glimpse of the efficacies of dance as a dimension of performance. In an undated page about "the welcome of Blacks [*Noirs*] upon an arrival in Karema coming from Mpala," Bwana Boma seemed quite taken by his joyful reception. As he landed on shore and began walking toward Fort Léopold, he was surrounded by "a swarm [*essaim*] of women" crying, "'Oh! Oh! Oh!' at the top of their lungs [*à tue-tête*] and provoking variations of tone by pinching their cheeks between their thumbs and middle fingers." The women rushed ahead of Storms, then awaited and surrounded him only to run ahead again, continuing their "Oh! Oh! Oh!" hocketing. Upon entering the boma, he distributed gifts and later heard drums and singing accompanying dance. Indeed, the lieutenant learned that during his absence, these same women had repeatedly danced "in favor of his success," and Storms concluded that "one finds that dance itself is a *dawa*!"—a medicine or magical device, that is. Attached to this same page is another that lists elements of a practitioner's basket that Storms examined at Lubanda and that may be the one presently held at the Royal Museum of Central Africa. The contents were used to create bundles to afford aggressive protection, promote successful big-game hunting, and to heal, as Storms described in a brief piece listing these same items and published in *Mouvement géographique*.[19] The joining of the two pages of Storms's notes suggests that he may have assumed dance to have similar agencies as dawa concoctions as he understood them. In a flash of insight that he did not pursue, Storms seemed to realize that if dance were dawa, then the women's

efficacious performances were responsible—in their minds anyway—not just for his victories but perhaps for his very survival.

However spectacular rugaruga war dances may have been, the idiom as Storms described it was not that to which Kizumina referred in his stories of Lusinga's demise, although I suspect that Storms's quick comment on dance-as-dawa reflects what Kizumina had in mind. A critical narrative detail is that as Bwana Boma's men positioned themselves in the cardinal corners of Lusinga's palisaded village, preparing to shoot and kill the chief on the third and final day of their subtle assault, they emphasized the central point where the corporal leading Storms's men threw himself to his back in an agile acrobatic move to sing and dance while Lusinga's women ululated. The stage was set, and however transitory Kizumina's reference may appear, the scene is altogether revelatory.

Storms's few words about a dance idiom around Lubanda resonate with old Bricks's description of the *kaparali*'s break to his back, for the lieutenant wrote of Tabwa performers' "prancing [*trépignements*] and most reckless movements," while "their grand art consists of the most unexpected leaps, rolling over on the ground, getting back up again, [and] somersaulting in every possible way." Storms further remarked that such "extravagant contortions" were felt necessary to the success of a performance. One can assume that any such "success" would have been debated by the audience, as Robert Schmidt found among northern Tabwa among whom "the spectators commented, one to another, on their impressions of the dancers' aesthetic qualities and the choreographic science of each one." Indeed, Robert Farris Thompson cites this very passage as evidence of indigenous African dance criticism in earlier times.[20]

Such acrobatic phrases were bravura breakouts from larger performance contexts, and the "extravagant contortions" noted by Storms were a demonstration of skill, grace, control, and honor reflected in a related movement practice popular among Bende people living around Karema in the 1880s. Bende were and are culturally and historically related to Tabwa living directly across Lake Tanganyika from them, and succession to certain Bende chiefdoms is said to be determined by Tabwa lineage elders. One can assume that expressive modes and means such as dance were shared across the lake as well. Jérôme Becker offered this most compelling description of a Bende dance:

> While the circle, like the chorus of a Greek tragedy, moves by turning about itself, and while marking the beat by the clapping of hands, two coryphées place themselves in the center. The more skillful leads the dance. He

undertakes crazy contortions, swinging his hips as though to dislocate them, and twisting his shoulders [in ways] worthy of a professional clown. His rival is there, not to answer but to imitate slavishly and nearly simultaneously his slightest grimace and every intention. Indeed, he looks on with fascinated intensity. One thinks of two watchmen of the guard staring at each other in the whites of the eyes. If the second dancer makes a mistake or omits the slightest movement, he humbly returns to the circle and another more deft presents himself to try to triumph at the test. For hours at a time, recognized dancers wear out their presumptuous competitors to finish, alone, the dance they have begun.[21]

Becker's erudition is striking, as were his wit and sympathy, and Johannes Fabian has much to say of this remarkable man. A coryphée is "a ballet dancer ranking above the *corps de ballet* but below the soloists," after the Greek term for a leader of the chorus in ancient dramas.[22] Becker's choice of this term is subversive in its own way, for it brings a reference to aristocratic European performance arts to bear upon an African idiom that would be disparaged in more ordinary colonial discourse. More specifically, for those knowledgeable of the mirroring moves of the Brazilian "dance-fight-game" called capoeira, Becker's words will sound very familiar indeed. The Bende dance does not seem to have been a martial art so much as an instance of "deep play"—that is, seemingly ordinary encounters that reveal the tensions and risks of society and the logic of problem solving.[23]

Angolan movement practices are historically related to capoeira and other African-inflected dance forms of the Americas. What has not been documented in any detail is how such idioms may have been shared among Bantu-speaking peoples as far to the interior as Lake Tanganyika and beyond. In turn, any such recognition opens up the diasporic term "Kongo," which is very often applied to elements of central African culture found throughout the Black Atlantic. Certainly many people were enslaved among Kongo peoples of Angola and transported across the dread Middle Passage, but other central Africans from farther afield were seized and taken to the Americas as well, and "Kongo" became a "catchall category."[24] That people from far inland exited Africa via Kongo lands—hence the gloss—should encourage investigation of central Bantu-speaking cultures as exhibiting cultural accomplishments related to those of coastal west-central Africa and the African Americas, including the dance vocabularies and phrases of capoeira.

The close-as-a-shadow challenges of virtuosic dancers described by Becker, the intimate pas de deux of sompo so admired by Schmidt, and the "reckless"

leaps and somersaults observed by Storms all led to unexpected outcomes, for each idiom was a contest, as Becker made abundantly clear. Indeed, one can surmise that over and above the entertainment afforded by such engaging movement practices, the creative mimesis suggested deeper subtlety and purpose. In particular, the dialectics of such dance marked by up/down reversals matched by horizontal revolutions must have informed Kizumina's understanding of the corporal's break to his back before Lusinga.

Insight from the noted philosopher and dance theorist José Gil permits us to propose a synthesis of these styles and purposes and to offer a hypothesis about Kizumina's choreographical allusions. Gil would have us "consider the body as a meta-phenomenon, simultaneously visible and virtual, a cluster of forces, a transformer of space and time, both emitter of signs and trans-semiotic." A body that is "inhabited by—and inhabiting—other bodies and other minds." Dancers' vitality extends beyond their bodies to energize circumstances and blur distinctions between person and place, in other words. The corporal's performance was such an achievement of "kinesthetic empathy," especially as his henchmen distributed themselves to the cardinal points so as to define his centrality at the moment he would dispatch the chief. Yet "to dance is to produce dancing doubles" and "one partner becomes the other, becomes the other's dancing energy." The tension created across the a/symmetries of the two is so paradoxical that Gil alludes to a dancer's "Möbius body"—that is, like that topological conundrum, the surfaces of one and the other body are conflated. The result is an "inter-corporeity" of the sort that Michael Jackson describes as lying "*between* people: a field of inter-experience, inter-action, and inter-locution."[25]

Following such logic as substantiated in the mirroring moves we have been considering, whether or not Lusinga joined the dance or simply sat entranced by it, the corporal and the warlord were locked in a highly charged "movement dialectic," sharing "energies" even as they pursued their diametrically opposed purposes.[26] Over and above such consequential synergy and the consummate acting of the kaparali through which he utterly fooled Lusinga, we can surmise that Kizumina had even more esoteric matters in mind.

When Spiders Speak and Eagles Dive

Let us speculate some more about how the "dance drama" framed the kaparali's deft moves as Kizumina told the tale. Dance is not simply committed to memory, Adrienne Kaeppler reminds us, for "although a particular performance is

transient, the structure is not, and even if a specific choreography is forgotten, knowledge of the structure of the system and the inventory of motifs will be remembered." The "system" so implied is what Susan Foster might consider the syntax of dance—the logic by which performance can be "read" and interpreted. In considering what codes, conventions, and esoteric meanings may be so perceived, we can take inspiration from Havelock Ellis, who famously remarked that "to dance is to take part in the cosmic control of the world"; from Marcel Mauss's assertion that "corporeal techniques" can be "methods of entering into communication with God"; and from Dierdre Sklar, who holds that "spiritual knowledge is as much somatic as it is textual."[27]

The "corporeal techniques" described by Becker, Schmidt, and Storms bore just such significance, as did the movement practices alluded to by Kizumina. When the kaparali broke to his back before Lusinga, he was executing a move similar to the "grand art" Bwana Boma witnessed that consisted of "the most unexpected leaps, rolling over on the ground, getting back up again, [and] somersaulting in every possible way." Such acrobatics were important to a related expressive domain among earlier Tabwa. Praise singers called *sikaomba* playing *nfukula* chest drums sometimes dropped to their backs in an agile—if "most reckless," in Storms's estimation—maneuver called "the eagle," missing nary a beat of their complex rhythms.[28]

Nfukula drums were no longer played around Lubanda by the 1970s, at least to my knowledge, but I did discover two turn-of-the-twentieth-century glass-plate negatives of sikaomba "poet-musicians" performing at the White Fathers' mission in Baudouinville (now Moba-Kirungu, DRC), and several examples of nfukula are now held in private and museum collections (fig. 3.1).[29] The drummer's intensity is palpable in the old photo, for the bulging muscles of his shoulders and arms are tensed as he clasps his drum to his chest, his knees are bent ever so slightly, and his feet are splayed to set his equilibrium as he stomps and plays the gourd rattles bound about his ankles. The feathered headdresses and sheaves of bamboo segments and leather strips must have accentuated the movements of the two performers, while the particular elements held symbolic and perhaps magico-medical potency. When I showed them the image, elderly chiefs Mpala and Kapampa both recognized the itinerant nfukula player as the renowned sikaomba Kifumbe, who once hailed from the village of Kala west of Kirungu. The territories of Mpala and Kapampa are some two hundred kilometers from each other, and that Kifumbe's celebrity should be recalled so many years later and over such a

Figure 3.1. *Nfukula* chest-drum player, Kirungu Mission, early 1900s. White Fathers Moba-Kirungu Mission (DRC), with permission.

wide region bespeaks how significant his arts were to the audiences of his moment.[30]

An nfukula consisted of a hollow wooden cylinder some 30 centimeters (12 inches) tall, 25 wide at the bottom, and 18 or 20 at the mouth. A head made from Nile monitor (*Varanus varanus*) skin was pegged to the drum with acacia thorns. The bottom was open and held tight to the chest to produce polyphonic "body music" as a complement to the drum's primary percussion.[31] A round hole piercing the side of the drum was fitted with *lembalemba* webbing from the nest of a terrestrial hunting spider (species unknown). Lembalemba is so dense and possesses such tensile strength that it acted as a kazoo. Changes in air pressure as the drum was beaten and thumped on the sikaomba's chest produced a reverberation, giving voice to spiritual presence.[32]

An anthropomorphic head carved in relief on the side of an nfukula now in the *Musée de la Musique* of Paris was invested by such a spirit, and that its left eye—closest to the aperture fitted with lembalemba—is raised in a triangular arch is a reference to the extended ken of spirit possession as depicted in other figural sculpture among Tabwa. Perhaps the sikaomba was "played" by the spirit so evoked, even as he beat his drum. Furthermore, the sides of this same nfukula and several others known from museum collections are decorated with registers of isosceles triangles known as *balamwezi*, the signature motif of Tabwa graphic expression.[33] *Balamwezi* means "the rising of a new moon" in recognition of the lunar dialectic of light and darkness, hence enlightenment versus the anxious ambiguities of arcana. As an inscription on the side of an nfukula, balamwezi patterning was a visual proverb insofar as it conveyed its sense of uncertainty, transformation, and, most significantly, the courage to persevere, even in the darkest hours.

A virtuoso sikaomba could make an nfukula "talk" in counterpoint to his singing and in a "voice" enhanced by the throbbing buzz of spirit. That the nfukula head should be made from the skin of a Nile monitor demonstrates practical reasoning, for this thin leather stretches well and can be fitted tightly, it is remarkably strong, and no other locally available material can match its timbre. Such a head contributes to the nuanced production of sound as the player slaps and damps the drum with fingers and palms, but the animal adds its own symbolism to any such production. Nile monitors are toothy lizards and dangerously large, sometimes 2 meters or more in length. Their subtle patterning offers them camouflage but also creates the chance of a hunter stumbling upon one by accident, much to both parties' chagrin. Monitors are equally comfortable on land and in water, and their peculiar liminality is increased when they run so rapidly that they appear to "fly" over the tops of vegetation when flushed or hunted, as I myself have observed.[34] The great reptiles are also deemed "silent," yet they facilitate the communication of mystical complexities through drumming. Nfukula rhythms were far more than the rhythms produced with them, in other words.

Sikaomba troubadours sang praises for chiefs, and Bwana Boma was so honored "constantly," especially for his defeat of Lusinga. He did not necessarily appreciate the tributes, witness his cranky comment about "drums played under his nose" in performances that "not only grate on your ears but that suffocate you in a cloud of dust," implying that movement accompanied the music. Sikaomba also sent men to battle by giving them courage.[35] Why, though, would "eagle" be the name of a performer's tour de force breaking to his back?

Figure 3.2. Bateleur eagle plunging to seize prey. Photo in Tanzania by John Booth ("Hawkgenes") 2009, with permission.

The montane forests around Lubanda are home to many birds of prey, including large and spectacular eagles. The African fish eagle (*Haliaeetus vocifer*) is especially common and sets a fiercely territorial cadence from perches along the shores of Lake Tanganyika that is so regular one can almost calculate distance by sightings of the birds' snowy-headed splendor.[36] Storms did not record the local term for "eagle" that would reveal the particular species in question, but it is *mpungu,* the bateleur eagle (*Terathopius ecaudatus*), that most readily captures Tabwa imaginations (fig. 3.2).

The bateleur is deemed "the most magnificent bird that flies in Africa" by the noted naturalist Leslie Brown, and in southeastern DRC a widespread praise for the Supreme Being alludes to this creature that "flies so high it seems to touch the firmament," in the words of the Tabwa ethnographer Stefano Kaoze. Indeed, the name in question, Kabezia Mpungu, is derived from the Bantu root *-ez,* connoting ability, intelligence, power, and strength, combined with *-ung,* suggesting the eminence of the Almighty Above.[37]

A pensive man of Lubanda told me that bateleurs "wander [the skies] without beating their wings." The eagle wheels effortlessly upon updrafts, and

from a speck so high in the sky that one's sight is defied, it plunges to snatch a snake as its favored fare. One is reminded of the discussion of the sompo dance idiom and its related verb, *kusompola,* meaning to swoop down on prey like a raptor seizing something that someone else is about to grasp. "Bateleur" is from the French and refers to tumblers performing nimble feats for popular audiences. The mighty bird's name must have been chosen with reference to its astonishing flips and dips during airborne courtship.[38]

Given such behavior, it is small wonder that Tabwa associate the bateleur with fulgurous convulsions brought on by meningitis, malaria, and other perilous maladies; and acute migraine headaches are specifically called *mpungu,* "bateleur."[39] Following the same associations, people in what is now northeastern Zambia feared that "witches" might use an "activating agent" made from the *chipungu* (bateleur eagle) in their nefarious concoctions to destroy the innocent, for just as an eagle will plunge from the heavens to seize one chicken out of a flock, singling it out through the raptor's "electricity," so may a rapacious aggressor fall upon a hapless victim. That the bateleur (*chipungu*) should be depicted in the ancient ornithomorphic sculptures of Great Zimbabwe further suggests its widespread and deep symbolic significance.[40]

From such ethnography, one gets the sense that *mpungu* is more a verb than a noun and that the high drama of the bateleur's reversal of up to down and back up again explains the corporal's breaking to his back in a move called "the eagle."[41] The performer's somersault is analogous to the bateleur's loop-the-loops and split-second descents, as sublime verticality is brought to bear upon terrestrial matters. "The eagle" may dance on his back, but in a salute to—and, most significantly, a *calling upon*—infinite powers of transformation rather than any form of submission, despite the semblance of doing just that to keep Lusinga captivated. "The eagle" would rise in triumphant turnaround, and great transformation would be effected as he ascended once again. As Kizumina recounted, "The *kaparali* sang and danced, sang and danced, sang and danced, then suddenly, pah! 'Ah-ah! Yo yo yo! Lusinga is dead! Lusinga is dead!' Pububububu, pububububu [indicating the sound of pandemonium]." In that lightning-strike instant, Lusinga's world changed forever and early colonial hegemony was established. The hypothesis advanced here is that as Kizumina understood it, such transformation was *caused* by the kaparali's moves. And as Bwana Boma might have concurred, the dance was dawa—magically and spiritually efficacious, that is.

You Say You Want a Revolution

The narrative incident of Lusinga's reversed expectations, like a bateleur eagle's deft flip, is what Roland Barthes might have termed a "cardinal function" of narrative, insofar as the corporal's dropping to his back posits relations neither up nor down but always in the in-between of a dialectic turning upon itself. Such moments "constitute real hinge points of the narrative" even as they remain "risky moments" of potential transformation. Again according to Barthes, the bateleur itself would be an "index" that "involve[s] an activity of deciphering" through which one "is to learn to know a character or an atmosphere."[42] Reference to the eagle's dive as dramatized in on-the-back acrobatics makes the inexorable inversions of power in Kizumina's story available to contemplation, for what goes around comes around. Lusinga will get his comeuppance but by the same logic, so must Bwana Boma.

"Lyrical metaphors emerge . . . in . . . associations made within and across expressive domains" as embodied in performance, John Janzen tells us.[43] Revelatory reflection of such associations lies in comparison between Tabwa practices and far better known activities among the eastern Luba neighbors whom Lusinga so strove to emulate. I would suggest that in his description of that fateful day at Chief Lusinga's boma, Kizumina alluded to movement practices from a Luba paradigm called *kutòmboka* and, indeed, that this idiom provided or shared the structure of a sikaomba's agile play.

As explained in the magnificent *Dictionnaire kiluba-français* of E. Van Avermaet and Benoît Mbuya, *kutòmboka* is "to execute a special dance (reserved for men exclusively) during the investiture of a chief, circumcision ceremonies, [or] a war (to obtain victory)." More particularly, it may suggest bounding with delight, such as when one receives something of value from a chief, and "these two ideas: a dance of exaltation and overwhelming joy converge on the occasion of a chief's investiture." The same term bears other associations, for the title *bwana mutòmbo* is how some Luba refer (or once did) to a master of indigenous medicines. The artist who carved chiefs' staffs of office as well as *nkisi* power figures was also known by this appellation.[44] It is not clear if in the old days there was a convergence of the two roles, doctor and sculptor, but one can guess there may well have been, for clearly the root of these terms suggests possession and manifestation of critically creative powers.

Remarkably, the verb *kutomboka*—without low tonality denoted by the *accent grave* of *kutòmboka*—appears to bear the opposite meanings of "to rebel

against authority" or "declare a war without legitimate motive as recognized through custom," while the derivative stative form, *butomboki,* is "insurrection" or "anarchy." As the Luba scholar Nkulu-N'Sengha Mutombo puts it, *kutomboka* suggests being "out of control" and may further refer to the assertion of "one's personality in an arrogant or prideful fashion, to say that 'I obey nobody, I am my own king, I am afraid of no one.'"[45] In other words, *kutomboka* connotes tensions about whether authority will be acknowledged, defied, or usurped. If I am correct in assuming that Kizumina alluded to *kutòmboka* (with or without tonality) in his story, his point would have been that Bwana Boma's men were honoring Lusinga through a Luba movement practice, much to the chief's solipsistic pleasure; yet the same dance would have possessed the seeds of subversion, activated as the kaparali suddenly shot the man dead while breaking to his back in an eagle's dive and a victim's destruction. Here one may recall—and wonder about—the dance of Bwana Boma's men as they threw themselves at his feet to celebrate their assassination of Lusinga. Was this in simple "submission" as Storms assumed?

Although the nature of Luba tonality suggests that *kutòmboka* is a different word from *kutomboka* despite their near homonymy, they form a couplet of centripetal and centrifugal forces realized in everyday speech through punning across the contrasted tonality. In this regard, "speakers permit themselves much more than do those who study idioms of speech," as Rik Ceyssens reminds us. In other words, shifts of tonality and plays on homonymy can create a "tropological space" of the sort that Foucault considered, through which "the spontaneous duality of language . . . is not quite the grammarian's space, or rather, it is the same space, but treated differently" for expressive purposes.[46] Indeed, this same dialectic is basic to notions of authority among Luba and related peoples, as dramatized in the epic struggle between Kalala Ilunga, to whose refined bearing and political prerogatives a successor aspires through kutòmboka investiture ritual, and Nkongolo Mwamba, the "drunken king" who personifies the anarchy of kutomboka.

The archetype for kutòmboka is the dance of Kalala Ilunga, as described in the Luba Epic.[47] As the story goes, Kalala was invited by his treacherous mother's brother, Nkongolo, to perform for him in celebration of victories the two had shared in recent skirmishes with their enemies. Nkongolo was lethally jealous of Kalala's growing acclaim, however, and in anticipation of the dance, he had a deep pit dug and fitted out with upward-pointing spears: Kalala would dance upon a mat covering the trap and fall to his death. The

symbolism of the incident is very complex, for Kalala and his father incarnate the moon through its various phases, whereas Nkongolo still makes himself manifest as the great solar serpent that breathes forth the rainbow from a subterranean lair to halt the rains and hearken the dry season. Through a pit trap, the culture hero's doom would be sealed by a reversal of up to down, celestial to terrestrial, light and enlightenment to obscurity and decay. Kalala was informed of the subterfuge, when, like a sikaomba, the drummer Mungedi inspired the hero's "cleverness" and led his steps so that he could avoid the pitfall. Kalala ended his performance in triumph, thrusting his spear through the mats to prove the presence of Nkongolo's deceitful device before bounding away to freedom. He would soon return, however, to take Nkongolo's head and establish the political prerogatives and protocols of royal demeanor recognized to this day as the models for civil behavior.

The signal moment of the hero discovering the pitfall is dramatized over and over by members of the Mbudye Society, in our times as in the past. Mbudye engages Luba heritage, bringing it to bear on momentous relationships and circumstances of quotidian political life; and a wide range of material and performance arts articulate the communicative processes so implied.[48] The responsibilities and prerogatives of Luba kings were celebrated through kutòmboka, but Mbudye members also provided a check and balance on royal authority, for they possessed the power to execute a king should he transgress the sacred prohibitions of his office. The revolutionary ambiguity of kutòmboka/kutomboka might be activated by Mbudye, in other words, for those who might exalt the king were (and are) the same actors who might see to his demise.

Nowadays, Mbudye members are renowned for their spectacular dance displays on public occasions ranging from the investitures of chiefs to the welcoming of honored visitors, Catholic holidays and ordinations to folkloristic festivals, political rallies to soccer matches. For their own purposes, Mbudye members mark moments of ritual significance such as the rising of a new moon, members' funerals, or initiations to the society and its ascending circles of knowledge, praxis, and mystical power.

Mbudye members are famous for their acrobatics, including the somersaults and "eagle" plunges of the sort we have been discussing. When they hurl themselves forward in a phrase called "to throw the *mpòngò*," after an arboreal squirrel whose fur is so light and fluffy that it flies up at the slightest movement, their costumes often lift in the back to reveal magical nkisi bundles strapped to their waists. The contents of these remain a closely guarded secret, yet their

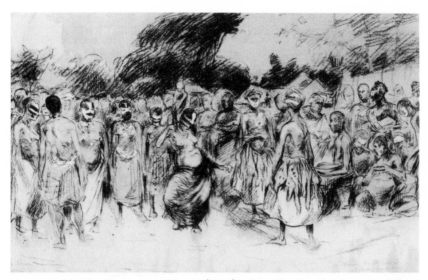

Figure 3.3. Mbudye dancers near Mpweto (DRC) in Léon Dardenne's watercolor of 1900. 26.5 × 42.5 cm. Gift of the Belgian Ministry of Colonies, 1911; HO.0.1.219, collection RMCA Tervuren, RMCA Tervuren © with permission.

startling size and association with the narratives of Mbudye performance, as well as the symbolic powers of costumes and choreography, all speak to great potency.[49] Indeed, the nkisi bundles and other mystically charged accoutrements of the performers are meant to be seen to assure the audience of the secret powers of Mbudye, and the bundles merge with the dance dramas, making the entire event an nkisi meant to inform and transform all those attending. Clearly, Mbudye dances vastly transcend the idle entertainment they also provide.

Turn-of-the-twentieth-century Mbudye dances are depicted in three evocative drawings by Léon Dardenne, artist for the Scientific Mission to Katanga of 1898–1900 led by Charles Lemaire.[50] These images and another by Dardenne of *Dancers at Chilombe* may be the only evidence we have of particular performance events in the area and of the era, and they are so vivid that, as Sabine Eyenga-Cornelis suggests, "the spectator has the impression of attending the scene." Dardenne captured the dancers' agility and virtuosic movements, especially in a picture of a "mortuary dance" in which a woman demonstrates what Robert Farris Thompson calls "polycentric levels of expression" (fig. 3.3). The Mbudye dancer throws her head to the left and her shoulders to the right, even as her hips also swing to the left and her knees to the right. In voluptuous response, she uses the different parts of her body to

Figure 3.4. Mbudye dance at Kinkondja (DRC) in 1987. Roberts and Roberts 1996, 146; photo by Mary Nooter, with permission.

work with and against the cuts, flourishes, and "rogue commas" of the musicians playing behind her. Indeed, in the woman's pose, which Dardenne has frozen as though a shutter had clicked, "the prose of human action becomes a poetry of valor, pleasure, and precision."[51]

Dardenne's drawings resonate with the photographs of Mbudye performance taken in the late 1980s by Mary Nooter (fig. 3.4). An Mbudye dancer and the bundle he wears around his waist merge in the complexities of an enacted, movement-based nkisi, producing transformations of its own. In a related vein, T. J. Desch Obi suggests that while fulfilling their "ritual protocols" as they prepared for battle, nineteenth-century Angolan men performing war dances might "break the effects of an enemy's charms." And among northern Kongo, a dance called *malambo* seen in the 1950s included a vigorous stamping of feet over a ground laden with potent medicines, the steps activating the substances.[52] In a similar way, vigorous Mbudye performance created a theater of healing, protection, and promotion to be remembered and brought to bear on problem solving; and the movement phrases of kutòmboka held efficacies of their own as they still may, extending to the dancer's every step. One can deduce that aside from mesmerizing Lusinga as he was consumed by lust for ever more efficient weaponry, Kizumina implied that the warriors' dance bore direct— and directable—powers. The chief was overthrown, that is, by far greater forces than the scant band that Bwana Boma had sent to take his head.

Kizumina had the kutòmboka paradigm in mind for another reason. Kutòmboka as a dance and more general set of concepts and purposes is so associated with the prestige of kingdoms of the Luba heartland that it has spread to neighboring groups, or perhaps it resonates with and reinforces the "cardinal functions" of their own performance idioms. For example, since the 1960s, if not earlier, versions of kutòmboka have been performed for celebrations of local government and as tourist attractions among the Eastern Lunda of King Kazembe, who live mixed with or adjacent to southern Tabwa chiefdoms of northeastern Zambia. David Gordon asserts that "behind the curtain of their timeless ceremonial traditions" such as *mutomboka,* the Eastern Lunda "dance of conquest . . . is a stage upon which chiefs and their entourages have collaborated to re-write histories, shape collective memories, and define their places in the postcolonial polity." Among Lozi people of east-central Zambia, Karen Milbourne explains that the relationship called *kutòmboka,* now understood to mean "to walk majestically" in a king's public display of power, is differentiated from *kuomboka,* referring to an event of great pageantry celebrating the king's prerogatives

in local, regional, and national heritage politics.[53] What is most striking from these examples is how generative a performance idiom kutòmboka can be in our own times, suggesting that earlier chiefs like Lusinga may have deployed it as they sought to enhance their status through reference to Luba political aesthetics. In particular, kutòmboka seems to be the choreographical counterpart to milandu as a dancing of memories, structures, relationships, and signal events meant to make or reinforce expedient histories.[54] As such, it would seem an obvious tool at the disposition of a storyteller as masterful as Kizumina.

Dancing the Divide

The dance idioms discussed here follow a "syntax" of codes and conventions shared among Bantu-speaking peoples of central Africa and on into the Black Atlantic.[55] Last reflections on Kizumina's account of the dance of assassins are stimulated by accounts of Kongo elements of capoeira as studied in west-central Africa by Fu-Kiau Bunseki and Robert Farris Thompson, among others. Marie-Claude Dupré's discussion of Kidumu masquerade among Teke people of the Republic of the Congo similarly emphasizes the performance of inversion through "semiotic art," as does the "foot-fighting" called *engolo* among people of southwestern Angola and northwestern Namibia as described by T. J. Desch Obi. The same term among Kongo refers to "sharp, sudden pauses [or] cuts (*nzéngolo*)" that "symbolize change."[56]

"Capoeira is a sort of 'magic theater' where situations that arise in life itself and between people are staged," Nestor Capoeira tells us, and performers spend much of their time "upside down, cartwheeling, handstanding, and ... close to the floor, hand spinning, attack evading and mule kicking." These positions are derived from Kongo and other west-central-African practices brought to Brazil through the transatlantic slave trade. "The world," as the Kongo philosopher Fu-Kiau Bunseki explains, "is like two mountains opposed at their bases and separated by the ocean. At the rising and setting of the sun, the living and the dead exchange day and night." Furthermore, day, night, and day again are like life, death, and rebirth, for "BaKongo believe and hold it true that man's life has no end, that it constitutes a cycle" in "a continuous process of transformation, a going around and around." In upside-down dance moves called *kinkindu*, Fu-Kiau explains, "you change everything when you walk on your hands. This means you are walking in the other world." Indeed, "touching the earth before the game, kneeling before the *berimbau* [bow harp], cartwheeling or otherwise

entering the arena upside down or close to the earth—all of these are ... expressions honoring forces beyond and beneath the horizon."[57]

Such reversals are a frequent theme in the necrogeographies of central Africa. "In the 'other world,' people walk upside down, make day into night, make right left, and have white skin" rather than black, writes Anita Jacobson-Widding, who, like Thompson, has long studied Kongo and other Bantu-speaking peoples. As we shall see later in this book, funerals often dramatize such inversions when "the hierarchical order, controlled behavior, and the prudish etiquette of normal social life are transformed ... into the chaos of people shouting, embracing one another, rolling on the ground, tearing their clothes off, performing ritual jokes, and excelling at obscenities." Such peculiar practices mark a striking hiatus in everyday life, even as they assure passage to the world beyond. "The message is as follows: 'Something has happened that has turned everything upside down. Death has come.'"[58]

North of the Kongo peoples in the borderlands between the republics of the Congo and Gabon, Teke Tsaayi men enact these same principles in Kidumu performances during which—at least in the late 1960s—they "cartwheeled many times, turning upside down as best they could, [in] a movement difficult to perform because the mask is held in place only by a string which the dancer grips tightly between his teeth." "Kidumu" is from a word that "refers to the noise of thunder and the fame of chiefs," and the performance idiom was adopted as "a token of political importance and power" in ways similar to kutòmboka in the Luba world. Kidumu's wooden masks are circular and flat, and their surfaces are adorned with red, white, and black motifs, as divided horizontally by a black line that is sometimes accentuated by a break in the surface plane. Such a "roof beam," as it is called, divides the mask's top and bottom in a way that Teke say is a mirroring between everyday life and the underworld. Indeed, a Kidumu mask collected by the early Swedish missionary Karl Laman was called Ntalani, meaning "'those that look at each other in a mirror' or 'those that are face to face.'"[59] The somersaults of men wearing such masks bring hallowed ancestral forces of the below to bear upon human—that is, political—forces of the everyday above. Such an achievement may have been especially pertinent late in the nineteenth century when the mask and its dance were invented or updated, for due to political upheavals, "fortunes seemed to revolve unpredictably."[60] Furthermore, the masks are hard to hold by the meager means of a cord gripped in the teeth and may be dropped, to the undoubted consternation of performer and audience. One wonders if the difficulty of the practice informs

the deep purpose of seeking spiritual intervention, for, like the uncertainties of the movement, such intercession can never be assumed.

South of the Kongo complex in southern Angola and northern Namibia, choreographies and martial arts play upon these same principles in a "stylistic manipulation of ancestral power." Healers and other ritual specialists gain "spiritual power through physical imitation of the ancestors" by walking on their hands or otherwise embodying inversion. So may those who "transform . . . the human body into a weapon" through kicks and sweeps, often delivered in the course of a cartwheel or handstand that allows a performer "to go over, under, or nimbly blend to escape any attack or situation."[61] Physical prowess learned through intense training was and is reinforced by numinous powers, then, as the "down" of the ancestors is brought "up" to arenas of human contest.

To apply these comparative insights to Kizumina's narrative intentions and cultural entailments, when the kaparali deftly dropped to his back like an eagle even as he entertained Lusinga with his bawdy song and oh-so-smooth moves, he made ready to dispatch the "sanguinary potentate" with a thunderbolt blast from the carbine held in the crook of his arm. Lusinga marshaled considerable power, both political and occult, for he could summon rugaruga mercenaries or the fiercest of lions (or *visanguka* lion-men) as the occasion might demand. If threatened, he could shape-shift to become a pheasant-like francolin and scoot away into the underbrush, or disappear like a will-o'-the-wisp drift of flying termites. In Kizumina's reckoning, countering such strengths must have required every resource available—*every* resource, that is, including empowering dance moves, all manner of arcane science, and auspicious interventions from the other world.

How better to enact counter-hegemonic inversion than as "an eagle"? Snatch that snake in the blink of an eye! Yet any such reversal will be ephemeral as cycles continue and what was down comes back up, only to descend once again. The seasons follow such a course, as described to me by a Tabwa friend through analogy to the *vizambano* wrestling of boys, one on top, but not for long. Just as the dry season shifts to drenching rains, the latter will cede its place. And just as lunar heroes like Kalala prevail over the solar excesses of Nkongolo, so will the latter return in diurnal dialectic. The dignity and orderliness of leadership as embodied by Kalala exist in tension with the ruthless self-interest of Nkongolo. They are "two faces of the same reality," as Théodore Theuws wrote of the revolving dialectics of Luba philosophy.[62] And even as Bwana Boma's kaparali broke to his back like a bateleur, assassinating Lusinga and taking his head, the cycle would continue with no one's laugh assuredly last.

4 · Tropical Gothic

The only thing going on was a war, and no one seemed to notice
but Yossarian.... And when Yossarian tried to remind people,
they drew away from him and thought he was crazy.

—Joseph Heller, Catch 22

Early in Storms's days at Lubanda, IAA Secretary General Strauch made it clear that he was discontent with the amount of information the lieutenant was forwarding to him and asked for more. Storms responded that he spent his days otherwise, with the implication that he had little time for such idle niceties as correspondence. From five thirty in the morning until two in the afternoon, he oversaw the construction of his boma every day, and at four he set off hunting in the hilly woods west of Lubanda. "For me, continuous work is the best remedy to ward off fever," he explained—a nonchalant remark, perhaps, but telling nonetheless.[1]

A shocking number of Storms's European peers visiting central Africa suffered mightily and many perished, and often gruesomely, from malaria, smallpox, cholera, dysentery, parasites, and other dire diseases, to say nothing of sunstroke, infected wounds, broken and unset limbs, and mental instability. Explorers felt assailed, as Stanley put it, by "Fatal Africa! One after another, travelers drop away...the torrid heat, the miasma exhaled from the soil, the noisome vapours enveloping every path, the giant cane-grass suffocating the

wayfarer, the rabid fury of the native ... the unspeakable misery of the life within the wild continent." Who could hope to cope with such unspeakable rigors?[2] Underlying all of these dreadful possibilities was a further sense of "fever (often capitalized in the sources), [that,] far from being regarded as just a medical condition and a reaction of the immune system to multiple causes, became essentialized as the ecstatic counterstate to ascetic hygiene." Indeed, as Johannes Fabian asserts, "Fever was an ideology" implying "the 'sacrifice' every traveler must bring to the black continent" and "a myth needed to make sense of the mortal dangers of exploration, a metaphor giving meaning to what would otherwise have remained as brutal facts." Fever was also something of "a bad love affair" that required its own "poetics," and such passions contributed to the sense of central Africa as personifying—more literally than one may now assume—everything fearfully primordial. Such menaces might be met with "ascetic hygiene," as Fabian suggests, but I would add that more basically at issue was an *aesthetic* hygiene, to be performed in any such ecstasis.[3]

The loss of fellow travelers weighed heavily upon Storms and must have added to his sense of urgency and occasional despair. He did fall perilously ill but somehow survived despite the oddities and inadequacies of the biomedicine of his time, which included its own risks of accidental or deliberate misuse.[4] Other factors were at play in Bwana Boma's "hygienic" organization of his days at Lubanda, however, for belle époque Belgium was gripped by fears of social and personal "degeneration" due to the excesses of the Industrial Revolution, increasing class consciousness, rapid globalization, and the terrors caused by radical social change. Such apprehensions could quickly become somatic, and as Jo Tollebeek notes, they found ready affirmation in Congolese colonial discourses through which "the black man could easily be regarded as a degenerate" and made the model of all that was wrong and "infecting" the world. One need only think of late nineteenth-century understandings of hysteria and related conversion disorders in Europe and North America to grasp the point.[5] Indeed, as we shall see in chapter 6, Lusinga came to exemplify just such frightening assessments. Storms's survival, then, not only depended upon overcoming constant physical challenges; it was a deeply existential trial as well.

Storms was presented with a model for how to organize his day and that of those within his rapidly expanding perimeter of authority. Jérôme Becker had created a detailed schedule of activities as commander of the Karema fortress, which he explained to Storms. Becker began his day at 5:30 AM with a reveille set to "The Fanfare of King Dagobert," followed by a crisp cold bath in a rubber

LE RÉVEIL.
(Dessin de E. DUYCK.)

Figure 4.1. Reveille at Fort Léopold in Becker's day. E. Duyck in Becker 1887, 2: 225; public domain.

tub—"nothing more salutary...to steel the nerves, especially if, in leaving the water, one gives oneself over to a few gymnastic movements." Such bracing exercise would reinforce the Western European sense of manliness that was important to the times as a means to avoid any sense of "degeneracy" while preparing one to confront the physical and moral perils of deepest Africa. Becker's salubrious activities were followed by a first breakfast, a rousting of any sleepy men still in their barracks, a round of the fort, an inventory of supplies to assure that nothing had been pilfered during the night, meteorological calculations, a second breakfast at ten served with "great pomp" while being fanned in "oriental fashion" against the coming morning heat, a spot of hunting, more inspections, an assembly at two to review the men and dismiss them to their own pursuits, and then a late lunch and languorous siesta (fig. 4.1).[6]

Let us pause for a moment. In suggesting that he began his day with a reveille set to "The Fanfare of King Dagobert," Becker must have left his readers wondering what ironies he meant to convey to his men—and to them. Dagobert was the seventh-century First King of All the Franks, and the "fanfare" named for him is more a silly song set to an old stag-hunting tune than the pompous flourish one usually associates with the term. In late eighteenth-century France, the lyrics were adapted to mock Louis XVI's "regaining Paris despite himself," and in the early nineteenth century to ridicule Napoleon's debacle in Russia. The "fanfare" begins with "The good King Dagobert had his breeches on backwards," and one can imagine why the amusing refrains remain so popular with preschoolers in France. Many verses follow, including one that refers to Dagobert's skin being blacker than a crow but that his queen's was blacker still. Perhaps more pertinent to the circumstances in which Becker found himself were words, once aimed at Napoleon's ill-fated adventures, that go as follows (with the humorous rhyming lost in translation): "The good King Dagobert / Wished to conquer the universe. / The great Saint Eligius [*Eloi*] / Said to him, 'Oh my king / To travel so far / Is so bothersome!' / 'Tis true,' said the king / 'Better to stay at home.'"[7] Did Becker really use this as his reveille at Karema, or was his mention of "The Fanfare of King Dagobert" a joke shared with erudite readers in reference to his indifference to colonial pretense and his own fall from favor once he returned to Belgium, where some felt he had been too friendly with "Arab" and African "enemies"?[8] In other words, did Becker wish he had stayed home and that others would as well? That Becker ended his two-volume *memoires* with the Flemish saying, "East, West, Home is best!" suggests as much.[9]

As a cultured man, Becker may have been making further oblique refer-
ence to the absurdities of the symbolist literature of his day, as writers who,
like Becker, were of Flemish background but spoke and wrote in French
sought to overcome stultifying conventional wisdoms through indetermi-
nacy, "semantic rupture," and "relational inconsistencies." One thinks, for
instance, of a line of Dagobertian free verse by the great Maurice Maeterlinck
to the effect that "I believe that the swans have hatched crows!" Given seem-
ing artistic disinterest in contemporary colonial adventures, Maeterlinck's
avowed distaste for allegory, and the "hectic juxtapositions" through which
he proposed to instigate imagination in the manner of a Hieronymus Bosch,
it is unlikely that his swans-to-crows reference was an allusion to race. Read-
ers were free to interpret any such wording as they would, however, and one
reactionary commentator found such work to be "néo-nègre" in its affront to
standard prose.[10] Howsoever that may have been, at the very least, Becker's
reference to reveille being set to a quaint nursery rhyme—like the daily
schedule at Karema that he described in such detail—offers a sense of the
theatrical peculiarities of European exploration as well as of the afterthoughts
that lettered men like Becker experienced while writing of their adventures
when once again ensconced in metropolitan social realities.

Storms adapted Becker's recommendations to his own needs and more
soldierly temperament. Most significantly, neither Becker's nor Bwana
Boma's regimens were meant for them alone. Storms wrote of how the reck-
oning of time was "not very advanced" among Congolese around Lubanda,
who determined moment and duration by the position of the sun in the heav-
ens. This was how Tabwa at Lubanda still determined rough estimates of time
in the mid-1970s, but such measures were integrated into far more complex
systems of thought concerning cosmology, season, ecology, astronomy, and
the practicalities of agriculture and fishing than Storms seems to have
grasped.[11] In imposing his clockwork schedule on those under his direction,
Bwana Boma was laying the foundation for a colonization of time that would
organize, regularize, and commoditize labor and, indeed, the rest of people's
lives, for generations to come.[12]

Of similar import, Storms tried to create a market at Lubanda, following
activities developed at the Karema fortress (fig. 4.2). Local and long-distance
trade were significant along the shores and inland from Lake Tanganyika,
with salt, iron, fish, and agricultural produce among particular resources that
Sultani Mpala and his people might exchange for commodities like palm oil

VENDEURS INDIGÈNES AU FORT LÉOPOLD. (Dessin de Frans VAN LEEMPUTTEN.)

Figure 4.2. Market activities at Fort Léopold. F. Van Leemputten in Becker 1887, 2: 57; public domain.

that were available in more tropical lands to the north, or things of practical or symbolic interest brought from the east African coast by caravan. Yet markets were not a traditional institution in this part of Africa due in large measure to low population density and loosely defined political organization, relative self-sufficiency, and exceedingly rugged terrain. Furthermore, anyone familiar with the late nineteenth-century texts of European explorers will know how bewildering the array of trade goods was, ranging from glass beads of many colors, sizes, and cultural connotations to various lengths and qualities of fabric from several industrial centers around the world. Storms commented on the sudden fluctuations in the value given to beads relative to cloth at Ujiji, and he maintained many choices of both commodities as detailed in an inventory he left to the White Fathers replacing him when he returned to Belgium in 1885. Like the ever changing tolls and tributes exacted by those whose lands were crossed by caravans, exchange at Ujiji and other entrepôts was negotiated following fleeting fashions and power-grabbing demands. Storms hoped to create a vibrant center of political economy at Lubanda similar to that of Ujiji, and his wish to organize a market constituted an early effort to colonize *value* through standards he would determine. In similar

spirit, the White Fathers who occupied Lubanda after him created their own currency cut from the metal foil wrapping certain goods imported from Europe, and such tokens would be the only ones accepted at mission stores, even when coins of the Congo Free State became available. Storms's earlier efforts proved ephemeral, however, and there has never been an established market at Lubanda other than within and for the White Fathers' mission, and even that had long since ceased by the 1970s.[13]

Mapping was another important task undertaken by Storms as a crucial contribution to the "totalizing classifications" that would characterize Belgian imperialism. The goal was "systematic description of *new* spaces"—to the lieutenant and his Belgian superiors, that is—and Storms's cartography "re-naturalized" the landscape on his terms and no one else's. An "encyclopedic obsession" would characterize colonial sciences of the sort that would "exhaustively cover, recover, fill out an unknown space, and give it frontiers."[14] Over and above the scientific—and scientistic—goals of mapping, through which what was "really" there in mountains, coves, creeks, and human settlements was recognized and recorded, at issue was a resulting sense of landscape.[15] "Landscape denotes the external world mediated through subjective human experience," Denis Cosgrove tells us. It is "not merely the world we see, it is a construction, a composition of that world." Indeed, "landscape is a way of seeing" directed toward "controlling the world." The cartography undertaken by Storms and his fellows was one way that landscape was conceived, based upon the "discoveries" of "exploration" as that idiom was understood in Belgium. Choice of metaphors and other literary devices of travel writing was another important means of creating landscape by which "the Congo" was produced, as Marie Louise Pratt might have it, through terms of reference foreign to local experience of being-in-the-world.[16]

Explorers named a few significant features of Lake Tanganyika such as Burton, Cameron, Hore, and Edith Bays and New York Herald Island, although these were obviously of more interest to British visitors (and Stanley, in the last case) than to Storms and his Belgian colleagues.[17] Other points were meant to be known by what Europeans had accomplished or suffered, including their deaths and inhumation. Another means of taking possession of place was by circumnavigating Tanganyika and calculating its longitude and latitude, thus permitting the longest lake in the world to be understood as a totality.[18] Through an economy of scale, such a sense was related to greater geographies of the Congo River Basin. Local people living at Lubanda or any other particular place

around the shores had no reason to know the lake in any so encompassing a manner as mapped by early European visitors. In the 1880s, for instance, hostile parties controlled many points of call, and movement around or across the lake had to be undertaken with extreme caution according to carefully crafted social relationships and the most acute local technologies available. Navigation by the rising and setting of stars vis-à-vis recognizable landforms was one such skill that permitted location to be determined even on the darkest night, while the sweep of the Milky Way provided a sense of travel duration to known destinations.[19] In the 1970s a holistic sense of Lake Tanganyika remained largely irrelevant, and people at Lubanda spoke of the lake as "endless" as it truly appears when gazing up or down its great expanses, despite the fact that many have visited Zambia or Burundi. Parenthetically, even this last assertion reflects cultural construction, for at Lubanda "up" is south rather than north, as the direction favored by Eurocentrism.

As a gauge of the conceptual changes he initiated in his mapmaking, Storms noted his difficulty determining the names of settlements: "Some give the name of a locale, others the name of the present chief, and others still the name of a chief who ceased to exist long ago." Such "confusion" was nothing of the kind, however, for place and personal identity were understood through situational dynamics whereby any and all of these references was/were/could be "correct" as might others still, depending upon the politico-economic or spiritual exigencies of the moment. Standardization would get such unruly places under sufficient control to depict them on paper once and for all, according to colonizing conventions. The cartography of Storms and authorities who followed him soon permitted determination of "rightful" habitation, population numbers, political loyalties, and almost immediately, the terms of taxation, either through corvée labor or colonial currencies.[20] Land would be measured, described, depicted, apportioned, and, above all, inscribed with expatriate memories and desires.

Such conceptions of colonial landscapes *of* memory differ from the landscapes *as* memory understood by local people. For Tabwa "wisdom sits in places," as Western Apaches say.[21] That is, progress on a mountain path or along the shores of Lake Tanganyika as one paddles by in a pirogue is marked by narrated landmarks referring to singular events from long ago, startling vistas, spirit and burial sites to revere or fear, jokes and proverbs that seem particularly apposite and usually at some local resident's expense, notable stands of medicinal plants, and the like. Far more important than what *has* happened someplace is what *might*. As mentioned with regard to Kizumina's politically determined

account of Lusinga's demise, "memory work" is a process of contest and negotia-
tion through which performance of *milandu* determines relationships of lineage
to territory. Landscape is inexorably *produced*, in other words. Furthermore,
"image-making practice and visual forms are implicated in the process of re-
membering and forgetting and thus are shaped by memory-work rather than by
accounts of distinct memories."[22] Storms collected finely carved objects during
his stay at Lubanda, including figural staffs, high-backed stools, and ancestral
figures, all meant by the artists making them to instigate "memory work." In
creating such beautiful things and the performances in which they found *place*,
histories were made, not received.[23]

One may reflect again upon the lieutenant's collections that were badly
damaged in the burning of his boma. Not all of Bwana Boma's things were
destroyed, for at least some of his artifacts and documents were brought back
to Brussels and are now in the collections of the Royal Museum of Central
Africa. Of these, a number are fire-scarred and must have been plucked from
the flames or retrieved from the ashes. The 150 glass-plate photographic nega-
tives that Storms had amassed at Lubanda appear to have been completely
lost, however. A letter from Albert Thys of the IAA acknowledges receipt of
some photographs from Storms, but no trace has been found of any such im-
ages to date, and it seems those that did survive were taken earlier in his mis-
sion, perhaps during his trek to Lake Tanganyika or when he was first sta-
tioned at Karema.[24] In many ways it is a wonder that Storms was able to take
any pictures at all, and his doing so is yet another indication of dedication to
his mission. As his friend and long-staying visitor Victor Giraud made abun-
dantly clear, "of all baggage, photographic apparatus requires the most care,
attention, and continual surveillance."[25] Protecting equipment and chemicals
from accident and local perils like rust and mildew was exceedingly difficult
in late nineteenth-century central Africa, to say nothing of successfully tak-
ing pictures, developing film plates, and striking images.

No mention is made of the subjects of Storms's photos, and we are left to
guess that at least some of them documented his accomplishments, especially
as he refurbished the fortress at Karema and built his new boma at Lubanda,
while others may have been souvenir shots of the stunningly picturesque shores
of Lake Tanganyika. Some may have portrayed European colleagues and visi-
tors, but might others have depicted Sultani Mpala perhaps, or even Lusinga?
Storms participated very willingly in the emerging colonial sciences of his
times, and it is conceivable that in his lost images Storms had documented

"racial types" that were "felt to epitomize, in a picture, the characteristics of an [entire] population," as was or at least soon would be the scientific vogue.[26] Unless an inventory or negatives unexpectedly turn up somewhere, we shall never know, and yet the fact that Storms took so many photographs leaves one yearning to know what vital visual evidence has been lost. Similarly, it is not clear if Bwana Boma processed his photographs while still in the Congo. If he did, might he have shown images to people in Lubanda? Evocative cases elsewhere in central Africa indicate that some early European visitors used darkroom arts to bolster their reputations for technological wizardry, suggesting they possessed the supernatural power to capture living essence.[27]

What we do know, of course, is how significant photography would prove to colonial authorities following Storms's early Congolese interventions, providing "documentation [that] served, above all, to 'know so as to dominate.'" Like other early European visitors to central Africa, the lieutenant brought with him "a lexicon of forms, poses, conventions, [and] norms" from his own visual culture that he applied—undoubtedly unwittingly—to the central African subjects of his photography. He would contribute to the colonization of the gaze, and to paraphrase the visual theorist Guy Gauthier, through such means "'natives' would be integrated into the colony by images. In envisioning them as exotic but through familiar European forms (the portrait, the studio, group photography, orientalist painting), Africans were held at sufficient distance: strange but assimilable. Such *mises en scène* of difference showed, above all, that there *was* a *scène* that could be obliged to obey the universalist norms of the conquering civilization." Photography in Africa was instrumental to establishing a "visual authority" of great disciplinary consequence to local communities, then, even as the typologies and ideologically determined portrayals of "primitive" Congolese "justified" the "necessity" of their very colonization.[28]

Other collections survived the arson at Lubanda. IAA Secretary General Strauch had requested that Storms gather tools and utensils, jewelry and "toiletries," musical instruments, pottery, and the like, for he expected that in a few years any such material culture would disappear through the transformative influences of "civilization."[29] Bwana Boma threw himself into this task with the great enthusiasm he showed in "systematizing nature" when collecting natural history specimens. Such activities "elaborated a rationalizing, extractive, dissociative understanding which overlaid functional, experiential relations among people, plants, and animals" and contributed to the distanced and distancing hegemonic discourses of colonialism.[30] The material

culture that Storms amassed was displayed at his home in Brussels, as will be discussed in chapter 7, and now constitutes an important research collection at the Royal Museum of Central Africa.

Storms's natural history collections included a large number of amphibians and reptiles, many preserved in alcohol for later anatomical inspection. Examples of more than twenty-five species of mollusk contributed to debates as to whether the unusual life forms of Lake Tanganyika had evolved from a branch of an ancient ocean or had diversified so radically through eons of isolation in the second largest body of fresh water in the world. The lieutenant also sent along pelts from two hundred different species of bird, many in multiple examples. His devotion of time and energy to scientific duties is clear from such astounding numbers and the care he must have shown in obtaining the specimens and overseeing their preservation and packing for shipment via caravan to the coast and on to Europe from Zanzibar. In acknowledgment of the lieutenant's contributions to natural science, a subspecies of African thrush was named after him (*Turdus pelios stormsi*) as were a ringed water cobra (*Boulengerina stormsi*, now known as *Naja annulata stormsi*), a 4-inch-long tetra fish (*Micralestes stormsi*), and one of the many varieties of tilapia (*Orthochromis stormsi*) that thrive in the waters of Lake Tanganyika. African names for and classifications of these same creatures were ignored as Linnaean taxonomic logic was imposed. Nor were the contributions of Bwana Boma's many African assistants ever mentioned, although, as Johan Lagae reminds us, they "played a fundamental rôle in the production of colonial knowledge," and local women often participated in such activities.[31]

At a theoretical remove, one may consider Storms's constructions of time, value, place, and natural order to be assertions of master tropes meant to "construct or reconstruct social hierarchies" in favor of the lieutenant's own ambitions and those he would achieve for the colony to come. The taxonomies to which objects were meant to contribute would "replace history with *classification*, with order beyond the realm of temporality," and colonial logic would be imposed upon nature itself. Through the seemingly innocuous process of assembling data, specimens, and artifacts, Storms wielded the considerable power necessary to engage in what Susan Stewart has called "synecdochal diremption"—the sundering process, that is, whereby small parts of persons, places, and circumstances were torn from the fabric of everyday lives and made to stand for the vast totalities of the Congo as defined from and for the metropole.[32]

Scientific activities of the sort were part and parcel of "an urban, lettered, male authority over the whole of the planet," Mary Louise Pratt tells us. "A descriptive paradigm" that seemed "an utterly benign and abstract appropriation of the planet" would be achieved through "a Utopian, innocent vision of European global authority."[33] Pratt's use of irony here is important, for "benign" must have been and always is in the eye of the beholder, but Storms and his peers undoubtedly believed they were pushing back the frontiers of knowledge, and who could fault them for that? It would seem that only Bwana Boma could have been deluded by any such pretenses, however, for local people surely must have been aware of the erosion of their prerogatives to define and understand their own world according to their own logic, classifications, purposes, and daily practices.

Of more direct significance to European interests, collections like the lieutenant's might suggest natural resources worthy of further exploration and potential economic exploitation. As essential as these totalizing processes were to inventing and implementing a colony, it would be through such efforts that Storms would construct his own, deeply personal reveries as he constituted the "Africa" of his elder years (to be considered in chapter 7). Even as the world that Bwana Boma would initiate was meant to be structured— and very clearly on *his* terms—Storms's last months in central Africa would prove anything but orderly, however, for reasons well beyond his control.

"The Mad Beine"

Although he was preoccupied by his boma at Lubanda, Storms remained responsible for the IAA outpost at Karema across Lake Tanganyika. Originally the lieutenant was to have been seconded in his command by Camille Constant, but because Constant fell ill upon arrival in Zanzibar and quickly returned to Europe, Émile Maluin was dispatched in his place. He, too, nearly succumbed to Fever in Zanzibar and was immediately evacuated. Soon one Victor Beine was on his way to eastern Africa, as a civil servant with two years' experience in the Dutch East Indies and other experience IAA directors deemed relevant. Carefully conveyed by diligent caravan professionals, Beine reached Lake Tanganyika in September 1883 and assumed responsibility for Fort Léopold as Storms occupied himself with affairs at Mpala-Lubanda.[34] In subsequent months, hardly any mention was made of the man in Storms's diaries, suggesting anything but warm relations between the two.

In February 1885 Storms set sail for Karema in a substantial, newly constructed two-masted craft that could transport nearly two hundred and that he christened *Le Strauch* after the IAA secretary general. For his voyage to Karema, Storms was accompanied by more than a hundred people, many of them remaining from Paul Reichard's expedition and now returning to the east African coast. A terrifying tempest blew up during the passage of the sort that still takes lives out on the lake nearly every year. Storms's passengers begged him for pieces of his clothing to throw overboard to appease the tempestuous wrath of Musamwira, the great spirit (*muzimu*) of the lake recognized by people living along the southeastern shores of Lake Tanganyika. Bwana Boma would agree to no such request.[35]

Nonetheless, the vessel finally reached Karema, where, much to his chagrin, Storms was greeted as "a liberator." In his absence, Victor Beine had allegedly ordered the undeserved beating of men associated with the boma, locking them up and raping their women. Beine feared people were trying to poison him, and Storms concluded that "he has gone insane, that's all I can say." Although his first impressions of the man seem to have been positive, Storms soon became furious with "the mad Beine" for a number of reasons, including a careless boating accident in which a caravan-load of cartridges and other armaments were lost that had just arrived from Zanzibar after a two-year delay. The lieutenant's acerbic comment was that "if he had been a nigger we would have beaten him with a stick."[36]

Allegations about Beine were by no means trivial, for Storms's rugaruga threatened to desert if Beine did not leave their women alone. Given what salty, armed-to-the-teeth characters rugaruga are said to have been, it certainly does seem insane that Beine should seek or seize relations with their women, and he must have done so at distinct risk to his own life and limb. His madness was not defined by these acts alone, however, for his aggressions included other anomalous behavior, and he was said to be all too aware of his own "nightmare without end."[37]

Beine's stated fear of "poisoning" may have been due to schizophrenic paranoia, according to later definitions of abnormal psychology, yet in a sense, his terrors were altogether realistic if they were informed by local practices of revenge for his gross mistreatment of women and the resulting outrage of their men. Because it is so difficult to judge what "madness" may have meant to those bandying about the accusation, a further possibility must be considered: that Beine was masking his own violence by claims of poisoning and persecution.

Here one may recall Aimé Césaire's pronouncement that "colonization works to *decivilize* the colonizer, to *brutalize* him in the true sense of the word, to degrade him, to awaken him to ... violence, race hatred, and moral relativism." Might Beine have been engaged in "a shift of responsibility for pain and suffering from one to the other"?[38] With no firsthand information available, we are left to ponder the reasons for Beine's aggressions.

Father Isaac Moinet, who would assume control of Bwana Boma's boma when he was obliged to return to Belgium in 1885, wryly commented that Beine's "thirty-six concubines" would be "more than enough to make him lose his head!" "Thirty-six" is a metaphor of multiplicity in colloquial French, as in the pointed expression "there aren't thirty-six solutions" to some problem that needs to be resolved simply and without delay. Beine may have enjoyed more or fewer than "thirty-six concubines," in other words, but certainly far more than the priest found tolerable, which may not have been any at all. One can assume that the missionaries had negative reactions to interracial liaison more generally, as when, two years later, Moinet's compadre Auguste Moncet described as a *cochonnerie*—swinishness, that is—the formal Catholic marriage of a Congolese parishioner to Léopold-Louis Joubert, the French ex-papal Zouave who was by then "king" of the de facto Christian Kingdom at Mpala-Lubanda.[39] Given how intimately associated carnal knowledge and imperial power was and is and how often "miscegenation" was considered aberrant in colonial circumstances, in all likelihood Beine's "mental alienation" was associated with his willingness to frequent African women.[40] They were driving him crazy, in other words, at least as far as the missionaries were concerned.

The violence of Beine's sexual predation seems to have been of little concern to Father Moinet otherwise, for he understood the "thirty-six" women to be concubines rather than persons violated by Beine—complicit in the act and even responsible for it, that is, perhaps because they were African and so naturally profligate in the missionary's estimation. As Storms put it, in the parts of central Africa he knew "the prostitution of women, with the permission and of course to the profit of the husband, is customary."[41] Nor did the lieutenant comment upon his adjutant's sexual activities in any documents I have found. He does not write of any "erotic tensions" or actual liaisons of his own, either, demonstrating a reticence or evasiveness similar to the ways that other Europeans visiting central Africa presented themselves in their writings. Yet an exception to this rule was Jérôme Becker, last leader of the IAA's third expedition to Lake Tanganyika (the other three Belgians having

succumbed to illness), who wrote quite candidly of erotic attraction during his residency at Karema and who may have been an unacknowledged influence upon Beine's untoward actions. Any such reflections are complicated by Becker's imposition of formal marriage upon the people he gathered about him, including those enslaved in the Marungu whom he ransomed and brought to settle around Karema, and by the harsh punishments he inflicted upon those he accused of adultery.[42] Different standards of European and African behavior were so implied.

Questions remain about "the assertion of European supremacy in terms of patriotic manhood and racial virility, . . . not only as an expression of imperial domination, but a defining feature of it." If Bwana Boma did abstain from sexual relations with Africans—or at least if he wished his readers to believe he did—perhaps his stance reflected Storms-the-stoic-soldier's "contortion and constrictions of the self" through a "homology between sexual repression and political dominance which led to an internalization of self-images of hardness and detachment as the appropriate 'manly' modes of colonial rule."[43]

However all this may have been, Storms was elated when Paul Reichard promised to take Beine with him when he returned to Zanzibar. Soon after, the lieutenant was aggrieved to learn that Beine had not accompanied Reichard after all and that instead he had been tied up and brought to Lubanda. "This is the worst news that could come to me," Bwana Boma lamented in his diary. "Here I am with two stations in very critical situations of all-out war, but still obliged to take care of a madman that I must put under observation." Indeed, aside from brief interludes when Beine stayed with the White Fathers at Chanza—including the days when Storms's fortress was burned to the ground—the lieutenant would be obliged to care for Beine until his own departure for Europe in July 1885, when the two traveled together to the east African coast.[44] Storms mentioned the man so infrequently in his ensuing writings, however, that one would hardly know Beine was still at the boma, let alone presumably held under some sort of restricted residency.

The paucity of archival information concerning Victor Beine may be due to his mental alienation, perhaps considered "unheroic" by those vaunting Belgian imperialist accomplishments. The *Nouveau dictionnaire des Belges* has no entry for Beine, for example, as it does for IAA officers bearing responsibilities similar to those originally assigned to the man.[45] Such a silencing recalls Michel-Rolph Trouillot's insight that the "the power to decide what is trivial—and annoying—is also part of the power to decide how 'what happened' becomes

'that which is said to have happened'" in a "mythicized history" of the sort that excludes the likes of Victor Beine. By "silence" Trouillot means "an active and transitive process: one 'silences' a fact or an individual as a silencer silences a gun. One engages in the practice of silencing. Mentions and silences are thus active, dialectical counterparts of which history is the synthesis."[46] Such an understanding of historical process can of course also be applied to how we know nothing of Lusinga lwa Ng'ombe, the man.

Several of the very few details about Victor Beine that we do know from archival materials cry out for further explanation. Is it possible that he was literally bound and brought to Bwana Boma? Storms does not comment upon how this was done, what it meant in terms of immediate impact on any Africans who might have participated in or observed the incident, or any long-term ramifications it may have had; but in days of such insecurity and fragile assertions of authority, the moral and mental collapse of an IAA officer would be threatening enough to any view of European superiority. Furthermore, publically binding the man like a raving lunatic or forcibly sequestering him would have been devastating to Beine himself, of course, but to the lieutenant as well, given painfully evident analogies to the pernicious mistreatment of the enslaved.

What would local people have thought of any such anomaly of European-on-European violence? Might they have assumed that Beine's behavior was simply the consequence of his "temperament" (*tabia*) as a European, as violent as such people could sometimes be? Or was he subject to the forms of alienation locally known as *wazimu* that are so often the consequence of the dire interpersonal conflicts of sorcery (bulozi)?[47] Such questions must be countered by what deeper purposes Beine's confinement served, for by defining the man as mad, Storms avoided any sense of responsibility for what Beine had done, to say nothing of his contribution to Beine's alienation by his evident distaste for the man. There would be no legal proceeding, no restitution, no apologies to anyone, including the African women and men so egregiously wronged. Surely such a demonstration of sheer arrogance by *both* Beine and Storms contributed to the establishment of colonial hegemony in the Congo in ways—one would hope, anyway—that neither of them intended.

A last reflection can be offered concerning the relationship between Beine and Storms. It is easy to understand why Bwana Boma might feel frustration when the man he had expected to trust to command the Karema boma so dismally failed to discharge his duties. Beine could not be counted upon

to support Storms's initiatives, and instead he proved a drain upon the lieutenant's overtaxed energies. What was worse, however, was how dependent Beine became in his madness.

Europeans exploring central Africa were beholden to more persons and processes than they were ready to acknowledge—even to themselves, one can imagine.[48] Despite the heroic poses struck in daily circumstances as well as in letters written home or memoirs published after return to Europe, even the most self-reliant of leaders like Storms were in the hands of African professionals who organized caravans and saw to the myriad details of travel. Hundreds of subalterns made life possible at Karema and Lubanda, and despite clever management of his advanced armament, one is left wondering why people allowed a martinet like Storms or a soul as tortured as Beine the distinct freedoms they enjoyed when these troublesome individuals were so vastly outnumbered. Because the evident nature of European conquest was still some years in the making, it is even more difficult to fathom why people at Lubanda took Storms and Beine seriously at all, over and above the superiority of their arms, although that fact did seem to tip balances of power to their favor. However that may have been, Storms was a very control-oriented person in his relationships with others and in what we can discern of his sense of himself. One can guess that the needs of Victor Beine were more distressing to Bwana Boma than the practicalities of caring for a debilitated colleague. Madness made human vulnerabilities all too evident at a time when Storms felt himself under siege from several sides. The lack of even a single word of compassion in his writings leaves one to assume that over and above his annoyance with Beine, the lieutenant was repulsed by the man's weakness.

Because he left no comments about such matters in his diary, we cannot know how direct Storms's ministrations to Beine may have been. Presumably, more often than not, African personnel saw to the man's needs, but what might they have thought of this example of European frailty? And how did they integrate the deaths of so many European visitors into their emerging views of imperialism? Answers would not emerge until after some years of colonial occupation.

Although next to no information can be found about Beine and none from the man himself, his plight seems to be a perfect tragedy: Unlike his fellow adventurers Camille Constant and Émile Maluin, Beine did not retreat to the homeland at the first fervid embrace of Fever, nor did he soldier on to glory or die in the doing as did so many. Rather, he lost his mind and slipped

into disgrace. He was a foil for the hard-edged but resilient Storms, at least as the lieutenant portrayed himself in his meager writings. How instructive it might be had Beine left descriptions of Bwana Boma! Any impression that Storms was always the consummate, no-nonsense military man is challenged by another archived anecdote, however.

Performing Europeanness

In December 1883 the French adventurer Victor Giraud arrived at Karema to find welcome respite from acute hunger, fearful harassment, and related travails as he and his men tramped about east-central Africa. Giraud described the reasons for his travels as simple interest in the sciences of exploration, following a paradigm of a seemingly "utopian, innocent vision of European global authority" so well articulated by Mary Louise Pratt.[49] Giraud is not remembered for any such accomplishments, however, and instead his expedition seemed more an exercise in futility than anything else, with little to show for his efforts. At any rate, Giraud was relieved to reach the imposing walls of the fortified *tembe* at Karema, for after "so many stops without shelter and so many nights without sleep, however this enclosure might seem as severe as a prison, I felt an impression of deliverance after long months of captivity."[50] Inside the fort was a large, two-story European residence fitted out with comfortable lodging and capacious storerooms. It was here that Giraud met Storms when the latter returned from a visit to Lubanda some days after Giraud's arrival.

The two became fast friends. Giraud described Storms at thirty-five years of age as "strong and solidly built, and he possesses a physiognomy that is frank, open, energetic, and that makes him sympathetic at first glance.... Broad-minded, someone who gets things done, chivalrous, he breathes deeply the great airs and grand emotions of Africa, and he gives body and soul to his mission."[51] The men would often be in each other's company for the next seven months, seemingly with nary a problem between them, in distinct contrast to Storms's difficult relationship with Victor Beine as just described.

The camaraderie between Giraud and Storms began memorably during their first evening together. As Giraud described it, "Among the other curiosities closed up in the European house, Storms showed me a large Barbary organ, perfectly conserved. It had belonged to the Abbé Debaize, and when this latter became ill, he left it at Karema. Before dinner, we cranked out all the old refrains, each in his turn, and in surroundings so primitive and savage [that] I felt

Figure 4.3. A busker of 1892 playing a Barbary organ like the Abbé Debaize's. Carte de visite by Overpeck of Hamilton, Ontario. U.S. Library of Congress Prints and Photography Division, cph.3c15967; public domain.

moved by these old-fashioned melodies." For Europeans hearing it played in the heart of Africa, Abbé Debaize's instrument never failed to produce the deepest nostalgia, for despite "how ridiculed in Europe" such a popular device may have been, "its music carried us back to civilization," as Becker reported (fig. 4.3).[52]

Storms had laughed heartily when he first heard the organ, yet the vulgarity of the instrument and the kitsch qualities of its catchy tunes must have helped overcome differences of rank, class, and nationality among the explorers, even as the music assisted them in "staging their Europeanness" for themselves first and foremost.[53] The resulting "tropical gothic" can be imagined through the cinematic tropes of our own times, for the barrel organ's melodies wafting through the drafty fortress of Karema bring hyperbolic images to mind even now.

To be sure, although Africans were not invited to all aspects of any such performances, they often provided the basic audience, and indeed the barrel organ was "an object of admiration for the natives" around Karema that Becker's men enjoyed on their days off, when they took turns playing "the dreamy melodies" of "an old Noël of Brittany" or "a languorous German waltz" and manifested "the ecstatic air of Javanese listening to the chords of a gamelan." Becker also had the organ played when he oversaw weddings of his dependents following a ritual he devised. "Don't laugh!" he begged his readers, assuming, of course, that the schmaltzy music and its associations with working-class street culture would be derided and perhaps reflect badly on his own class-based aspirations. "Not even the sacred organs filling the arches of our basilicas with their powerful harmonies would have produced . . . the thrilling impression that seized my ecstatic Blacks!" Becker exclaimed.[54]

Johannes Fabian cites such passages as evidence of the capacity of music "to create shared experiences" and so "subvert barriers and distances" separating Africans from their early European visitors.[55] Becker seemed wary that his readers might suspect any such sense of common pleasure, however, and instead attributed the delight of "his" Africans to their naturally overwrought excitability. Local people surely understood and made use of these spectacular productions in their own ways, however, as they performed the Europeanness of their masters to their own transformative religious and political ends. In this regard, and although historical ethnography is silent on the point, there may have been parallel reactions to such haunting melodies as were found among Kongo people: "When the villagers of Mbanza Manteke thought, in 1885, that the sounds of the harmonium of the Protestant missionary Henry Richards were the voices of the dead, they were merely commenting on all music as they

understood it."[56] As in so many other circumstances, one is left wondering what the "ecstasy" of central Africans listening to the Barbary organ, as reported by Becker, may have meant to the Africans themselves.

The Demise of Debaize

Finding such an out-of-place thing as a barrel organ at Karema must be understood in the contexts of "theatrical enterprise" that typified much late nineteenth-century central African exploration, taken at times to a "sideshow" extreme.[57] For example, the original owner of the barrel organ, Abbé Michel Alexandre Debaize, seems to have cut a tragicomic figure during the few weeks he spent along the shores of Lake Tanganyika before his quite sudden death. Aside from explaining how the musical instrument came into Storms's hands, the case of Father Debaize—and especially his supposed madness—provides a contrast to our understanding of Victor Beine's troubled days in central Africa.

Shortly before his ordination in 1872 and subsequent assignment to a tiny parish near his home in rural Normandy, the Abbé Debaize happened to teach classes to the son of Jean-Baptiste-Sebastien Krantz, a man of great prominence who had organized the Palace of Industry for the 1867 Universal Exposition of Paris and who would direct the entire Parisian world's fair of 1878. Krantz took a liking to Debaize and provided the encouragement and mentoring that would lead him to undertake the African project for which the young man developed such extraordinary passion.[58]

How or why the abbé first hoped to visit central Africa remains unclear, but to prepare himself for such a mission he began training in "Oriental" languages (Arabic and "Coptic"), observational sciences (astronomy, geology, geography), and practical natural history skills (preparation of faunal and botanical specimens). As his African plans began to take shape in 1877, Debaize traveled to Rome and was granted an audience with Pope Pius IX, who told him how happy he would be to have a priest report to him "the moral and social conditions of the many populations" of central Africa that were as yet so little known to the Holy See. The abbé next visited Brussels to offer his services to Léopold II, having learned that the first IAA expedition was being organized at the time. Debaize was disappointed to learn that Léopold felt the IAA expedition must be led by Belgians, whom he had already selected.[59] Much more was on the king's mind, as the Berlin Conference and creation of the Congo Free State would prove only a few years later.

Krantz came to the abbé's assistance, asking influential friends to approach the French parliament to sponsor a three-year mission to cross Africa from Zanzibar to the Atlantic. Few in France were interested in expanding its colonial empire at the time, but such an undertaking would meet a perceived nationalist need for a French hero of the stature of David Livingstone, Richard Burton, Gustav Nachtigal, or Henry Morton Stanley, while defining and serving nascent imperialist goals for central Africa. So successful was the presentation to the parliament in February 1878 that despite being completely unknown to them, the deputies accorded Debaize the astounding sum of one hundred thousand francs, making his expedition "the most important mission that France had conferred upon an explorer until then."[60]

Although solely couched in humanistic rhetoric, had he been successful, Michel Debaize would have created a French version of the "White Line across the Dark Continent" that Storms would later hope to trace for Léopold II.[61] The abbé was peculiarly secretive even in correspondence that was otherwise quite conversational, and whether or not he perceived the political implications of his expedition is not at all clear. In 1878—and so shortly after Debaize's services were rebuffed—Léopold tried to hire the Italo-French adventurer Pierre Savorgnan de Brazza to explore lands along the lower Congo. The offer was declined because of loyalties to France, and instead de Brazza became a competitor to Stanley in opening west-central Africa to European endeavor, claiming the northern banks of the lower Congo for France and founding the outpost at Stanley Pool that would eventually become today's great city of Brazzaville.[62] The scant documentation by and about Debaize reveals no explicit plan for him to meet de Brazza midway across the Congo, and perhaps French actions in this regard were as impromptu as Belgian plans seem to have been. Instead, the abbé was to make the entire trek from east to west accompanied by the African employees of his enormous caravan of more than nine hundred porters—including fifty porters for porters.[63]

The father was so obsessed with his forward progress that he took few of the scientific measures that were his ostensible purpose, and his rare letters were filled with requests to tell no one of his aims or setbacks, which were alluded to but not fully explained. The abbé's dissimulations included a desire to suppress information about a nearly fatal sunstroke he suffered in Aden on his way from Marseille to Zanzibar, and his odd symptoms and sudden death were due to further bouts of insolation exacerbated by the dehydration of dysentery that he suffered along the shores of Lake Tanganyika. No precautions were taken as to

who might assume the direction of his caravan should the explorer fall ill, and when he did perish his expedition abruptly ended. Yet as a sympathetic writer suggested, "The Abbé Debaize's name was doubtless little known and his life uneventful prior to his setting out on this expedition; but there is good reason to believe that had he lived he would have proved a rival worthy of Stanley and Livingstone in the field of African discovery, and his labors more immediately advantageous to the cause of religion."[64] Indeed, had he been able to continue on westward from Lake Tanganyika—just conceivably—the partition of central Africa might have been different as a consequence.

Less sanguine assessments of the abbé were proffered. According to Joseph Thomson, the unfortunate Debaize was "totally oblivious of all the requirements of a traveler.... Troubles soon beset him on every hand; his men deserted and plundered him at every step. He got into trouble with the natives, several of whom he treacherously shot, a proceeding which afterwards led to the murder of the missionary Penrose.... Living on bread soaked in brandy, he appears to have lost his senses." When he finally reached Ujiji on the northeastern shores of Lake Tanganyika, Thomson continued, Father Debaize "was almost mad, with shattered health, and with the expedition a perfect wreck of its former self."[65]

The LMS missionary Edward Coode Hore was in Ujiji at the time and brought Debaize into his home, where he succumbed in December 1879.[66] Thomson reported that he, too, was in Ujiji when the father died, and was present for the

> examination of Debaize's stores[, which] revealed some strange things. There were twelve boxes of rockets and fireworks, which would require about forty-eight men to carry them, several boxes of dynamite (for what conceivable use no one knows), two large barrels of gunpowder, innumerable revolvers and guns, two coats of armor, several boxes of brandy, two loads of penny pop-guns, a load of small bells, large quantities of botanical paper, insect bottles and tubes smashed, surgical instruments, boxes of medicines without labels, photographic apparatus, every conceivable appliance for geographical research—though he was perfectly ignorant of the working of even the most simple instrument. He brought with him also a hurdy-gurdy, valued at 12,000 francs.[67]

This last was the well-worn Barbary organ that Storms and Giraud would enjoy four years later.

The abbé's "intended scheme of progression through hostile countries was truly French," Thomson further opined,

and admirable in its absurdity. When he came to a village with the natives ready to oppose his passage, he would try the softening influence of music on the savage breast, by strapping the hurdy-gurdy on a man's back, and with another to turn the handle, march peaceably, as became a priest, against the heathen. If, in spite of this, the savage breast refused to be softened, their blood would then be on their own hand! ... With all the calmness of the French nature, he would clothe himself in complete armor, raise confusion in the enemy's ranks by a discharge of rockets, and march deliberately to victory or death.

Whether or not the abbé ever had any such intention cannot be ascertained, and it seems far more likely that Thomson, tongue in cheek, was linking Debaize's various "strange things" and peculiar acts into a comedic scenario. In so doing, Thomson demonstrated the withering irony that some sharing his nationality have long reserved for their Gallic brethren, perhaps intensified by anti-Catholic sentiments; and he was surely given to exaggeration when he wrote such an account for the delectation of his cosmopolitan readers. But just how calumnious was Thomson being? He was not kind in his assessment of Belgian management of the IAA post at Karema, either, and in furious riposte, Becker accused the young man of "Münchausenian exaggeration" and wondered if his scabrous reflections were those of "a lunatic or a street urchin."[68]

Debaize's "trouble with the natives" that contributed to "the murder of the missionary Penrose," according to Thomson, refers to an incident that the abbé described with little detail in a letter penned as his caravan proceeded westward. The father's throng was crossing "an immense forest" between Uyanzi and Tura, about halfway between Tabora and Karema in what is now west-central Tanzania, that was deemed "excessively dangerous" because of rugaruga highwaymen operating there. Catholic missionaries passing through the same woods had been attacked and robbed of a great many supplies not long before, as was Émile Storms a few years later. Debaize took precautions against any such assault, and when suspected thieves were perceived lurking about the camped caravan, the abbé's heavily armed men pursued them. Several were killed and "a certain number" were captured as were several women. Nothing more is said of the men who were apprehended— were they enslaved? executed?—but the women were "liberated," since "the ferocious brigands had taken them from their families."[69]

The identities of those slain by Debaize's men seem to have been of no significance to the abbé. Nor were those of the nine hundred who constituted his

caravan, for only two names are recorded in available documents, one to be entrusted with further responsibilities, the other an "unequivocal scoundrel" to be incarcerated at the explorer's behest.[70] All others were unseen and quickly forgotten by all but their own friends and families. While such invisibility might be dismissed as somehow symptomatic of Africa or at least of caravan trade, rather than of those engaging the continent with such disregard for the humanity of people upon whose goodwill their success depended, Kizumina's tales suggest that Africans do remember at least some details of such incidents and encounters, in their own ways and for their own purposes.

Debaize wrote defensively that he had been "forced to act right from the beginning without hesitation and with the greatest energy, to sacrifice the existence of a few of these miserable people who have been the terror of caravans for such a long time in order to save more precious lives." The abbé further averred that "this battle that I could not prevent has given me a reputation that, I hope, will [allow me to] avoid others," but he nonetheless asked that his armed action be kept a secret from his European supporters.[71] Given what we know of the violent operations of Stanley and other European proto-colonizers of Debaize's days as well as the next several decades, the abbé's aggression was not striking at all.[72]

The father's supposed ignorance of scientific instruments is belied by letters written by savants who guided his training, and indeed such abilities were essential to the case for funding his expedition presented to the French parliament. Nor does the meager documentation of Debaize's caravan offer any hint of popguns, suits of armor, or other strange things to be found among the abbé's trade goods, although his vast baggage was said to include unidentified "toys and trifling articles of fantasy" that may have comprised some or all of these.[73] Nor, for that matter, was Thomson's presence noted by Hore or the others describing Debaize's demise and the subsequent disposition of his belongings. It is difficult to deduce much from any of this, other than that Thomson's views were not shared by other witnesses.

Thomson did capture the Gilbert-and-Sullivan-like follies of central African exploration, his own odd posturing included. As strange as they may seem, however, Debaize's effects as listed by Alfred Rabaud can be explained as "necessities" of a well-financed, European-led caravan into the heart of Africa as understood at the time. The more than seventy thousand yards of unbleached muslin, the ton of copper ingots, twenty rhinestone diadems, six thousand sewing needles, six hundred copper bells, and the "hundred dozen" boxes of

matches can all be understood in this way; and even the "two loads of penny pop-guns"—reported by Thomson and perhaps falling within the rubric of "toys" listed by Rabaud—must have been destined as gifts to children by an amiable young abbé. Debaize's goods might be compared to what Stanley found necessary in stocking the station he founded near the mouth of the Congo River, which included "jack-in-the-box and monkey-trick toys, Tyrolese hats, velvet smoking caps," and the like, soon traded to local Africans for palm oil and other goods desired by European residents. Similarly, that Debaize brought "twelve boxes of rockets and fireworks" with him, as Thomson suggested, to distract and intimidate those who might attack him was a tactic used by other explorers such as Savorgnan de Brazza. But the "two coats of armor"? They are mentioned by no one but Thomson, not even in the abbé's own inventory. Were they Thomson's invention, or did Debaize mean them to be princely gifts for bellicose potentates?[74] We are left to imagine, as Thomson intended his readers to do, a benighted crackpot clanking about in the underbrush.

Father Debaize's aberrant behavior and physical deterioration were due to sunstroke. In severe cases, hyperthermia can result in confused and hostile behavior and may make the person appear intoxicated. Cramps, vomiting, organ dysfunction, seizures, coma, brain damage, and death can result.[75] Some days before he fell into blindness, increasingly grave convulsions, and pernicious fevers, the abbé's hat had been stolen, and without it he had suffered a massive *coup-de-soleil* while boating on Lake Tanganyika.[76] Thomson interpreted these same symptoms with distinct lack of charity. They were also an all too readily legible sign of what "Darkest Africa" and its siren Fever visited upon the sturdiest of men, as they did to more than a few Beines and Debaizes, to say nothing of the countless Africans who also succumbed to such debilitating forces as understood through their own medical paradigms.

A sympathetic eulogy published by Rabaud stands in stark contrast to Thomson's mockery. Rabaud praised the young cleric and implored his countrymen to remember those like him who might have failed in their heroic missions but who deserved French public recognition nonetheless.[77] Rabaud did rue the fact that anyone so young and passionate yet so utterly inexperienced as Debaize should have had such huge responsibilities thrust upon him. The abbé's obsessive secrecy may have been due to mental instability—and this would have been Thomson's appraisal, one can surmise; but again, it is quite possible that such behavior was due to—or at least exacerbated by—sunstroke. Debaize was a driven man, and he cast aside expectations of scientific observation in

order to push on across the vast continent and realize the grand goals he had set for himself. But how could one so grossly unprepared for an expedition deemed of sufficient national importance as to be granted one hundred thousand francs by the French parliament *not* be paralyzed by an insane fear of failure?

The absurd expectations for Debaize's expedition are painful to contemplate even now. Rabaud certainly had a point: for every "hero" who completed his mission, many more "failed." They died painful or ignominious deaths before achieving their goals, and the same can be said, of course—and many, *many* times over—of the Africans who assisted or resisted these pioneers of colonial hegemony. We are left wondering what *had* France gained from the abbé's tragic adventures, but a more pertinent question would be, what *might* have been achieved had Debaize completed his mission? Rather than falling into complete obscurity, might the abbé have participated in the grand imperialist endeavors soon to captivate Western Europe?

Boatloads of Madmen

What, then, of Storms, cranking out moldering melodies on the Abbé Debaize's Barbary organ? Was such cultural production a function of Bwana Boma's bravado, singing in the face of great odds against his own survival? Or was it the sign of a more homely nostalgia and a slightly softer side? André Breton once quipped that "Christopher Columbus should have set out to discover America with a boatload of madmen"—as he undoubtedly did, we are left to assume.[78] Émile Storms resided in the heart of Africa with at least one deranged soul in the person of Victor Beine, and he sang the tired tunes of a barrel organ that had once belonged to another who became gravely disoriented and died. Breton was reflecting upon the stultifying nature of Western culture that precludes unfurling "the flag of imagination" that is necessary to fathom other systems of thought while escaping the dictates of one's own. With such a thought in mind, what might Beine or Debaize have understood about the nature of early colonial enterprise that Storms could or would not? More significantly, what of Storms and his proto-colonial conceits did local people understand through the insanities of the adjutant and the abbé, as set to the wheezing strains of the Barbary organ?

The Abbé Debaize's demise and Storms's frustration with Beine bespeak the larger issue of how thwarted expectations and mad antics always intervene in the best laid plans. Histories are rarely if ever linear, and as suggested

through Thomson's assessment of Debaize or Kizumina's of Lusinga, they are more often than not a matter of competing accounts. The dynamics of coping with the unexpected leads to the making of histories rather than to construction of a one-size-fits-all meta-narrative, as milandu-style historiology makes clear.[79] This is to say, then, that the stories of the psychopathic Beine or the unfortunate Debaize are as integral to the blur of incompatible incidents and mutual incomprehensibilities in the encounter years of the mid-1880s as any other events understood from any side. Indeed, the "imperialist theatricality" of European exploration was often marked by madness, and the "nightmares without end" of Victor Beine and the "strange" actions and possessions of the Abbé Debaize find their places in harrowing horrors of the sort.[80] Paradoxically enough, the two men's torments were as "normal" as the clockwork life that Becker and Storms hoped to impose at their bomas.

5 · Storms the Headhunter

"I do not intend to complain," said Cincinnatus, "but wish to ask you, is there in the so-called order of so-called things of which your so-called world consists even one thing that might be considered an assurance that you will keep a promise?"

—VLADIMIR NABOKOV, *INVITATION TO A BEHEADING*

Among points that deserve further attention is Lusinga's decapitation by Bwana Boma's men. There is nothing mysterious about the taking of heads in such days of violence, and clearly Storms was not the only one to be doing so, for at least some Tabwa, Yeke, and others demonstrated similar obliviousness to restraint. Perhaps the beheading of Lusinga seemed appropriate to the lieutenant because of the history of European capital penalties, for along with other "spectacles of punishment" through which the body of the accused became a theater of truth and revenge, late nineteenth-century Belgium knew the guillotine. Once called "patriotic shortening" in France to mask "the delirium of death" in farce, the guillotine still haunts the various nations that have deployed it.[1] As an aside, in the 1890s as the violent profit taking of the Congo Free State increasingly required justification through a "civilizing" mission, a standard image was a man being beheaded with a sword and his head then whipped away by a rope tied to a bent sapling—as though such a horrifically "primitive" act had nothing in common with the guillotine of the metropole. Any recognition of the sort would be deemed ludicrous, for it

would run counter to the essential sense of "the 'savage' slot ... that helped constitute the West as we know it."[2]

Decapitation also has a deeper history in Europe, of course, including the display of the heads of traitors and heretics, famously in the demise of Saint Thomas More in 1535.[3] In a distinctly peculiar exposition, Ugo Janssens has suggested that Storms's taking of heads in the Congo was due to his heritage, which Janssens has traced to early Gaul. "Ancient Belgians" resorted to beheading as they confronted their Roman conquerors, and Storms did the same as a "new Belgian (colonial soldier)," Janssens concludes.[4] Given such real or imaginary precedents and the encouragement given to Storms by the secretary general of the AIC to collect a few skulls for scientific purposes, it would be preposterous to consider Lusinga's execution to be a case of Belgian headhunting. Still, how else might people at Lubanda have understood the aftermath of Lusinga's assassination, over and above the raw politics of the moment?

The annals of anthropology are replete with tales of obscure people taking heads in distant times and places, providing an ideologically charged trope reminiscent of "cannibalism."[5] While many such accounts were surely colonial phantasms, it would be erroneous to dismiss them all as such. For example, Renato Rosaldo offers a down-to-earth, now-classic account of the practice among Ilongot people of the Philippines in the early 1970s. In the reasoned words of a man Rosaldo knew, headhunting was construed as "a way of 'having others see what has been severed in two so they will be frightened.'" As much could be said for the beheading of Lusinga, and even Rosaldo's broader ethnography resonates with Storms's violent rancor, especially as recounted by Kizumina. Furthermore, for Ilongot, "headhunting resembles a piacular sacrifice: it involves the taking of a human life with a view toward cleansing the participants of the contaminating burdens of their own lives. ... What is ritually removed, Ilongots say, is the weight that grows on one's life like vines on a tree. Once cleansed through a successful raid, the men are said to become 'light' in weight, 'quick' of step, and 'red' in complexion."[6]

In just such a way, Bwana Boma achieved revenge for the ear-tugging effrontery of Lusinga, and his "red" pleasure and derision could not be more obvious in Kizumina's account as well as in the lieutenant's own words. Might his catharsis have been the more "light-footed," however, as he pondered the "contaminating burdens" of his thwarted ambitions of Stanley-like splendor? And to pursue the analogy, although Storms's motives may not have been of the order of Ilongot vendettas, the burning of Bwana Boma's boma was a next

step of interpersonal violence that would continue intermittently back and forth with advantage to the colonizer and then to the colonized throughout Belgium's imperial moment, just as Storms predicted.[7] Indeed, the heartache and revenge continue in only the thinnest-veiled of guises, as many Congolese have felt occupied rather than served by their central governments and rebel movements rage in response.

Examples like Ilongot headhunting suggest relationships between victim and victimizer that are so obviously intimate that an odd mimesis must be at play. Storms denigrated Lusinga and other Africans living around Lubanda. That is, as he defamed *les nègres* with his adjectives and assumptions, Bwana Boma "completely blackened" them, as the Latin roots of the verb "denigrate" would have it, dismissing them through "savage" stereotypes that became their only reality in his mind, in his projections to metropolitan readers, and, indeed, as the colonial period would progress, in Congolese imaginations to some extent.[8] Yet as we shall see, Storms and his fellow proto-colonial officers were acutely interested in the human labor that these same Africans could be obliged to provide as the basis for incipient capitalism. Working Africans would be necessary even as—and in a sense because—they were debased, in other words, and an intersubjectivity—however hierarchical—quickly arose from such ambiguities. As Michael Taussig suggests with regard to bestial metaphors applied to indigenous people of the Amazon in the early 1900s, "It was only because the wild Indians were human that they were able to serve as labor—and as subjects of torture. For it is not the victim as animal that gratifies the torturer, but the fact that the victim *is* human, thus enabling the torturer to become the savage." As colonizers assumed the savagery imputed to the colonized, places were traded, whether or not either party was fully aware of or would ever admit to or condone the fact.[9]

Hints of how nineteenth-century Tabwa may have understood the taking of Lusinga's head also reveal esoteric interpretations and purposes, for, to paraphrase Luise White, "stories of chief's heads can link the history of politics with that of cosmology."[10] Important to White's phrasing is the implication of a history of cosmology that must accommodate ongoing events such as Swift-of-Foot's confrontation with Bwana Boma. In the epic tales shared by Luba, Tabwa, and other central African peoples, it is not just that the "black" culture hero defeats the "red" antagonist to create human culture as known to those telling and listening to such narratives, but that he does so by beheading. As the structural anthropologist Luc de Heusch has suggested,

the separated head of the antihero is a "solar" entity, and the cultural classifi-
cations of life as Luba recounting such stories know them assume their basic
order through just such elemental disjunctions as when the hot and red "sun"
is separated from the antihero's "humid," terrestrial body.[11] That Lusinga
should be the one calling Bwana Boma "red" reverses expectations then, for
in Kizumina's telling it is Lusinga who fulfills the antagonist's role in the
cosmological saga. In other words, although all accounts agree that Lusinga
was beheaded by Bwana Boma's men, Kizumina and those listening to his
mulandu narration had an opportunity to use such a narrative structure for
their own political ends as they sought to downplay Lusinga's political legiti-
macy in colonial and postcolonial contexts by "proving" that the chief was as
bound to be beheaded as the antihero of their cosmogony; and yet Bwana
Boma was the "red" one in mimesis with his adversary.

Lusinga's decapitation presents yet another irony. At least some precolonial
Tabwa chiefs were buried in a very distinctive manner, sharing a funerary model
with Luba-ized and eastern Luba people to be detailed in chapter 9. When an
important chief died, elaborate drama was devised that resulted in preservation
of his skull. Lusinga's head was not to be so revered, however. Instead, Bwana
Boma took it with him to Europe, and the chief's cranium remains in the drawer
of a Belgian museum to this very day. As Kizumina recounted the story of
Bwana Boma's punitive expedition as a politically purposeful narrative, the
mockery of Lusinga's severed head carries the additional charge of funerary
ritual denied. And when Bwana Boma held the bloody thing aloft and asked,
"Are you the one who pulled my ear and called me a *kabege* and a *kamushulwe*
and a *kasuke*?" the head could only "grin" and remain silent.

What are the heady lessons of European and Congolese accounts of
Bwana Boma's battle with Lusinga? What balance of the senses or mental
faculties is upset, as the word "heady" may imply?[12] Although one could elab-
orate upon the differences between the written history of Storms and the oral
narratives of Louis Mulilo and Kizumina, of more direct interest is the com-
plementarity of these culturally conditioned forms of representation. Storms
was not just writing for himself when he kept his diary or composed long
letters to colleagues, for much of his reporting moved directly into print for
European readers avidly following the exploits of headstrong African "explor-
ers," the revelation of new natural resources and "juicy" business opportuni-
ties, the heinous ravages of the east African slave trade, and other matters of
interest concerning the "Dark Continent" as it was understood during King

Léopold's "Century of Progress"—with all that such tired tropes connote now, perhaps as they did then.

Storms's published accounts were understandably self-serving in their justification of his actions, their emphasis of certain accomplishments and ignorance of other facts, and their promotion of his career. Rather than taking the initiative, however, it seems that his early dispatches were submitted for publication on his behalf by publicity-seeking IAA officials.[13] In this regard it may be recalled that the lieutenant had to be urged by his superiors to provide more written information to them about his central African exploits, and that his response was basically that he was too preoccupied with other matters to spend his time writing long letters. In his reticence, he distinctly differed from the sensationalist "new journalism" of Stanley, whose innovative self-fashioning contributed mightily to the sense of charisma that so many came to attribute to him. Indeed, "as an experienced journalist, Stanley wrote better and far more vividly than his predecessors, giving his work a popular appeal that enabled him to shape European perceptions of Africa well into the twentieth century." Over and above the impacts and implications to those he visited, Stanley realized that the trials of his "discoveries" would exist for the metropolitan audiences he so avidly sought only if he actively publicized them in writing, lecturing, and managing his public persona.[14] Storms came to no such conclusions, and he seems to have chosen obscurity for reasons that remain unclear. Furthermore, rather than the splashy outlets exploited by Stanley, those to which Storms's texts were submitted were parochial and propagandistic, as when the paper *Mouvement géographique,* in which several of his pieces appeared, sought "popularization of the idea that colonization of the Congo was a specifically *Belgian* enterprise."[15]

Despite Storms's seeming reticence vis-à-vis publishing, his self-aggrandizing and politically focused endeavors while in the Congo were not dissimilar to the workings of Tabwa *milandu* as conceived by a lively mind like Kizumina's. The old man told a formulaic tale informed by an insider's detail of what mattered to his kinsmen who participated in the taking of the arrogant Lusinga's head, or who were a party to the event's life-shattering repercussions, or were listening to his narratives of the mid-1970s. Kizumina made allusions from the readily grasped to the deeply esoteric, and all were couched in salacious hilarity. He made arcane references to the understandings of his own culture about such matters as what beings, practices, and circumstances are "red" as he created a stereotypical portrait of Bwana Boma that was no less polemical than Storms's various diatribes about the shortcomings of the "niggers" (*nègres*) among whom

he lived and whose lives he sought to manage. Yet the purposes of Kizumina's narrative were also directed to local-level politics as he sought to confirm Mpala's legitimacy as senior to Lusinga even on profoundly cosmological levels, and to explain the shockingly aggressive but altogether localized "working misunderstandings" of colonialism as personified by Bwana Boma.[16] In their intent, then, the two accounts converge in disequilibrating, "heady" ways despite their differences in focus, genre, detail, and violence.

The "Helots" of Karema

Such accounts may be as interesting for what they do not report as for what they do. In particular, there is the matter of the east African slave trade that was a primary justification and, no matter how horrible its ravages most assuredly were, some would say the foremost alibi for Léopold's colonial conquest of the Congo. In Storms's diary from his days at Lubanda, over and above many references to slave raiding by coastal "Arabs" and their minions as well as by Yeke and more local warlords, the lieutenant mentioned being directly involved in a number of incidents in which people were enslaved as at Lusinga's or were given away as slaves as after the death of Mpala. Significantly, although he decried slavery in general terms, he never mentioned the pain and suffering of those bereaved, wounded, raped, imprisoned, or enslaved by his men or at his behest. Instead, his readers were left to assume that they somehow deserved their fates, in their complicity with those who would thwart his ambitions.[17]

In Kizumina's story, Bwana Boma was so grateful for the *matabishi* of two enslaved people given to him by Sultani Mpala that he thanked the chief "fourteen times." At the very least, such a narrative moment underscored Kizumina's sense of the ambiguities of the slave trade, and incidents reported in Storms's diaries contribute to such uncertainties. In February 1885, for example, when a local man lost a musket entrusted to him, the lieutenant's matter-of-fact comment was "I take him as a slave; it is my right."[18] No mention was made of the man's possible manumission. Also receiving little attention in written or oral accounts were the hundred or more persons whom Storms kept under bondage within a special *tembe* adjacent to Fort Léopold at Karema on the southeastern shore of Lake Tanganyika. These were *esclaves rachetés*—persons "bought back" from enslavement but still in bondage.

Jules Ramaeckers, predecessor to Storms as commander of the fortress at Karema, outlined how such people would be obtained and then treated.[19]

En plein travail. (Dessin de A. Heins.)

Figure 5.1. Industrious people at Fort Léopold.
A. Heins in Becker 1887, 2: 217; public domain.

They would be purchased from the caravans dragging them eastward and settled in a collective dwelling adjacent to the boma at Karema. For the first two years of living there, they would be obliged to work for the station six days a week, from six in the morning till two in the afternoon. Their responsibilities would be primarily agricultural, and they would be given food and clothing in compensation. During the third and fourth years, they would receive small, personal houses near the boma, provide labor three days a week rather than six, and receive clothes but no food. For a final two years, they would be pressed into service for the boma one day a week and would receive no compensation at all. Thereafter the esclaves rachetés were free to leave Karema, but the goal would be to assure that they had become sufficiently attached to the land and lifestyle at the boma as to want to settle there permanently, contributing to and defending the post as its fate would be their own. Any who sought to escape during their six years of bondage would be hunted down, brought back, and punished. A first offender would receive two hundred lashes; spend a month in chains; and begin a new, longer cycle of three three-year obligations. A second flight and recapture during these same nine years would occasion execution by a firing squad.

The key to Ramaeckers's plan lay in the assertion he made to his superiors that his "propositions are nobly humanitarian, for I only release a man to

liberty after having healed him of his capital vice: laziness. And after six years, I will have habituated him to work."[20] Ramaeckers deemed the "laziness" of Africans to be innate, and they were "slaves" in essence rather than, or at least more than, through capture or sale, as the past participle "enslaved" connotes. In other words, the onus was shifted: lazy Africans were corrupt and merited their subjugation—and this despite the fact that life at Karema depended upon the obvious industriousness of local people (fig. 5.1).

Marnia Lazreg's assertion is apposite even if her attention should be upon torture during the Algerian War: "To attach the qualifier 'humane' to the noun torture" or, in Ramaeckers's case, to the unstated phrase "involuntary servitude," "in the context of pain and suffering meant more than giving this practice acceptance. It emptied it of its political meaning and transformed it into an act of charity."[21] The *esclaves rachetés* would be redeemed, in other words, through their purchase from the slavers, but even more significantly, from their own vices. Indeed, the French verb *racheter* bears just such ambiguity, for while its obvious translation is "to buy again," as when one purchases something already sold at least once, it also carries a sense of redemption and atonement for sins— in this case, the victims' sins rather than those of the victimizers.[22]

Ramaeckers died of dysentery in February 1882 before he could realize his plan, and Jérôme Becker succeeded him as commander of the fortress at Karema.[23] The first major contingent of enslaved persons was ransomed in the Marungu by men sent by Becker, and they were transported across the lake to form the nucleus of the settlement that Ramaeckers had hoped to found at Karema. An unusually sympathetic drawing by A. Heins published in Becker's *La vie en Afrique* depicts these Tabwa people wading ashore with their meager belongings, ready to begin their lives anew (fig. 5.2).[24] Becker showed distinct affection for this community, perhaps as reflected in Heins's depiction.

Although it is not clear to what degree Ramaeckers's harsh expectations were ever met, especially with regard to deserters, it does not seem that they were applied rigorously. Becker most frequently referred to the esclaves rachetés as "helots" (*ilotes*). That is, they were peons or serfs, after Becker's understanding of the ancient Spartan model of indentured persons who were neither enslaved nor free. Such a term was in keeping with feudal vocabulary that Storms occasionally used in writing of "suzerains" holding "fiefdoms" in southeastern Congo, and that would be deployed during the first decades of the colonial period when an understanding of local political organization would provide the ideology for *la politique indigène*.[25] Vocabulary of the sort also served a certain

ARRIVÉE DES COLONS MAROUNGOUS.
(Dessin de A. HEINS.)

Figure 5.2. "Redeemed slaves" from the Marungu reach Karema.
A. Heins in Becker 1887, 2: 269; public domain.

mystification, for again following Marnia Lazreg, euphemisms like "helot" jus-
tified bondage and attendant abjection by creating "psychological distance"
between those suffering such indignities and those administering them.[26]

Storms succeeded Becker at Karema, and the French explorer Victor
Giraud soon visited the lieutenant and photographed the helots' accommoda-
tions, as rendered in two engravings published with his writings. Giraud
quoted (or, more probably, paraphrased) Storms as saying that "aside from a
few general work obligations"—he used the term *corvée* here, referring to "a
day of unpaid work required of a vassal by his feudal lord"—the helots

> have no other occupation than their own farming. During harvest, I
> [Storms] appropriate half of their maize, and when there is a period of fam-
> ine I give them rations. They seem happy with their lot, [and] do not desert;
> their two years completed, they do not even try to take advantage of the
> liberty given to them. A born slave will never be anything but a slave. As for
> the slave born free but reduced to servitude through warfare, he seeks to
> desert and if he cannot succeed, he allows his life to flicker away more and
> more miserably, rather than to subject himself to the odious yoke.[27]

There was apparently no irony here, for Storms seemed oblivious to the paral-
lel between what he wrote about "slaves born free" and conditions of the
helots according to Ramaeckers's proposal and his own direction.

In Storms's reckoning, the helots' emancipation would be possible after two
years of labor rather than the six prescribed by Ramaeckers, but the matter of
their status was complicated by the lieutenant's further pronouncement:

> I share the opinion of those who wish to see the slave trade disappear in the
> slow and progressive way which alone can lead to civilization. A radical
> abolition favored by many theoreticians these days can only bring a result
> opposed to what they hope to attain and in reality, lead to a much more
> disastrous solution that slavery itself.... Wishing to render all slaves free
> by a stroke of the pen strikes me as tearing our children from the breasts of
> their mothers and throwing them in the road so that they can go and pro-
> vide for their own needs.[28]

According to Storms, then, King Léopold's Century of Progress should
proceed slowly with regard to freeing those who were enslaved or otherwise in
bondage, and who would now be understood as "our children." However pater-
nalistic he may have been in the mid-1880s, Bwana Boma could only be under-
stood as a master of "debt slaves"—an assertion that is even more provocative

given the difference between the lieutenant's public pronouncements and his more private musings and actual actions. Indeed, in this regard Becker wrote that he was "diametrically opposed" to Storms's seemingly liberal stance regarding the evils of slavery, for Becker found that those enslaved were better off "saved from abjection" in this way than if they remained in their primitive and even more brutal circumstances.[29]

Further discussion of these important matters lies outside the scope of the present volume. Suffice it to say that the effects of slavery, both domestic and long-distance, would be hotly debated in Belgian colonial circles and lead to armed interventions, including the Belgian antislavery expedition to Lake Tanganyika of 1888 that was led by Jacques de Dixmude and for which Storms served as technical director. At this point Storms's later writing about slavery from his vantage as "a pioneer of Civilization" reflected his espousal of European politics of the moment as he decried the cruelties of the trade in ways that differed quite radically from his more private musings only a few years earlier. He called for a naval blockade of slave trafficking across Lake Tanganyika and the creation of more outposts like those at Karema and Mpala-Lubanda, from which expeditions could be launched to put an end to slave raiding west of the lake. Unless impeded by lack of funding, Storms concluded, "certain success can be assured . . . without great difficulties and almost without bloodletting."[30] Sadly, this would not prove the case for the 1888 mission of Jacques de Dixmude, which was successful but saw substantial loss of life. Indeed, slaughter would continue well into the 1890s, when the slave trade was replaced by other forms of oppression, including that associated with the gathering of red rubber. It should also be noted that various forms of forced labor continued to the very last years of Belgian colonial rule in the Congo and through the Mobutu years of the Republic of Zaïre. Congolese were still obliged to offer their time and energies for non-remunerated road maintenance, and depending upon the region, cash crops were demanded and labor recruitment was enforced.[31]

Bwana Boma's "Detestable Reputation"

Storms's diary entries offer hints of what at least some people of his "empire" thought of his motivations and activities. The lieutenant was concerned that the authority he maintained through "Zanzibarites," rugaruga, and other expatriate mercenaries was ephemeral, in part because the ultimate loyalties of such employees must logically lie in their own vested interests and their

own homelands, especially given how hard it proved to keep them from pillaging even as they saw to his orders. To do so was "normal," Storms's men told him, for "in war they run the risk of being killed, and as a consequence they ought to profit from battle."[32] One can imagine how those falling victim to men in Bwana Boma's service must have felt as they were brutalized.

Storms decided that his mercenaries must be sent home as soon as possible, and with the urging of his superiors in Belgium he moved to organize a permanent force of local young people. He would pay such men less than he did in hiring *wangwana* and yet create a "place of friendship" for people from different regions and chiefdoms who were enemies because of current warfare. Bwana Boma would build solidarity among the young men and would have them live for a time with wangwana so that they could learn to speak Swahili and thus gain a sense of superiority over those living away from the boma who did not know the language. *Wangwana* also possessed more cosmopolitan qualities that would sharpen the young people's dull wits (*se degourdir*), Storms felt. Most important, such a loyal community would guarantee the boma's security while providing it with agricultural produce, and some young men could be trained as sailors to seek goods lacking at Lubanda but found elsewhere along the shores of Lake Tanganyika and its various tiny ports of call.[33] For all these reasons and more, Storms asked the chiefs under his aegis to send him their trusted sons to settle at the boma, and he did receive a handful. But he bemoaned his inability to recruit more readily, admitting, "I have a detestable reputation, and people say they do not want to give me their children because I am only asking for them so that I can kill them." Others "got it into their heads that once they had come to live with me they would be enslaved." Nonetheless, Storms continued his efforts to create a community of difference at Lubanda, as would the Catholic missionaries who assumed control of his "empire" in 1885 and soon transformed it into a "Christian Kingdom" of and for their own devices.[34] Colonial hegemony was quickly taking shape, in other words, as were all the politico-economic ambiguities so implied.

Given the methods and purposes of Émile Storms, one could assert that the "pathologies of power" and "pyramid of violence" that have been constructed in the Congo over the last century and a half, body by body and soul by soul and now extending through the genocidal early years of the twenty-first century— five to ten million lost in northeastern DRC and counting—had their beginnings with the likes of Bwana Boma.[35] Yet the noted Congolese historian Isidore Ndaywel è Nziem has suggested that "contrary to Belgian opinion that seems more sensitive to events during the half century of Belgian rule of the Congo

and the adventures that took place there, Congolese wish to turn more essentially toward the history of the present. One can affirm that in their eyes, the hecatomb resulting from Rwando-Ugandan aggression [of the 1990s and early 2000s] is by far more scandalous that the 'cut-off hands' of the Léopoldian period." The activities of Émile Storms may seem absurdly inconsequential to present-day Congolese, in other words, who have suffered for so long and who are at such grave risk of even more pain as "the bleeding edge of a running war" threatens to engulf them.[36]

Certainly Storms did not start the bloodletting, for there is ample evidence of senseless killing and callous ruin of lives before he reached the southwestern shores of Lake Tanganyika in 1883. But it is equally true that Storms's bloody actions fit the local mold: Lusinga and Ukala took heads, and so did he; they enslaved the helpless, as he did too; they made empires of force and arrogant privilege, and so did Bwana Boma. Was he any different from other warlords operating in southeastern Congo during his time? Bwana Boma must have been utterly comprehensible to Africans caught up in the violence of the late nineteenth century, as I daresay he would be to Congolese today, were they to know his story. And at the ever deeper levels of consciousness revealed to us by Kizumina, Storms makes sense as well, for as he lent his "white" countenance to all that was "red," "hot," and ruthless, his face became the new face for the eldest of horrors.

Postscript to Part One

Storms was no Kurtz and I am no Conrad. It is difficult, however, not to ponder commonalities between Storms and the "sordid buccaneers" plying the Congo River whom Joseph Conrad encountered during his late nineteenth-century wanderings and who would later inform his most celebrated tale.[37] Yet it is with trepidation that I refer to *Heart of Darkness* at all, since to do so has become a tiresome trope made the more problematic by Chinua Achebe's accusation that "Conrad was a bloody racist." That such a

> simple truth is glossed over in criticism of his work is due to the fact that white racism against Africa is such a normal way of thinking that its manifestations go completely undetected. Students of *Heart of Darkness* will often tell you that Conrad is concerned not so much with Africa as with the deterioration of one European mind caused by solitude and sickness. They will point out to you that Conrad is, if anything, less charitable to the Europeans

in the story than he is to the natives. . . . Which is partly the point: Africa as setting and backdrop which eliminates the African as human factor.[38]

While it is easy to take Achebe's points, I find them to be the reason one *should* continue to allude to *Heart of Darkness* as indicative of the very issues I seek to illuminate through a contrast of Congolese and Belgian histories of the assassination of Lusinga in December 1884.

Bwana Boma and his wangwana and rugaruga, like Conrad's expatriate "pilgrims" operating along the Congo, "grabbed what they could get for the sake of what was to be got." As certainly,

> it was just robbery with violence, aggravated murder on a great scale, and men going at it blind—as is very proper for those who tackle a darkness. The conquest of the earth, which mostly means the taking it away from those who have a different complexion or slightly flatter noses than ourselves, is not a pretty thing when you look into it too much. What redeems it is the idea only, [. . . even if] a taint of imbecile rapacity blew through it all, like a whiff from some corpse.[39]

Storms's stories hardly suggest colonial redemption, for the "idea" to which Conrad alludes was articulated through persecution rather than benevolence. And could the "imbecile rapacity" in which Bwana Boma participated fail to have an effect upon the man himself—as it surely did upon Victor Beine?

In his influential manifesto of 1955, Aimé Césaire elucidated a two-edged "law of progressive dehumanization," asserting that colonization "dehumanizes even the most civilized man" and that colonial activity "based on contempt for the native and justified by that contempt, inevitably tends to change him who undertakes it."[40] Kurtz and Storms both took heads of the "niggers" they confronted, to use their own term of reference. But the one had them placed on pikes so that the severed heads leered inward toward his morbidly collapsing self, thus reversing the panoptical gaze of incipient colonial hegemony, while the constructions of Bwana Boma did just the opposite.[41] Furthermore, the lieutenant brought Lusinga's and two other skulls to a metropolitan scientist who used them to compose narratives of darkest difference. If Kurtz recognized "the horror" of imperialist enterprise, it seems that Storms may never have done so, at least from what one can tell from his seemingly indifferent appraisals of his actions and his behavior back in Brussels. If Kurtz took the horror unto himself, Bwana Boma cast it back upon soon-to-be-colonized Congolese, victimizing the victims yet again and for long thereafter.

Part 2 · Remembering the Dismembered

Les lettres du blanc sur les bandes du vieux billard.
The white man's letters on the cushions of the old billiard table."

Les lettres du blanc sur les bandes du vieux pillard.
"The white man's letters on the hordes of the old plunderer."

—RAYMOND ROUSSEL, "IMPRESSIONS OF AFRICA"

6 · The Rise of a Colonial Macabre

I saw him immediately as headless, as becomes him; but what
to do with this cumbersome and doubting head?

—ANDRÉ MASSON, ON ACEPHALUS

We have not yet finished with Lusinga's head. Émile Storms's reasons for taking it may seem as obvious to readers nowadays as they may have been to the lieutenant and those in Europe to whom he explained his efforts through his various reports and letters: Bwana Boma was simply trying to put an end to a "sanguinary potentate" and so establish peace and order for the good of all. Why *not* take Lusinga's head? In so doing, Storms could match brutality with brutality and hope to establish his authority among people whom he found to be bloodthirsty, while participating in the "scientific" mission of the IAA as urged by the secretary general himself.[1] After his return to Brussels, Bwana Boma would submit Lusinga's skull to the scrutiny of metropolitan physical anthropologists, and that would be that. There was more at stake than such obvious ends, however, and furthermore, surely unbeknownst to the lieutenant, the taking of Lusinga's head touched upon far more esoteric levels of reckoning for at least some Tabwa of his time.

In chapter 9 we shall consider how Lusinga might have been buried had he not met his demise so abruptly in the hands of Storms's assassins. Ironically enough, the elaborate rituals that Lusinga and Kansabala—his perpetual

"mother's brother"—adopted according to what they understood of and adapted from eastern Luba and related paradigms for noble behavior included ritual decapitation after death and the veneration of skulls, but for very different purposes than the fates suffered by Lusinga and his severed head. As we shall see, these matters are compelling evidence of "cosmologies in the making" or what James Fernandez calls "the fabulation of culture," as Lusinga sought to legitimize his newfound "royalty" on the one hand, and as European scientists established a sense of "Africa" from evidence such as Lusinga's skull on the other.[2] A further dimension of the making of Congolese cultural histories is how Tabwa preservation of skulls differed from the keeping of ancestral figures like the famous one seized from Lusinga's village by the men of Bwana Boma that now resides in the Royal Museum of Central Africa in Tervuren, Belgium. And in concluding this book, Lusinga's magnificent sculpture will be compared to a watercolor portrait of Émile Storms as a means of teasing out further indication of the "contrapuntal perspectives" of the colonial moment.[3]

The "Social Life" of Lusinga's Skull

Natural history museums often conserve vast holdings of human remains, usually collected by archeologists in parts of the world other than their own, or among people different from those with whom such scientists, museum staff, and visitors would most readily identify. One has only to ponder the vast holdings of American Indian skeletal materials by museums across the United States to get the point.[4] It is hard to know what is "natural" about such institutions, other than their tendency to naturalize assertions and relationships for ideological purposes, but this is a hoary and ongoing story.[5] From many points of view, including what might be glossed as a Tabwa one, such museums are bizarre places indeed, for it is easy to understand them as haunted by the rancorous powers of the unburied. Nor is anything but an odd anthropomorphism clarified by late nineteenth-century Belgian assertions—as metaphorical as they presumably were meant to be—that contemporary museums were moribund places and "graveyards" with "deathly presentation[s] of objects." Even more gruesomely, in the words of the sociologist Cyrille Van Overbergh, Belgian museums of his time "resemble[d] some huge body whose limbs are randomly spread, each performing its own function in isolation, with no connection to the heart or the brain: so many lifeless beings, hence the impression of a cemetery."[6] As Stephan Palmié suggests with regard to a Cuban counterpart, through

similar collecting the Museo Antropológico of Havana "had turned into a giant *nganga*" or medicinal bundle of Kongolese inflection, "animated by the enslaved remains of the powerful dead. Conjuring science out of violated bodies had become a republican drum of affliction." In other words, governmental ("republican") authorities in Cuba have had recourse to skeletons in museum closets, perhaps to tell new tales of integrative purpose, perhaps to deflect attention from histories they would rather be forgotten. Here Johannes Fabian's caveat comes to mind, about "how much we stand to lose when we forget that Africa remembers."[7]

In 1964 the Royal Museum of Central Africa transferred 650 human skulls obtained by various means during colonization of the Congo from its collections to the Department of Paleontology at the Royal Institute of Natural Sciences in Brussels.[8] Among them is Lusinga's, listed as number 151.[9] The crania of Tabwa chiefs "Maribou" (Malibu) and "Mpampa" (Kapampa) are also in the collection, having been obtained by Storms after battles fought on his behalf but in which he himself was not directly involved. Details of these encounters are very sketchy, but it seems that some of Bwana Boma's men were engaged in a "theater of war" more than 100 kilometers south of Lubanda and that the effrontery of Malibu's boast that "I have vanquished the Arabs and the Wangwana, and the white men are no more terrible than they—I will kill all of you!" led to his speedy demise. As Storms commented in his diary, "People know that I have taken a few chiefs' heads in my collection, and it inspires bloody horror [*une sainte horreur*]. They say I want the heads of all the kings of this land."[10] Decapitation of a few notable Africans was of great strategic value to the lieutenant, as we have seen.

Lusinga's name is scrawled across the left side of his skull in a faded, nineteenth-century hand (perhaps Storms's own?) and inked again in smaller, darker block letters below the catalog number "A.A.151." These inscriptions are only indexical, no matter how lyrical the old-fashioned penmanship may seem all these years later. They are significantly different in this regard from the writing on René Descartes's skull that documents the various possessors once the cranium fell into popular hands, as these graffitists wished to associate themselves with the philosopher's grandeur; nor does Lusinga's skull bear any longer inscriptions like the eulogistic ode in Latin inscribed across the forehead of Descartes's.[11] Quite clearly, Lusinga's cranium bore no poetic or talismanic powers for those who came to possess it.

Faint tattoo-like lines in red and black pencil or ink are traced across the brow of Lusinga's skull, intersected by a short, black line segment designating

the equilateral midpoint. These must be the result of craniometric investigations. Ironically, though, the markings replicate a common scarification pattern among Tabwa called "the face of the cross" (*sura ya musalaba* in Swahili) that they shared with and may have adapted from Mbote hunter-gatherers living in remote outbacks of their mountainous lands.[12] The crossing lines just above the bridge of the nose are said by Tabwa to indicate the seat of dreams, intuitions, and breakthrough ideas. No description of Lusinga's countenance has been found to date, other than Storms's dismissing him as "an ugly mug" and Thomson's passing comment that the man was "lubbery-looking"—although this probably referred more to his bearing than to his face. We do not know if Lusinga bore "the face of the cross" as a "mark of civilization," but chances are that he did not. Lusinga looked to Luba models for bearing and being, and the smooth face of the majestic figure of his matrilineal ancestors that Storms's men seized during their destruction of Lusinga's village is in keeping with eastern Luba body arts and sculptural styles, as opposed to central and southern Tabwa figures that display facial scarification very prominently.[13]

Lusinga's skull bears evidence of a postmortem indignity in damage extending from below the left cheekbone, through the lower nasal cavity and maxilla, to below the right cheekbone. This is the result of Lusinga's severed head being paraded about on the end of a spear while his villages were sacked, as per Storms's account. In comparison to other Congolese skulls kept in the same drawer of the institute's reserve, Lusinga's bears a strikingly reddish hue, as though rubbed or otherwise treated with a chemical substance. One can speculate that this may have been undertaken in Lubanda as the skull was prepared for its expedition to Belgium, although any such practice, if it did occur, would have had local cultural purposes.[14] The symbolic potency of such coloration will be clear from discussion of Kizumina's narrative devices.

The three crania collected by Storms were discussed during a session of the Anthropological Society of Brussels by the eminent medical doctor and physical anthropologist Émile Houzé, in a talk attended by Storms himself. Houzé (1848–1921) was a professor at the University of Brussels and is considered "one of the fathers of Belgian anthropology" who "systematically analyzed the ethnic characteristics of Belgian populations."[15] The Anthropological Society was founded in 1882 and as cultural historian Jo Tollebeek tells us, its "fanatical anthropometrists" such as Houzé "measured all manner of physical qualities—including, of course, the cranial index—in hundreds of representatives of the social and ethnic groups they were studying and, as a consequence, [they]

collected an almost overwhelming mass of statistical data." Other scientists in the *société* applied their findings to paleoanthropology, comparative anatomy, and "criminal anthropology," while Houzé, who stood out among them for his "great energy," studied race, evolution, and the "degeneration" believed perceptible through physical characteristics "given the status of 'stigmata.'"[16]

Lusinga was introduced by Houzé as "cruel, greedy, and vindictive" in life and was said to have been a big man, measuring about a meter 80. That is, Lusinga may have stood 6 feet tall, and, incidentally, if he did he would have towered over most Tabwa men of his time as well as Bwana Boma, who was only about 5 feet 2 inches tall(160–164 cm). Neither Houzé nor Storms offered any character traits or other circumstantial information about Tabwa chiefs Malibu and Kapampa, whose skulls were nonetheless measured and discussed for comparative purposes. The cranial capacities of both were more than 1,600 cubic centimeters and so significantly greater than the average for late nineteenth-century European men. Houzé's exposition must be situated in debates then ongoing about whether correlations might be drawn between cranial capacity and intelligence within and between Western European communities, and between Europeans and what were understood as the different races of the rest of the world. Whether or not the potentially disturbing fact that the cranial capacities of both Malibu and Kapampa were larger than those of noted figures of European history such as René Descartes influenced the composition of Houzé's talk is not clear, although it seems highly unlikely that he would have pondered the possibility that the formula larger-cranial-capacity-equals-greater-intelligence might extend to Africans.[17] Who knows, in other words, whether Malibu and Kapampa possessed exceptional intellects by whatever measures such qualities might have been determined in their own communities or anyone else's? For even if they did, such reckoning would run counter to racial theories of the day and be left unstated. At any rate, Lusinga's smaller cranium was the topic of the soirée.

Houzé described Lusinga's skull according to arcane criteria using words composed of Latin and Greek roots that no one but the small circle of like-minded physical anthropologists would be likely to comprehend or appreciate. For example "the fronto-zygomatic cephalic index (bistephanic x 100/bizygomatic)" of Lusinga's skull is 76.12 (no units are given), while that of Malibu is 80.29.[18] Houzé made no effort to explain why knowing such details would be important, nor what the numerical difference between or among Lusinga's, Malibu's, and other skulls might indicate or connote. Instead, he engaged his "passion for a code" following the craniometric models and procedures proposed

by Paul Broca, among others, to whose work Houzé alluded in his talk, and he exemplified the degree to which "evolution and quantification formed an unholy alliance" in the latter years of the nineteenth century. In hindsight, the result seems scientistic rather than scientific—that is, Houzé's baroque polysyllabic terms and the minute metric measures accompanying them (often in millimeters taken to hundredths) may have impressed his audience and represented the kind of presentation that influenced racial discourses of the day, but what *did* they convey? As Stephen Jay Gould has suggested, it is not that a "leader of craniometry" like Houzé was a "conscious political ideologue," for such scientists considered themselves to be "servants of their numbers, [and] apostles of objectivity." Rather, through such assertions "they confirmed all the common prejudices of comfortable white males—that blacks, women, and poor people occupy their subordinate roles by the harsh dictates of nature."[19]

Interest in and arguments against physiognomy and phrenology as sciences of the times must have informed Houzé's presentation and its reception by his audience. Indeed, even if Houzé himself did not subscribe to the more popular aspects of such notions, people throughout Europe and the Americas avidly did as they sought to understand each other—and especially those deemed significantly different from and "inferior" to themselves in behavior, social class, or "race"—through such "readings" of appearance. If this were the case, Lusinga's "cruelty, greed, and vindictiveness" as reported to Houzé by Storms found physical confirmation in the man's cranium in Houzé's and his audience's estimation, as the scientist reduced Lusinga-the-person to a few bits of archival information.[20]

Some of Houzé's measurements are especially revealing of a "colonial macabre" that was taking shape in Belgium and across Europe. Houzé determined that "the frontal temporal crests" of Lusinga's skull "are sharp and very defined: over the parietals, these crests curve inward to join the *sagittal* suture. This is an ape-like characteristic."[21] Such an assertion about "the apishness of undesirables" was a sign of the times, for as Gould has suggested, "any investigator, convinced beforehand of a group's inferiority, can select a small set of measures to illustrate its greater affinity with apes." Gould's next thought was that "this procedure, of course, would work equally well for white males, though no one made the attempt."[22]

The last word of Houzé's phrase was *pithécoïde*, derived from the Greek term for "ape," and it would seem that the august observer, contemplating Lusinga's skull as closely as if it were poor Yorick's own—but most decidedly

without Hamlet's sympathy for the man who once was—was alluding to his ongoing thoughts about human evolution. Tensions would heighten some years later when a long-anticipated "missing link" between men and apes was discovered in 1891 by Eugène Dubois and dubbed Pithecanthropus, now understood as *Homo erectus*. Houzé was an active and acerbic participant in debates about Dubois's assertions, and one can surmise that his application of a term like *pithécoïde* to Lusinga's skull was anything but casual.[23] Furthermore, at 1,370 cubic centimeters, Lusinga's cranial capacity was notably smaller than that of the other two skulls Storms submitted to Houzé's scrutiny, and "the biorbital angle is very open." Whereas this feature might not be "an ape-like characteristic," with such an assertion proving that matters of the sort were very much on Houzé's mind, in his view the smaller skull capacity *was* "a characteristic of inferiority in human races" and so, for the scientist, a further point of never-the-twain-shall-meet differentiation between Africans and Europeans as extrapolated from Lusinga's example.[24]

There followed a long "digression" in the presentation, as Houzé himself called it, in which the scientist reflected upon the rude living conditions of persons such as Lusinga.

> The African races that interest us are little dressed if dressed at all, and so they are exposed to all the events and influences that would make the cutaneous tegument [the skin, that is] grow thick.... Let us say that if the peripheral nerves are less perfect in some races, this gives us a way to verify a central mechanism: the more an organ functions the more pathological manifestations have power over it. In the United States in 1862, for example, statistics proved that mental alienation is much rarer among Negro slaves than among white people. Ever since his emancipation, the Negro has had to work for himself, he has had to shake himself of his native torpor, exercise his senses, and his greater cerebral activity has had as a result an augmentation of mental illness![25]

One can suspect that by inserting this anecdotal information in his lecture, with its reference to the "native torpor" of "thick-skinned" Africans loaded with cruel ironies, Houzé was advancing the polygenetic theories of "adaptive force" developed in the early nineteenth century by Jean-Baptiste Lamarck that Houzé and others adapted to new, oft-ideological purposes later in the nineteenth century. Indeed, through his various disquisitions, Houzé sought to prove that Africans and Europeans could have no close common origins whatsoever.[26]

In his comments about Lusinga, Houzé may have been making further, implicit reference to the sort of "sinister caricatures" that later colonial authorities felt were created as Africans sought integration into Congolese cosmopolitanism.[27] For Houzé and those describing race relations in Civil War America (1861–1865), increased assimilation of people of African heritage into European or Euro-American affairs would inevitably lead to the breakdown of Africans' health and their more general corruption, while endangering the non-Africans around them. As the American physical anthropologist Samuel Morton had it in works such as his influential *Crania Americana* of 1839, "The races had resulted from multiple Creations, demonstrating God's intent to deliberately create blacks for the purpose of serving their white betters as slaves." Mid-nineteenth-century anti-abolitionists in the United States asserted that "black people were constitutionally unfit for freedom," Amina Mama reminds us, for the "stresses of being civilized" would inevitably lead to their insanity; it followed that African colonization was for people's "own good."[28] In his presentation about Lusinga's skull, Houzé came to just such conclusions, and although perhaps for less "scientific" reasons, Bwana Boma actively shared this sense of the order of things as we have seen through his thoughts on slavery in central Africa.

The observations and associations of the nature of Lusinga's skull by someone so eminent as Émile Houzé seemed to vindicate Storms's assassination of the chief for overtly political as well as deeper ideological reasons, but something quite different was being created in the process. Houzé "read" and so articulated the cranium like a text, and such a determination—or imposition—of meaning was in itself a mode of possession taken a step beyond Lusinga's actual decapitation. It was also a profound profanation, given Tabwa veneration of the skulls of certain chiefs for spiritual and political reasons. Through anthropometry, Houzé participated in the modes of "construction of otherness in objects" of his time, and the Tabwa chief was reduced to a "type" without consideration of the idiosyncrasies of the man as an individual.[29]

Houzé was intent upon formulating more sweeping deductions than these, however, for he expected to use craniometry to distinguish among what he understood to be disparate human races. In 1899 he designed an ethnographic gallery for the proposed Palais du Peuple in the Parc du Cinquantenaire of Brussels that would display costumed manikins "to illustrate human evolution over the centuries," with an additional "overview of present-day races, from Mongol and Hottentot to Fulani." The project was

meant to contribute to a popular museum (that is, in contrast to the perceived elitism of arts institutions of the day) "where the wonders of the world and the discoveries of science and industry would unfold before the eyes of visitors in the form of striking images." Although the initiative was never realized, it influenced display strategies later implemented at the Congo Museum in Tervuren—that is, today's Royal Museum of Central Africa—and Houzé's grand ambitions were clear.[30]

Houzé's analytic processes would lead to applications that were useful to the colonial enterprise, whether or not anthropometrics were any more politically "neutral" than photography and other early diagnostic and surveillance technologies of the time. Indeed, such scientific advances were often linked to other purposes, as when members of Houzé's circle at the Société d'Anthropologie de Bruxelles became engaged in "criminal anthropology" after the debates around Cesare Lombroso's influential treatise of 1887 concerning the craniological indices of "born criminals." Their work was meant to assist law enforcement and the judicial system. More generally and very quickly, Houzé's pronouncements served the social Darwinism that would "justify" Belgian Congolese colonialism for decades to come, with its motto "Dominate to Serve" ringing loudly. As his research progressed, Houzé became "convinced that Central African populations were not capable of any form of civilization" and that "natural" processes would lead to the "extinction" of such "degenerate" people.[31]

The last term is significant, for belle époque Belgium, like the rest of Western Europe, was riven by a dire dialectic contrasting euphoria concerning the development of astounding technologies and the wealth-producing "progress" they fostered, with "the threat of degeneration … accompanied by negative feelings: somberness, pessimism, fear of decline and decay."[32] In the United States such menacing notions were further cast as hysteria and—as odd as the term may sound nowadays—"over-civilization" attributed to the debilitating afflictions of middle- and upper-class women of European descent, in distinct opposition to the allegedly boundless fertility and physical energies of women of color and/or little means. In such circumstances, bourgeois male anxieties about women's growing education and franchise were fueled by medicalized notions of physical corruption and "reconceptualized … as a racial threat." In Belgium social and political movements led by "hygienists" would save the day by instituting "a 'great clean-up operation'" to heal and promote the body politic. As Tollebeek notes, these concepts also

found their way into colonial thinking, for "the black man could easily be regarded as a *dégénéré*" and feared as a contaminating influence upon European persons and institutions.[33]

Sentiments of the sort would become painfully evident in the policies and writings of Monsignor Victor Roelens, who, after being named apostolic vicar in 1895, ruled the White Fathers' de facto "Christian Kingdom" for fifty years with the heaviest of hands, first from Mpala-Lubanda and then from Moba-Kirungu. Despite his particular impacts, Roelens's sense of and basis for "the right to colonize" was "paradigmatic" within Catholic missionary circles in the Belgian Congo, in the estimation of V. Y. Mudimbe.[34] The vicar portrayed the generic Congolese as "an impulsive [being] who obeys the dominant impression of the moment without great reflection" and for whom "intelligence and will intervene rarely in the habitual circumstances of his life." He further asserted that an African's intelligence "atrophies under the influence of the press of passions," and indeed, in the venerated father's estimation, Africans were "atavistically depraved," their lives wracked by "insouciant lack of reflection" and "bestial frenzy." "One must have seen our pagan Blacks in their primitive state as I have," the by-then-elderly prelate confided to his readers. "One must have sounded the depths of their soul[s] and analyzed the sentiments that animate and direct them to know the pigsty of depravity in which the human beast can wallow."[35]

Roelens's choice of the words "atavistic" and "depravity" spoke directly to evolutionary discourses of the times, for not only were such terms of reference deemed appropriate for describing "bestial" Africans, but they also signaled the fear that through "atavism," less desirable classes and "born criminals" among Europeans would be subject to such primitive drives and outbursts as well. It was Roelens who also wrote of how Congolese seeking to participate in the cosmopolitan "civilization" that justified their colonial submission were but "sinister caricatures" of the Europeans they would emulate. One is reminded of Homi Bhabha's ruminations concerning how "colonial mimicry," as "the desire for a reformed, recognizable Other, as *a subject of difference that is almost the same, but not quite*," produced both "resemblance and menace." Colonizers came to fear their own success in "civilizing" the "natives," in other words.[36]

Dire prognostications like those of Monsignor Roelens had an effect on intra-European relations as well. In the latter half of the nineteenth century, the tendency to "perceive race relations abroad in light of class relations at

home" was fairly common. Following such logic, Houzé not only studied African crania like Lusinga's, but he also "measured thousands of Belgians to prove that Flemish and Walloons belonged to different races," and he predicted that the "Flemish would soon perish in the struggle for life" as opposed to the Walloons, whom he deemed "a more civilized race" that was sure to endure. As Stephan Palmié asserts with regard to British development of the Caribbean slave trade, "the experience of civilizing alien races had begun to provide images 'good to think with' at home as well," through "a cultural dialectic shuttling languages of class and race back and forth between domestic and colonial contexts." Furthermore, such models were informed by the insecurity of "reverse colonization"—that Africans might be overly influencing their European masters, that is, and that "atavistic descent" might result among those of lower classes, rural backgrounds, or other less refined and more vulnerable temperaments.[37]

These discriminatory perspectives recall contemporary theorizing by the French anthropologist Georges Vacher de Lapouge, excoriated years later by Aimé Césaire for his assertion that slavery "is no more abnormal than the domestication of the horse or the ox."[38] Based upon craniometry, Vacher de Lapouge's *L'Aryen et son rôle social* of 1899 was a most influential work that sought to equate "race" with regionalism and social class in ways that proved important to the development of fascist ideologies of the early twentieth century. In particular, Vacher de Lapouge held that Europeans constitute three "races": *Homo europaeus,* as generally blond, Aryan, and Protestant; *Homo alpines,* subservient and mostly dark-haired Roman Catholics; and *Homo mediterraneus,* as Turks and other swarthy "low-lifes." Through "selectionism," Vacher de Lapouge argued, eugenic policies could and should be implemented to favor the first of these while eliminating those deemed most "degenerate." Émile Houzé offered a most sarcastic riposte, dismissing Vacher de Lapouge's efforts as "naïve but pretentious," lambasting the "Baltic barbarians" of Germany so favored, and concluding that "the Aryan has only ever existed in the imagination of his creators." Despite how progressive Houzé's position might sound in afterthought, his hundred-page treatise was a thinly veiled effort to reassert his argument concerning the difference in cephalic indices between Flemish and Walloons, to the distinct intellectual and more general evolutionary advantage of the latter.[39] With reasoned finesse, in other words, Houzé sought to instigate "racial" discrimination between the most significant cultural communities of Belgium. As an aside to

the present discussion, we may note the similarity between his manipulation of narrative for political ends and Kizumina's exposition of Lusinga's demise as a device of ongoing debate about the relative seniority of Sultani Mpala and Lusinga's namesake of the 1970s.

Other than his participation in such malignant debates, Houzé's various findings and, indeed, Storms's own activities as a collector of natural-science specimens, ethnographic artifacts, and skulls for Houzé's craniological projects can be understood in another way. As Marc Poncelet asserts, Belgium existed as an independent monarchy only as of 1830, and ongoing frictions between its Walloon and Flemish citizens "rendered illusory any recourse to an idea of grandeur to preserve or rediscover. It was therefore necessary to invent everything—hence the capital role of several scholarly milieus in constituting the legitimacy of civilizing and then colonial vocations." Toward the turn of the twentieth century, "remarkably zealous" scientific organizations sought to assert Belgian views in international discourse, and "the Congo was a field altogether appropriate for this new pretense of universality, [for] from the very first, it provided fertile soil for [scientific] specialization. . . . The Congolese adventure was that of Europe, of humanity; for science is 'global.'" In such circumstances, "Colonial science was to be taken seriously."[40] Houzé and his colleagues were precursors of such an ideology of progress based upon the "serious" sciences of their times. And lest one assume that such assumptions can be dismissed as strange artifacts of days gone by along with phrenology and nineteenth-century theories of race and biological determinism, it may be noted that at least some Belgian schoolbooks of the early 1980s continued to promulgate just such craniological approaches to the perceived racial inferiority of Congolese and other "exotics" that Houzé espoused a century earlier, illustrating such arguments with the facial angle diagnostic of "the primitive" and other scientistic premises.[41]

"Thinking a Head"

In Houzé's hands, Lusinga's skull was *chosifié*, as one can say in French— "thing-ified," that is. Perhaps that is all a skull can be, for as Rémy Bazenguissa-Ganga muses, while thinking of mass graves from frightful conflicts in Congo-Brazzaville, "to the naked eye, what more resembles a bone than another bone?" Yet Tabwa of Houzé's time thought otherwise, and one recalls Aimé Césaire's broader comment that colonization itself was a process of

"thing-ification."[42] Lusinga's cranium might provide information to a savant like Houzé and possibly to other European scientists since his time, but its only other significance would be provided by narratives of Storms's triumph. In the process, the skull died a "second death" to become what Walter Benjamin might have called a "cultural fossil" that was (and remains) passive, static, and removed from the "transitory vehemence" of Lusinga's arrogance, self-defense, and demise.[43] Most significantly, the cranium has long since been divested of Lusinga's *person* and his own stories of who he was and wanted to be, to say nothing of the place the same skull would have occupied in Tabwa practice had it remained in the Congo, as will be explained in chapter 9. Instead, his *crâne chosifié* sits forgotten in a drawer of a Belgian museum "in which ... [are] ... stored not so much materials that might *be* of interest as materials that had once *been* of interest."[44]

Lusinga met his doom in December 1884. I have come across no exegesis or other evidence that the chief's spirit remained as the restless presence that Tabwa called a *kibanda*—that is, a ghost seeking revenge for iniquitous death.[45] Nor have I found in oral or written materials any Tabwa request for the return of Lusinga's skull or even any indication that his family might wonder where it is. Other chiefs were decapitated by explorers and colonial authorities in the early years of the Congo Free State, with the Yeke warlord Msiri among the most famous. Johannes Fabian presents genre paintings of Msiri by the Zaïrian artist Tshibumba Kanda Matulu including one of his beheading by European authorities. Tshibumba sensed that this was "the moment when the sovereignty of the black people was definitively lost" and told Fabian that "in all truth, we don't know where this head went. Is it in Europe, in some museum, in the house of Léopold II, or with whom? Up to this day, we don't know."[46] In all likelihood, Lusinga's people are similarly mystified if and when they think about whatever happened to the remains of Lusinga lwa Ng'ombe.

Compelling contrastive cases are nonetheless available in the politically motivated British return of late nineteenth-century chief Mkwawa's cranium to Hehe people of south-central Tanzania; the post-apartheid search in Britain for the skull of Xhosa chief Hintsa, who was killed in 1835 under contested circumstances and whose corpse may or may not have been decapitated; the quest for Chief Chingaira Makoni's head by his Zimbabwean descendants; the apotheosis of André Matswa of Congo/Brazzaville, in large part because French colonizers never produced his bones after saying he was dead, thus engendering a sense of his Christlike transcendence; politically fraught return to Namibia of

Herero and Nama skulls taken to colonial Germany for craniological examina-
tion in the early twentieth century; and the Leiden Museum's unanticipated
return of the skull of Badu Bonsu II, an Asante chief beheaded by the Dutch in
the 1730s, among other cases.[47] As Luise White suggests, such searches for heads
and other vestiges "are not only a debate about the vulnerability of African
bodies, but about the vulnerability of African borders" and social identities
more specifically. Most infamous in this regard is the tragic case of Sara Baart-
man, displayed and reviled in Europe as "the Hottentot Venus" for many de-
cades. Furthermore, White continues, "It is with tales of commonplace insults
and uncommon beheadings that people debate the terms and the categories in
which change takes place."[48] Kizumina's account of the demise of Lusinga could
be understood in such a way, while the silence about what has become of Lusinga's
skull bespeaks the rural isolation of most Tabwa people and the more general,
conflict-driven abjection that has characterized political circumstances in
southeastern Congo for decades.

So far we have pondered the fate of Lusinga's severed head, but what of
his body? All we know of his headless cadaver is that Storms's rugaruga stood
it up and danced around it in triumphant derision according to Kizumina's
history of the event recounted in the mid-1970s. The Tabwa term for a decapi-
tated body is *kiwiliwili,* a word that in other dialects of Swahili can refer to the
trunk of the body or—through its duplicative emphasis—to corpulence. A
late nineteenth-century robber baron from eastern Africa who settled in
lands just west of Lake Mweru took or was dubbed Kiwiliwili as his nom de
guerre, perhaps in reference to his diminutive or stout stature, but more likely
because of how he reduced those who would resist him.[49]

Lusinga's decapitation constituted a "dismembering of meaning" as well
as of his embodied person, destroying further opportunity for "identification
and adoration" with or of the man, as Georges Bataille ruminated about the
mythical figure Acephalus.[50] Lusinga's kiwiliwili—seat of the heart and soul
(*mutima*), the agency of work, and the man's fertility—was cast aside, perhaps
to be buried by his survivors but more probably to be dismissively incinerated
as his village was pillaged and razed, his women raped and enslaved, and his
possessions hauled off to Bwana Boma's boma by the lieutenant's cavorting
assassins. Such disregard will haunt the remaining pages of this book.

7 · Art Évo *on the* Chaussée d'Ixelles

Africa doesn't exist. I know. I've been there.
—AFTER MICHEL-ROLPH TROUILLOT, *SILENCING THE PAST*

Storms took Lusinga with him to Europe in another way. When his men brought him the chief's head, they also brought Bwana Boma a most remarkable wooden figure embodying Swift-of-Foot's dynastic title and matrilineage.[1] Storms carried this and other trophies back to Belgium with him, and a series of photographs taken in 1929 show the figure in the drawing room of his *maison de maître* (row house) at 146 Chaussée d'Ixelles in Brussels (fig. 7.1). There it stands among geometrically arrayed weapons and carefully composed displays of souvenirs from Lubanda and the other African locales visited by the lieutenant.

The discussion to follow is based upon the assumption that the salon and another room, also photographed in 1929, were still arranged as Storms knew them before his death in 1918. No documentation proves or disproves this assertion, and in the late nineteenth and early twentieth centuries it was common for mourning rooms to be preserved as they had been enjoyed by deceased loved ones in "an implied narrative of melancholy."[2] Indeed, a velvet rope can be seen to transect the salon in one of the pictures, as though setting portions of the room off-limits to visitors and underscoring the likelihood

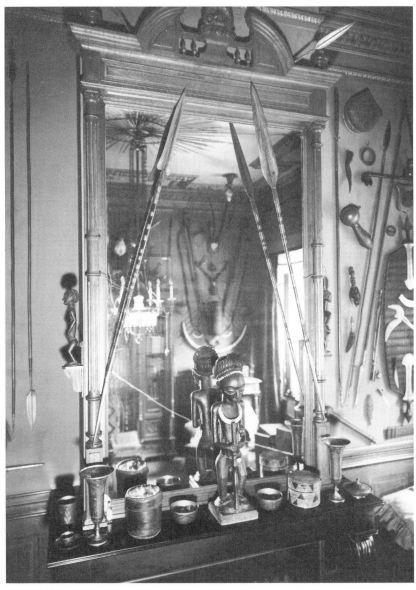

Figure 7.1. Storms's drawing room with "Lusinga" on the mantel in 1929.
Photo by G. Hotz, RMCA HP.1930.653.1, collection RMCA Tervuren;
photo G. Hotz, s.d., with permission.

that the Widow Storms kept the room as her husband had last known it. That the couple had no children reinforces the possibility that the rooms were left as shared by the couple in their later years. Furthermore, one of the photos shows a desk in the corner of the drawing room. Papers are carefully arranged to one side of a blotter, and a lamp has a shade with an image of African women bearing loads on their heads. One can imagine that it was while seated here that Bwana Boma lost himself in reverie and letters, surrounded by vestiges of his brief moment of glory in the Congo.

The Storms residence no longer exists in recognizable form. The property was rezoned as commercial space in 1955 and transformed into a paint store. Since 1992 it has been occupied by a Japanese travel agency, with an upper-floor rental apartment and the proprietor's residence behind the house, elegantly remodeled from what had been the Stormses' carriage house.[3] Nearby, much of what used to be the staid streets of Ixelles has become Matonge, the vibrant Congolese inner-*cité* of Brussels now filled with boisterous restaurants and *boîtes de nuit* and named for an equally exuberant neighborhood of Kinshasa that is "the fast-beating heart" of that sprawling city's night life and hypnotic music.[4] It is hard to imagine what Bwana Boma would have thought of either place as they exist nowadays.

Phantasmagorias of the Intérieur

The nineteenth was "the century of the intérieur . . . developed as a protected, private space in opposition to the public sphere of social life and the world of work. It indicated a division of life into areas which, historically novel, was a characteristic of bourgeois-capitalist culture." These tendencies became increasingly evident in the last decades of the century, when, through such an aesthetic tactic, "individuals respond[ed] to the abstraction of social life outside by constructing a complete complementary world inside."[5] Here we shall reflect upon Storms's motivations for and methods of displaying his collections, recalling that "we must consider the intersection between the ways we see them literally and the metaphorical vision our culture has of them"—or, that is, that Storms's temporally defined visual culture had. As Susan Vogel explains of museum exhibitions and decorative displays more generally, "Most visitors are unaware of the degree to which their experience of any art . . . is conditioned by the way it is installed."[6] A sense of Storms's understanding of his Congolese adventures would be lost if one were to ignore how

he presented and, indeed, relived them in his later years back in Belgium through his creative manipulation of both Congolese and Belgian material culture.

The figure of "Lusinga" was given pride of place in the general's parlor on a mantelpiece before a large and ornately framed mirror.[7] Along with other objects, the sculpture must have stood as "tangible proof of the exploits of the master of the house and national hero" and signaled "a symbolic apotheosis of the project of conquest," as Jean-Bernard Ouédraogo holds with regard to more general contexts of colonialism.[8] Yet just as certainly, "Lusinga" participated in Bwana Boma's own phantasms of African life.

The pier glass (*trumeau de glace*) or overmantel mirror of Storms's drawing room was a standard measure of bourgeois opulence following an idiom already popular in Europe for over two centuries. Large flat mirrors of the sort create an illusion of grand and "fantastical magnitude."[9] The general's glass was set in a frame of warm brown wood with lateral supports in the form of thin, annulated Ionic columns. These were surmounted by a wooden structure replete with spindles, lathed knobs, and a semicircle transected by a carved, shell-like device that echoed the capitals of the columns. African iron spearheads pointed upward and away from either side of this central structure, and full spears attached by fine wires to the columns lay in front of the mirror and pointed their blades at an angle toward the central structure on top in such a way as to further frame the figure of "Lusinga." Smaller Tabwa figures stood like obdurate sentinels to either side of and facing away from the mirror, animating the enchanting device from shelf-like plinths.[10] The pier glass was a proscenium staging what could be seen in the mirror, with "Lusinga" as its central focus. The "inaugural scene" of such theater might have gone something like this: "After a moment of stupor, on this threshold . . . the conqueror wrote the body of the other and traced there his own history."[11]

The figure of "Lusinga" was dwarfed by the complexity of the room's obsessively contrived appointments, an effect increased by the mirror's reflection of the walls behind the viewer. A pair of antelope horns, what appear to be a stuffed African fish eagle (*Haliaeetus vocifer*) and another bird in a glass case, a brace of small elephant tusks, and a pair of what may be hippo teeth are displayed beside a large wooden whatnot holding harder-to-discern books and curiosities. The elephant tusks were joined at their openings to form a crescent in harmony with the curved hippo teeth above them and resonant with the gleaming white pendant of bushpig tusks that "Lusinga" wore about

Figure 7.2. Storms's drawing room showing his memorial bust in 1929. Photo by G. Hotz, RMCA HP.1930.653.7, collection RMCA Tervuren; photo G. Hotz, s.d., with permission.

the neck—the one crescent before the mirror, the others in the mirror behind the figure reflected like moons in water.

A second, smaller mirror was mounted on the wall perpendicular to the mantel, between two windows and opposite the door leading into the room (fig. 7.2). The windows appear translucent, for nothing can be seen through them, either because of a thin shade with a fringed bottom (left down in one photo and raised in another) or because their glass was ground or frosted, with the lowest register of panes configured in an Orientalist design of leaded segments. As a result, the windows permitted light to filter into the room but kept one from seeing through them to the outside. In creating a set of images different from but partly captured by those of the pier glass, the two mirrors offered "reflections into infinity, but above all . . . the division of the space into multiple niches" in such a way as "to appear unlimited." Indeed, as Walter Benjamin put it, "Let two mirrors reflect each other; then Satan plays his favorite trick and opens here in his way . . . the perspective on infinity."[12] The looking glasses also focused attention inward toward the center of the room rather than toward the windows or through a doorway, and so, in a sense, they "promote[d] the interplay between reality and illusion, between the actual

and the virtual, undermining the status of the boundary between inside and outside." Beatriz Colomina writes thus of the use of mirrors in period homes designed by Adolf Loos, the renowned turn-of-the-century Austrian architect. Loos held that "'a cultivated man does not look out of the window,'" and Storms seems to have shared his lofty sense of home as sanctum.[13]

A gleaming white bust of Storms stood before the smaller mirror, its breast bedecked with medals and a cape draped about the left shoulder in such a way as to reveal a dress epaulet on the right. The work was sculpted by Marnix d'Haveloose in 1906 and presented to the Royal Museum of the Belgian Congo in 1930, where it could still be seen in 2010 in an alcove of the Memorial Gallery dedicated to those who had explored and colonized the Congo at King Léopold's behest. A marble copy stands atop a pedestal in a park next to the towering Interior Security building on the Square de Meeûs in Brussels, while one in bronze graces the tomb of General and Madame Storms in Laeken Cemetery.[14] In the 1929 photograph of the Stormses' drawing room, a wreath lay in memoriam before the bust while above it a sacred ibis (*Threskiornis aethiopicus*) peered down from its platform above an ostrich egg hanging almost to the mirror's edge.

The drawing room was filled with fortress-like furniture as well as Congolese *objets*. In front of the fireplace a couch was covered in rich, deeply patterned fabric. Leopard skins were flung across its back in such a way that a smaller one was partly overlain by a larger pelt, as though an insouciant female feline were being mounted by a male. Two overstuffed fauteuils, upholstered in the same velvet as the couch and trimmed with long fringe from seat to floor, bore lace antimacassars protecting their plush backs. Flanking them were a pair of wooden chairs of ornate and waxed lathing, their straight backs gaily decorated with birds and flowers and their cushions bearing bright geometrical motifs different from others in the room. An oriental rug united the furniture, but rather than serving as "the soul of the apartment," it added its own florid designs to the visual frenzy. "Things disappeared beneath upholstery and coverings, rendering the spatial construction invisible" in a room like this. Indeed, "it was less a living space than a space for the imagination."[15]

Heavy curtains were opened for the photographs taken in 1929, but they could be pulled so that the drawing room would be "sunk in twilight." As Storms participated in such a "cult of draperies," "the intérieur was . . . shielded . . . from the external world." A personalized universe was created "in the blurred mood" of such a room that was "reflexively charged in romanticism . . . through a remove from reality, work, and functionality." "Sophisticated techniques" were

"employed to break any direct rays of light" and so foster sensory and ideological achievement. One such device was "the excessive use of light-absorbing materials, like velvet on the furniture" of the divan and armchairs of the Stormses' drawing room, thus increasing the intimacy of the chamber.[16]

A chandelier broke the plane of what one could see in the pier glass and the mirror behind the bust of Storms. When lit during soirées, the light of its candle-like fixtures—originally for gas lighting, in all likelihood, but fitted with bulbs by the time the photograph was taken—must have scintillated in the mirror. The quality of light changed with the electrification of bourgeois homes that began in Brussels in the 1890s, for shadow was exiled and intimate subtleties were lost to the flattening effect of incandescent bulbs; yet even so, the chandelier must have made the room even more marvelous.[17]

Increasing the drama, a circle of more than forty iron-tipped arrows radiated point-outward from where the chandelier was attached to the ceiling. Given such imaginative constructions, it must have been difficult to concentrate the gaze upon any particular object in the room. Furthermore, the pier glass reflected portions of the hectic designs behind the observer in a view interrupted by persons standing before the mirror. As a result, the displays were kaleidoscopic in their "staccato frenzies," and "Lusinga" was lost as was anything else in particular. But this was the point, for such "compulsive filling up of the interieur . . . [became] a kind of magical defense" against the frenetic streets beyond Storms's bedraped windows—streets where the general's Congolese adventures had quickly become quaint at best.[18]

Reference to a kaleidoscope is more than a casual analogy, given Sir David Brewster's explanation of the "philosophical toy" he invented. For Brewster, "the justification for making the kaleidoscope was productivity and efficiency," with these terms to be understood in the context of early nineteenth-century European formulations of the Industrial Revolution just under way. "Since symmetry was the basis of beauty in nature and visual art," Brewster declared, "the kaleidoscope was aptly suited to produce art through 'the inversion and multiplication of simple forms.'"[19] It is my contention that however resonant Storms's design delirium might have been with bourgeois interior decoration of his time and place (to be considered momentarily), this same concatenation reflected what Jonathan Crary calls "the production of the observer in the nineteenth century [that] coincided with new procedures of discipline and regulation" such as the kaleidoscope. Following Walter Benjamin's "claim that in the nineteenth century 'technology . . . subjected the human sensorium to a complex kind of

Figure 7.3. Storms's billiards room in 1929. Photo by G. Hotz, RMCA HP.1930.653.12, collection RMCA Tervuren; photo G. Hotz, s.d., with permission.

training,'" Crary asserts that people were taught to see a particular way through optical devices, strategies, and related "attentive practices" that in turn contributed to and reinforced larger ideologies.[20]

Phantasmagorias were to be found in the general's billiards room as well as his salon, again as depicted in a photograph taken in 1929 (fig. 7.3). Panels covered in richly flowered brocade were framed by woodwork to display Tabwa ancestral sculptures within winsome patterns of lethal weapons set off by highly charged magical horns. These panoplies were completed by glass boxes holding cheerful complexities of taxidermic African songbirds. Before a great pier glass over a fireplace, an extravagant, footed mantel clock surmounted by figures of some indiscernible sort was stationed in the same central position afforded "Lusinga" in the drawing room. Another mirror was situated between windows at the end of the room so that both glasses offered prismatic visions. Here, though, the pièce de résistance was in the middle of the room. Parallel and a foot or so from the ceiling, five spears lay behind a shield made of reed and hide. A long metal pipe emerged from this configuration, leading down to a pair of tasseled lamps hanging low over a pool table so as to illuminate the general's game. A luxury edition of *L'Illustration congolaise* was casually placed on the table for

the photograph.[21] Clinging to the vertical support was a blue monkey (*Circopethecus mitis*) stuffed in an animated pose recalling the creature's once-upon-a-time arboreal hijinks in montane forests flanking Lake Tanganyika. Storms must have shot it to bring home with his colorful birds and human skulls—lives snuffed out with equal dispatch.

The 1929 pictures of Storms's rooms were careful compositions by a photographer identified only as Monsieur G. Hotz, who recorded the Stormses' salon and billiards room after the general's death as his collections were being prepared by his widow for transfer to the Royal Museum of the Belgian Congo.[22] The images are devoid of all but the "stilled lives" of objects in Bwana Boma's carefully constructed displays.[23] With regard to these, the emphasis must be upon an active verb rather than a passive noun, for instead of being an example of *nature morte*, literally "dead nature" or "still life" as the genre is known in English, the general's displays were examples of *culture morte*, "stilled culture."

In a sense, the figure of "Lusinga" standing before Storms's pier glass was a memento mori, especially in 1929 when Monsieur Hotz produced his fine photography, for by then the old soldier's bust stood mute before its mirror perpendicular to the fireplace. One is reminded of the triumphal parade of a successful general in ancient Rome, when the hero was followed by an enslaved person commanded to utter softly, "Remember that you [too] must die" (*memento mori*), or, as Tertullian had it, *"Respice post te! Hominem te esse memento*—Look behind you! Remember that you are but a man!"[24] By 1929 Lusinga's ghostly whispering seemed silenced, for Bwana Boma had joined him in the afterlife, perhaps in a realm behind the mirror. Yet the figure still stood on the mantel as a dark-wooded homunculus reminding any who might know of its spiritual investments that its agency was ongoing, even as it bespoke the wrenching deterritorialization through which it had been brought to Ixelles and the racial categories with which it might be associated through emerging colonial sciences like those promulgated by Émile Houzé.

Like "Lusinga," the rosette of once-bevenomed arrows on the general's drawing-room ceiling must have served as an "inducer of associations" recalling brutalities even though the projectiles themselves would no longer pierce or poison. Indeed, the arrows radiated in celestial—or at least ceiling-high—harmony, however outrageous a "visual oxymoron" such a display might have been.[25] In Storms's delirium, raptors and remnants of fearsome beasts would be in fugue with savage idols. As Walter Benjamin noted, the allegorist "dislodges things from their context and, from the outset, relies on his profundity to illuminate

their meaning." In the drawing room, signification was to be controlled and "naturalized," and colonialism could calm turn-of-the-century anxieties about the Congo. To paraphrase Diana Taylor as she takes the part of the colonized Other, "The native was the show; the civilized observer the privileged spectator. Those viewers who looked through the eyes of the explorer were (like the explorer) positioned safely outside the frame, free to define, theorize, and debate their (never our) societies." From the vantage point of the Chaussée d'Ixelles, any such hideous people and places as those of an imagined Congo could be distanced so that turn-of-the-century fantasies might reign.[26]

It is important to note that Storms did believe certain Tabwa creations—and especially their remarkably sculptural high-backed stools—to be "veritable *objets d'art*" and that "the artistic sentiment ... [was] very widespread" among people living southwest of Lake Tanganyika.[27] Yet it is likely that any sense of artistry experienced by Storms's visitors was attributed to his tasteful arrangement of artifacts in the drawing room rather than to the objects themselves, for it would be years before any African sculpture would be "respiritualized (in Western terms) as an aesthetic object" and broadly considered "art" in Belgium.[28]

During the later years of Storms's life one can imagine an animated and convivial salon as the elderly general stood with a hand resting upon the mantel, intoning epic adventures to his wife's rapt guests, who could engage in "vicarious intrepidation," to borrow a felicitous phrase from Annie Coombes. Through his conquest of the wretched Lusinga, Storms undoubtedly believed he had brought the beginnings of "civilization" to some remote corner of darkest Africa. Anyone invited to enjoy such drama would see Bwana Boma's reflection in the mirror next to that of his prized wooden figure, seized at his behest on that fateful day in December 1884. Depending upon their angles to the mirror's plane, they might also see their own images and those of other guests, decked out in fin-de-siècle finery. The pier glass proscenium must have provoked a "theater of reflection" as personages observed—and in some ways created—themselves before an unruly African primitivity firmly under the control of patterns, codes, and narratives of Storms's devising.[29]

Through the Looking Glass

Let us extend our speculation about Storms's presentation of the "Lusinga" figure before his pier glass so as to understand what it may have been like to visit the drawing room when the general was still in his prime years, but also

to get a sense of cross-cultural ironies. That is, what might Tabwa have thought about the effects so produced, and how might the effects have resonated with elements of their own visual epistemologies? In chapter 3 we considered the danced dialectic of reversals calling upon spiritual agencies and efficacies. How might the magical room on the Chaussée d'Ixelles have responded to such perspectives and purposes?

It is not surprising to learn that contemporary divination techniques among Tabwa, Luba, Bwile, and related southeastern Congolese peoples include mirrors and other reflective surfaces that "allow [diviners] to locate agents of the invisible world." Indeed, western Luba "sum up this idea very poetically by calling a mirror 'the eye of the underworld' (*kalunga*)," and a derivative of this same term, *kilungi*, is what eastern Luba call an image reflected in a mirror.[30] Using such terminology, if a Tabwa person were to see "Lusinga" on Storms's mantelpiece, the figure's kilungi would be visible as well as a glimpse of the beyond. And as we shall come to understand later in this book, the mirrorlike surface of water is a threshold to the dead that was breached in nineteenth-century burial rituals for important chiefs such as Lusinga.

Optical technologies of Storms's time also permit one to wonder about—and wander into—the looking glass over the general's mantelpiece. "Each age has its visual unconscious, a central focus for its perceptions (most often unperceived as such), [and] a figurative code that imposes a common denominator of dominant arts," Régis Debray tells us. As Jonathan Crary would add, "The most significant form of visual imagery in the nineteenth century, with the exception of photographs, was the stereoscope. It is easily forgotten now how pervasive was the experience of the stereoscope," yet, like photography, it was "nonetheless part of the same reorganization of the observer, the same relations of knowledge and power" mentioned above. Indeed, "no other form of representation in the nineteenth century . . . so conflated the real with the optical." Such a visual unconscious led to "the emergence of . . . new optically constructed space[s]" in Belgian museum displays as they did chez Storms on the Chaussée d'Ixelles.[31]

As Crary explains, "Pronounced stereoscopic effects depend on the presence of objects or obtrusive forms in the near or middle ground," and here one can contemplate the centrality of "Lusinga" in front of Storms's overmantel mirror. "The most intense experience of the stereoscopic image coincides with an object-filled space, with a material plenitude that bespeaks a nineteenth-century bourgeois horror of the void; and there are endless

quantities of stereo cards showing interiors crammed with bric-a-brac, densely filled museum sculpture galleries, and congested city views."[32] Viewing "Lusinga" in Storms's drawing room provided just such a claustrophobic composition, for the delirium of arrows, eagles, and broken tusks could be seen in the mirror as though behind the figure. An observer might become lost in such a mesmerizing swirl, with reverie the result. And in pondering the general's "looking-glass house" with all of its curious reversals and jarring juxtapositions, one is left to wonder who Storms himself would have been in life had it not been for Lusinga. Such an open-ended question brings us back to why the general may have chosen to decorate his home as he did.

Was it Madame Storms who arranged her husband's souvenirs so tastefully, perhaps choosing the fabrics, furniture, and floral designs even as she guaranteed the home's privacy and respectability? Was an interior decorator employed, and if so, how were decisions made? As her husband advanced in military rank, Henriette Dessaint Storms "had no trouble maintaining her social class, being of good education, well-dressed and perfectly styled—in a word, a woman of the world." Yet as such, her sphere remained "the domestic and private, her role to care for" her man. Madame Storms promoted her husband assiduously and is remembered for her Friday salons when she received "friends, acquaintances, and personalities from the worlds of politics and business."[33] Whatever her design roles may have been, she oversaw maintenance of the house and its drawing room between her husband's death in 1918 and Monsieur Hotz's photography session of 1929.

Most obviously, as the Storms couple created phantasmagorias within their townhouse, the general made "the transfiguration of things his business." His Congolese objects were so far removed from their original contexts and purposes as to be "free of the drudgery of being useful." Indeed, in a sense Storms committed what Roland Barthes called "the assassination of the object," for the "Lusinga" figure was flayed of its "adjectival skin"—that is, of all its evident and arcane references.[34] Such disregard was part and parcel of imperialism but may have bespoken Storms's own sense of frustration and anomie, especially later in life. In such artfully confected *intérieurs* as the general's, "things simply sat there, like untouchable images of the divine in an imaginary cult of boredom," and any "aura of uniqueness" was lost through an "utter equivalence" resulting from "economic and psychological indifference." Indeed, as he aged, Bwana Boma may have become caught up in just such a "cult of boredom" as he attempted "to overcome his social seclusion through the community he share[d] with the things he collect[ed]."[35]

The quality of Bwana Boma's Congolese belongings as souvenirs is also apposite, for "the souvenir displaces the point of authenticity as it itself becomes the point of origin for narrative[s]" when objects are submitted to "ideological refunctionalization" by the master of the house. History was erased as Storms imposed an "order beyond . . . temporality" upon the things in his collection, made more relevant to his milieu in bourgeois Brussels by a sense of the chaos, "fundamental absences" of ability and purpose, and inevitable "belatedness" soon to be associated with colonial subjects.[36]

In decorating his salon and billiards room, Storms did not create a cabinet of curiosities following that well-known idiom from many years before. In particular, one must suspect that the symmetries of his displays were not a reflection of "the harmonious unity of the world" meant to "illustrate the authority of God," as was the purpose of Renaissance *Wunderkammern* (wonder cabinets), nor was eclecticism or an "aesthetic of randomness" his goal. Instead, one can imagine that Bwana Boma sought to recall—or prove, if necessary—the significance of his central African endeavors, hence his own personal worth and social position. Even more significantly, through the tightly geometrical exposition of his collections, Storms sought to suggest his control of African life deemed dangerously "unruly" by definition. Such an impulse foreshadowed "the orderliness of empire" achieved through classification by means of "disciplinary languages concerned with authenticity, connoisseurship, provenance and patronage that drew some closure on knowledge."[37] And, in turn, Storms's installations reflected a broader sense of the need to develop "colonial sciences" in Belgium for ideological as well as commercial purposes as discussed briefly above.

Art Évo on the Chaussée d'Ixelles

It is not clear when Storms began displaying his souvenirs as he did. His fantasies were consistent with the ways that weapons and other African materials were exhibited in vaunted venues such as the Palais de l'Industrie in Paris, where in 1878 E. T. Hamy presented a geometrical montage of Gabonese materials amassed by Alfred Marche; or the Musée d'Ethnographie du Trocadéro (also in Paris) where dense compositions of Pierre Savorgnan de Brazza's central African collections were on view in 1888; or perhaps the "Stanley and African Exhibition" at the Victoria Gallery of London in 1890. Most probably, though, Storms was influenced by the Barnumesque exoticism of the Mysterious

Continent pavilion of the 1894 Universal Exposition of Anvers/Antwerp, which was largely dedicated to the heroism of Stanley, and even more specifically by the precisely organized fields of weapons of the 1897 Brussels Universal Exposition.[38] Storms was a member of the Commission de Patronage for the 1897 fair, and he was also acknowledged for having contributed his expertise regarding peoples of southeastern Congo.[39] His involvement in the exposition was quite direct, then, however honorary it may have been.

A contemporary reporter for the *New York Times* suggested that the heart of the 1897 exposition was an ethnographic pavilion filled with Congolese household articles, weapons, and agricultural implements "completed" by a military salon replete with artifacts from Belgian battles with "Arab" slavers. Some of this material was exhibited in an "African village" inhabited by nearly three hundred Congolese brought to the 1897 fair, as part of a "modernist celebration" of their subjection, as Filip De Boeck has reflected in long after-thought. That several Congolese perished and were buried in Tervuren remains distressing.[40]

More directly significant with regard to Storms's drawing-room displays was the pronounced visual ethos in which they can be situated. A sense of the world as "endless exhibition" arose in late nineteenth-century Western Europe when through "spectacle and visual arrangement" one beheld "the organization of everything and everything organized to represent, to recall, like the exhibition, a larger meaning." With more specific reference to belle époque Brussels and its "ambition toward specular dominance over a totality," aside from the 1897 Universal Exposition one need only think of the magnificent Galeries Royales Saint-Hubert near the Grand Place as an excellent example of mesmerizing displays of commodities that suggested "'signifier[s] of' something further."[41] This immense, glass-encased arcade of attractive shops, restaurants, apartments, and offices was created in the mid nineteenth century as "a place of rendez-vous and flânerie favored by people of Brussels and tourists during all hours of day and night," as "a coherent and prestigious urban entity, [and] a city within the city, unique in the world for the richness of its program and the quality of its architecture." The "something further" signified by such a striking setting was "the new reality of a capitalist society emerging from the Industrial Revolution... marking the triumph of a new social order." The exhilarating exhibition aesthetic of the Galeries, however motivated by "a veritable cult to consumer products," must have informed all aspects of life in Belgium itself and many in the Congo as well.[42]

A further achievement of fin-de-siècle arcades, museums, and fairs was "the disciplining of the popular gaze" that contributed to "the production of the observer in the nineteenth century" mentioned above, and ultimately to contrivances such as those of Bwana Boma's drawing room. As idle as the flâneur's meandering through the Galeries Royales Saint-Hubert might appear, and as entertaining as the opportunities might be for discovering unexpected relationships in the "aggressive incongruities" of shop-window displays so dear to surrealists, a "scopic regime" was nonetheless very much at play.[43] And in Storms's drawing room, such disciplined visuality was not only gendered and class-based, but it also bore explicit overtones of the imperialist hegemony that Bwana Boma had helped to introduce to central Africa.

In reflecting upon the motivations for and outlines of Storms's aesthetic sense, one must further consider the broad-based artistic ferment of Brussels. A number of movements and groups emerged during the last decades of the nineteenth century, each remarkable in its own way but none of more lasting interest than Style 1900, now better known as Art Nouveau. Storms's home does not seem to have shared any such atmospheric purpose, perhaps because the general was too conservative politically and spiritually. That his townhouse was located on a stretch of the Chaussée d'Ixelles where other military heroes had their retirement homes may be significant in this regard; but perhaps he lacked the financial means and social position to be so "progressive." We see none of the architectural flourishes, none of the furniture that seems to burgeon and grow just beyond our ken as is so characteristic of Style 1900. Such apparent lyricism may have concealed an "art of darkness," however, for as Debora Silverman suggests, curving tendrils of wood and iron may have referred to rubber vines and lashes of the "imperial whip" as visual expression of a "voracious entitlement to earthly bounty" matched by the sanctions "necessary" to civilize unruly Congolese. If so, the Stormses' decorative decisions would have echoed such an aesthetic.[44]

Unlike the decorative astonishments of Art Nouveau so understood, the "progress" of Storms's display was at variance with the heady political economy of his time and instead constituted "a repression of the industrial present" through a retreat to the seclusion of his thickly curtained phantasmagoria.[45] Given Storms's contributions to Émile Houzé's politically motivated elaboration of evolution and eugenics, one could further suggest that rather than Art Nouveau, the general's drawing room was evidence of an *Art Évo*— short for *évolution*—based upon the "natural" qualities of the human and animal

artifacts he arranged so wistfully but with reference to the fraught sciences of the day promulgated by Émile Houzé.[46] Although Storms did not refer to Congolese as "naturals" in writings I have consulted, Becker used the term liberally and it was of currency in colonial circles. Frantz Fanon's acerbic words come to mind: "Hostile nature, obstinate and fundamentally rebellious, is in fact represented in the colonies by the bush, by mosquitoes, natives, and fever, and colonization is a success when all this indocile nature has finally been tamed." A similar logic of "tamed" eclecticism achieved in Storms's *Art Évo* resonates with the assemblages of ferocious beasts, glittering minerals, and exotic "natives" in natural history museums to our very day.[47]

Lest this seem too innocent an assessment, however, the general's displays also exemplified what Barbara Saunders calls an enduring "Congo-Vision" that has taken "anonymous objects and kept African people out of sight and out of history." Congo-Vision "colonizes and regulates meaning. It interrogates, maims and murders. It colludes with and incorporates other oppressive and exploitative visions, and yet it claims to purvey the untainted 'truth'"—as determined by scientists such as Émile Houzé, we might add.[48]

Despite such ruminations—however harsh some may be—we are left to guess why Storms displayed his collection as he did, over and above the narrative opportunities that souvenirs always present and the obvious sense of European "civilization" of which Storms was most certainly a proponent. It is also difficult not to suspect a certain poignancy at play, thinking back to Bwana Boma's bitter disappointment with collapse of the mandate that, to some degree anyway, would have put him on a par with Henry Morton Stanley. Not only was Stanley given Olympian stature through fairs and other celebratory means, but Storms's admittedly ephemeral role was ignored in most contemporary writing about central African exploration such as Adolphe Burdo's near apotheosis of Stanley.[49] The "Emperor of Tanganyika" had only a handful of souvenirs—including a stuffed monkey frolicking above his billiards table—to show for his fleeting flicker of fame.[50] Nonetheless, in saving his things, he saved himself.

A Dynasty of the Improbable

Émile Storms seems to have enacted his imaginary on the Chaussée d'Ixelles to the end of his days. "Lusinga" stood on his mantelpiece as material evidence of his triumph over the "sanguinary potentate" and his establishment

of nascent colonial order in southeastern Congo. Marie Louise Pratt helps put these matters into perspective. The ordeals and discoveries of exploration must have been "unforgettably concrete" to Bwana Boma, yet such achievements have no existence of their own. They are only "real after the traveler . . . returns home" and "brings them into being through texts: a name on a map, a report to the Royal Geographical Society, . . . a diary, a lecture, a travel book. Here is language charged with making the world in the most singlehanded way, and with high stakes. As the explorers found out, lots of money and prestige rode on what you could convince others to give you credit for."[51] "Failure" led to oblivion of the sort suffered by Victor Beine and the Abbé Debaize. For whatever reasons, Émile Storms did not choose to write a self-celebratory book, nor did he promote his accomplishments through other means that might lead to the prestige to which Pratt alludes. Instead, he retreated to bedraped quiet to commune with his souvenirs, enjoy his vibrant spouse's Friday salons, and sometimes shoot a little pool.

Finally, it seems highly unlikely that any Tabwa person visited the Storms residence, but what if someone had? If an individual with the intellect, humor, and political acumen of Kizumina had entered 146 Chaussée d'Ixelles, what might he or she have thought of Bwana Boma's peculiar juxtapositions of familiar objects? Would the visitor discern some new sense in well-known things when they were so surreally reconfigured? Early encounters and subsequent colonial times presented many opportunities for—and, indeed, the necessity of—creative culture-building, as Kizumina's story of how Lusinga sought to understand the "red" being of Bwana Boma illustrates. The epistemology inherent to production of milandu narratives, as well as the confection of magic to cope with ever changing circumstances, provided just such intellectual tools to earlier Tabwa as they do today. Still, in seeing "Lusinga" on the mantel before a stunning looking glass with all of its reflections and refractions, would our hypothetical visitor have grasped that the pretenses of Swift-of-Foot, the would-be "potentate," had been transmogrified in Bwana Boma's drawing room, thereby animating the old man's "dynasty of the improbable" rather than Lusinga's own dreams of empire?[52] Or would the exhibition have been dismissed as an old man's nonsense?

And to end this chapter, its epigraph derived from Michel-Rolph Trouillot may be brought back into play: Africa didn't exist. Storms knew. He'd been there.

8 · Lusinga's Lasting Laughs

*"A thing itself is a person or pertains to a person" [and] this intimate
conjunction of person and things ... establishes ... an "irrevocable
link" between their donors and recipients, a link with an onerous
burden which can even make a gift "dangerous to accept."*

—Brad Weiss, "Forgetting Your Dead," citing Marcel Mauss's The Gift

The continuing "life" of the "Lusinga" figure as it stood on Storms's mantelpiece
raises "what if" questions: if the sculpture had remained in Lusinga's hands—
supposing, of course, that the "sanguinary potentate" had managed to hold on
to his head—what might it have represented to and, more significantly, done *for*
the chief and his people? Asking now does reverse the ordinary order of things,
since locally defined efficacies and purposes obviously preceded Bwana Boma's
seizure of the figure; but if he was aware of these at all, Storms understood such
capacities and practices through his own culture and as a function of his own
political agenda. Here we shall engage another archaeology of knowledge based
upon archival materials and exegeses from Tabwa of the 1970s. Among people
then living in and around Lubanda, overt use of sculpture had long been cur-
tailed because of intense pressure from Catholic missionaries. Material mani-
festations of spirit and agency remained important nonetheless, however clan-
destine the praxis was compared to overt ways that sculpture was used in the
days of Swift-of-Foot and Bwana Boma.

To backtrack a bit, in the mid-1880s Émile Storms found lands around Lubanda to be "bestrewn with . . . countless small villages, each nearly independent from the others, and without political cohesion." Father Pierre Colle estimated that most villages in the area were composed of "five to fifteen houses, for which the chiefs are independent, so to speak," while the Tabwa ethnographer and Catholic priest Stefano Kaoze added that such chiefs "did not have supreme authority over their inferiors. Here in the Marungu, each individual . . . is independent."[1] Such assertions were echoed by Sultani Mpala, who told me that in the old days, it was *kila watu, kila watu*—"each group of people, each group of people"—with little linking any of them politically. Lusinga sought to take advantage of such fragmentation as he consolidated his authority following models adapted from eastern Luba neighbors.

Despite pretenses of empire as imposed (and improvised) through occasional armed intervention, Jan Vansina has suggested that "even the main Luba kingdom was first and foremost a construction of the mind. Regional communities belonged to it because they *proclaimed* that they belonged to it," and the shared historical consciousness so implied was bolstered through material and performance arts. Even as far afield as where Lusinga operated, emblems and acts could be adopted to reflect "a Luba-inspired concept of 'civilized life.'" In becoming increasingly "Luba-ized" in this way, to borrow the aptly processual term of Edmond Verhulpen, Lusinga embellished and invented traditions "to establish continuity with a *suitable* historic past."[2] Indeed, he should be understood as "one of those 'gifted individuals who have bent the culture in the direction of their own capacities,'" as Ruth Benedict wrote many years ago of the American Indians with whom she worked.[3] In Lusinga's case, one may add "political ambitions" to such "directions" in which culture was "bent."

Among his strategies for self-aggrandizement, Lusinga commissioned a large wooden figure to embody his matrilineage and the dynastic name he sought to establish, as "a visible *transition* between the visible and invisible worlds" to which he might look to protect and promote his interests (see fig. 1.2). For this he turned to a carver who was familiar with the eclectic aesthetics of people living west of Lake Tanganyika around the confluence of the Niemba and Lukuga Rivers, who are now understood to be eastern Luba or Hemba.[4] Whether the work was created before or after Lusinga "descended like an avalanche" on lakeside communities north of Lubanda cannot be ascertained, but the sculpture was meant to proclaim and legitimize his ascending political

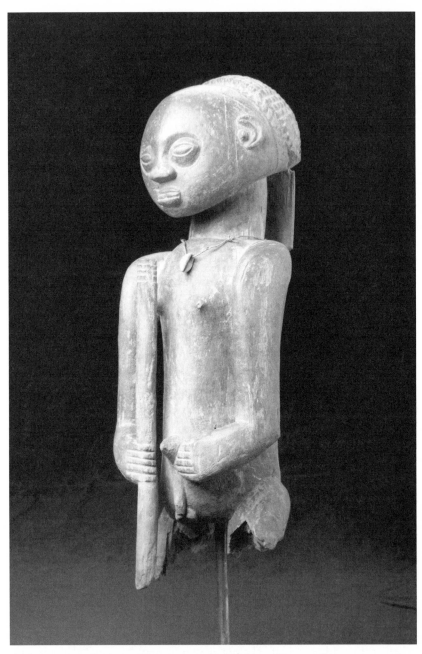

Figure 8.1. Ancestral figure similar in style and purpose to "Lusinga." H. 57 cm.; wood, fiber cord, cowrie shell; unknown artist. Collection of Richard and Jan Baum, Los Angeles; photo Jessica O'Dowd, with permission.

stature. Stefano Kaoze described a similar commission of sculpture by Tumbwe, a politically prominent chief living near the mouth of the Lukuga River well north of Lubanda who was (and is) related by clan and matrilineage to Lusinga. Tumbwe acquired the services of an artist adept in eastern Luba styles and had a series of ancestral figures carved that were consecrated and shared with his mother's brother, Kiubwe, as a testament to their close kinship and political affiliation. Kaoze reported that Tumbwe's figures were destroyed around 1920 by a colonial agent who was disgusted by such "idolatry." Remarkable figures associated with Tumbwe and related northern Tabwa chiefs do exist nonetheless, most notably in a monumental sculpture in the Katherine White Collection of the Seattle Art Museum and an equally powerful work in the collection of Richard and Jan Baum of Los Angeles (fig. 8.1). Both are stylistically related to the "Lusinga" figure.[5]

Lusinga's use of sculpture was not original, and its large size was in keeping with works by Hemba and other Luba-related peoples along the Lukuga River. Yet the figure's size and elaborated purposes were unusual to people around Lubanda, who, at the time, did not produce or engage works of this importance and in these ways as far as one can tell, and who were said to possess relatively few sculptures of any sort despite a few small ones collected by Storms.[6] Still, three figures so closely related stylistically as to be by or copied from the hand that produced "Lusinga" were collected in 1901 by a Lieutenant Bischoff among Tongwe or Bende people north of Karema in what was by then German East Africa. They lack patination and were never used. Might Lusinga have commissioned them to distribute to lineage-based allies across the lake in an ill-fated effort to extend his influence?[7]

One can assume that Lusinga expected to keep his ancestral figure in perpetuity to be inherited and cherished by his successors and that such permanence would have been of great value unto itself. Brad Weiss's insights from research among Haya people of northwestern Tanzania are apposite, for "*keeping*—upon which inalienability depends—is a generative, productive practice, one that literally reproduces the future through the motivations to transaction, and aspirations to ownership that inalienable possessions engender." As Annette Weiner has suggested, "The primary value of inalienability . . . is expressed through the power these objects have to define who one is in an historical sense. The object acts as a vehicle for bringing past time into the present, so that the histories of ancestors, titles, and mythological events become an intimate part of a person's present identity." In commissioning

and then carefully preserving the sculpture, Lusinga must have hoped to create or elaborate upon a dynastic history for himself and to have it be recognized by others. Weiner further stressed that "inalienable wealth takes on important priorities in societies where ranking occurs," and one can assume that Lusinga aspired to establish a social hierarchy among otherwise strikingly egalitarian people living in widely scattered, tiny communities.[8] Any such practices would have been subject to negotiation, however, with the potential of their rejection by competing factions.

The "Lusinga" figure stands some 28 inches tall and so is far more prominent than most Tabwa sculptures of the chief's time.[9] Its proportions emphasize the head, portraying a being of balance, inner and outer beauty, intelligence, and influence as further reflected in the shaven forehead and turban-shaped coiffure adorned with feathers following fashions among Luba-influenced people of the day. The face of the figure "is so inhumanly smooth and serene that it seems bathed in mist" and to be otherwise at an otherworldly remove from the "wrinkles" and "warts" of everyday life, as the art critic Holland Cotter writes of stone sculptures from Ankor Wat. Reference to eternally youthful appearance of the sort is so common in African art as to be one of the "canons of fine form," Robert Farris Thompson tells us.[10]

The eyes of "Lusinga" are opened wide and stare forward. They seem to exchange a gaze with those privileged enough to meet them but to possess an interior vision as well, perhaps in "a discussion shared between [the] two worlds" of the living and the dead. A paradox is posited, however, for the figure is inhabited by the spirits of Lusinga's matrilineage that are already in and of the afterworld. Might their regard reverse that of humans so that by looking "inward" as the eyes of "Lusinga" seem to do, they are looking "outward" to the affairs of their survivors whom they have left but still love? Ideas and practices have their own histories that change over time, of course, and it is only possible to speculate about how the theologically inclined intellectuals of Swift-of-Foot's day might have understood and interpreted such perplexing matters. Keeping in mind the brilliance of later savants like Kizumina, one *can* be certain that deep thought was given to any so vital a matter as the "vigilant generosity" of the ancestors.[11]

Given the size of the head, "Lusinga's" legs seem foreshortened as though a proper viewing would be from above as Leza, the otiose supreme deity, might view the figure. Such an effect is heightened by the prominent brow and compact face that is slightly bowed as though in deference. While such

an allusion might seem altogether benign, Leza is associated with the sun as a blindingly powerful source of *bulozi,* the ambiguous ability to harm and promote.[12] One can speculate that the "Lusinga" figure's proportions establish such a relationship with divine capacity, as will be elaborated in the next chapter's discussion of how Lusinga might have been buried had he not been assassinated by Bwana Boma's mercenaries.

Like the elongated neck that emphasizes the head, "Lusinga's" frontal stance and abbreviated legs bring attention to the head and torso as distinctly significant features of anatomy—although they are radically opposed to each other with regard to pertinent symbolism. Furthermore, the legs are flexed at the knees despite the vertical strength of the torso, suggesting the stately dance steps of Tabwa elders, perhaps in circular movements both celebrating and defying death and the passage of time.[13]

"Lusinga" wears a necklace of two bushpig tusks joined at the openings to form a gleaming white crescent.[14] Bushpigs (*Potamochoerus porcus*) are the emblematic animal of Lusinga's Sanga clan, and he and his fellows would have drawn an analogy between their own proficiency in farming and the animals' efficient "cultivation" as they root about in the earth with their tusks. Stefano Kaoze, who recorded this datum, was of the same clan himself. A singular of bushpigs may include an extended family of thirty or more that are uncanny in their ability to avoid the best-laid traps, skirt or dig under the thickest thorn hedges so carefully (and painfully) constructed to keep them out, and otherwise ravage gardens if and when they please.[15] Such wily willfulness is possible because bushpigs possess *malosi,* a keenly projective eyesight shared only with dogs, side-striped jackals, hyenas, and bateleur eagles. All of these can see what others cannot, including into the other world. Nzwiba, once a great gun-hunter and healer, told me that bushpigs and bushbucks (*Tragelaphus scriptus*) eat cannabis, which makes their eyes gleam red with malicious intent, and their cunning signals the illicit advantages of bulozi. As an example, he said that if an old sow finds farmers guarding their ready-to-be-harvested fields through the night, she will perform a dance to send the hapless souls into deep sleep. This ability recalls a *kabwalala* magical bundle used by thieves and marauders, Nzwiba continued—and so, we may add, it is like the device suspected in the burning of Bwana Boma's boma. Once the bushpigs have eaten their fill and in the process have destroyed the rest of the crop, the same crafty swine will dance or defecate, startling the farmers to wakefulness but too late to do anything but bemoan their losses. It is easy to see why

bushpig behavior provided motive metaphors for the treachery and bellicose tactics of ambitious persons like Lusinga.

The figure's crescent necklace made further allusion to lunar phenomena, and especially to the rising of a new moon that Tabwa associate with hopeful but always ambiguous aspects of political authority. At the rising of a new moon, Lusinga removed the figure from the little building in which he kept it tucked away in his compound and anointed it with the precious palm oil that still exudes from its sticky surface as an offering to his ancestors. Even so small a detail can be revelatory. Although African oil palms (*Elaeis guineensis*) do grow around Lubanda, they must be planted and carefully cultivated whereas they grow in great natural stands in more tropical climes north of the Lukuga River. The oil pressed from their seeds was an important regional trade item in precolonial times and would have been obtained by Lusinga in exchange for smoked fish and game meat, locally smelted and forged iron implements, and salt from the saline spring along the Muswe where he settled. In other words, the tiny, oily beads on the surface of "Lusinga" bespeak significant politico-economic relations. Even more significant, however, is the sense that such a surface suggests histories of "tactile engagement" and an "epistemology of touch" united the person cherishing the figure and the spiritual presence inhering within it.[16]

"Lusinga's" left or "female" hand lies next to his pronounced navel in reference to the chief's mother and matrilineage. His right or "masculine" hand holds what may be a staff of office, and if so, it makes further reference to Luba-style authority as expressed through prestige objects that are well known in museum collections for their delicate carving and intricate symbolism. Luba staffs map geographical and social relationships to spiritual agents and senior chiefs. They are visually mnemonic and their iconography is narrated when needed to determine prerogatives and differential status. Or perhaps the object held in hand was meant to be a stylized musket as a device of evident power in Lusinga's heady days of violent plunder. In either case, the staff extends the hand as a prosthesis that affirms solidity of stance through reference to ancestrally sanctioned powers.[17]

Monsieur Hotz's 1929 photograph of the "Lusinga" figure on Storms's mantelpiece shows a strand of light-colored beads across the top of the high forehead below the elaborate coiffure. In another photo of the series, the figure that Storms reported to be "Kansabala's wife" wears a seemingly similar string of beads around the brow, but like "Lusinga's" beads they are now

missing from the sculptures exhibited at the RMCA.[18] Given the resolution of the photographs, it is difficult to see the tiny objects well, yet their irregularity is striking and quite unlike what one would expect of the smooth and lustrous glass trade beads imported into central Africa in Lusinga's day. Instead, their size, color, and form are characteristic of locally fabricated beads made from the hard shell of a spotted, knobby seed called *mpiki* (*Cleistopholis patens*). A necklace of these was an identifying symbol of Bugabo, a society of healing, hunting, and community protection among peoples of southeastern Congo that remained important well into the colonial period.[19]

Among their arcane powers, Bagabo could deploy lions against their adversaries, and it will be recalled that Storms suggested that Lusinga had "the reputation in all these lands of being invulnerable. He can change himself into a lion . . . and if need be, he can make himself invisible. This strength of Lusinga is not contested, and gives him unbelievable power." In this same regard, Robert Schmidt held that "any *mugabo* really worthy of the name" could summon lions, and that among the magical bundles possessed by Bagabo was one that contained fur, claws, and urine from these ferocious predators. Such a bundle would be buried under the floor of a mugabo's home, and when he wished to call forth a lion he could tap the spot with the feline tooth he wore on his necklace of mpiki seeds, and the beast would appear wherever its master wished to attack someone.[20]

Such an assertion refers to a complex of Tabwa beliefs and practices concerning the natural history of lions as metaphors for political authority. Some elders were known to be *bafuga-simba*—that is, "those who raise lions" to protect fields from baboons, bushpigs, and other clever beasts, even as they guarded their master's village from clandestine attack by lions sent by their adversaries. Other elders commanded *visanguka* lion-men who engaged in terrorism by randomly killing persons associated with an enemy and disguising their acts as those of "man-eating lions." Lusinga was in the thick of this and was implicated in a number of visanguka engagements with a rival clan. In 1885 and 1886, shortly after Storms returned to Belgium, followers of the Yeke warlords Ukala and Chura fell victim to visanguka, quite possibly dispatched by Lusinga's surviving kin in revenge for their close relationships with Bwana Boma. Ukala asked the missionaries at Mpala-Lubanda for permission to strike back, saying he knew who had sent the lions and if nothing were done, "it will no longer be possible to live in this land, as all of the Marungu will send us their lions." The mission scribe commented that he

found "the proposition grave, the argument well made, and yet we laughed" at what the priests derided as the childish beliefs of the "natives." It would be some years before the Fathers understood the nature of the menace, as nativistic purposes were further served when visanguka attacked people associated with Catholic missions, especially in the 1890s but from time to time throughout the colonial period.[21]

Monsieur Hotz's photograph of "Lusinga" also shows two duiker horns (probably from *Sylvicapra grimmia*) wedged point-downward between the right forearm and torso, as though they were filled with medicines. Such horns are convenient receptacles for magical substances. Duikers are said to sleep during the daytime with their eyes wide open, thus underscoring the vigilance of any such device placed in their horns. It is not clear whether the horns were original to the figure, for they have long been separated from it, nor do they appear in the line drawing in the Jacques and Storms monograph. Yet in combination with the mpiki beads and their allusion to Bugabo, such amuletic devices suggest more deeply esoteric and explicitly political dimensions to the "Lusinga" sculpture than meet the eye since their removal.[22]

In describing the Tabwa figures he collected, Storms insisted they were not "fetishes," although they might be "garnished" with medicinal materials and so "serve as *porte-fétiches*"—that is, supports and vehicles for magic.[23] As mentioned, "Lusinga" no longer shows any evident talismanic devices to protect and promote the chief and his followers in circumstances of quotidian need. Its more direct purpose was to be incorporated into social life, for it bore and conveyed what might be understood as "ancestral social efficacy" regarding prestige, privileges, and rights. Alfred Gell wrote thus of *malangan* figures made by people of northern New Ireland (Papua New Guinea), based upon the research of Suzanne Küchler among others. While malangan (which are still made) are vivified for transient funeral proceedings and then "killed" and sold with impunity to outsiders—hence their being found in so many museum and private collections around the world—Tabwa figures like that of "Lusinga" seem to have been created to be perdurable and so to serve as "proof of a group's immortality" as a "'solution' to the problems of the fragmented character of social life and the inescapability of loss, death, and decay."[24] Because production of Tabwa sculpture blossomed in the later nineteenth century and then declined greatly in the latter half of the colonial period due to pressure from Catholic missionaries and colonial authorities, we may never know the subtleties of such figures' powers nor exactly how they were used. Comparative research like Küchler's,

Weiss's, and Weiner's, and secondary reflections like Gell's are all the more intriguing as a consequence.

While Storms might dismiss sculptures like "Lusinga" for "having the pretension of representing earlier chiefs," they were—and perhaps still are for some—far different from and more than this. Storms explained that figures like "Lusinga" were kept in small houses otherwise similar in architecture to those inhabited by Tabwa chiefs. "A sleeping mat and all the other goods of a household, plus a gourd in which beer is poured each time any is brewed" were among the things kept in such a sanctum.[25] For Lusinga, the figure that Storms would eventually capture and bear away to Europe "was" his dynastic lineage as a living essence with which the chief could commune while sharing freshly brewed beer and long meditative hours through the night. In this the figure constituted a "compressed performance" of the practices and associations to which it alluded and to Lusinga's own interactions with his matrilineal ancestors.[26]

In the 1970s, Sultani Mpala Kaloko maintained a little building in a guarded corner of his fenced-in backyard where he occasionally repaired to spend the night in quiet reflection through communication with his forebears. Even though the wooden figures once associated with his matrilineage had been sold to or purloined by representatives of a European art dealer (and the details of this loss were never explained to me, quite deliberately it seemed at the time), Mpala had commissioned figures in sun-dried clay to replace them as the living presence of his ancestors. He showed them to me only once and was very reticent about doing so at all or about discussing the works after he had revealed them to me—and this despite his being so open regarding other, far more esoteric and politically controversial matters. I was never certain whether his hesitation was because of lingering effects of the early White Fathers' harsh persecution, for the missionaries apprehended those possessing "idols," chained them before the church, and instructed parishioners to insult them on their way to Mass, or because he felt remorse at the loss of whatever wooden figures he once treasured.[27]

Forces with Blurred and Unknowable Limits

The "Lusinga" sculpture is of an idiom that Tabwa call *minkisi* (singular: *nkisi*). Luba-inclined persons like Lusinga might have added a qualifying adjective to this, as *minkisi ya mipasi* (or *mihasi*) or "*minkisi* of the ancestors," as opposed to the *minkisi ya mihake* endowed with evident medicinal charges.

Through their minkisi Tabwa participate in an instrumental idiom shared among Bantu-speaking groups of central Africa. An enormous literature describes this cultural complex manifested in material and performance arts ranging from dramatic masks of Chokwe and related groups of Zambia, Angola, and the DRC to the astonishing nail-studded figures of Kongo peoples of northern Angola and westernmost Congo, once used to levy and execute dire imprecations.[28] Because of the transatlantic slave trade, minkisi are also found throughout the African Americas, witness the *inkisses* of Brazilian Candomblé and the *pakèt kongo* and *wanga* constructions of Petwo as central African contributions to Haitian Vodou.[29]

Despite similarities of logic and purpose, Mulinda Habi Buganza is wise to note the need to avoid "facile generalizations and premature syntheses" when distinct differences in nkisi concepts and uses exist among particular cultures. Indeed, as Wyatt MacGaffey states, "There is no good translation for the ... word *nkisi* (pl. *minkisi*), because no corresponding institution exists in European culture. In Kongo thought a[n] *nkisi* is a personalized force from the invisible land of the dead; this force has chosen, or been induced, to submit itself to some degree of human control effected through ritual performances."[30] Among Tabwa, minkisi have sometimes been associated with spirits of the earth (*ngulu*) or deceased diviner-healers and possibly other persons of noted reputation such as iron smelters (*ngezia*) and great hunters of old, but most commonly they give form to matrilineal ancestors. Tabwa *minkisi ya mipasi* preserve and make available "the entire agentive capacity of the deceased for future redeployment" toward a variety of important ends. The spirits of Lusinga's immediate ancestors inhered in the figure that Storms's men seized and would have been a source of moral and supernatural support to the chief, but the sculpture also bore the less specific presence of longer-lost persons of Lusinga's matrilineage with whom he might communicate and from whom he could receive inspiration. Most significantly, the figure was highly interactive and "a *promise*, a restless sign, a harbinger of that which awaits."[31]

Minkisi provide a more diffuse, altogether difficult-to-define efficacy produced by relationships, practices, performances, and places. These are not generally reified or spoken about overtly, and the word *nkisi* refers more to the vehicle and conveyance of potentialities for which people at Lubanda have vague descriptors like *nguvu*, which refers to "strength, power, authority, force," and *uwezo*, meaning "strength, might, power, capacity, authority, ability, faculty."[32] Such a sense of occult force merges with notions, medicines, and practices of the ambivalent arts of bulozi.

The aura of an nkisi accrues with histories of purpose and constitutes the raw possibility of accomplishment and change. Its nguvu is further increased by the "bodily engagement" and interactive performances that one or more persons share with it over time and that in a sense "complete" the device just as it "completes" them. The nguvu or strength of an nkisi can be obtained and engaged both collectively and privately and may or may not be associated with medicinal or magical elements meant to achieve particular tasks. Most significantly, the combination of remembered ancestors and the transformative power accrued over time meant that sculptures like that of "Lusinga" once served as *lieux de mémoire* in conceptually enchanted landscapes following the mnemonic principles Tabwa shared with Luba through music, dance, and related performance idioms.[33] Minkisi also engaged "underscapes" inhabited by ancestors dwelling in the subterranean world of the great spirit Kibawa, as well as ngulu earth spirits, and in some circumstances they may still do so, although forms and purposes are changing all the time.

Material culture among neighboring Luba has long been richly complex and is among the best known of African arts. The evocative forms of anthropomorphic figures, caryatid stools, and staffs of office encode important information used in composing and telling their owners' inexorably updated and competing histories. Such narratives are articulated using less well known objects, among which the *lukasa* memory board stands as a device of Einsteinian brilliance.[34] Lukasas are hourglass-shaped wooden boards sometimes surmounted by one or more carved wooden spirit heads or tiny figures. The "inside" surfaces of many lukasas are studded with glass trade beads pegged down with acacia thorns. Others are decorated with incised or protruding ideograms. The "backs" of lukasas are generally decorated with geometric designs reminiscent of the large scales of tortoise shells. Such motifs can be "read" by persons educated in the esoterica of Mbudye, a society associated with Luba royalty discussed in chapter 3. Knowledgeable persons can assign to or discern in these constellations and contingencies a number of different sorts of information, including the epic stories explaining the origins of humankind and cultural institutions, seating protocol at the royal court, the mapping of medicinal trees and plants in the king's compound, and other complex data sets. Most significant, however, are political interpretations by "men of memory" (*bana balute*) who construct particular histories in the course of adjudication of land rights or other important matters.

For the most part, Tabwa do not seem to have adopted the lukasa, although a few turn-of-the-century staffs and walking sticks do incorporate lukasa-like

shapes into their iconography. "Reading" such staffs entailed understanding political and genealogical hierarchies (one motif located above or next to another) and more diffuse relationships among details such as matrilineal descent or interaction with spirits, similar to the ways that particular narratives are mapped and recounted using Luba staffs and stools as mnemonic devices.[35] The most ready explanation for Tabwa *not* adopting lukasa concepts and practices is that Luba associated with kingdoms of the Lualaba lakes generally observe patrilineal descent, and their proprietary notions of status, land rights, and other forms of wealth are informed by highly complex political realities of the Luba "state," as intriguingly amorphous a polity as it seems to have been in late precolonial times. Tabwa, on the other hand, observe matrilineal descent and—with the exception of a few late nineteenth-century chiefs like Lusinga—have long lived in small communities of the sort encountered by Storms, in which chiefs are understood as leaders who guide by wisdom and example rather than rulers who assert their authority through force. The needs for managing complex information to create narratives of political legitimacy differ between these two modes of pre- and early colonial social organization. Similarly, the ways that the Mbudye Society was responsible for assuring political stability as a check and balance to royal prerogative were not adopted by Tabwa from Luba neighbors, although "men of memory" were and are important to local-level politics, with Kizumina one such gifted orator.[36]

Still, a logic of mnemonic forms and practices is shared among Luba and Tabwa, and *minkisi ya mipasi* like "Lusinga" served as *aides-mémoires* for both literal and conceptual scapes of power and prestige. The figure would focus narrative attention as do the clusters of beads or incised motifs on a lukasa or the sculpted forms of a Luba staff. Such an nkisi would be a locus for "the political economy of memory, with its strategic remembering and deliberate forgetting of shared images" to "articulate what is held in common by an otherwise divisive and fragmentary society," as Walter Melion and Suzanne Küchler write of malangan figures of New Ireland.[37]

The sculpture of "Lusinga" also participated in the chief's person, both as the individual he was and expected to be and as a member of a greater collectivity of his own ancestors and those of his peers who looked to him for leadership. One is reminded of Wyatt MacGaffey's provocative elucidation of relationships between great Kongo chiefs and their minkisi: "Chiefs relied heavily on major *minkisi,* objects that were themselves 'chiefs.' In turn, chiefs were also *minkisi,* treated at times as though they were objects." Such dynamic transaction is what

René Devisch calls "interanimation" with regard to Yaka, a west-central Congolese people with highly developed sculptural traditions. Furthermore, again among Kongo, "all persons, including both *minkisi* and ordinary people, consist of a body of some kind and an animating spirit, which can be transferred into another body by appropriate procedures." And to redirect Alfred Gell's assertions when writing of these same Kongo minkisi figures, "an instructed person" among Tabwa who approached the figure of Lusinga's matrilineal ancestors would not have seen "a mere thing, a form" to which one might or might not "respond aesthetically." Instead, he or she would have perceived in the sculpture "the visible knot which ties together an invisible skein of relations, fanning out into social space and social time."[38]

For some time now, anthropologists have written of the ways that in many cultures, objects may participate in human "personhood" in these ways. Other scholars have dismissed such assertions to concentrate upon the human agency implied in any such culturally specific claims. One is reminded of the caveat of Bruno Latour that "purified," either/or distinctions, such as whether objects may or only humans can possess agency, preclude deeper understanding of—in this case—an nkisi as "a force with blurred and unknowable limits, intersecting with equally fluid subjectivities."[39]

Formulating a "very permissive manner" for understanding what he called "distributed persons," Alfred Gell held that "social agency can be exercised relative *to* 'things' and social agency can be exercised *by* 'things.'"[40] The difference between persons and objects may be far less well defined than one might imagine, in other words, and Gell took great pains to stress that this is no "exotic" notion, but a very widespread one, witness the bonds that European girls may have with their dolls or middle-class men with their cars.

Stolen Souls

Storms clearly understood his possession of the "Lusinga" figure as a war trophy via a property regime that was very different from what the same nkisi meant to the Tabwa chief and his people from whom Bwana Boma's men seized it. The "use value" he saw in the sculpture was directed toward his own self-presentation rather than any of the purposes Lusinga and his followers might have intended. One is reminded of Giorgio Agamben's discussion of profanation associated with consumer societies versus sacred purposes of times past: "The impossibility of using has its emblematic place in the Museum. The

museification of the world is today an accomplished fact. One by one, the spiritual potentialities that defined the people's lives—art, religion, philosophy, the idea of nature, even politics—have docilely withdrawn into the Museum"—sometimes via drawing rooms like Bwana Boma's.[41] Since Storms's collection was given to the RMCA, "Lusinga" and similar objects have served further "enunciatory functions" as signs of primitivity underscoring the purposes of Belgian "civilization." But as opposed to such reinvention, one might conclude through Tabwa reasoning that Bwana Boma had "enslaved" the spiritual essences that inhered in the nkisi as Lusinga knew and communicated with the sculpture. If so, vengeful ghosts (*vizwa* or *vibanda*) of Lusinga's matrilineage are trapped in a vitrine of the Royal Museum today, "out of sight and out of history" other than that of Belgian hegemony, whether or not anyone—Lusinga's descendants, Tabwa, Congolese more generally, or anyone else—remembers or continues to care.[42]

This said, I am *not* making a romantic plea for the immediate repatriation of the figure, as national museums of the war-torn DRC may not serve Tabwa interests and they have not been immune to plundering for the international art market. For the time being, at least, "Lusinga" may be better preserved in Belgium. Still, who decides what the past(s) of such an object may have been, let alone what should be done to preserve, ignore, or destroy one history in favor of "alternative imaginaries" engaged by Tabwa and other Congolese in the near future? Such questions have no ready answer at present, if, indeed, they ever can.[43]

"Enslaving 'Lusinga'" by evacuating the wooden figure to Europe may have included a more literal sense for Tabwa than one might assume from non-Tabwa perspectives. Tabwa share a sense of partitive being with other Bantu-speaking peoples of central Africa, as suggested. According to such an ontology, the soul (*mutima*) is embodied in life but can also travel through dreams and visions and is vulnerable to theft by malicious persons through a process that Tabwa call *kujendula*. *Mutima* can mean "soul" in Kitabwa, or it can refer to the heart or, more generally, "the belly," in more figurative ways. The word "soul" in English is so burdened with Judeo-Christian implications, especially as understood and applied by missionaries to Tabwa at Lubanda, that it must be used with caution, to be sure.[44]

A mutima may be stolen several ways and for many reasons through the processes of kujendula, and the details are determined through divination and its revelations of etiology. Macabre histories are composed that tell of the violence done to a person as the mutima is enslaved. Sometimes a mutima is

forced into very mundane labor, providing invisible help to farm, fish, or hunt more efficiently than the capacities of ordinary people. Someone who is notably successful in any such pursuit or in profit-oriented business ventures is suspected in this regard, including those associated with representatives of Mobutu's "kleptocracy" of the mid-1970s when many felt preyed upon rather than assisted by the "public servants" of their central government.[45] "Swahili" people from the east African coast were also occasionally mentioned by Tabwa in the 1970s as stealing souls through kujendula-related acts. Such nefarious deeds are perpetrated through traffic with a spirit of Lake Tanganyika called Mamba Mutu, to whom Faustian promises are made for unusual success in commerce by sacrificing the souls of one's own children. In such behavior, Mamba Mutu is a central African version of the pan-African apotheosis of capitalism known as Mami Wata. Sometimes the stolen soul is obliged to commit atrocities in the community, including further *majenda* (soul-theft). The perpetrators of such loathsome acts are considered walozi of the worst kind, and they may include Europeans and other expatriates engaged in sapping the vitality of the colonized in ways that are tantamount to cannibalism or vampirism.[46] By this same logic, Storms took far more from Lusinga and his people than an heirloom sculpture. By this same logic, Storms himself was a most aggressive and destructive mulozi.

Rationalist readers—including some Tabwa, no doubt—may find any such proposition absurd. An object bearing one or a collectivity of souls? Objectified souls enslaved? Émile Storms a sorcerer? Nonsense. Surely these are "beliefs" not to be taken seriously by any but the believers themselves, in all their benighted ignorance.[47] No one ever told me that Storms had "stolen the soul" of Lusinga. Nonetheless, according to what I understand of Tabwa thought, such an assertion constitutes a logical possibility. And what if we *were* to take seriously the various truths subaltern people like Tabwa at Lubanda have long sought to impart to missionaries, colonizers, anthropologists, and others who are more politically and economically "significant" than they? Some have asked such questions for years, of course. As an anthropologist in search of "imaginative horizons," Vincent Crapanzano's assertion is a call to action:

> We assume enormous moral and political responsibility in our constructions and representations of our subjects. If, in the name of one science or another, we dismiss most everything the people we study hold important—their religions, their values, their expressive culture[s], their culinary habits, their

sexual practices—as epiphenomena, ultimately reducible to some ecological adaptation, evolutionary response, cognitive predisposition, or genetic makeup, we devalue those people, sully our understanding of themselves and their own world, and promote our own parochialism.[48]

As opposed to such myopia, perhaps "spirits," "ghosts," and "enslavements" might be understood as "real" in a number of different ways, including how they "signify a notion about relations between past and present that underlie a contemporary order but remain unacknowledged, unspoken, or even unthinkable within its reigning narrative conventions and definition of the *historically real*."[49] These matters will be revisited shortly.

As important as the "Lusinga" nkisi was to the chief and his matrilineage, another object was more directly venerated: the skull of Lusinga's dynastic predecessor. In order to understand how Tabwa might contrast a distinctly anthropomorphic, aesthetically expressive sculpture animated by "ancestral social efficacy" and the skull of a particular person, in the next chapter we shall reflect upon what funeral procedures might have been followed by Lusinga's family had he *not* been decapitated by the men of Bwana Boma and his skull taken on to Belgium. We shall also consider ironies at play, for the figure—at least to Western eyes—seems fairly lifelike in an "arty" sort of way, and it is not difficult to fathom why Storms understood it to represent Lusinga himself rather than the more recondite essence of Lusinga's matrilineage. Yet it was the *skull*—a "bone" of the sort dismissed by Hegel as "a mere thing" and "nothing in itself, much less" a person's "true reality"—that gave voice to an individual chief's continuing presence after physical death as a most "concrete symbol." The degree to which "the issue of death throws into relief the most important cultural values by which people live their lives and evaluate their experiences" will become clear as well. An obverse reflection posited by Johannes Fabian is also worth pondering: "The anthropology of death is [itself] a form of dying, or of conquering death—which, in the end, may be the same."[50]

Mistreating Treaties

Émile Storms had a number of intersecting political and personal motivations for his bellicose activities at Lubanda, but it would seem that he was especially piqued by the effrontery of Lusinga, and in furious disdain he sent his men to assassinate the chief and bring back his head. Two weeks after the attack by

Storms's men, the lieutenant reported that he was "in negotiation with Kansabala, the greatest chief of the Marungu, to make him recognize my suzerainty." An elaborate treaty declaring Kansabala's submission was drawn up in Swahili written in Arabic script by Paul Reichard, who was still visiting Bwana Boma. A draft of the treaty in Swahili but written in Roman letters exists as well, although partially burned in the arson of Bwana Boma's boma. Reichard's Swahili is too literal a translation from the author's native German, for in trying to express the concept of Kansabala's submission, he wrote that the chief and his dependants *wameangukia katika imara ya wazungu wa Leopo*—that is, they "'fell into' or 'fell in with' the 'strength, stability, solidity' of Léopold's *wazungu*," this last referring to Europeans like Storms. In more standard Swahili, however, the first verb, *-anguka*, "to fall," may connote "the use of witchcraft," for "witches . . . cause corpses to leave their graves, and people leave their beds when asleep and float in the air from their houses" in the soul-stolen enslavement of kujendula.[51] It is conceivable, then, that over and above the absurdity of supposing that a treaty would be similarly understood by Europeans and Congolese—and the connivances based on just such "treaties mistreated" as vast swathes of Africa were claimed on their basis— Kansabala and his people may have understood the agreement quite differently from how the lieutenant and his German colleague intended.[52]

In accepting Kansabala's submission, Storms believed that matters with the chief and his people were resolved at last. In mid-March, however, he learned that Kansabala had assembled his men in resistance to his authority. He also heard that the title of "Lusinga" was to be filled by a man chosen by Kansabala rather than by Bwana Boma. Storms considered this a treasonous insult to the authority he was struggling to establish, for he thought he must be the one to see to chiefly succession for all those within his "realm" as he would when Sultani Mpala succumbed to smallpox in June 1885. He could not let such a threat go unanswered.[53]

Kansabala's choice of a successor to Lusinga is not difficult to fathom following Tabwa social organization in the second half of the nineteenth century. Tabwa share a sense of "positional succession" with peoples of southwestern Congo and northeastern Zambia as recently articulated by Manuela Palmeirim, a scholar of the Lunda (Ruwund) kingdom in southwestern DRC. Here she bases her discussion on the writings of Ian Cunnison on Bwile and Audrey Richards on Bemba, both peoples of northeastern Zambia living intermingled with southern Tabwa. Through positional succession, when a

prominent person dies, his or her names and roles are assumed by living members of the matrilineage so that "attributes, past experiences and status associated with that name" are handed on. "By this token, the kinship terminology does not take into account the passage of genealogical time, the recipient of a name being often addressed by the very same kinship terms which were used by the eponymous predecessor."[54] Through this proleptic process, past becomes present, and as we shall see, Tabwa burial practices underscored such a sense of temporally merged identities.

In the Tabwa-related communities that Cunnison studied, most inherited names were abandoned after two or three individuals had held them, at least in earlier times. Seeing to succession was all the more important politically, then, if one was to maintain a dynasty; but negotiability of such status was frozen by colonial policy that perpetuated titles as though they were timeless following feudal models borrowed from medieval European history. A succession of Lusingas now stand in mutual dependency to those holding the title of Kansabala through a relationship understood as that of sister's son to mother's brother in a society that observes matrilineal descent. In theory, when a Kansabala dies, he will be succeeded by the Lusinga of the moment, and a new Lusinga will be chosen; however, local-level politics may redirect such choice to someone else.

Any such subtleties of social organization were of no immediate concern to Bwana Boma. Alarmed that Kansabala was seeking to name the new Lusinga, the lieutenant deemed that a further campaign against both the new Lusinga and Kansabala would be necessary and politically expedient. The ramifications of what would prove to be Storms's last expeditions would have lasting consequences.

9 · Composing Decomposition

Remembering is never a quiet act of introspection or retrospection.
It is a painful remembering, a putting together of the dismembered
past to make sense of the trauma of the present.

—Homi Bhabha, *The Location of Culture*

What funeral practices might have been undertaken had Lusinga met a natural—
or at least a local—demise? While I would assert that Lusinga explicitly engaged
in "culture-building" as he sought to validate his emerging authority through the
commissioning of statuary and other visible and performative means, he was not
doing so from whole cloth. Instead, he was adopting and adapting eastern Luba
practices that were sufficiently resonant with Tabwa political culture as to be ac-
cepted locally. Such creative work included burial of chiefs.[1]

The archaeological record suggests how elaborate funeral rites could be for
earlier peoples of the region, but archival materials concerning such matters as
precolonial burial of chiefs are meager indeed, and Storms left the barest of
notes that are not specific to any given chief, community, or moment in time.[2]
Most Tabwa with whom I worked in the 1970s knew very little of such proce-
dures, and it is likely that a combination of secrecy, the inventive but discontinued
maneuvers of ambitious individuals like Lusinga and Kansabala, and nearly a
century of colonial intervention—especially by Catholic missionaries based at
Mpala-Lubanda and Moba-Kirungu—mean that few details have been retained

if they were ever widely known or generally practiced. Nothing resembling a "genealogy of performance" has been maintained or can be retrieved, then, and we have no glimpse of the inevitable "anxiety-inducing instability" of any given performance event when arguments about who does what and how are played out according to the particularities of local-level politics. As Victor Turner asserted, "There is no 'authorized version' of a given ritual" like a chief's interment, and indeed, because of inexorably shifting social dynamics, "no performance . . . ever precisely resembles another."[3] Nor do available data permit an understanding of local variation in symbolism and broader purpose from one burial, village, chiefdom, clan, or ethnic difference to the next, to say nothing of the development of procedures across time. Surely there *was* variation, as one would expect among communities so loosely related to each other—if at all—as were Tabwa of the late nineteenth century. The archaeology of performance to be offered here will be a deductive quest, then, as stimulated by a most intriguing entry in the White Fathers' Mpala Mission diary concerning the death and burial of Sultani Kansabala, Lusinga's "mother's brother."

The "Emperor" Strikes Back—Again

By early March 1885 Bwana Boma was anxious to return to Lubanda from a brief visit to Karema, because he had learned that a new Lusinga had been named without his authorization. This same sojourn was when Storms was obliged to deal with upheavals among his men garrisoned at Fort Léopold due to the bizarre behavior of the tormented Victor Beine, and one can imagine that such aggravations contributed to the lieutenant's haste in setting sail for Lubanda across the lake's expanse. Indeed, rather than Beine, Storms left the talented professional Sef bin Rachid to hold Karema. Sef hailed from the Comoro Islands and led supply caravans to and from the east African coast on behalf of Storms and earlier IAA officers. These latter not only had confidence in the man's established abilities and knowledge of caravan procedures and politics, but they also were frankly fond of him.[4]

As soon as Storms regained his boma in Lubanda he began planning an expedition against the new Lusinga, deploying his main force of over one hundred. The lieutenant hoped to supplement his rugaruga irregulars with wangwana and men from Mpala and other chiefdoms within his purview. He was immediately confronted by these latter who insisted that they be given new red cloths of the sort that the rugaruga sported with such panache, so as

not to appear the "slaves" of these latter.[5] Such "'ghastly finery' [of rugaruga was] designed to inspire terror," and "during a battle or a siege, they would point to the cloth and shout to the defenders: 'This is your blood!'" The argument between Bwana Boma and his men was a manifestation of identity politics made the more complicated by the probability that some wangwana were themselves still enslaved.[6] After great acrimony, Storms was able to muster forty local men to bolster his force. Even as he sent them off there was further dispute, because his rugaruga wished to bear standards of their own "nations" east of Lake Tanganyika. Storms seized all banners and insisted that only his own flag would be carried.[7] Such insubordination suggests that Bwana Boma was still seen by some to be of a piece with Congolese warlords of his day.

Bwana Boma's trusted man Ramazani led the force that climbed the mountain trail from Lubanda and quickly seized Kansabala's fortress, only to discover that the chief and many of his henchmen had escaped to neighboring Chief Mwindi's. Ramazani duly attacked Mwindi's stronghold ten days later. As they approached and fired their first shots, Storms's fighters were met with raucous guffaws and a hail of arrows that so infuriated the mercenaries that they threw themselves upon the palisade to climb its walls "like cats." The stockade fell and was pillaged and burned. More than 150 were seized as "spoils of war" by and for the men of Bwana Boma. Ramazani and the rugaruga returned to Lubanda in triumph, firing their muskets with such abandon that Storms grumbled that his men wasted more ammunition in celebration than they had spent in battle. Nonetheless, it was in this context that he proclaimed, "All authority that is not based upon force is worthless and illusory" and added, "The primary condition for us is to be the strongest in the land.... If I must humiliate myself before neighboring chiefs" by refusing to undertake engagements such as that with Mwindi, "what protection can I give to the European posts placed under our protection?"[8]

Kansabala and Mwindi escaped the attack despite its ravages, and Storms wrote that he would allow them to ponder their circumstances, for if they did not submit quickly, he would attack them again—and soon he did, gathering three hundred, who responded with vivid dances when he distributed ammunition to them. As T. J. Desch Obi notes, in precolonial central Africa such performances were seen as "omens of bravery and success," as one assumes to have been the case here, but "in other cases they could be a form of breaking the effects of an enemy's charms."[9] Would that we knew more about the efficacy of these choreographies mentioned in such tantalizing brevity.

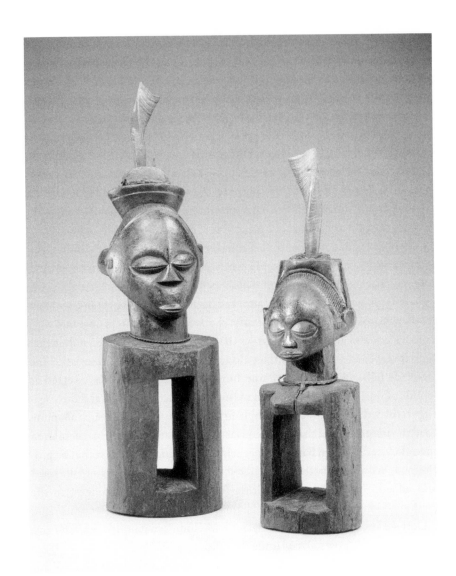

Figure 9.1. Ancestral figures of Kansabala, his wife, and their matrilineages. H. 70 and 56cm.; wood, bark cloth, iron, leather, fiber cord, bushbuck horn, rock crystal, natural substances; unknown artist. EO.0.0.31663 and EO.0.0.31664; collection RMCA Tervuren, photo R. Asselberghs, RMCA Tervuren© with permission.

The rugaruga brought many "fetishes and idols" back to Storms from Kansabala's fortress, including a pair of figures said to represent "Kansabala and his wife" that, like the sculpture of "Lusinga," are now deemed "treasures" of the RMCA (fig. 9.1).[10] Both are stylistically related to the sculpted heads atop *mpungwe* posts (sometimes called *kalunga* or *lagalla*) that were still in use in the 1970s by Tumbwe and other Luba-influenced chiefs northwest of Lubanda, where Lusinga and Kansabala were said to have originated.[11] While the figures were meant to affirm and sanctify Kansabala's authority, the male is carved from medicinally potent *Ficus mucosa* wood and both hold powerful magical bundles in their hollowed tops. These are covered with barkcloth and pegged into the cavities with wooden splints that may have had symbolic as well as practical purposes. Two iron spikes are driven into the bundle in the head of the "Kansabala" figure to activate it following circumstantially determined intentions, and traces of camwood around the ears and hairdo suggest the sculpture's active use in Kansabala's day. Bushbuck horns filled with more medicines are inserted into the bundles, pointing downward. Bushbucks (*Tragelaphus scriptus*) are truculent and may chase a farmer from his own garden, barking "insults" (*matusi*) as they do. Like bushpigs, they are said to eat cannabis to increase their "red" arrogance (*kiburi*), and as "sorcerers" they convey leprosy that leaves a victim striped and spotted as are they. Tabwa chiefs assiduously avoid bushbuck meat, yet these same chiefs are protected and promoted by magic-packed horns that make bushbuck bellicosity instrumental on their behalf.[12] Kansabala had ample reason to activate just such devices.

With Lusinga's skull in hand and whatever collections he rescued from the burning of his boma, Storms left for Belgium in July 1885, leaving his fortress at Lubanda to Fathers Moinet and Moncet. The missionaries quickly made Bwana Boma's boma the center of a "Christian Kingdom" with all attributes of a nascent state other than international recognition. The kingdom retained its vigor well into the twentieth century and continued to influence local and regional politics in less direct ways through the 1970s.[13]

In mid-September 1885 Kansabala sent a representative to Lubanda to beg the priests' pardon. He was encouraged to make "complete submission to the Station" and pay "tribute" (*hongo*). Kansabala sent the fathers an elephant tusk, a child (presumably enslaved), and five hoes forged from locally smelted iron, and he signed yet another treaty. The event was deemed most felicitous by the mission scribe, for "the country has therefore been subdued definitively, [and] there is no longer anything to fear. . . . We can now inhabit all of

the Marungu at will . . . as one family of four to five thousand new people that we can one day evangelize."[14] Any such sense of tranquility would be short-lived, however, for the depredations of east African and local slavers grew far worse in the late 1880s and early 1890s than ever before, putting the Christian Kingdom at Lubanda and those dependent upon it at very distinct risk.

A mere month after his submission, Kansabala died, probably of smallpox in the raging epidemic that had taken the lives of Sultani Mpala and so many others. Informed of the death, the priests insisted that they would oversee Kansabala's succession, but they were asked to wait. Early in 1886 Father Moinet wrote in the mission diary that "the great chief Kansabala is sufficiently decomposed (which is easy to believe, since he died on November 20th and this is February 1st) that his skull has become detached from his body. They did not want to bury him until this last sign that the head could no longer hold on [*ne tient plus*], so that they can put it in an honorific place"—in other words, until a natural decapitation had occurred, however unnaturally.[15]

Burial of Tabwa Chiefs

Sultani Mpala explained to me that in the old days when an important Luba-influenced chief like Kansabala or Lusinga became moribund, several of his granddaughters would close themselves up in a house with him.[16] The community was apprised of the seriousness of the illness, but people would understand that he was being healed. Inside the building a granddaughter held the wracked body on her lap in a manner described by the verb *kulela* ("to cause to sleep") ordinarily used to describe the cradling of an infant, but a term with distinct sexual overtones. After the moment of physical death, a granddaughter moaned as though the chief were still alive but in dire agony.

The corpse was cared for in this way for four days and then placed in a huge gourd, a great earthen jar, or an *nkondwa* receptacle made from red *kabamba* (*Brachystegia*) bark. As one woman told me with characteristic bluntness, by then "it was only bones and rotting flesh." The White Fathers at Lubanda reported that as the chief was placed inside such a vessel, his knees were tucked to his chest, his arms were crossed clutching a bow and arrow, a feathered headdress was placed upon his head, and a large shell was placed over his mouth. The container was placed on top of a platform with pots beneath it to catch "worms and fluids," for these effluvia would be used by surviving kin as strong but otherwise unidentified "amulets."[17]

Decomposition was allowed to continue until the skull detached itself from the spine, as in the White Fathers' diary entry. During this time medicines were used to quell the noisome odors so that outsiders would not realize that the chief was long gone. Ripe fruit of a wild plantain called *busule* was used for this, Mpala told me, as were the cedary-smelling roots of *kilaolao* (*Cyperus articulatus L.*). This latter is a grass used in Tabwa medicines to promote fertility, especially after a birth while awaiting a next conception. Aside from its pungent odor, one can assume that kilaolao contributed its powers of regeneration to the managed transformation of the chief. An *mpande* (conus-shell disk) was bound over the mouth of the cadaver "to prevent rapid putrefaction," but in the end, the brain (*ubongo*) "ran out like water," I was told, and once the skull fell from the spine, it was rubbed with crimson *nkula* powder to "close" it to bulozi or other misuse.[18] Given the hue of Lusinga's skull that was still perceptible when the skull was removed from its museum drawer in Brussels more than a century after the chief's head was taken by the rugaruga of Bwana Boma, one wonders if such a treatment was administered by Tabwa preparing it for transportation to Europe, however esoteric and, perhaps, surreptitiously symbolic this intervention may have been.

Some say the entire skull of a chief was preserved, while others held that a circle of bone would be cut from the forehead. As Kizumina explained, a grandchild carefully "removed the chiefliness" (*alitosha busultani*) in this way, using an adze. *Kizio*, Kizumina continued, is the same term once used to refer to the tops of enemy skulls, from which beer was savored by the fiercest warriors of yore. The relic of the deceased chief was carefully hidden in a special shrine house within the chief's compound, and Storms suggested that the deceased man's fingernails and toenails might be revered in the same manner as the skull. In case of war or other calamity, the chief's cranium was "the first thing saved," a missionary wrote, for as an elderly kinsman of Sultani Mpala told me, should it ever be lost the successor would perish instantly.[19] The same conversation led the man to wonder whether or not Mpala Kaloko's skull or kizio would be preserved, now that the withering criticism and physical chastisement of the White Fathers were so greatly diminished in Lubanda. Would people return to earlier practices? I never learned the answer to this question, as Congolese civil strife prevented any communication I might have had about such esoteric matters when Mpala Kaloko did pass away some years after my departure.

The rest of a chief's corpse suffered a different fate from the skull. In the dead of night, grandchildren took the vessel holding the headless remains to a swampy pool in the woods. The skull of the chief's predecessor would be placed

with the body, even as the skull of the just-deceased man was kept for his successor. The grandchildren executed the young woman who had cared for the moribund leader, and her body was cast into the waters along with the chief's cadaver. Others would "want to go with Grandfather," Chief Zongwe explained, and they too would be killed. Even if they wept for mercy, their own mothers (the chief's daughters) would deliver them to their deaths, Zongwe added. His own family was notorious for the alleged execution of forty enslaved people at the death of the Zongwe of Bwana Boma's times, and the lieutenant tried to put an end to such practices among those who submitted to his authority.[20]

A territorial administrator of the Congo Free State named Charles Delhaise reported that when a chief was to be buried among some Tabwa, a stream would be diverted from its course and a 10-foot-deep grave oriented north-to-south would be excavated in its bed. A chamber was then dug into the western side of the grave.[21] What Delhaise did not mention is that because of local topography, streams flow roughly from west to east as they empty into Lake Tanganyika. As a consequence, not only would the chief's body face eastward when placed in this cavity, but once the stream was returned to its course, the flow would be in this auspicious direction as well. Indeed, Tabwa hold that at death the words of the wise return to the east, where they provide a "dawning" sense of wonder and enlightenment to their survivors.

Two wives, bound cross-legged, were seated in the streambed chamber and the jars of "rotten material" (*pourriture*) collected from the chief's decomposition that was not preserved for magical ends were placed on their laps. Boys holding the chief's pipe and iron tobacco-coal tongs were also seated in the cavity, which was then sealed from the vertical shaft with mats, burying the people alive. Enslaved persons were slain and their bodies thrown into the main pit. The grave was sealed and another person was sacrificed upon it as the diverted stream was allowed to regain its course.[22] Sultani Mpala said that once those assembled for the burial heard the spirits of previous chiefs already resident in the watery grave say, "Ah, he has come to us," they would leave the site. Another added that as "lions of the water," crocodiles would consume the slaves' remains. Thereafter the place was known as a *mwipupa*, with reference to the offerings made there to the spirits of chiefs. As a young schoolteacher with whom I was discussing these matters reflected with revulsion, drinking water was drawn downstream from the very place where Mpala's predecessors were buried. In earlier times, such a necrogeography suggests that spiritually endowed water may have been actively sought rather than avoided as polluting in any way.[23]

Once burial was complete, people returned to the village, but not without incident. Grandsons who were *baendo* (joking partners) of the deceased would dress in leopard skins and paint their faces red on one side and black on the other. Village women braided their hair and dyed the right side red with *nkula* (camwood) and the left side white with chalk. Such face and hair painting bespoke participants' liminality and may have been a reference to funerary practices of the Bugabo Society, known to use this same color symbolism during burial rites.[24]

In these fraught circumstances, marauding grandsons were known as *vimbwi,* or "spotted hyenas" (*Crocutta crocutta*). These animals' peculiar physiology allows them to consume the skeletons of animals stripped of flesh by lions and other predators, and they are known to exhume human cadavers. Indeed, bones are so essential to the diet of hyenas that their scat is often white from undigested calcium and therefore "hot," according to Tabwa. Hyenas' humanoid "laughter" will raise the hair on the bravest neck, and Tabwa are struck by the beasts' apparent—and alarming—lack of sexual dimorphism. From their point of view, Aristotle got it right: the hyena's "nature is that at one moment it is masculine and at another moment feminine, and hence it is a dirty brute."[25] The grandsons were also *bitambwa,* from a Tabwa verb meaning "to crawl along or creep like a vine." In this, an analogy can be drawn to the word "rampant" in English, which usually means "extending unchecked" and is from the same root that gives us "rampage." In early English usage, "to ramp" might refer to climbing plants, but it could also imply a sinister threat, as when a fierce animal rears up and advances menacingly on its hind legs, as one sees so often in medieval heraldry.[26] Tabwa reflecting on such matters would likely think of the lions and other wicked were-animals with which chiefs like Lusinga were associated.

The grandsons donned *nsala* (headdresses) made from the scarlet plumes of Lady Ross's turaco (*Musophaga rossae*), usually reserved for warrior homicides. Furthermore, "their souls [*mutima*] were red" like the camwood and feathers they sported, and they lusted for blood. They had begun *kisama* (interregnum), and great caution was to be observed, for all goods in the "rampant hyenas'" path could be seized, slaughtered, or held for ransom. Kinsmen of the chief hastened to tie chickens and goats at a crossroads at the edge of town to placate the furious grandsons and spare the village their wrath.

Sometime thereafter, the months-long processes of chiefly succession took place. Storms wrote that when a presumptive chief had sufficient support, "he

was immediately installed in his new dignity" and all cooking fires were extinguished. Mpala Kaloko said a deceased chief's clan advisors (*babanzi*) would select a successor among his sisters' sons (*wepwa*). Great care was taken, for if they were to release the chief's skull to anyone whose qualities proved less than adequate, a "great wrong" (*kosa kubwa*) would be committed, the implication being that supernatural sanctions and political repercussions would surely ensue. Storms added that after the appointment, an *ng'anga* "féticheur" would light a new fire by friction and everyone would take embers home. Dancing and drinking would follow for "an unlimited number of days."[27]

Once chosen, the successor would be closed up within a house, Mpala continued, and the grandchildren would dance a *muzamvi*—an obscure term recognized by only a few elderly people. The performers circled the house, ululating (*kupiga tupundu*) and singing the bawdy songs associated with the parents of twins. Kizumina recalled a fragment of such a song, which he sang for me in Swahili: *Anarudia, anafufuka, anafufuka*: "He returns, he awakens, he awakens." *Kufufuka* here refers to an awakening from death or a death-like state rather than sleep, and the term is derived from a verb meaning "cause to revive, bring to life again, resuscitate, restore."[28] In succession, the chief who had been cradled by his granddaughter was "awakened" and "brought back to life" through the efficacies of muzamvi choreography, as well as those of the broader ritual of which such a dance was a part. In other words, the difference between the man who had died and the one who followed was blurred and in certain ways irrelevant, since the chief's spirit lived on as did his dynastic name and political roles through positional succession.

In the last phases of transition, a new chief was given an axe, a spear, and some nkula (camwood) powder by those who had seen to his succession. An mpande (conus-shell disk) was bound over the man's mouth, and grandchildren carried him around his village. Zongwe explained that with the shell still sealing his lips, the chief would be instructed to desist from foolish acts even as he was told that henceforth, all good and all evil enacted in his chiefdom would be his responsibility. He would choose a new name to accompany his dynastic title and receive special gifts in celebration of the event.

Putrescence as Essence

In those Tabwa communities that followed some version of the ritual processes just described, a drama was staged that sought to transcend—and therefore

control—death itself. This "art of dying" was orchestrated to lead to "a progressive deconstruction of the image of the defunct, insofar as this image belonged to all sorts of memories of the living."[29] The intricacy of the process was made clear when people of Kansabala asked the White Fathers to wait while the ritual took its course rather than rush to appoint a new chief. Furthermore, while it may have been unknown to some that the chief was "really" dead as the young woman moaned and pretended he was not, others were well aware of what was transpiring, whether or not it would be their place to admit as much to anyone but expatriate authorities like the priests. As many studies have suggested, audiences are often far more aware of the backstage workings of performance than it is their role to know or divulge in any public way. The point is not the veracity of the moment, but its purposes.[30]

Again, did any of this ever happen as described, or are such stories simply mythologizing about other people in earlier times? To the degree that we are able to reconstruct such activities, it is not always possible to know what did happen as opposed to what might have. Yet the preservation of skulls seems beyond doubt, and it is this datum that concerns us most here. As Peter Brown asks of devotion to saintly relics in early Christianity, "How better to suppress the fact of death, than to remove part of the dead from its original context in the all too cluttered grave? How better to symbolize the abolition of time in such death, than to add to that indeterminacy of space?"[31]

In the recesses of an enclosed building, decomposition of the chief's body was closely managed, even as it was allowed to occur "naturally." If this seems shocking, we must keep in mind that revulsion and pollution are primarily cultural constructions and that those European observers reporting Tabwa activities in letters, diaries, and publications were undoubtedly subject to late nineteenth-century Roman Catholic definitions of sin and its corrupting embodiments as "the pollution of the soul," regardless of whether they themselves were practicing Christians. Tabwa were and are as "pollution-conscious" as anyone else, and yet "we find corruption enshrined in sacred places and times," because "a voluntary embrace of the symbols of death is a kind of prophylactic against the effects of death." Recognizing as much, what might seem most distressing moments and materials produced during a Tabwa chief's burial are put into perspective.[32]

The particularities of the living chief were reduced to facilitate his attaining ancestral status in a realm where, it was hoped, his mutima would remain at peace and not bother his survivors as an enraged ghost. "Radical devaluation of

the deceased's individuality" was thus achieved. Significantly, though, rather than inhuming the chief's moldering remains, his *putrescence* became *essence* as various elements of decomposition were put to use as *vizimba,* activating agents in medicines for healing, fertility, and transformative processes of warfare, big-game hunting, and iron smelting. Production of exuviae was a partitive process wherein "physically detached fragments of the victim's 'distributed person-hood'—that is, personhood distributed in the milieu, beyond the body-bound-ary"—could be made available. Such outcomes in turn suggested the regenera-tive powers of death—that is, a "distillation of life out of death" that would lead to the renewal of time itself.[33] Still, there is no denying that such burials of chiefs must have been gruesome affairs, and the degree to which they influenced the ritual actors' lives was substantial, given that the process took months for the skull to fall from the spine as indicated in the White Fathers' diary entry of February 1886. Furthermore, it was said that the young woman most *intimately* involved—with all oddly erotic nuances of that term intended—would be ex-ecuted as the process drew to a close, as would others among the chief's closest dependents.

Although Lusinga was held personally responsible and executed for his acts as Bwana Boma perceived them, it must be assumed that the chief re-ceived substantial support and solidarity from those around him. Indeed, among the changes Lusinga may have instituted as he sought to legitimize his bid for power was what John Iliffe might recognize as a shift from the "hori-zontal" sense of honor shared among remarkably egalitarian Tabwa farmers and fisherfolk through the flexible expectations of matrilineal descent, to a "vertical" honor code directed toward exaltation of a ruler—with the emerg-ing social hierarchy so implied.[34] Let us consider these matters in some detail, for they are of the utmost importance to an understanding of the communal basis for the event of chiefly burial, as well as the cultural ends that Storms's punitive expedition precluded for Lusinga's survivors.

Putting to death those most closely related to the chief was an example of what Joseph Roach calls "the performance of waste." Roach is reflecting upon Georges Bataille's sense of the "catastrophic expenditure" engaged through choreographed violence and Lewis Hyde's "comparison of the economy of sac-rifice to the circulation of blood."[35] As "blood relatives" through matrilineal descent, the grandchildren of a chief like Lusinga or Kansabala were considered the man's "wealth" (*mali* in Swahili) "as though they were his slaves," Chief Zongwe told me—and this in a late nineteenth-century context in which

human life was suddenly, radically, and obscenely commoditized through the burgeoning east African slave trade. "The word 'slavery' carries with it a bundle of connotations—all of them nasty," Frederick Cooper reminds us, and all of them synecdochal for social relations that were hugely fraught, influenced as they must have been by particular histories as well as by regional and global complexities. As many have discussed over the years, domestic slavery resulting in the restricted independence of war captives or others whose lives might be controlled and labor exploited was often marshaled to strengthen lineages by incorporating people through fictive kinship. In what would be to the advantage of an ambitious person such as Lusinga, this stratagem could undermine the autonomous power of lineages as well, "giving an aspiring king or ruling class a power base independent of entrenched kinship groups."[36] In this regard, Lusinga's turn to rugaruga mercenaries reinforced his ability to rule rather than lead so that he could overcome the paradigm of small-scale lineage-based chiefdoms that otherwise was and to a large degree still is the norm among Tabwa. Such conceptions and uses of people were nonetheless very different from the slave trade to, within, and from eastern Africa in the second half of the nineteenth century.

As Bataille had it, the victim of human sacrifice "is a surplus taken from the mass of *useful* wealth." The person so relinquished is "consumed profitlessly, and therefore utterly destroyed. Once chosen, he is the *accursed share,* destined for violent consumption." Sacrifice of the Tabwa chief's granddaughter was conscious denial of the "inalienability" and permanence of such a relationship that Tabwa usually associated with the living bonds of kinship, as they still do.[37] Such a process led to the young woman gaining pronounced importance precisely because her life was "wasted" with such impunity, again following Bataille and Roach. By permitting the destruction of his most intimate "wealth"—presuming, that is, that it was the chief who decreed or at least agreed to such finalities—the man demonstrated limitless power that absolved him of emotional attachment. Furthermore, for a "sanguinary potentate" like Lusinga or the equally ruthless Kansabala, the "profitlessness" of such waste might have been a shocking, purposefully heinous way to announce the "normalcy" of ruthless engagement in the slave trade through brutalities that might even be directed toward their own extended families.

The granddaughter's performance seems to have ended her "surrogation" of the chief, to again borrow a term from Roach, as she pretended through her own groans that he was still alive, even as his decomposition continued and she

"cradled" his cadaver on her lap.[38] The young woman had taken the chief's place for those unspeakably painful weeks of seclusion, and her execution also stood in for his own demise: she perished as a consequence, but he was only physically deceased, for his skull was kept as the locus of spirit realized through veneration. As such, the cranium would inform everyday events in consultation with the person who succeeded to his name, office, and, indeed, his very being.

Care must be taken to avoid the value judgments about such matters implicit—or frequently enough, painfully *explicit*—in missionary, colonial, and even some later anthropological accounts. Rather than dismissing a practice like the human sacrifices of a chief's funeral as blindly brutal, one can wonder what the young woman's own motivations as well as those closest to her might have been in such dire circumstances, while trying to grasp why European observers reported events through the terms and political perspectives they chose, so as to grasp the "double mediation" of cultures converging.[39] Furthermore, we must consider the transition from performance of funerary practices before the arrival of Europeans to the enforced obligation to seek permission to engage in such activities, as Kansabala's kin experienced when they requested that the White Fathers defer naming the chief's successor until completion of the ritual process.

Must we, in other words, necessarily understand that the woman was forced to give up her life against her will? As Peter Metcalf and Richard Huntington note with regard to just such elements of funerary ritual,

> the interpretation of emotion presents ... special problems for the anthropologist, because we are not equipped to deal with inner states. Even within our own cultures, it is hard to be sure that outward appearances match true feelings. How much harder will it be where the meaning of no posture, or gesture, or tone of voice can be taken for granted? Observers who imagine that they can see plainly into the emotions of people of different cultures are bold indeed.[40]

How do we know, that is, and especially when we have no way of experiencing the young woman's "posture, gesture, or tone of voice," that she as well as others whose lives would be sacrificed did not "*want* to go with Grandfather," as Chief Zongwe said they would exclaim? If we take such a statement seriously—as we should, since who are we to override what people are telling us of what their own histories mean to them?—then "the performance of waste" and the attendant sense of "catastrophic expenditure" must have been all the more

poignant. If such persons *were* willing to give up their lives to assure the continued presence of Grandfather, one can imagine that their devotion was reciprocated by the eternal spirit of the man whose physical death they were managing. Perhaps the woman's self-sacrifice was like the suicide of royal women in the Great Lakes region of central Africa who sought to accompany the king to the Afterworld. Or perhaps what was at issue was a matter of shared honor as demonstrated *by* the young woman *for* the deceased chief.[41] Bataille's assertion concerning "the accursed share" leads one to such a sense, for "the curse tears him [or, in the Tabwa case, her] away from the *order of things;* it gives him [or her] a recognizable figure, which now radiates intimacy, anguish, the profundity of living beings." In other words, the granddaughter and others who perished may have acted as martyrs for profoundly significant causes of solidarity. If so, it would be presumptuous to deny them their agency. Instead, what was significant may have been "the exercise of free, rational choice in undergoing death."[42]

Another dimension of the woman's sacrifice is suggested by her "cradling" of the cadaver in the early phases of the ritual, for her own sexuality and fertility were tragically at play. As Bloch and Parry have suggested, "death is often associated with a renewal of fertility" and so, in its own ironic ways, "death is a source of life." Indeed, death may be "transformed into regeneration by acting out a victory over (and thus giving recognition to) the finality and uncontrollability of death."[43] This is certainly the achievement of the ritual process we are considering, although it would seem that fecundity was not emphasized to the degree it may be in societies where rain or food are less plentiful or for whom animal husbandry is essential. Rather, Tabwa chiefs are associated with both the general well-being of their followers and management of particular resources such as river fishing through contact with *ngulu* (Earth spirits).[44] Balance, both cosmic and political, was of the utmost importance to ordinary social relations among Tabwa, whether or not it was the goal of politically ambitious individuals like Kansabala and Lusinga.

The granddaughter who cradled the moribund Tabwa chief seems to have possessed transcendent qualities that were of such consequence that she would not survive their deployment. As Hubert and Mauss reflected more than a century ago, "sacrifice is the means, *par excellence,* of establishing communication between the profane world and the sacred world." As she perished, the granddaughter secured the promise of such communication and her surrogation of the deceased chief would be eternal, for her death not only

joined but in a way surpassed the agency of her grandfather. As Hubert and Mauss might have asserted, the life force she sacrificed permitted the chief's continued presence through the reign of his successor. As opposed to their thesis, however, the woman's immolation does not seem to have led to her own apotheosis, although it certainly affirmed the enduring centrality of matrilineal descent to social life.[45]

If one understands that practices like those outlined here were meant to assure the continuance of the chief's presence despite physical death, the young people willingly wanting to go with Grandfather were making ultimate sacrifices to see that this occurred.[46] Over and above the political machinations in which Lusinga seemed to be such a willing proponent and player, the frightful circumstances of late nineteenth-century life in southeastern Congo must also be taken into consideration. So much death and destruction—both man-made and due to famine and epidemics of smallpox and cholera, but with malaria, tuberculosis, sleeping sickness, intestinal parasites, staphylococcus infections, and other dire maladies ever ravaging—made the maintenance of life uncertain at best. The death of the granddaughter, however much she may or may not have willfully martyred herself, must be understood as a sacrifice made in hope of community stability.

Before seeking deeper understanding of the anatomical symbolism at play in the funeral rituals we are considering, let us return to a last detail of Kizumina's account: the slow dance of muzamvi around the successor's abode to a tune celebrating resuscitation. Members of Bulindu, once an important women's society among Tabwa, also performed a slow, circular dance, especially at the death of one of their numbers. Bulindu concerns women's medicines and healing, and, as Christopher Davis explains, it is felt that over the course of their lives Bulindu members consume "so many medicines to preserve themselves that they cannot die a natural death. Without the performance by other adepts of a process which undoes the medicines (*kushindula*), such persons will physically rot while still speaking coherently. The graphic realism people use when describing this situation presents the striking image of a body devastated by putrefaction, stench and maggots, from which continues to flow the thin, clear stream of the human voice; pyrrhic victory over death."[47]

Bulindu had disappeared by the 1970s, although some spoke of a resurgence. What was the efficacy of its earlier choreographies? Like their dance, the circling of muzamvi reversed the order of things and so proved transcendent. One is reminded of the "dance of assassins" as Lusinga's fortunes were reversed,

and muzamvi marked achievement of continuity as the body of the chief was released from life while his spirit "awakened" in his successor.

Capital Truths

"It is not only because you risk losing it that your head is precious," Julia Kristeva reminds us. In order to understand why chiefly funereal rituals took such a grisly turn, one must investigate a Tabwa sense of anatomy that differentiates head from body. For Tabwa, the head is the seat of consciousness, perception, intellect, dreams, prophecy, and spiritual inspiration. It is subject to a range of particular illnesses and related vulnerabilities. Because the head is closely associated with social persona and political authority, it is deemed supremely masculine, while the body is "female" for its procreative functions. The body is also the seat of the mutima ("soul"; sometimes called *roho*) and of emotions like joy and hope that are associated with the heart and liver. Such a head/body dialectic reflects the gender politics and social interdependencies of matrilineal descent. Pondering such relationships, Roy Willis has suggested that many southern Tabwa ancestral figures materialize the contrast between "male" and "female" poles in the exaggerated elongation of their necks.[48] Significantly, neither the "Lusinga" nor the "Kansabala" figure stresses such polarity in its iconography, for in this feature they follow the aesthetics of Luba-influenced groups for whom descent is more readily associated with male lines.

Ordinarily, Tabwa dead are buried without the separation of head from body that was once orchestrated for certain chiefs. Instead, *vilio* (wakes) are held to mourn the loss while quick interment is effected with the assistance of *baendo* (joking partners) from clans different from that of the deceased. The mutima or "soul" never ages even as the body does, and at death it breaks free of the body to escape like an unseen wind.[49] The mutima wends its way westward along Mwila, the "path that crosses no streams," running along the watershed of a mountain chain adjacent to Lake Tanganyika to the cavern of Kibawa. As mentioned above, Kibawa is the great chthonic spirit who receives the dead and presides over the ongoing existence of their souls. During the 1970s, people at Lubanda spoke of the possibility of traveling to Kibawa's cavern to seek resolution of the most intractable problems from "the court of the dead." Not all souls proceed directly to Kibawa's cavern, however, for those of persons who have died by violence or who have otherwise left life with unresolved conflicts wander as vengeful ghosts (*vibanda* or *vizwa*). These

sometimes take the form of terrifying half-beings encountered on the darkest nights along Mwila and who may attack human passersby, visit their survivors through troubling dreams, or afflict their aggressors through illness and misfortune. In their divided form, such vibanda embody the need for resolution of conflicts so that souls may find peace.[50]

One reason for the grotesque funeral ritual described here may have been to emphasize the dismembering of the chief's cadaver and so create a hiatus between this world and the one beyond. As a consequence, the skull of the chief would be a "hostage from the beyond," to borrow an apt phrase from Julia Kristeva, and *not* find peace within Kibawa's cavern.[51] The mutima spirit could therefore be enjoined to inhere in the *nkisi ya mipasi* figure maintained by his successor even as the venerated skull assured continuity of inspired intellect. Such an obligation would remain precarious, however, since ghosts are altogether unpredictable by Tabwa reckoning except insofar as they are demanding of attention. In exchange for the power to effect supernatural undertakings, the spirit would need to be appeased through respectful ministrations, including the sharing of newly brewed millet beer.

The disjunction of and recombination of skull and body also transcended time. The skull was of an *ancestor,* as a person lost in the past though kept in the present until finally released in the burial of his skull with the body just deceased. The *then*-ness of the earlier chief's physical life was joined to the *now*-ness of the one just lost, whose skull would be retained for venerated consultation by the successor chief. "What will have been" was posited by the practice, in all paradoxical glory.

In those cases when the burial was realized as the remains of a chief were seated in the "pure repose" of "an enthroned attitude" in the bed of a diverted stream, further symbolic work was achieved.[52] It is difficult to imagine a more clear-cut realization of a threshold than this, for the grave was placed between one bank and the other and beneath the waters that would flow again once their course was restored. Generally speaking, thresholds are neither here nor there and seem without substance of their own, for their only purpose is to mediate, differentiate, and define transition. As such, a threshold presents "pure possibility" of interpretation and can "enfranchise speculation," as Victor Turner suggested more broadly concerning liminal phenomena, for through such "betwixt-and-between-ness" "there is a certain freedom to juggle with the factors of existence." A vitality results from the apparent contradiction of right and left mediated by the streambed in "a permanent and

balanced opposition" that is basic to social structure and the aesthetic principles through which it is contemplated and realized.[53] What better non-place than this, then, to assure that paradoxes such as the transcendence of death might be realized?

Access to this submerged realm was blocked to mere mortals by the reflective surface of the water. The land of the dead reversed the world of the living. Yet the living saw *themselves* when they looked at the waters again flowing over the chief's grave, and to underscore the perplexities, the Luba term for images seen in a mirror is *kilungi,* from the same root as Kalunga as the name that some Luba give to the place or the keeper of the dead.[54]

That a streambed might lead to the realm of spirits results from odd effects considered above with regard to the pier glass of General Storms's drawing room. Reflective surfaces are sometimes used in divination by people of the region, for they assist a practitioner to see—and perhaps to visit—the "other side." But people also fear that mirrors are haunted by the recent dead. Mirrors turn things around, and when Tabwa rituals associated with death and burial are completed, one should not look back lest the dead perceive and attach him- or herself to survivors. Similarly, at the beginning of Bulumbu possession séances a medium exits backward from the room where his or her ordinary self is asleep, thus underscoring the reversal of worlds; and as we have seen, certain Tabwa dance phrases, acrobatic tumbling, high kicks, and breaking to the back like "an eagle" all reverse "up" and "down" so that the dead may join and inform the living.[55]

Yet even as the surface reflected and interrupted access to spirit, it allowed intercourse between the living and the dead through the skull that a chief's survivors preserved to permit communication with the one whose wise words still enlightened, while his fertile body was consigned to the underworld with the skull of his predecessor. Indeed, the deceased chief embodied the vertical joining of worlds, and such burial further realized the paradox of a threshold that promotes contact with lost loved ones while defining the breech that can only be overcome in death and ancestorhood.

And finally, once the stream was allowed to regain its course, flowing down the mountains from west to east over the tomb of the chief and toward Lake Tanganyika and its shoreside communities, the reflective waters provided yet another opportunity for instrumental metaphor. An insight comes from Heraclitus, who has left us the famous aphorism "You cannot step twice into the same river." Flow and change are inevitable, in other words, and such

inexorable movement suggests vitality itself.[56] An equally pithy Tabwa couplet collected by Stefano Kaoze conveys something of the same sense: "There where waters were deep is now sand; there where there was sand are now deep waters." The level of Lake Tanganyika changes constantly according to the seasons, the heaviness of up-country downpours fed to the lake by creeks and rivers, and longer-term drought or excessive rains. And so—inexorably—do the features of the rocky shorelines where Tabwa seek to eke out their livings. In his annotation, Kaoze explained that "just as in the sea one often sees a succession of depths and sandbars, so here in our lowly world people's fortunes change, and a rich person becomes indigent and a poor one wealthy."[57] Unifying all such vicissitudes was the chief, deemed "father of his people," but of greater significance is Kaoze's play upon dialectic through the cited proverb as one thing inevitably and incessantly becomes its other.

Upstream lay the mystical, magical grave, then, where as his final gift, a chief linked the dead with the downstream vitalities of everyday existence that like the waters themselves, moved unstoppably onward. One can imagine that a further subtlety was among the motivations for burying chiefs under the waters, for the ritual process realized the chief's "perpetual perishing."[58] The constancy of rushing waters contributed to how the streambed burial must have been understood, and the joining of a former chief's skull and his successor's body referred to but overcame the objective reality of death through perpetual kinship in dynastic chiefs like Lusinga, Kansabala, and Mpala.

Spirals of Time

In his tomb a chief joined his predecessors accompanied by the souls of those sacrificed "to go with Grandfather" to the reversed realm of the dead. One is left to wonder about lost details of such a complex burial procedure and the philosophy it helped to realize. Was the granddaughter herself active after death as she assured that the chief's vital essence would remain? Might she have been contacted as a medium? Neighboring Luba have made extensive use of a similar underwater idiom in succession rituals through which those aspiring to royal authority must submerge themselves completely and perform miraculous acts as assisted by the spirits of prior kings.[59] A shared symbolic logic undoubtedly informed the practices of late nineteenth-century chiefs along the shores of Lake Tanganyika like Lusinga and Kansabala who aspired to Luba grandeur.

Figure 9.2. The spirals of *mpande* conus-shell disks reflect Tabwa senses of time and matrilineal descent through "inheriting the belt." Ink drawing to scale, Allen F. Roberts, 1978.

More ethnography illuminates the subtleties of the fraught drama of chiefly burial and its social significance. Light and enlightenment are given material form in mpande of the sort that appeared at least twice in a chief's funeral and succession. These shells were—and to an extent still are—important sumptuary property for Tabwa persons of pronounced reputation. In earlier times, disks cut from the blunt ends of cone shells of the Indian Ocean were traded all the way across central Africa as high-status emblems sometimes called *vibangwa*

or *vilungi*. The milky white circles of shell, lustrous and smooth on the outside and concealing a flat spiral within, were sometimes left with a lip so as to create a cup to receive small offerings during votive activities, but more often they were pierced in the middle to facilitate being worn on the forehead, on a thong around the neck, or on the belt by late-nineteenth-century Tabwa chiefs (fig. 9.2).[60] Such close association with the body meant that the shells not only enhanced communication of particular status and prerogative, as might be especially important in the turbulent days that have concerned us here, but they also brought about the embodiment of cosmological paradigms of deep significance. Here an ethnographic riff about mpande and how their interior spirals symbolize the passage of time will put the agency of these objects into perspective regarding burial of chiefs Kansabala and Lusinga.

Although one can only be conjectural in reconstructing such arcane and largely lost knowledge of the sorts of "qualitative representations" of time that preoccupied Henri Hubert a century ago, precolonial Tabwa appear to have understood time to be a spiral, as other Bantu-speaking people are said to have done.[61] As Wyatt MacGaffey explains, earlier Kongo held that the universe has "a non-reversible time dimension and thus . . . a spiral form" marked by "a sense of the dead as moving, by a series of transformation[s] in the after-life, through a hierarchy of increasingly remote but also more powerful and functionally less specific positions in the other world." Use of snail shells and other spiral devices "spatialized time" while symbolizing "persistence, . . . growth and change." Following similar logic, Tabwa origin myths tell of the first sentient beings emerging from a seemingly endless aardvark burrow or a pool of water so deep and arcane as to be "black," whence they moved outward in concentric waves to populate the earth. The dimensions of below and above the plane of the inhabited earth inform lateral growth of the spiral of life, but retain their reference to the ultimate abode of the dead in the ground or beneath the waters.[62]

Descent from these earliest humans is conceptualized in a related way through an idiom of cumulative social identity known as "to wear the belt" of a recently deceased kinsperson. In earlier times, Tabwa wore aprons of barkcloth secured by belts, and at least some chiefs wore beaded belts that were inherited by their successors; but nowadays the "belt" that is inherited is usually the European-style clothing with which an individual has been most closely identified in life.[63] Nonetheless, the idiom remains the same and alludes not just to the "belt" of someone who has died but to the "belts" that that person had inherited during his or her lifetime, and in turn implies those of earlier ancestors. Kinship

is conceived as a set of concentric circles growing smaller as they reach the "belt" of the first remembered ancestor, at the beginning of time.

Such a sense of the composite person is not as metaphorical as that term might be understood outside of Tabwa culture looking in, for the boundary between self and these others telescopes through time with "layers of biographical (relational) experience accreted together." Alfred Gell writes thus of "fractal personhood" as developed in the work of the anthropologist Roy Wagner in Melanesia, and of genealogy as "the key trope for making plurality singular and singularity plural." Indeed, "any individual person is 'multiple' in the sense of being the precipitate of a multitude of genealogical relationships, each of which is instantiated in his/her person; and conversely, an aggregate of persons, such as a lineage or tribe, is 'one person' in consequence of being one genealogy: the original ancestor is now instantiated, not as one body but as the many bodies into which his one body has transformed itself." As Wagner puts it, "A genealogy is thus an enchainment of people.... Person as human being and person as lineage or clan are equally arbitrary sectionings or identifications of this enchainment, different projections of this fractality."[64]

Mpande present spiraling "enchainment" in a most appealing way—that is, Tabwa deem them beautiful because they are so lustrous and so powerful. Like a mandala, the mpande's spiral presents "a symbolic pantheon" of chiefs twisting back in time to an apical ancestor or ancestress who emerged from an aardvark tunnel or deep pool, represented by the central hole drilled in the shell. Any such associations work centrifugally as well, offering ancestral inspiration to the chief of any given today. The shell is also a lunar symbol, and in one Tabwa cosmogonic myth an mpande and the moon are interchangeable, while in other stories an mpande is understood as "the eye" or cavern of Kibawa, the great spirit that keeps the dead. The shell may also refer to a clan ancestress' womb and her "spiral" of descendants, as is reflected in patterns in nineteenth-century scarification.[65] All of these symbolic references and the transcendent "work" they did—and to an extent still do (at least through the 1970s)—were brought to bear when an mpande was bound over the chief's mouth at his death and again when he "returned" and "awakened" in the person of his successor.

After succession, the most cherished possession of the chief became the skull of the predecessor he had now "become" through positional succession.

a b c When B dies he is buried with A's skull that he has venerated;
A B C D B's skull is kept by his successor, C, whose skull will
 eventually be preserved by D.

Here again, Roy Wagner's model of "fractal personhood" comes to mind, and especially his use of the term "enchainment" as one person subsumed another through this most intimate of means.[66] At death the Tabwa chief's body would be buried with the skull of the chief who came before him and with whom he had communed through the years of his leadership via the ministrations offered to the cranium he so revered. The skull of the chief was decidedly *not* "thing-ified" as a *crâne chosifié*, like Lusinga's was in Houzé's hands. Instead, it was a vital presence integrated with the being of the living chief, as proven when he himself eventually died—unless, that is, Bwana Boma cut off his head and took it with him to Belgium.

Final Thoughts

Heady questions remain. As Julia Kristeva muses,

> If the vision of our intimate thought really is the capital vision that humanity has produced of itself, doesn't it have to be constructed precisely by passing through an obsession with the head as symbol of the thinking living being? . . . Through a ritual of the skull, of beheading, of decapitation, which might be . . . what allows us to stand up to the void that is none other than the ability to represent the life of the mind, psychological experience as the capacity for multiple representations?[67]

The skull of Lusinga would have been like any other simple "bone," as Hegel had it, and indistinguishable were it not for the oddly elaborate ritual just described. Yet through symbolic processes, the cranium was recognized as a relic of the man himself to be cherished by his successor until this latter's demise. At the same time, although somewhat generic in style, an ancestral figure like "Lusinga" might appear so much more lifelike than a skull, yet as a "relay with the divine" its spiritual inherence and aesthetic references were collective rather than personal.[68] Is there an irony in something as common as a skull being so very special while something as efficacious as an ancestral figure makes common rather than specific reference? The chief's skull provided one sort of contact with ancestral powers, the figure another. Might it be that the disparity between the similitude of the one and the "realism" of the other is something only non-Tabwa would be likely to ponder? Or was the ritual decapitation and subsequent reverence of the particular man's skull a necessarily thoughtful complement (in Kristeva's terms) to the varied inherences of the figure?

Both skull and figure possessed spiritual presence and were consulted, protected, and otherwise brought into active social life. The cranium, though, was "produced" through the complexities of composed decomposition and so shifted from the idiosyncrasies of living toward the homologies of the dead. Lusinga's skull would have been preserved as a "hostage from the beyond" in order to keep the chief's spirit in proximity, but however interrupted during the successor's lifetime, the ancestral path had been begun and would be resumed and completed through burial beneath a stream as the cranium of the one chief was "enchained" with the acephalous *kiwiliwili* of another. The figure, on the other hand, was already less and more than the man who possessed it. Ancestral spirits inhabited the *nkisi* as a collectivity defined and activated by perduring signs of beauty and strength to transcend any particular soul like Lusinga lwa Ng'ombe. We shall return to these thoughts one last time in our final pages.

10 · Defiances of the Dead

*Speaking for the first time of things never seen, . . . this language
carefully hides that it says only what has already been spoken.*

—MICHEL FOUCAULT, *DEATH AND THE LABYRINTH*

Storms's African souvenirs remained in his widow's possession until the early
1930s. As Boris Wastiau comments, by then they had become "family relics,
metonyms of the deceased, . . . thereby implying new 'rituals' of remembrance
and devotion"—to Henriette Dessaint Storms and her family and friends,
that is, rather than to the people who had made or used the objects and from
whom the lieutenant had seized them. The ongoing "social lives" of the things
seem to have left any such possibilities far behind. The general's collections
were donated to the Royal Museum of the Belgian Congo in response to the
efforts of Frans Cornet, head of the RMCB's Moral, Political, and Historical
Sciences Section, which was dedicated to memorializing Belgian accomplish-
ments in the Congo. As Maarten Couttenier reports, the section was founded
in 1910 to counter international criticism of atrocities of the Congo Free State.
A "glowing" revisionist image featuring "the colony's 'intellectual and moral
development' towards 'progress'" would downplay or simply ignore "negative
aspects such as . . . forced labor, mutilations, rapes and murders that occurred
during the economic exploitation of 'red rubber' and the violent military
occupation."[1]

Cornet's approaches to colonial families of "the heroic period" were sometimes met with resentment, for "'the poignant memories, [and] the stoically endured sufferings'" of early officers seemed betrayed by the indifference or outright opposition of many Belgians to the colonial project. Madame Storms seems to have shown no such reticence. Cornet promised her that he would write a biography of her late husband, and perhaps her decision was made easier as a consequence. The book was never written, however, for reasons that remain unclear.[2]

A Memorial Room, now known as Gallery 8, was created at the RMCB in the early 1930s as a "Congolese Pantheon" within an inner-court arcade. The names of fifteen hundred Belgians who had given their lives in central Africa or who had provided significant service to the colonial enterprise in its early years were inscribed on a wall. Beneath these, photographs from the museum's Propaganda Service depicted "progress" in the Congo between the earliest years of Belgian intervention and the 1930s. Other photos mounted around a portrait of Léopold II contrasted housing, crafts, and ritual activities that were believed to be typical of "Negro life" in the Congo with images of the "'perfection of the current medical services and the importance and beautiful organization of the mine exploitations.'"[3] "Primitivity" versus "progress."

An ivory bust of King Albert I was placed adjacent to these displays after his death in 1934. In an alcove framing the sculpture of the regretted monarch, an eye-level plinth held a bust of Edmond Hanssens, an army captain who died in the Congo in 1884 after two years of service with Henry Morton Stanley, during which he was responsible for outposts from the Atlantic well up the Congo River. Directly opposite was a gleaming white bust of Émile Storms by Marnix d'Haveloose, donated to the museum in 1930 by Storms's widow.[4] That this memorial was in such close proximity to the king's suggested recognition of the lieutenant's contributions to proto-colonial history; and that the busts of Hanssens and Storms were placed either side of that of the king's "represented the occupation of Central Africa" from west and east coasts, respectively.[5] A "White Line" had been drawn across the "Dark Continent," however much in afterthought.

The materials of Gallery 8 as presented in 2010 allow us to guess something of how Storms wished to be remembered and how curators and his public have invented him over the years since his death in 1918. In the corridor perpendicular to the alcove still occupied by the bust of Storms stands a

Figure 10.1. Storms's mementos in a vitrine at the RMCA, 2010.
Photo by Kathleen Louw, with permission.

lighted vitrine holding mementos of Bwana Boma (fig. 10.1).[6] Rustic matting covers the ceiling, back, and floor of the case, suggesting adventures in exotic places. A watercolor portrait of the lieutenant by James Thiriar is the center-piece of the display, which includes clothing and other effects seen in the picture as well as several scientific instruments, a central African drum, and a small oil painting of "The *Strauch*," the sailboat so proudly crafted by Storms to ply the waters of Lake Tanganyika.

James Thiriar was a noted Belgian illustrator who specialized in depicting historic military uniforms and battle scenes of the World Wars and who occasionally designed costumes for the Brussels opera.[7] In his picture of around 1930, *Le lieutenant É. Storms en 1885,* Thiriar portrayed Bwana Boma as a bit the Zouave, a bit a pirate of Penzance. A red fez rides high on the brow, its jaunty tassel behind the ear (fig. 10.2). The subject sports an impressive beard and exuberant mustachios. He wears an open-necked shirt beneath a tight, white, double-breasted jacket that is met abruptly at the waist by a swashbuckling red sash. A canteen flask lies upon the intrepid soldier's hip, its strap extending bandolier-style across his robust breast. Light-colored,

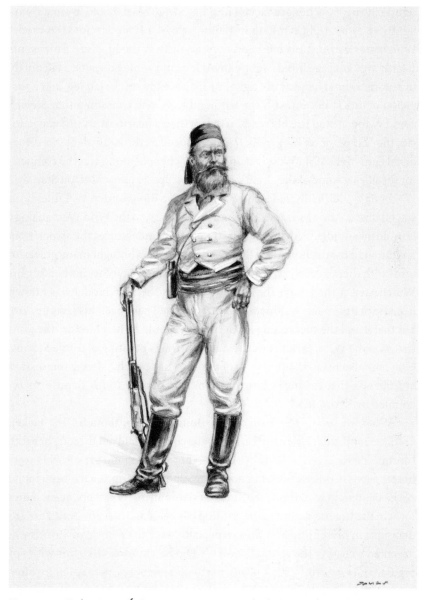

Figure 10.2. *Le lieutenant É. Storms en 1885*, a watercolor by James Thiriar. HO.0.1.641, collection RMCA Tervuren, RMCA Tervuren© with permission.

tightly fitting breeches are tucked into knee-high black boots. Bwana Boma lightly rests his right hand upon the muzzle of a lever-action, 1866-model Winchester carbine, his left hand nonchalantly at the hip.[8] He frowns, his sternly vigilant gaze lifted slightly to his left, and while he seems a tad portly in repose, a slight bend of the right knee, his weight on the left leg, and a suspicion of quick motion with the left hand leave one to assume that Storms could swing up and fire his weapon in less than a heartbeat. With braggadocio, the "Emperor of Tanganyika" is introduced as the equivalent of a dime-novel hero of the Wild West and, in all his cocky splendor, a worthy competitor for at least some of the attentions lavished upon Henry Morton Stanley.

Buffalo Bill (William F. Cody) and Pawnee Bill (Gordon W. Lillie) both staged their extravaganzas in Belgium in the 1890s, so the Wild West analogy is by no means idle.[9] A detail of Thiriar's portrait underscores the association, for although Bwana Boma and the IAA commanders brought many powerful arms with them to central Africa, in the watercolor we see Storms holding his Winchester at the ready. The "Yellow Boy," as the 1866 model was known because of its bronze "gunmetal" frame, may well have been his favorite arm, but that it and the succeeding model of 1873 should be heralded as "the guns that won the West" is not coincidental to Thiriar's painting of Émile Storms. One may also recall that firearms of the sort made such a strong impression at Lubanda that Lusinga's lust for them contributed to his demise, as recounted by Kizumina.

What *are* we to think of Bwana Boma's get-up, though? The jacket, breeches, and red fez seen in Thiriar's watercolor are laid out directly beneath Storms's portrait in the RMCA vitrine. They do exist and presumably were his property, in other words, but no photograph or description has been found of the lieutenant wearing such things, and this attire was by no means a uniform of the times. Furthermore, nothing has been discovered about Thiriar's decisions in presenting him thus, especially since the picture of Storms was executed well after the general's death.[10] Did Storms dress like this with any regularity, or was the attire for very particular purposes, perhaps more often once back in Belgium than while serving in central Africa? In other words, like the delirious displays of his drawing room, was the clothing something other than a selection of practical items?

Famous images of Henry Morton Stanley and Savorgnan de Brazza suggest how significant costuming was to the invention of late nineteenth-century heroes of African exploration. For example, many photographs of Stanley

depict him at key moments of his life, but two stand out as most memorable. One is a head-shot of Bula Matari—"the Stone-Breaker," as the ambiguous nickname by which he was known that would become synonymous with harsh colonial occupation of the Congo. We see Stanley wearing the high-crowned, multi-perforated, visored hat that he himself invented to cool his fevered temples in the tropics. The cap's black band sets off the scowl of his umbrous mustache, and a "havelock" sun flap suggests odd ailerons, as though the contraption might fly off his head at any moment. The effect would be comical were so tall a cap to be worn by so short a man, *if* the person in question were anyone but the indomitable Henry Morton Stanley. The same portrait's foreboding glare discourages any such impertinence.[11]

The other matrix image of Stanley is from a series of *cartes de visite* shot in a London studio in 1872 that show the armed stalwart in his trusty pith helmet. Stanley wears a white service jacket and loose above-the-knee mosquito boots, and an opened holster on his belt holds a cartridge revolver positioned for a quick, right-handed cross-draw. He gravely gazes to his left as he holds his large-bore, double-barreled, percussion shotgun at the ready, his finger on the trigger. The Congolese boy dubbed "Kalulu" (after the trickster hare of central African lore), whom Stanley brought to Europe with him, glumly plays the role of a porter by carrying a percussion musket by the barrel, its stock over his shoulder (fig. 10.3).[12] As depicted by Thiriar, Storms assumes a pose so reminiscent of Stanley's that, aside from the former's Orientalist touches, the two men seem purposefully of a piece.

In contrast is the way that de Brazza is portrayed in a classic photograph by Félix Nadar. De Brazza is unarmed and wears the loose head wrap and worn-and-torn robe of a most humble "secular saint." The picture "emphasized poverty, sacrifice, and redemption," and de Brazza "looks like a barefoot prophet," Edward Berenson observes—"an apostle of humanity and civilization who brings enlightenment to the Dark Continent." Aside from his own goals for "the image he so assiduously cultivated," de Brazza's persona was of great propagandistic value to French colonial concerns aided by the popular press. This was especially so in contexts in which his compassion could be contrasted with Stanley's brutality as the two strove to establish territorial claims to the same stretches of the Lower Congo, but de Brazza's "charismatic allure" also helped unite a fractious French Republic that was still reeling from ignominious defeat in the Franco-Prussian War. Today's cultural politics finds Nadar's evocative image useful as well, as both France and Congo-Brazzaville

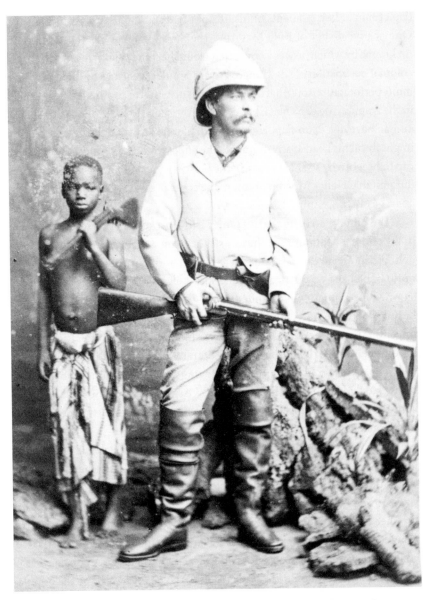

Figure 10.3. Henry Morton Stanley and "Kalulu" in 1872, *carte de visite* by London Stereoscopic and Photography Co. Russel Train Africana Collection, Smithsonian Institution Libraries, SIL28-277-01; public domain.

again bill de Brazza as "the peaceful conquerer"—however "oxymoronic a sobriquet" this may be.[13]

At a more general level, exotic attire of the sort shown in all of these pictures had several purposes, including, at least for Stanley and de Brazza, the selling of memoirs and subscriptions to lectures and other ploys to merchandize African adventure to avid late nineteenth-century audiences. Because Storms did not seem interested in or able at such self-promotion, it would appear that other ends were envisioned in his portrait. Again, because no written description or photograph has been found of him wearing the clothing depicted in Thiriar's watercolor, it remains difficult to interpret Storms's motivations or the artist's either; and yet notions of "manliness" and attendant forms of muscular, militant chivalry that were so sought in the fraught circumstances of turn-of-the-century Western Europe must have been central influences for how Bwana Boma wanted to be remembered and how Thiriar presented him to the world.[14]

Explorers were the heroes of late nineteenth-century everymen and -women in Europe and North America. The clothing donned, arms borne, poses struck, perils survived, loneliness endured, lessons learned, compassion shown, and violence meted all stood for far more than the individuals themselves or the particular activities in which they engaged, no matter how singular the explorers' personal histories. How, though, does such an idealized vision as "Lieutenant Storms in 1885" by James Thiriar differ from the equally aestheticized "Lusinga" expressed by a virtuosic east-central African artist? The style and spiritual investments of the latter clearly differ from the flourishes of the former, and yet the works have more in common than not. Recalling the logic of *milandu*, the principle purpose of these representations was and still is to instigate narratives about what could be, as well as what might have been.

Cries and Whispers

In 2010 the serene bust of Émile Storms was still on view in the Memorial Room of the Royal Museum of Central Africa, but it shared its alcove with a larger-than-life figure of a Congolese man in an altogether jarring juxtaposition (fig. 10.4).[15] The work is titled *Defiance*, and it was created in 1909 for the Paris Salon by Herbert Ward, a noted British sculptor who had served with Stanley in the Congo. The man so depicted is most belligerent. His chin is thrust forward in furious resolve that, in a sublimated yet deliberate feature of "visual rhetoric," stresses the "slope" of his forehead as a revelation of

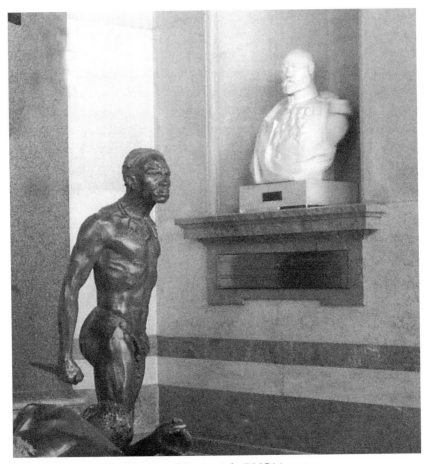

Figure 10.4. *Defiance* and the bust of Storms at the RMCA in 2010.
Photo by Kathleen Louw, with permission.

evolutionary inferiority to those who might scrutinize his countenance for
clues to the "arrested development" and "decadence" of Africans.[16] The man's
pronounced muscles are taut and bared, and he wears only a loincloth. A long
knife is clutched in his right hand, slightly hidden behind his back but ready
to stab, while his left is clenched in a very tight fist, and he stands ready to
stride forward in attack.

"The 'realist' colonial gaze [*regard*] is the gaze of Medusa," Jean-Pierre
Jacquemin tells us, and as "it petrifies the colonized," it abandons them to a
limbo of generic representation.[17] One is left to assume that *all* Congolese
must be as eternally "defiant" as the African of Gallery 8 is portrayed—but

of what? "Civilization," most probably, as colonizers defined the term. Yet given the proximity to Storms's bust, how is the "defiant" man *not* imbued with the ghosts of Lusinga and his countless contemporaries ready to avenge their bloody dooms of the mid-1880s?

Whatever Ward intended the man to be defiant about, his pose is open to any narrative a viewer wishes to supply, and the lurking figure still provides a frisson of "savage" menace to young museum visitors passing by to peruse the memorabilia of heroic explorers in vitrines along the perpendicular hallway. Sculptures like *Defiance* serve as "totalizing metaphorical vehicles," and all these years later they "materialize the imaginary of Otherness" in what could be described as Gallery 8's "space of subjection." In contrast to the darkly depicted hostility of the anonymous Congolese man, Bwana Boma's imperious scowl is fixed in marmoreal pallor. Through the bust, Storms is removed from the "racial somatocentricity"—that is, exaggerated attention to the body to the exclusion of the mind—characterizing the full-figure sculpture of the generic African. As Frantz Fanon suggested, "In the white world, the man of color encounters difficulties in the elaboration of his corporeal schema. Knowledge of the body is a uniquely negating activity." Instead, through his bust, Storms is "located in an ideology in which bodylessness is the precondition of rationality."[18] Physiognomy and phrenology play upon popular consciousness even as they did in belle époque Belgium, and one can imagine that had Émile Houzé realized his plans of 1899 to create an ethnographic gallery "to illustrate human evolution over the centuries," works by Ward would have found a welcome place as they long have in the RMCA and the Smithsonian Institution's National Museum of Natural History in Washington, D.C.[19]

It seems that the 2010 location of *Defiance* was temporary, as it and other large sculptures were removed from the RMCA's small rotunda when a public research corner was created there, and a more permanent exhibition space for the works was being planned for 2015. Over and above the sheer need to put *Defiance* somewhere, the choice of Gallery 8 may have been made because as a European work of art, the Ward figure would be at home among other European creations and their narratives, Mary Jo Arnoldi surmises.[20] This is not the first time such a juxtaposition has been created, however, as revealed by a circa-1930 photograph of the Royal Museum's Salle de Mémorial. In the image, a different larger-than-life figure of an African stands spear in hand before the sublime bust of Storms. Arnoldi suggests that the figure might have been a mannequin from the Congo displays of the 1897 Universal Exposition

held in Tervuren.[21] No matter how functional such placement may be, however, visitors are free to draw their own ideological inferences. Indeed, was the specter of Lusinga stalking Bwana Boma in the 1930s through this other sculpture as he seemed to be doing so "defiantly" in 2010?

The "Lusinga" figure is displayed in a case with other Tabwa sculpture in a space adjacent to Gallery 8. As the preceding pages have suggested, "Lusinga" has much more to say, Bwana Boma's "ventriloquism" notwithstanding. Indeed, talking back was and still is precisely what the figure wants to do. One can almost hear its cries and whispers, in much the same way that the conceptual artist Fred Wilson summoned the souls of African masks through an installation called "Spoils" in his celebrated "The Other Museum" exhibition of 1990. Six west African masks were gagged and blinded by colonizers' flags while a woman's voice entreated, "'Don't just look at me, listen to me. Don't just own me, understand me. Don't just talk *about* me, talk *to* me. I am still alive.'" To complement such urgings, captions and wall texts were composed as though by the vanquished, and elitist provenance was replaced by notation of those from whom the objects were "stolen," in Wilson's terms. In this regard, one can only applaud an interpretive exercise begun by RMCA curators in 2008 to invite Congolese artists to "reinvent forgotten narratives" of objects in the museum's displays and reserves, with the explicit goal to "break the anonymity" of its collections.[22]

The figure of "Lusinga" is now considered among the masterpieces of the RMCA and has traveled the world as such. In 1986 it was featured in the exhibition "The Rising of a New Moon: A Century of Tabwa Art" seen at the Smithsonian Institution's National Museum of African Art, the University of Michigan Museum of Art, and the RMCA, where it would be the first traveling exhibition that museum had presented to the public since 1927, it was said at the time. To paraphrase Walter Benjamin, "cultural treasures" such as the "Lusinga" sculpture "have an origin which one cannot contemplate without horror," yet RMCA staff of the time insisted that no label copy or other mention would be permitted to explain how this and a few of the other objects in the exhibition had been obtained in December 1884 through the punitive expedition of Émile Storms that is the subject of this book.[23] "Lusinga" was to be seen but not heard.

When this same Tabwa object and others were on display at the RMCA in 2010, a label informed visitors that the figures were "seized in 1884 by Lieutenant Émile Storms' men who came to punish chief Lusinga and his maternal uncle

Kansabala for having been too ambitious in taking part in the slave and ivory trade and in particular for having opposed him."[24] Despite such a brave attempt to rethink colonial history, "Lusinga" was grouped with a panoply of Congolese sculptures and given no specific identity of the sort afforded Bwana Boma through his bust and display of memorabilia, including James Thiriar's water-color of the dashing lieutenant. Storms's effects were virtually voiceless as well, for in a way Bwana Boma was "collected" even as he amassed and classified objects of ethnographic and natural-history significance during his days at Lubanda. He, too, is now and has long been a "specimen" subjected to "synec-dochal diremption," to apply Susan Stewart's apt phrase again.[25] That is, some small portion of his existence has been torn away from his physical and intel-lectual being as Belgian and Congolese histories about him have been negoti-ated over time. At the RMCA these bits have been made to stand for ill-defined abstractions like "heroism" as one looks back to the earliest establishment of colonial hegemony in the Congo. One can say the same of Lusinga's ancestral figure and skull, silent in museum vitrine and drawer. Lost is any sense of how they were understood and would have been performed in confirmatory rituals had they remained in his family's hands. Such reductionism is difficult to avoid, as museums must present a very few artifacts to tell the biggest of stories. Counter-narratives like those conveyed in these pages must await their day.

Last Provocations

This book has been divided in two. The first five chapters present competing yet imbricated histories of two hugely ambitious men: one Congolese, the other Belgian. As the protagonists engaged in a deadly pas de deux, they mir-rored each other in ways that neither could have fathomed nor would have admitted if he did. Both men aspired to far greater glories than either attained, and one took the head of the other. A second section traces what happened to the skull and other soulful parts of the African once they were exiled to Eu-rope and the Belgian incorporated them into his phantasmagorias, along with what might have happened had they remained in the Congo. The protago-nists' mimesis set the scene for colonial hegemony soon to be imposed in the 1880s and for attitudes still with us all these years later, yet the madness of encounter is as significant as any so evident outcomes.

To reflect such *bizarreries,* the epigrams opening the two parts of *A Dance of Assassins* are taken from the purposefully perplexing French writer Raymond

Roussel, "President of the Republic of Dreams," as Louis Aragon dubbed him. Roussel never visited Africa, and so—as Michel-Rolph Trouillot might have it—he knew all about it. Through the slightest phonetic shift of *pillard* (plunderer) to *billard* (billiard table), Roussel composed two different sentences with nearly the same words: *Les lettres du blanc sur les bandes du vieux pillard* (the white man's letters on [about] the hordes of the old plunderer), and *Les lettres du blanc sur les bandes du vieux billard* (the white man's letters—or white letters—on the cushions of the old billiard table). Within the hesitation between *pillard* and *billard,* Roussel unleashed a nonsensical novel with the first sentence its instigation and the second its resolution.[26]

We have seen that Congolese sometimes engage Rousselian semantic subtleties, as in the distinction between *kutòmboka* as a dance of exaltation/exultation at a chief's assumption and presumptions of authority, and *kutomboka*—without low tonality—as a reference to rebellion. The words shadow each other like *sompo* dancers, and punning across such febrile differences is the stuff of oratorical genius. Following similar principles, deeper dialectics give shape to Tabwa philosophy as one force gives way to another, only to be reversed in an unending spiral of time. Roussel's meta-grammatical shift from *pillard* to *billard* would be understood by brilliant narrators like Kizumina, who conceal such abstruse idioms in their ribald humor. Pillard and Billard had their moment, too, though now long forgotten by most. That they still whisper to and about each other should be evident by now.

Appendix A · Some Background on Our Protagonists

LUSINGA LWA NG'OMBE (ca.1840–1884) and his mother's brother Kansabala Kisuyu hailed from Buluba (Urua or Uguha in early European accounts), the generic name for lands northwest of Lubanda inhabited by eastern Luba and Luba-influenced people. Pierre Colle's important ethnography of 1913, *Les Baluba,* concerns just such communities that were peripheral to Luba polities along the lakes of the Upemba Depression and the banks of the Lualaba River, as a major tributary of the mighty Congo. Indeed, the foremost figure of Colle's account, Chief Kyombo, was of the same clan as Lusinga, and as Colle explains, Kyombo actively sought Luba material and performance arts in emulation of his powerful neighbors.[1] Lusinga took similar measures, and his praise name, "Ng'ombe," makes esoteric reference to Luba kings, tributary gifts, burial places, and ancestral spirits. At greater geographical and intellectual distance, the name resonates with social relations and cultural principles personified by Ryangombe, the hero of societies of the Great Lakes region of east-central DRC, Burundi, and Rwanda.[2] Such references are consistent with the thesis of the present book, that Lusinga lwa Ng'ombe was a most ambitious actor in times of radical social change.

Both Lusinga and Kansabala are said to have lived near the confluence of the Niemba and Lukuga Rivers west of Lake Tanganyika before moving to where our story finds them in the vicinity of Lubanda. Little is known of their earlier histories, although one colonial source reports that in those days Lusinga was recognized as the senior kinsman of Tumbwe, who would soon surpass him

in political stature.[3] In the 1920s and '30s, Belgian colonial administrators seeking to understand the genealogies, dynastic lines, and interrelationships of local chiefs so as to establish indirect rule through a hierarchical *politique indigène* paid relatively little attention to Lusinga's history, perhaps because of the remoteness of his mountain domain. Such matters were and are exceedingly complex, given the ways that purposeful and competitive histories are generated according to situational need through the *milandu* idiom discussed in chapter 2.

Lusinga and Kansabala were said to have been Kalanga, an ethnonym associated with a chiefdom north of the Lukuga, but more generally an imprecise term applied to people sometimes known as Kunda or Lumbu.[4] At Lubanda, "Kalanga" is an epithet for people deemed "unsophisticated" because of their residence in remote lands well to the west of Lake Tanganyika.[5] Lusinga and Kansabala were of the Tusanga or Bena Tanga clan, as are Kizumina, Mpala, Tumbwe, and other personages important to the present discussion. Tusanga live in chiefdoms scattered northward from a reputed homeland in the Mofwe marshes near Lake Mweru, and from Lubanda on to the Lukuga River they are often called Batumbwe, an ethnonym derived from the dynastic name of the important paramount living near the present-day city of Kalemie. The late Dr. Geneviève Nagant spent many years in Kalemie as a lay missionary who carefully collected and synthesized reports and oral narratives concerning political histories of Chief Tumbwe and his close kin, and interested readers are directed to the rich documentation of her unpublished theses of 1972 and 1976 at the École Pratique des Hautes Études in Paris. "Holoholo" is another ethnonym sometimes applied to these same people, but it is a sobriquet more than a social designation. In the present text, Tusanga are understood as Tabwa, after an ethnic gloss frequently used at Lubanda that includes other clans as well.[6] The relative seniority of lineages vis-à-vis that of Sultani Mpala is important to local-level politics at Lubanda as disputed via milandu narratives, for land rights and related prerogatives hang in the balance. According to hierarchies established by Belgian colonial authorities, those who succeeded Lusinga lwa Ng'ombe are subservient to Kansabala but superior to Mpala—to no one's satisfaction, especially within the ranks of supposedly "inferior" chiefdoms.

ÉMILE-PIERRE-JOSEPH STORMS (1846–1918) was born into the French-speaking Flemish family of Baptiste-Joseph-Renaud Storms and Hélène-Caroline-Joséphine Hansez in the small town of Wetteren in Eastern Flanders,

not far from Ghent. Nothing has been found of any siblings Émile might have had, and because he and his wife had no known children, it appears that the family's descent ended with Émile. General and Madame Storms are buried in Laeken Cemetery, Brussels' most socially prominent resting place, located near Léopold's sprawling *domaine royal;* yet in 2010 the tomb was nearly covered by bushes, and cemetery staff attributed such lack of care to a family long without issue.[7]

Storms's dossier from the Belgian Ministry of War (#8547) is available at the Royal Museum of the Armed Forces and Military History in Brussels.[8] When he was only fifteen, Storms joined the 6th Line Regiment of the Belgian Army as a student bugler (*clairon*), and the next year he was promoted to corporal. He advanced through noncommissioned ranks, and as a sergeant-major in 1869 he joined the forces led by Léopold II himself when a Belgian observational force defended the border with France during the Franco-Prussian War (1870–1871). In the course of this engagement, Storms was made second lieutenant and received a commemorative medal for the campaign. Oddly, no particular record of his war service appears in his official transcripts, and he made no mention of such activities in his Congo diaries or other documents. Storms was advanced to lieutenant in 1876, and through his recognized "rectitude and energy" was seen as "a model of order and work."[9] In 1878 Storms was admitted to the War College. He was assigned to the High Command of the 9e Line Regiment in 1881 and transferred to the Institute of Military Cartography in 1882 to accommodate appointment to the IAA as commander of the fourth expedition to central Africa that same year. His small-town background, early entry into the armed forces, and steady rise through the ranks suggest he was a military man of his own making, although hints do exist of a bourgeois family background that may have gained him notice.

Upon return from the Congo to Belgium in 1885, Storms returned to military service. In 1888 he was technical director for an antislavery expedition to Lake Tanganyika organized by the IAA with backing from Cardinal Lavigerie, founder of the White Fathers order staffing the outposts Storms had strengthened at Karema and founded at Lubanda. It seemed as though Storms might lead the mission himself, but when he met Henriette Dessaint (1861–1945) as he was working toward that end, he gave up any such plans so as to marry her the next year.[10] As Storms retired from active military service in 1909, he was promoted a last time to lieutenant general. Aside from service medals and being honored by membership in the Order of Léopold and the

Order of the Royal Lion of Belgium, Storms was decorated by the governments of Persia, Romania, and Serbia, although he is not known to have served in any of these countries. Madame Storms was also recognized as a *chevalier* of the Belgian Order of the Crown.

When he first returned from Africa, Storms resided on the Rue de Pépin in a decidedly upscale neighborhood, perhaps reflecting his parents' social standing. After marrying, the couple lived in Namur for some years to be close to Storms's military assignments, and thereafter they moved to the Chaussée d'Ixelles in Brussels for the rest of their lives, as discussed in chapter 7. Storms served as director of the Fund for Army Widows and Orphans for a few years after his retirement, and he and his spouse undoubtedly lived at ease from his pension as a lieutenant general of the Royal Army as supplemented for his African service.[11] Bwana Boma died in Brussels in 1918 at the age of seventy-two.

Madame Storms gave most of her late husband's writings and central African collections to the Royal Museum of the Belgian Congo (now the RMCA) in 1930 and Lusinga's skull in 1935. Lacunae in Storms's archival records may be due to several factors, but it is possible (although unlikely) that compromising information was redacted at the time of these gifts. As Maarten Couttenier has recently discovered in an unpublished report by museum curator Frans Cornet, who was charged with bringing such materials into the museum's archives, it was felt that "'it is best not to show strangers travel diaries that tell stories of relationships liable to provoke controversy.'"[12]

Appendix B · A Note on Illustrations

Illustrations chosen for this book have been selected from the very few that portray the persons, events, relationships, objects, and places that are its subjects. Not a single depiction of Lusinga has been discovered other than the sculpture embodying his matrilineage that was seized by Storms's men and is now to be found at the Tervuren museum, as discussed at length in chapter 9. The only sense we have of what the man may have looked like is derived from the two or three descriptive adjectives in visitors' accounts, and these were far from precise—or charitable. Portraits of particular central Africans are nearly nonexistent in explorers' texts or popular magazines of the time, in part because of the long poses still necessary and other practical aspects of the day's photographic technologies, but also because political purposes of illustration were first and foremost to contribute to proto-colonial ideology by depicting "natives" in very particular ways. That these pictures are cultural constructions of their day may seem self-evident, yet the paucity of scholarly attention to visual materials of the sort prompts this appendix.[13]

Émile Houzé's expositions of African craniometry had lasting repercussions, as suggested in chapter 6, but contemporary European and North American audiences without training in science were immensely interested in these same debates about how to "read" the dangerous "degeneracy" of others, even as they thrilled to adventures among exotic people and in parts of the world encountered by Europeans for the first time. To illustrate articles in wildly popular geographical broadsheets, magazines, and books about

exploration, artists portraying central Africans and their European visitors often adapted principles of physiognomy and phrenology to "show that their art was a science" and to suggest that through their work, readers might share in the "progress" of their times.[14]

Portrayals of central Africans varied in benignity. With very few exceptions, they were generic renderings, but then again, as we see in figure 1.4, so were many pictures of bearded European explorers cast in pith helmets and immaculate attire. Most Africans were depicted from a distance with little or no effort to differentiate between one dark face and the next. "Blackness" was further exaggerated by technical aspects of the engraving process itself. Some faces had no features at all, as though particularity might be oxymoronic for people deemed to look, act, and *be* so exactly alike. What difference might it make, then, that virtually the same drawing of an African woman appeared in two narrative pictures of Storms by Albert Ronner, as we see in figures 1.4 and 1.7?[15]

Poses given to Africans were typically those of fearful violence, sloth, or the drudgeries of manual labor. Warriors in feathered headdresses were shown in harrowing frenzies that seem borrowed from Wild West fantasies. Occasionally, physical disproportion exceeded ordinary artistic license, leaving one to wonder to what degree the goal was ever meant to be documentary in any literal sense at all. Most telling are depictions of African faces that are so exaggerated that one can only assume they were meant to elicit shocked or humorous response, especially in juxtaposition with the visages of Europeans like Storms, who, to paraphrase Victor Giraud, "possessed a physiognomy that was frank, open, energetic, and that made him sympathetic at first glance" (fig 1.1). Parenthetically, David Livingstone was appalled by the manner in which Africans were portrayed in European publications, and he demanded corrections of illustrations accompanying his own writing several times, apparently to some avail.[16]

Intriguing insight into such representation is provided by Hugues Legros in his discussion of the "the person of [the Yeke ruler] Msiri in European imagination." In the early 1890s, after the partition of Africa but before borders were fully decided, British and Belgian interests vied for control of the astonishing mineral wealth of southern regions of the Congo Free State. The two powers—with Portugal and Germany eagerly in the eaves—competed for Msiri's loyalties because of his acumen in gaining and maintaining control of vast networks of inter-regional commerce. "To perfect the exotic and adventuresome image of Katangan expeditions, it was necessary to add a savage

and bloodthirsty chief who wandered about in a landscape entirely modeled by European imagination and the appetite of colonial powers," Legros tells us. Significantly, "The more Katanga was [deemed] beautiful and rich, the more Msiri was represented as physically ugly, unintelligent, cruel, bloodthirsty, and tyrannical."[17]

Storms's friend Paul Reichard visited Msiri, for example, and as mentioned in chapter 1, he was infuriated by the warlord's political maneuvers at his expense. Seemingly in revenge, Reichard described Msiri as possessing a countenance so "hideous" that "one might think he were standing before a caricature."[18] Caricature surely enough, but of the German's cruel composition. The point was to portray such corporeal and moral "corruption" so as to make the civilizing heroism of the colonizers appear more pressing, for such a repugnant person as Msiri and all the atrocities he stood for would need to be eliminated before Europeans could realize their manifest destinies by capitalizing on the glorious potential of Katanga. One wonders to what degree Joseph Thomson's descriptions of the "sanguinary potentate" Lusinga might have been similarly motivated.

Period pictures of Africans were meant to be "read" according to well-established European conventions. Allusion has been made to the tensions of late nineteenth-century Western European and North American life, as elation at increased access to middle-class lifestyles was matched by fear of "degeneracy" within society and through contact with perilous "others." A gauge of insecurity was the widespread desire to fathom personal capacities and innate limitations based upon the supposition that the mind is manifest in facial features and the size and shape of one's head. That the book *Heads and Faces: How to Study Them* could have an astounding initial run of forty thousand copies in 1887 suggests the enormity of interest in such matters, as do the avid attentions that were paid to phrenological prognostications about suitable marriage, career choice, and whether or not to move from the metropole to the colonies.[19] Famous Europeans and Euro-Americans of the time were portrayed as exemplars of the traits the fortunate few might discern in their own constitutions. David Livingstone was widely deemed a model of "the motive temperament," for example, as his "long face, high cheek bones; comparatively large front teeth; rather long neck," and otherwise "strongly marked features" bespoke "strength, toughness, and capacity for great endurance" as requisites for the "mental, spiritual, and physical success" for which the great man was so revered. Africans were hardly mentioned in such diagnostic

handbooks, except as a distant foil for all that readers hoped to discover in themselves. Several European explorers, including Cameron and Livingstone, did sketch "phrenologically inspired 'head galleries' depicting several heads side by side for comparative purposes," however, and one can suspect that the idiom informed visualization more generally.[20]

Physiognomy led popular readers to reduce a face to prominent features associated with "identifiable meaning," leading to ready assumptions about Africans as occupants of the lowest rungs of an evolutionist ladder. Frighteningly, though, concatenations of these same features might also disclose "throwbacks" to "primitive" characteristics of "degenerate" Europeans. An "architecture of the face" could be discerned "hidden in the folds of the physiognomy, in the angles, the volumes, and forms of the wildest criminal's face and body offered up to the geometrical study of the anthropologist." Through Cesare Lombroso's studies of recidivist prisoners, for instance, it was thought that one could recognize "born criminals" on the basis of certain anatomical and physiological signs, especially "prominent jaws, a sparse beard, frontal sinus, 'sinister and shifty eyes,' ears sticking out, facial asymmetry, squinting, and a sloping forehead." Such factors were called upon as photographs of notorious scoundrels were analyzed and discussed in the popular press. Audiences for such media would make similar deductions when viewing illustrations of central Africans and the Europeans visiting them.[21]

Thinking along such lines, let us take another look at figure 1.5. It seems such a simple picture and not especially well achieved at that, for the façade of Storms's boma stretches curtain-like from one side of the image to the other with no differentiation except the entrance and its portcullis at the vantage point. No matter, for the contrast was thus established between the vastness of Bwana Boma's construction and the seeming simplicity of the African dwellings standing before it. These are of sufficient detail to make one wonder if the artist was working from one of the photographs Victor Giraud was known to have taken, yet the quickly limned features of the ungainly and lethargic people were similar to traits held by Lombroso to be degenerate, and so these were indeed "typically degenerate" Africans.

A final thought: Many of the evocative illustrations for Giraud's *Les lacs de l'Afrique Centrale* (1890) were executed by Édouard Riou, a student of Gustave Doré and the celebrated illustrator of Jules Verne's most significant early novels. Riou's work is remembered for its "romantic realism," and his success in evoking "faraway exoticism and futuristic awe" was such that his pictures

are still reproduced in reissues of Verne's *Five Weeks in a Balloon* (1863), *Voyage to the Center of the Earth* (1864), *Twenty Thousand Leagues under the Sea* (1870), and other *Voyages extraordinaires*. Indeed, so integral to the novels were Riou's images that, as one observer remarked, "it is not the text which defines the illustration, but the illustration which defines the text and which transports the reader beyond" as "a catalyst to dream." A picture that Riou created for Stanley's *In Darkest Africa* was altogether Vernean, for example, and was a "most imaginative and strange landscape, which diverges from all known real environments."[22] Riou's images were anything but passive in other words, for they shaped readers' experiences of subject matter, however fantastic the tales might be to the average reader. And "fantasy" was the watchword, for as depicted, the people, places, and events of central Africa in the 1880s were feeding European proto-colonial imaginations—or so hoped the authors and their illustrators.

Glossary

Bulozi/ulozi, reductively glossed as "sorcery" or "witchcraft" in English: Arcane and ambiguous sciences whose purposes and justifications are always subject to negotiation.

Congo Free State (1885–1908); Belgian Congo (1908–1960); Republic of the Congo (1960–1965); Democratic Republic of the Congo (1965–1971); Republic of Zaïre (1971–1997); Democratic Republic of the Congo or DRC (1997 to present): Names for the country that is the subject of this book, informally called Congo/Kinshasa.

IAA = International African Association: Founded in 1882 in the name of science and to further antislavery efforts, but in effect a tool of King Léopold II's imperialism.

IAC = International Association of the Congo: Founded in 1878 in explicit support of Léopold's expansionism.

Kabwalala: An evil medicine putting victims into deep sleep to rob them with impunity.

Kujendula: Capturing a *mutima* (soul) for illicit ends.

Marungu: A massif topped by light forest, southwest of Lubanda.

Milandu (singular: *mulandu*): Histories composed to justify political positions and prerogatives.

Muzungu (plural: *wazungu*): Swahili for people of European heritage or pretense.

Nègre in French: To avoid anachronism or unfair interpretation of late nineteenth-century writers' motives, one must recognize that *nègre*, like its translation as "nigger" in English, is an ambiguous, racialist, oft-offensive term that possesses it own histories of emphasis, paternalism, degrees of derision, and joking camaraderie. One is reminded of use of the word *nègre* in Pan-Africanist Nègritude precisely because, as Aimé Césaire explained, "there was shame about the word." One also recalls Joseph Conrad's use of "nigger" to describe Congolese people in *The Heart of Darkness* in times and circumstances roughly contemporary to those of Storms. While *nègre* can also be translated as "Negro," such a benign term seems out of place when words like *noirs* ("blacks") were also used by Becker and others. The matter remains controversial, and readers are invited to decide what they feel would be the appropriate translation in late nineteenth-century quotations cited in this book in which the word *nègre* is embedded. (See Asim 2007; Césaire 2000, 89; Conrad 1967; Becker 1887, 2: 286.)

RMCA: The Royal Museum of Central Africa in Tervuren, a town adjacent to Brussels. Formerly the Royal Museum of the Belgian Congo. For history and programming, see www.africamuseum.be.

Rugaruga: Disaffected youths who organized marauding bands in eastern Africa or served as mercenaries to coastal ivory and slave traders, ambitious chiefs, and early European visitors such as Émile Storms.

Sultani: An honorific loan word from Arabic via Swahili meaning "ruler" and often used in the 1970s with reference to Chief Mpala of Lubanda.

Tabwa: An ethnic gloss extended to people of many backgrounds now living in southeastern DRC. "Tabwa" is a situational term, and the same people often understand their social identities through clan, lineage affiliations, or other parameters.

Wangwana: Persons associated with coastal east Africa, although often enslaved in central Africa, taken to the coast, and then sent back to central Africa to engage in ivory and slave trading for coastal masters.

White Fathers: Roman Catholic Missionaries of Our Lady of Africa who took possession of IAA stations in Karema and Mpala-Lubanda after the Berlin Convention of 1885.

Urua/Warua/Buluba: The land and people now understood as eastern Luba or Luba-ized people.

Notes

Introduction

1. Despite convention, "east," "central," and "west" will not be capitalized when referring to regions of Africa. To do so alludes most readily to colonial designations, yet following such logic, the DRC is not part of Central Africa in English as defined according to British colonial policy. The French phrase *l'Afrique centrale* underscores how arbitrary such choices are.

2. Anon. 1883.

3. Stoler 2002, 14; Auden 2007. On Belgian "exclusionary populism," see Ceupens 2006.

4. Houzé 1886; Denoël 1992, 380.

5. It should be noted that the museum will undergo renovation beginning in 2012 as this book is in press, so discussion here pertains to years just prior to that.

6. Stevens 1995, 215.

7. Jackson 2005, xi, xxv–xxvii; V. Turner 1964, 1980; Abu-Lughod 1991, 153–54.

8. Said 1994, 19, 32; cf. Mudimbe 1997, 176; Jeurissen 2006, 35; Lalu 2009, 265; Chakrabarty 2000.

9. Asad 1991, 322; Pratt 2008, 5; cf. Mudimbe 1986, 12; Roberts and Roberts 1996.

10. Mudimbe 1988, 19; Clifford 1986; Abu-Lughod 1991, 154, 142; L. White 2000, 50.

11. Comaroff 1997, 165; cf. Stoler 2002, 23, 163.

12. Palmié 2002, 23; Morris 1969, 1544; Bhabha 1997, 153; cf. Abu-Lughod 1991, 149. Crapanzano 2004 and Jackson 2005 are inspirational in these regards.

13. *Rashomon*, discussed here in Jackson 2005, 2, was produced in 1950 by the Daiei Motion Picture Company of Japan. Vansina 1996, 12; cf. V. Turner 1970a. Nora 1989; Roberts and Roberts 1996, 2007; A. Roberts 1985.

14. Jackson 2005, xii, xix, citing Fernandez 1982, 215; cf. Geschiere 2004. Van Acker 1907, 163; cf. Johnson 1988, 249. On *bulozi* as evil, see Kimpinde 1982, 174–82; on *bulozi* as positive, see A. Roberts 1986c.

15. Ballard 1983, 91.

16. Annaert-Bruder ca. 1965; Jewsiewicki 1987; cf. Vansina 2010, chap. 5; Storms ca. 1884; Colle 1913, 6; cf. Kaoze 1910–1911, 418. On river fishing at Lubanda, see A. Roberts 1984, 2009a; cf. Gordon 2006a.

17. Ethnicity in and around Lubanda is discussed in many of my writings, e.g., A. Roberts 1985, 1989, 1996a; cf. Petit 1996b.

18. T. Bennett 2005, 68.

19. On recent decades of violence in eastern DRC, see Muhindo 2003, Clark 2004, T. Turner 2007, Prunier 2008. Thanks to UCLA African Studies MA students Krista Barnes and Marisa Lloyd for taking time out from their research in Zambian refugee camps to visit Lubanda on my behalf in 2009.

1. Invitation to a Beheading

The title of this chapter is borrowed from that of Nabokov's novel of 1989.

1. On Congolese sobriquets for Europeans, see Biaya 1995, Likaka 2009.

2. Anon. 1885a.

3. Thomson 1968, 2: 51.

4. Sheriff 1987, 183–90; Meier 2009, 18; cf. Fair 1998. On Swahili and *wangwana* (also written *waunguana*), see Spear 2000.

5. Jacques and Storms 1886, 66; Ceyssens 1998, 116; Rockel 2009, 89.

6. A. Shorter 1972, 276; cf. Smith 1968, 280–81; Storms 1888–1889a, 14; Bradshaw and Ndzesop 2010. On possible etymology of *rugaruga*, see Johnson 1988, 402; Fabian 2000, 290.

7. Storms 1883a and 1888–1889a, 14, 15; Joubert 1889, 57; Anon. n.d.2.

8. Becker 1887, 1: 222.

9. Storms n.d.3, and n.d.6; Alpers 2003. On the east African ivory and slave trade, see Alpers 1975, Coupland 1967, Ross 1992, Sheriff 1987, and Wright 1993, among many others.

10. Thomson 1968, 2: 46. Smith 1968, 252, presents a map of period trade routes through the region.

11. R. Schmitz 1909; Cameron 1877, 1: 246, 299; cf. Vellut 1998, 322n23; Stanley 1879, 33, 97; Wissmann 1891, 226 and passim.

12. Thanks to Adrian Wisnicki for reviewing Livingstone's diaries on my behalf to verify this assertion from Waller n.d., 286–87, 399–413. Newly restored versions of the diaries are available at http://livingstone.library.ucla.edu/livingstone_archive.

13. Ibid.; Stanley 1872; Thomson 1968, 2: 46. In his novel *The Whales in Lake Tanganyika*, Lennart Hagerfors (1985, 71) wonders if Ujiji residents may have considered Livingstone a bedraggled lunatic rather than the hero whom the world knew from afar.

14. Thomson 1968, 2: 46; cf. Wolf 1971, 147; A. Roberts 1984.

15. Thomson 1968, 1: v–vi, 2: 25–56; Anon. 1881.

16. Anon. 1881.

17. Fabian 2000, 12.

18. Rotberg 1971, 9–10, emphasis added; cf. Pratt 2008, 78, 82. Thomson suffered chronic illness late in life, and "discomfort clouded his mental horizons and transformed a cheerful, self-confident, energetic youth into an aging, broken-down relic" sadly given to fulminating about "the inferiority of black-skinned persons"; see Rotberg 1971, 290, 301.

19. Thomson 1968, 2: 46; cf. Cameron 1877, 1: 292–316.

20. Thomson 1968, 2: 46–50; cf. Wolf 1971, 124–25; Hore 1886.

21. Jacques and Storms 1886, 68; A. Roberts 1985, 1996a.

22. Storms 1883a; 1888–1889a, 15; and 1883–1885, 11 April 1885.

23. Thomson 1968, 2: 48, 51; Rotberg 1971, 89; R. Burton 1860, 2: 66. On Lusinga's earlier history, see appendix A.

24. Storms 1883–1885, 19 April 1885.

25. Wolf 1971, 124–25; Thomson 1968, 2: 51–52.

26. B. Schmitz 1903b; Morisseau 1910, 15.

27. On the economic significance of regional saline springs, see Roelens 1948, 94–96; Reefe 1981. On regional iron smelting and forging, see A. Roberts 1993c; Dewey and Childs 1996.

28. Verbeken 1956, 42 and passim; Legros 1996, 13, 27, 29. On Msiri, see Munongo n.d.; Tilsey 1929, 123–201; and especially Legros 1996. I accept the latter's point that the portrayal of Msiri as barbaric was of great utility to a fantasy of colonial heroism (see appendix B), but I find that Msiri's actions merit description as those of a "warlord" as that term is applied to other ambitious leaders of his time, including Lusinga; on other central African "condottieri merchants" of the period, see Wright and Lary 1971.

29. Miller 2002.

30. Jacques and Storms 1886, 65.

31. This from Tabwa narrative. Storms made no mention of the incident and suggested that the Ukala who joined forces with him was the original man from north-central Tanzania. Yeke were no longer evident near Lubanda by the 1970s, their descendants having been absorbed into local clans through matrilineal descent.

32. Among many others, see Kestergat 1985, Braeckman 1992, Stengers 1989, Wynants 1997.

33. Letter from Léopold II to Strauch, 8 January 1884, as quoted in a letter by Stanley in Maurice 1955, 20–21; cf. Hochschild 1998, 65; Ewans 2002, 58. The IAC is sometimes called the International Congo Society in English.

34. Storms 1884d.

35. Cited in Wack 1905, 8–9; also see Wynants 1997, 94–95.

36. Rahier 2003; Twain 1971, 52. This horrific estimate has been repeated many times over the years (e.g., in Hochschild 1998), and refers to the "demented brutality" of Léopoldian years; yet aside from its obvious polemical utility, it must be interrogated. See Marechal 2005; Vansina 2010, chapter 5.

37. Jeal 2007, 231; cf. Cornelis 1991, 42; Bouttiaux 1999, 596.

38. Ndaywel è Nziem 2005, 35.

39. Storms's military dossier (#8547) is available at the Royal Museum of the Armed Forces and Military History in Brussels. He is addressed as "Lieutenant" in records of his Congo years, but occasionally as "Captain" in anachronistic honor; see appendix A.

40. Anon. n.d.1; Poncelet 2008, 41; Stengers 1989, 51, 75–76. Becker 1887, 1: 399–454, offers details of IAA expeditions preceding that of Storms; cf. Heremans 1966, N. Bennett 1960.

41. Anon. 1883. Warm thanks to Louis de Strycker for bringing this obscure penny pamphlet to my attention.

42. Ewans 2002, 62–73; Jeal 2007, 189; neither mentions Storms. N. Bennett 1960; Heremans 1966, 35; neither mentions Stanley.

43. Burdo 1886, 509; Anon. n.d.1.

44. Anon. n.d.1; Strauch 1883c; Bontinck 1974, 129, 263–65; Strauch 1883d.

45. Becker 1887, 1: 399–454; Giraud 1890, 445. No vestiges of Fort Léopold remain, but the Roman Catholic mission that replaced it is still in use; thanks to Kathleen Smythe (pers. comm. 2010), who last visited Karema in 2002; cf. Smythe 2006, 2007; Pas 2010.

46. Reichard 1886; Schalow 1888; Becker 1887, 1: 396–97; Fabian 2000, 18–21 and passim. Storms 1883a; Verbeken 1956, 142.

47. Verbeken 1956, 141.

48. Storms 1884c; Nagant 1972, annex 4, 32–33.
49. Storms 1884c.
50. Storms 1886a, 188, and 1883–1885, 5 May 1885; also see Becker 1887, 2: 512–13 and Heremans 1966, plate 4.
51. On *tembes,* see Becker 1887, 1: 223–24 and Anon. 1896a; Foucault 1980, 154.
52. Wack 1905, 37–38.
53. Storms 1885d, 3.
54. Ibid.
55. Storms 1883c; Thomson 1968, 2: 50.
56. *OED* 1982, 1673, citing usage in *Oliver Twist.*
57. Burdo 1886, 521; Storms 1885d, 4.
58. Storms 1885d, 4.
59. Anon. 1894.
60. Storms 1884b. On translation of the French term *nègre* as "nigger," see appendix B.
61. Fabian 2000, 48.
62. Storms 1883b.
63. Strauch 1883b; again, confusion of the IAC and the IAA is to be noted.
64. Storms 1883–1885, 25 October 1884.
65. Storms 1883–1885, 2 December 1884. On Tabwa lion symbolism, shape-shifting, and lion-man terrorism, see A. Roberts 1983, 1986a; cf. Gossiaux 2000, Marks 1984; Singleton 1989; Pratten 2007, West 2005.
66. Giraud 1890, 463; Storms 1883–1885, 2 December 1884.
67. Storms 1883–1885, 2 December 1884, 19 April 1885.
68. Verbeken 1956, 143; Fabian 2000, 146–48, 195, citing Reichard 1884a, 305–307.
69. Maurer and Roberts 1985, 112–13. Much documentation was destroyed during World War II, and the particular provenance is unknown.
70. Fabian 2000, 147, citing Reichard 1884a, 166–67; Verbeken 1956, 143.
71. Storms 1883–1885, 4 December 1884; Storms ca. 1885.
72. Storms 1883–1885, 6 December 1884; Storms ca. 1885; Heremans 1966, 53–55.
73. Storms 1883–1885, 15 December 1884, 18–19 March, 1 April 1885.
74. Storms 1883–1885, 4 May 1885, 4 December 1884; cf. Anon n.d.1.
75. Strauch 1883a, 1884a, 1884b; Thys 1885a. The initiative was delayed for financial reasons and then canceled with the partition of Africa at the Berlin Conference of 1884–1885. Like Storms, Becker was bitter about being summoned home; Fabian 1986, 168n31.
76. Anon. 1885d; Giraud 1890, 508. The order in which Storms received and read letters cannot be determined. Stanley (1885, 134–67) makes no mention of Storms, nor is there any correspondence from or to Storms listed in the Stanley Archive of the Royal Museum of Central Africa. See http://www.africamuseum.be/collections/browsecollections/humansciences/stanley/alphabetical_archive?g=A, viewed April 2012.
77. Anon. 1885d; Burdo 1886, 1: 537–38.
78. Burdo 1886, 1: 535.
79. Storms 1884d, 1884a. These exchanges occurred before Storms's assassins attacked Lusinga in December 1884, and one is left to wonder what effect his anger had upon the initiative.
80. Jeal 2007, 236, 260, 269, 281; Hochschild 1998, 70–72; Wynants 2005, Cornelis 1991.
81. See Jeal 2007, 266–79 and passim.
82. Giraud 1890, 508–17.
83. Storms 1884a, 1884d.
84. Vanthemsche 2007, 33–34.

85. Stengers 1989, 53–58.

86. See Ndaywel è Nziem 1998, Vanthemsche 2007, Renton et al. 2007, among many others; Strauch 1884c.

87. Thys 1885b.

88. Storms 1883–1885, 12 April 1885. Storms's expression here, *Allez vous-en!* (Get lost!) is especially demeaning.

89. Anon. 1885a.

90. Anon. 1885c.

91. Moinet 1886a, 1886b. Moinet was making further reference to the Christian Kingdom he had been sent to create at Mpala-Lubanda; see A. Roberts 1989.

92. Anon. 1885b. Dulcigno is the Venetian name for the Albanian coastal town of Ulcinj, now in Montenegro, which won its independence from the Ottoman Empire in 1878 after long contestation; see Wikipedia, en.wikipedia.org/wiki/Ulcinj.

93. Lalu 2009, 102; A. Roberts 1987, 1989; Mudimbe 1994.

94. Anon. n.d.1. The White Fathers—so called for the white robes they wore in their earliest posts in Algeria—are more formally known as the Missionaries of Our Lady of Africa as founded in 1868 by Cardinal Lavigerie and now headquartered in Rome; for overviews of their central African achievements, see Heremans 1966, A. Roberts 1989.

95. Storms 1885a, 13 June. Carter and Cadenhead led an ill-fated mission to introduce Indian elephants to eastern Africa as beasts of burden; on their demise, see Becker 1877, 1: 399–454.

96. Moncet 1885d; Storms 1883–1885, 4 May 1885; Jacques and Storms 1886, 80.

97. Storms 1885b; Storms 1883–1885, 19 May 1885.

98. Storms 1883–1885, 2 June 1885; Storms 1885a; Moinet 1885–1888, 2 June 1885.

99. Both men and women perpetrate and can be victims of such crimes. We cannot know whether the axe handle, wood, and beads were meant to serve the purposes ascribed to them by Mpala, raising questions beyond the present exercise; on ingredients of *kabwalala,* see A. Roberts 1980.

100. Colle 1913, 297; Van Avermaet and Mbuya 1954, 84; Grévisse 1956, 78; Anon. 1929, 291.

101. Wauthion 1939a, 1939b; Storms 1885a, 25 July; cf. A. Roberts 1996b.

102. See A. Roberts 1986a.

103. Malaquais 2002, 11; cf. MacGaffey 1972. Thanks to David Gordon for discussion of this point, pers. comm. 2009.

104. Storms 1885b; Moncet 1886.

105. Storms 1883–1885, 3 June 1885; Giraud 1890, 522.

106. Moinet 1885–1888, 8 July 1885; Storms 1883–1885, 30 June, 7 July 1885.

107. Storms ca. 1885b, 10–11.

108. Storms 1883–1885, 7 and 12 July 1885.

109. Boulger 1898, 25.

110. Storms 1883–1885, 19 July 1885; Storms n.d.1 and 1885c; Jacques and Storms 1886, 62.

111. Storms n.d.1; Moinet 1885–1888, 8 July 1885.

112. Moinet 1885–1888, 16 July, 11 August, September 1885; Moinet 1885d; Moncet 1885a, 1885b, 1885c.

113. Casier 1987; A. Roberts 1987, 1989.

114. Guillemé 1892, 22.

115. Storms 1888–1889a; François 1990, 47; Verhoeven 1929, 14; Denoël 1992, 663.

116. See appendix A.

2. A Conflict of Memories

1. Lalu 2000, 46–49; Lalu 2009.

2. A. Roberts 1979, 1987, 1988a.

3. See Muhindo 2003.

4. On "men of memory" see Reefe 1975, 50; Roberts and Roberts 1996; A. Roberts 1996b.

5. The travesty was committed while searching for a particular firebrand who had confronted the central government since the early 1960s; see A. Roberts 1989, 207, 214; A. Roberts 1996b.

6. Lewis 1992, 7, musing about the writings of Roy Wagner 1981.

7. A. Roberts 1984, 2009; cf. MacGaffey 1972. I recorded this long exchange and then had it transcribed by Bw. Maswapizya, an unemployed primary school teacher.

8. The epidemic occurred around 1914; see Roelens 1948, chapter 7.

9. Kizumina's antipathy should not be understood as unanimous hostility to the Church, for a great many people in and around Lubanda have been and are ardent Catholics; see ETA ca. 1987; Kimpinde 1982; cf. Roelens 1921, 1948; A. Roberts 1984, 1987, 1989; Mudimbe 1994.

10. Portelli 1981, 162, cited in Tonkin 1995, 3; Fernandez 1986, 24; Heusch 1982a.

11. Morris 1969, 626; Tillotson 1685.

12. See appendix A.

13. Jacques and Storms 1886, 81. Louis Mulilo reverses the pretense of Swahili and proto-colonial hegemony; see Fabian 1986, 24–33.

14. Van Acker 1907, 52; Colle 1935, 467; A. Roberts 1982.

15. By *ascari* or "soldier" in Swahili, Louis Mulilo referred to Storms's *wangwana, rugaruga,* and other east African mercenaries.

16. Kizumina told me the story four times in 1976 and early 1977; the following is from a transcribed tape recording.

17. Sheriff 1987, 183–90. Storms is called "Sakala" in Moinet 1887; B. Schmitz 1903a, 317; Nagant 1972, annex 4, 27.

18. Storms n.d.1.

19. These are generic terms for firearms. Moinet 1885c offers an inventory of Storms's weaponry. On colonial use of firearm technologies, see Headrick 1981, 109–10.

20. *Kikala, kikala, kikala kyamono bwali, kwamona abanakazi, shaiminino, kikala kyamono bwali* in Kitabwa. *Bwali* is the staple starch dish. "They shat," *wamenyamba mavi* in Swahili as spoken at Lubanda, connotes grossly humorous exaggeration rather than defecation.

21. Implicit here is that the "different parts" of the village were determined by the cardinal directions.

22. There could be no cattle at Lusinga's because of tsetse flies.

23. Kizumina used the generic term for people rather than a reference to their being enslaved.

24. *Matabishi* is an Arabic loan to Swahili meaning "gratuity" or "bribe."

25. Katampa Kinga, "bicycle rider," here refers to M. Thuysbaert, a colonial agent at Moba in 1918.

26. Mpala and Storms were "namesakes" (*majina*) because of their *lusale* blood covenant.

27. Van Acker 1907, 42; Van Avermaet and Mbuya 1954, 338; cf. Cunnison 1969, A. Roberts 1980, Cancel 1989, Roberts and Roberts 1996, Gordon 2006b.

28. Vansina 1985, 3, emphasis added; MacGaffey 2000, 63; cf. V. Turner 1980, 147–49.

29. See Heusch 1982a, 1991; A. Roberts 1986c, 1988a, 1991.

30. Ash 2009, 4, emphasis added, writing of Henri Bergson. On Tabwa divination, see A. Roberts 1988b, 2000; among Luba, see Roberts and Roberts 1996 and M. Roberts 2000.

31. Hoskins 2010, 32.

32. Hocart 1935, 114; cf. L. White 1994, Beidelman 1963.

33. Davis 2000, 48, and ditto for Tabwa use or avoidance of blood in medical practice. On meanings of blood elsewhere in Africa, see Gottlieb 1997 and especially L. White 2000.

34. On similar interpersonal and intergroup pacts elsewhere in the region, see Legros 1996, 40. L. White 2000, 14, and L. White 1994.

35. This engaging topic cannot be pursued here, but see Ceyssens 1975, L. White 2000.

36. Anon. 1894; see also C.K.R. 1896, 280.

37. Anon. 1894; Bhabha 1997, 154.

38. Maret 1995.

39. Jacques and Storms 1886, 81; cf. Davis 2000, 6–13.

40. A. Roberts 1994b. The First Shaba War affected Lubanda only indirectly, as increased Zairian military presence in Kalemie, to the north, greatly restricted movement on the lake.

41. A. Roberts 1988a.

42. Fabian 2000, 68–69, 93. On postcolonial discourse concerning the denial of African voice, see Lalu 2009.

43. Henige 1974, 30, cited in Willis 1981, 79.

44. Fabian 2000, 47; Legros 1996, 8; Mwami Msiri: King of Garanganze, www.kingmsiri.com, viewed June 2011.

45. Mudimbe 1997, 161.

46. L. White 2000, 30; Pratt 2008, 197.

47. See A. Roberts 1988b, 2000.

48. Oliver 1968, 208–11; cf. R. Burton 1860, 2: 75–78; Cameron 1877, 1: 285–87; Colle 1913, 64–65; Alpers 1968, 240–44; Alpers 1975, 248–50.

49. Alpers 2001, 119, 123.

50. Johnson 1988, 326, 546; cf. Ceyssens 1998, 148–49. Etymology did not inform common usage at Lubanda in the 1970s.

51. Cf. Bockie 1993, 41; Buakasa 1972, 29.

52. A. Roberts 1989, Mudimbe 1994; cf. Rubbers 2004, as discussed in Jeurissen 2006.

53. E.g., MacGaffey 1972, Fabian 2000, and many others.

54. Sahlins 1995, 25.

55. See M. Roberts 2007a, 2007b.

56. A. Roberts 1989; Pratt 2008, 4. Léon Dardenne's watercolor from 1900 depicting the White Fathers' printing press in Mpala makes the point eloquently; see L. Thornton 1990, 54.

57. Harries 2001, 418; Fabian 1983, 1986; Hunt 1999, 55; MacGaffey 1993, 48; cf. Tonda 2005, 99.

58. Fernandez 1986, 181.

59. A. Roberts 1993a; cf. Jacobson-Widding 1979, V. Turner 1966.

60. Jacques and Storms 1886, 107; Maurer and Roberts 1985; Roberts and Roberts 1996.

61. Wolf 1971, 145; Hore 1886, 194. To "pomatume" was to heavily oil the hair; "bodkins" were long hairpins, often with ornamented heads; Morris 1969, 1018, 147.

62. Jacques and Storms 1886, 29; on Tabwa body arts, see A. Roberts 1985, 1986b, 1988c.

63. A. Shorter 1972, 276; A. Shorter 1968, 241. *Rugaruga* may also refer to "jumping" (*kuruka* in Swahili) as in dance or battle strategy.

64. Storms 1883a, 1886b, 7; Jacques and Storms 1886, 28; cf. Kasfir 2007, 212–16.

65. Wolf 1976, 170.

66. Davis 2000, 62.

67. A. Roberts 1996b, 2000.

68. Womersley 1984, 1; Heusch 1982a; A. Roberts 1991; Mudimbe 1991, 90. On hyena lore, see A. Roberts 1995b, 74–76.

69. A. Roberts 1991 and 1993a; on how symbols instigate action, see V. Turner 1970.

70. "Nzwiba," a name for majestic raptors, is a pseudonym used at the behest of a celebrated but politically controversial healer.

71. When Yeke Chief Ukala died in 1886, his son sought to succeed him, but as a *kinkula*, the young man was deemed "a born criminal" according to local thinking, and he was not granted the position. See White Fathers 1885–1889, 53–73.

72. Fabian 2001, 184.

3. Histories Made by Bodies

The title of this chapter is paraphrased from Foster 1995, 10.

1. Storms ca. 1885. The play on Marx's "means of production" is in J. Thornton 1998, 98–99.

2. The section title and "roaring coarseness" are from Untermeyer 1959, xvi. Jacques and Storms 1886, 40.

3. Gogol 1985. "Paripatetic Penis" is from Cosentino 1982, 64. Association between nose and phallus is common in world folklore; see Róheim 1992.

4. Iliffe 2005, 146.

5. Disgust at local ritual was an early missionary topos, e.g., Roelens 1948.

6. A. Roberts 2011; M. Roberts 2011.

7. On Tabwa music, see Weghsteen 1964; on Luba music, see Gansemans 1980, 1981.

8. D. Shorter 2009, book title, 206. On contested uses of the term "choreography" by dance scholars, see O'Shea 2007, 10–12.

9. Johnson 1988, 471; Van Acker 1907, 93. Thanks to David Roussève for discussion of these points.

10. Evans-Pritchard 1928, 446.

11. Foster 1995, 12, 9.

12. Schmidt 1912, 407–12. Opposed lines of dancers resonated with a dialectical aesthetic manifest in precolonial village layouts; see A. Roberts 1980, cf. Fernandez 1986, 61–62. Inspiration for this section is drawn from Inomata and Coben 2006.

13. Dorst and Dandelot 1969, 108–109; Van Acker 1907, 38; Kaoze ca. 1930; A. Roberts 1980, 339–43.

14. Van Acker 1907, 45–46; Van Avermaet and Mbuya 1954, 366; R. Thompson 2005, 134.

15. See Colle 1913, 674; cf. Steiner 1995, 212–14; Stuckey 1995.

16. Kasfir 2007, 212–16; Jacques and Storms 1886, 38–39; cf. Storms cited in Becker 1887, 2: 508.

17. Desch Obi 2008, 8.

18. Fabian 2000, 118.

19. Storms n.d.8, published as Storms 1885e. Attached to this latter document is "LES DAWA: Ce qu'ils contiennent, et destination." Storms also collected a healer's basket containing a great many medicinal ingredients (now RMCA 31681) as well as horns and a tortoise shell packed with magic (31682–91).

20. Jacques and Storms 1886, 37–38; Schmidt 1912, 410; R. Thompson 1974, 1; cf. Fernandez 1986, 54; Strother 1998; Lamp 2004; Ranger 1975.

21. Storms ca. 1884; Becker 1887, 2: 238–39. Bende culture and history have yet to be studied in detail; see Lechaptois 1913, 27–41; Avon 1915–1916; Hatchell 1940.

22. Fabian 2000; Morris 1969, 300.

23. Accessible works on capoeira include Capoeira 2002, G. Taylor 2005, and Desch Obi 2008. Lewis 1992 applies Geertz's notion of "deep play" (1973, 412–54) to capoeira in Brazil. Thanks to J. Wesley Days for discussion of capoeira, 2010.

24. On ethnic "umbrella" terms like "Kongo," see Wright and Lary 1971; cf. Rockel 2009.

25. Gil 2006, 28, 23, 25, 35; "kinesthetic empathy" is from Foster 1995, 7; Jackson 1998, 3.

26. Lewis 1992, xxiv.

27. Zarilli 2008, 201; Kaeppler 1991, 109; Foster 1986, xviii, 92 and passim. Ellis 2007, 132, cited in Brelsford 1974, 21 with regard to central African dance; Mauss 1979, from a lecture of 1934; Sklar 2001, 4.

28. Jacques and Storms 1886, 38; Storms ca. 1884.

29. Moinet 1885–1888, 23 September 1885; Maurer and Roberts 1985, 266; Maurer 1985, 278; cf. Van Acker 1907, 165. The glass-plate negatives were left at Kirungu Mission, and contact prints deposited at the White Fathers' archives in Rome.

30. People in southeastern DRC had little access to photography in the mid-1970s, and it is possible that the chiefs recognized the image as that of an *nfukula* player and remembered the renown of Kifumbe; whether or not he is the person portrayed is not certain.

31. On the "clapping, slapping, snapping, stepping, and vocalizing" of "body music" from African and other cultures, see the compelling work of Keith Terry at Crosspulse, www.crosspulse.com.

32. Van Acker 1907, 43; Van Avermaet and Mbuya 1954, 105; cf. Janzen 1992, appendix C.

33. Musée de la Musique no. E996.22.1, Yale-van Rijn Archive 0022374; thanks to Frederick Lamp for tracking this object down for me. Maurer and Roberts 1985, 196–97; A. Roberts 1986d, 1985.

34. A. Roberts 1995b, 65–66.

35. Storms 1883–1885, 27 March, 4 May 1885; Storms ca. 1884.

36. Williams 1964, 59, 62, 65.

37. Storms ca. 1884; Brown 1972, 69; Kaoze 1942, 10.; cf. DeBeerst 1894, 3; Van Acker 1907, 55; Van Avermaet and Mbuya 1954, 65. The Congolese comparative linguist Clémentine Faïk-Nzuji (1992, 47–50; 2000, 66–69) finds the root -*úng* in "almost all Bantu languages" and summarizes its sense as "mysterious and unfathomable realities found in the permanent aspirations of man without being directly accessible to him, except through the intermediary of symbols"; cf. Ceyssens 1998, 115; Martinez-Ruiz 2010, 206.

38. Dubois 1981, 71.

39. Davis 2000, 133–35, 51.

40. Moore 1940, 229; cf. Jacobson-Widding 2000.

41. On animals as "verbs," see Ingold 2006, 14.

42. Barthes 1977a, 91–97.

43. Janzen 1982, 148.

44. Van Avermaet and Mbuya 1954, 709; cf. Boulanger 1985, 123–24; M. Roberts 1994a.

45. Van Avermaet and Mbuya 1954, 710–11. Thanks to Professor Mutombo for this personal communication, 2009. On the tonality of Luba-related languages of southeastern DRC, see Gillis 1981, x–xii; Blakely and Blakely 1987, 84–85. Kitabwa spoken inland from

Lake Tanganyika is not tonal, I was told (see DeBeerst 1894), but more Luba-inflected dialects may be to some extent.

46. Van Avermaet and Mbuya 1954, xi. Thanks to Thomas Hinnebusch for this personal communication, 2009. Ceyssens 1998, 115; Foucault 2004, 17–18.

47. On the Luba Epic, see Heusch 1972, 1982a; Mudimbe 1991; Reefe 1981; Roberts and Roberts 1996; Studstill 1984; Vansina 1968. The epic is the subject of a novel by Elsing 1956. Heusch's "Le roi vient d'ailleurs" (1991) and my own "Where the King Is Coming From" (1991) bookend the mythical incidents mentioned here.

48. Nooter 1991; Roberts and Roberts 1996.

49. Mbudye performance is illustrated in M. Roberts 1996, 138–47. Secrecy among Luba and other African peoples is considered in Nooter 1993.

50. Devroey and Neuhuys-Nisse 1965; Maurer and Roberts 1985.

51. Eyenga-Cornelis 2003, 103; Cornelis 1995, 194–95; R. Thompson 2005, 65, 128, 12.

52. M. Roberts 1996, 138, 143, 146–47; Desch Obi 2008, 22, 233; R. Thompson 2005, 76.

53. Brelsford 1974, 36; Boulanger 1985, 123–24; Gordon 2004, 64, 72, 78; Milbourne 2003, 349.

54. Mnemonic choreographies among Luba, Tabwa, and related central African peoples are broached in M. Roberts 1996, 143–47; cf. Centner 1963; R. Thompson 1974, 1981, 2005; Blakely and Blakely 1987, 1994; Strother 1998; Felix and Jordán 1998; Simbao 2010.

55. On the "syntax" of dance, see Foster 1986, 92.

56. R. Thompson 2001; R. Thompson 2005, 127; Dupré 1991; Desch Obi 2008.

57. Capoeira 2002, 4; R. Thompson 2001, 3; Fu-Kiau Bunseki 1974, 34; Fu-Kiau Bunseki 2001, 35; cf. Faïk-Nzuji 2000, 31–33.

58. Jacobson-Widding 1990, 62–63; Jacobson-Widding 1988, 144; Jacobson-Widding 1979. Thanks to Danny Dawson for many discussions of Kongo lore.

59. Dupré 1991, 217, 219, 222–23, 226–27.

60. Vansina 1984, 127–28.

61. Desch Obi 2008, 30, 38–39, 43.

62. Theuws 1968, 11.

4. Tropical Gothic

1. Storms 1884b.

2. Stanley 1909, 296–97, cited in Koivunen 2006, 10.

3. Fabian 2000, 61–62. This chapter's debt to the themes and sensitivities of Fabian's *Out of Our Minds: Reason and Madness in the Exploration of Central Africa* (2000) will be obvious. On Tabwa understandings of and treatments for fever, see Davis 2000, 44 and passim.

4. Fabian 2000, 66–71. Burdo 1886 lists Belgians lost in early central African exploration, and Pas 2010 documents Catholic missionaries who died in service.

5. Tollebeek 2005, 54, 58; cf. Showalter et al. 1993.

6. Becker 1887, 2: 224–39, 356; cf. Berenson 2011, 10–11.

7. My translation is from lyrics at Le Roi Dagobert, www.chansons-net.com/Tine/E133.htm, viewed in spring 2010.

8. See Fabian 2000, 51. Assessment of rapacious "Arab" activities glossed in the master narratives of incipient colonialism diverge or conflict upon closer scrutiny. For example, Adolph Burdo, author of *Les Belges dans l'Afrique centrale* (1886), also wrote *Les Arabes dans l'Afrique centrale* (1885) in similarly florid tribute to potential business partners deemed to have long striven to bring "civilization" to the "savages." Cameron (1877), Livingstone (Waller n.d.), and other early European explorers whose very lives depended upon these same "Arabs" could be equally laudatory.

9. Becker 1887, 2: 486; thanks to Johannes Fabian for bringing this phrase to my attention and translating it.

10. Gorceix 1997, 39–42, citing Maeterlinck's "Cloches de verre" poem of 1889.

11. Jacques and Storms 1886, 8; A. Roberts 1980, 69–128.

12. See Cooper 1992; cf. Mudimbe 1994, 110–11.

13. Storms 1883–1885, 10 May 1885; Storms n.d.5, ca. 1884; IAAPB 1892; A. Roberts 1989.

14. Storms n.d.7; Anderson 1993, 173; Poncelet 2008, 59, 113–14, emphasis added; Fabian 1986, 24; cf. Pratt 2008, 198.

15. By "scientistic" I refer to activities undertaken in the name of positivist Science in ways that occlude or deny their cultural construction; the term comes to the fore in chapter 6.

16. Cosgrove 1985, 13, 15, 38; Pratt 2008, 4, and chapter 9.

17. From a map in Hore 1886.

18. Stanley 1872, 1879. Ramaeckers's tomb as conceived and constructed by Becker is an example of attempted place making; Becker 1887, 2: 204, 223, 357.

19. A. Roberts 1981, 2005, 2012.

20. Such matters are much discussed; see Fabian 1986, 32 and passim; Wood 1992, Anderson 1993, Poncelet 2008, 53–64.

21. Basso 1996.

22. Küchler 1994, 86, writing thus of New Ireland and alluding to Australian Aboriginal art "with its graphic denotation of a landscape which bears the imprints of ancestral actions."

23. Maurer 1985; M. Roberts 1994a, 1996.

24. Thys 1885a. An exception is M. Vanaise's drawing of "slaves at work" based upon a photograph by Storms; see Storms 1888–1889a, 83.

25. Giraud 1890, 79; Leduc 2006, 61, 64, discusses how rarely central African explorers engaged in photography, despite the medium's widespread use elsewhere in the world.

26. Leduc 2006, 61; cf. Poole 1997; Poncelet 2008. Use of photography in Africa to document "types" seems to have begun somewhat later than in other parts of the world; see Boëtsch 1995, 58.

27. E.g., Prins 1992; cf. Giraud 1890, 79.

28. Cornelis and Lagae 2011, 4; cf. Geary 2002. Gauthier 2008, 39, 44. Ouédraogo 2002, 21, 57, 94. Also see appendix B on the illustrations of the present book.

29. Strauch 1883b.

30. Pratt 2008, 29, 37.

31. Dollo 1886; Pelseneer 1886; Hartlaub 1886, cf. Bouttiaux 1999, 596. *Micralestes stormsi* is described at www.fishbase.org/summary/speciessummary. php?id=11149, the tilapia (cichlid) at Wikispecies, http://species.wikimedia.org/wiki/Orthochromis_ stormsi. Lagae 2005, 138, citing Becker 1887, 1: 147.

32. Durham and Fernandez 1991, 208; Stewart 1993, 151; Stewart 1994, 204.

33. Pratt 2008, 37–38.

34. Strauch 1883a, 1883d; Burdo 1886, 510; Anon. n.d.1.

35. Anon. n.d.1; Storms 1883–1885, 6 February 1885. On Musamwira's exactions, see Becker 1887, 2: 306; Cameron 1877, 1: 269.

36. Storms 1883–1885, 9 February, 18 January 1885; cf. Heremans 1966, 42.

37. Storms 1883–1885, 6 March 1885; Moinet 1885a, 1885b.

38. Césaire 2000, 35; Lazreg 2008, 116.

39. Moinet 1886c; Moncet 1887; A. Roberts 1989.

40. Stoler 2002; cf. Papastergiadis 2002.

41. Jacques and Storms 1886, 54.

42. Fabian 2000, 79–86, with reference to Becker 1887, 1: 167–68; Becker 1887, 2: 360.

43. Stoler 2002, 16; Papastergiadis 2002, 169, with reference to Ashis Nandy's *The Intimate Enemy* (1983).

44. Storms 1883–1885, 7, and 26 March 1885; Storms 1885b; Heremans 1966, 35.

45. Denoël 1992.

46. Trouillot 1995, 115, 118, 48.

47. Cf. Davis-Roberts 1985; A. Roberts 1986c, 1988a, 1994c, 1996b, 2000.

48. See Fabian 2000, 276.

49. Pratt 2008, 37–38.

50. Giraud 1887, 389–90.

51. Ibid., 390–91

52. Ibid., 392; Becker 1887, 1: 267, 2: 355. The Barbary or barrel organ, sometimes mistaken for the smaller hurdy-gurdy, is "a mechanical instrument consisting of bellows and one or more ranks of pipes housed in a case, usually of wood, and often highly decorated" (Wikipedia, http://en.wikipedia.org/wiki/Barrel_organ, viewed spring 2010). Music is encoded on a cylinder or "barrel" by pins that trip keys and sound notes via air forced through the mechanism as the crank is turned. Kathleen Smythe found no evidence of the organ during her months of dissertation research at Karema (pers. comm. 2010), nor did Father Piet van der Pas during his many years at the Catholic mission of Karema (pers. comm. 2010).

53. Fabian 2000, 55; Stoler 1992, 321.

54. Giraud 1887, 121–22, Becker 1887, 1: 267, 2: 235, 286; cf. Edholm 1995, 147.

55. Fabian 2000, 110–11.

56. MacGaffey 1993, 58. A harmonium is a keyboard instrument with hand- or foot-operated bellows that force air through reeds to produce notes sounding rather like those of an accordion (Wikipedia, www.en.wikipedia.org/wiki/Harmonium, viewed spring 2010).

57. Fabian 2000, 121, 105.

58. Rabaud 1880b, 8; Chandler 2000.

59. Rabaud 1880b, 8–9; cf. Bradley 1881, 12.

60. Rabaud 1880b, 9–13; Rabaud 1880a, 187; Livingstone 1992, 218; Ewans 2002, 68.

61. Fabian 2000, 49, mentions Debaize in the context of French efforts to explore central Africa from east and west.

62. Ewans 2002, 64, 66–69; cf. Dion 2007; Jeal 2007, 250 and passim. Bernault 2010 analyzes the reinvention of "the gentle explorer" by Congolese president Sassou Nguesso; cf. Berenson 2011, ch. 2.

63. Rabaud 1880b, 24–25, 33.

64. Ibid., 27, 61; Bradley 1881, 12.

65. Thomson 1968, 2: 93.

66. Wolf 1971, 103; Hore's letters concerning Debaize are reproduced in Rabaud 1880b.

67. Thomson 1968, 2: 96.

68. Ibid., 2: 96–97, 191; Becker 1887, 2: 115–35; Jacques and Storms 1886, 1. Later in life Thomson was closely associated with the imperialist adventures of Cecil Rhodes, bearing out Belgian suspicions.

69. Thomson 1968, 2: 93; Rabaud 1880b, 40–41, citing a letter posted from Malabu on 19 November 1878; Storms 1888–1889a, 14. On the death of Penrose, see Burdo 1886, 267–69, including a full-page engraving depicting the missionary's heroic demise.

70. Rabaud 1880b, 41.

71. Ibid.

72. Stanley's violence is deemed overstated by some; see Jeal 2007. Stanley's own lurid descriptions suggest otherwise; see Berenson 2011, 37, 272.

73. Rabaud 1880b, 29–31.

74. Ibid.; Jeal 2007, 243; Berenson 2011, 58; Rotberg 1971, 95, who took Thomson's assessments of Debaize at face value.

75. PDR Health/Physician's Desk Reference, www.pdrhealth.com, viewed summer 2010.

76. Rabaud 1880b, 56.

77. Ibid., 24, 65, 67. As president of the Geographical Society of Marseilles, Alfred Rabaud saw the young abbé off as he set sail for Africa and then offered a nationalist eulogy; Rabaud 1880a.

78. Breton 1972, 5–6.

79. See Cunnison's *avant-la-lettre* masterpiece "History on the Luapula" (1969); Roberts and Roberts 1996; Gordon 2006b.

80. Cf. Fabian 2000.

5. Storms the Headhunter

Cincinnatus, the Russian protagonist of Nabokov's novel, is surreally imprisoned and knows he will be beheaded for capital crimes without knowing why or when.

1. Foucault 1995, 8 and passim; on Belgian use of the guillotine, see "The Guillotine," European History, About.com, http://europeanhistory.about.com/cs/frenchrevolution/a/Guillotine.htm; Kristeva 2012, 95, 97, 101.

2. Anon. 1896b, 253; Cornelis 1995, 192–93; the "savage slot" is from Trouillot 1991, 18.

3. See Stahl 1986; Ackroyd 1999.

4. Janssens 2007, 175. How or why Janssens equates resistance to Roman conquerors with the execution of Africans remains unclear.

5. See Arens 1980 and its many responses.

6. Rosaldo 1980, 63, 140.

7. Storms 1883–1885, 12 April 1885.

8. Morris 1969, 352; cf. Fabian 1996, 1998b.

9. Taussig 1992, 152–53, emphasis added; cf. Lazreg 2008, 213–33 on intersubjectivity and colonial war in Algeria; and Césaire 2000 for more general comparisons

10. L. White 1997, 325.

11. See Colle 1913, 353–59; Heusch 1972, 51 and passim.

12. Morris 1969, 607.

13. Strauch 1884a.

14. Berenson 2011, chapter 1, 35; cf. Pratt 2008, 200.

15. Lagae 2005, 137, emphasis added; cf. Poncelet 2008, 47, 59. Storms did seek publishing outlets for his antislavery efforts, but these remained very modest in scope; see Storms n.d.2, 1888–1889a, 1888–1889b, 1888–1889c. Cf. Duchesne 1892.

16. Cf. Dorward 1974.

17. Cf. Lazreg 2008, 114 and passim.

18. Storms 1883–1885, 21 February 1885.

19. Ramaeckers 1882.

20. Ibid.

21. Lazreg 2008, 115.

22. Dubois 1981, 610.

23. Becker 1887, 2: 191. Fabian (2000, 18) briefly mentions that Becker was accused of attempting to murder Ramaeckers for some reason, though he was cleared of charges by a military tribunal.

24. Becker 1887, 2: 267–69; cf. Guisset 2003, 115.

25. Morris 1969, 613; A. Roberts 1987, 1989.

26. Lazreg 2008, 112 and passim.

27. Giraud 1887, 392–93. On feudal definitions of "corvée," see Morris 1969, 300.

28. Storms n.d.2.

29. Becker 1887, 2: 518–20.

30. Verhoeven 1929,14; Denoël 1992, 663; Halen 1992; Storms 1888–1889b; cf. Vauthier 1896.

31. Verhoeven 1929; Ndaywel è Nziem 1998; Mulambu-Mvuluya 1974; Vanthemsche 2006, 91.

32. Storms 1883–1885, 11 April 1885.

33. Strauch ca. 1882; Storms 1883–1885, 29 March, 11 April 1885, Storms n.d.7; cf. Fabian 1986, 27.

34. Storms 1883–1885, 29 March, 10 May 1885; A. Roberts 1989.

35. Said 1994, 223, citing Eqbal Ahmad; Braeckman 1992; cf. Clark 2004, Saunders 2005, 78; Renton et al. 2007.

36. Ndaywel è Nziem 2005, 32; Huff 2009, reviewing Prunier 2008.

37. Conrad 1967.

38. Achebe 1990, 124.

39. Conrad 1967, 215, 232.

40. Césaire 2000, 68, 41; cf. Fanon 1991.

41. Conrad 1967, 270.

6. The Rise of a Colonial Macabre

The chapter title is adapted from Ngahuia Te Awekotuku 2006, 124. The epigram is by Masson, explaining his drawing of a headless figure for the cover of *Acéphal,* a short-lived journal of the mid-1930s edited by Georges Bataille; cited in Brotchie 1995, 12.

1. Strauch 1883b.

2. Barth 1993; Fernandez 1986, 167.

3. Said 1994, 19.

4. Great progress has been made through the Native American Graves Protection and Repatriation Act of 1990; see National Park Service, www.nps.gov/history/nagpra, cf. Mihesuah 2000.

5. Among others, see Conklin 2008, Karp et al. 2006, Karp and Kratz 2000, and Karp and Lavine 1991.

6. Nys 2008, 118, 113; Van Overbergh 1913.

7. Palmié 2002, 248. A "drum of affliction" is transformative healing ritual; see Turner 1981. Fabian 2006, 150.

8. Sincere thanks to Boris Wastiau, then an RMCA curator of ethnography, for tracking down Lusinga's skull at my behest in 2008. As Wastiau (2009) writes, "The whereabouts of those skulls was subsequently so suppressed in Belgian scholarship that even remarkably thorough PhD research on the history of Belgian physical anthropology at the [Tervuren] museum had not led to their discovery." Wastiau is referring to the work of Maarten Couttenier, who subsequently published photographs of Lusinga's skull and showed it to Congolese artist Sammy Baloji. In turn, Baloji created a photographic work from five images of the cranium in a series called "Aller et Retour" during a 2008 residency at the Musée du quai Branly in Paris; see Couttenier 2004, 198; Couttenier 2009, 111; Baloji 2010. Lotte Arndt (2013) puts Baloji's work on Lusinga's skull and other "vestiges of oblivion" into broader perspective. Thanks to Bogumil Jewsiewicki for discussion of Baloji's work.

9. I have decided not to publish a drawing or photograph of Lusinga's skull in deference to the secrecy in which it would have been revered by his family had it remained in their hands. Thanks to Evan Maurer for discussing this matter in 2011.

10. Storms 1883–1885, 18 April, 4 May 1885.

11. Shorto 2008.

12. Mbote share language and culture with Tabwa; they have hardly been studied, but see Terashima 1980.

13. A. Roberts 1986b, 1988c; Maurer and Roberts 1985; Rubin 1988.

14. Neighboring Bembe performed just such practices; see Gossiaux 2000, 82–83.

15. Denoël 1992, 380. Storms was an honorary member of the society and Houzé its president in 1888; BSAB 1888–1889, 5, 14. Houzé's career is discussed briefly in Couttenier 2005b and 2009; see also Beyers 2003 and Tollebeek 2005.

16. Tollebeek 2005, 57–58.

17. Couttenier 2005b, 78; Gould 1981, 89, 92–95; Shorto 2008, 197. Houzé conducted at least one similar exercise; see Houzé 1885.

18. Houzé 1886, 46.

19. Poole 1997, 141, citing Baudrillard 1981, 93; cf. Said 1994, 222; Gould 1981, 74. Paul Broca's *Instructions craniometriques* (1875) was the model for Houzé's methods and purposes.

20. See Poole 1997; Hartley 2006; Baridon 2005, 161; cf. D. Taylor 2007, 19 and passim.

21. Houzé 1886, 44.

22. Gould 1981, 113.

23. Theunissen 1990, 104.

24. Houzé 1886, 44, 48.

25. Ibid., 54.

26. Gould 2002. Thanks to Maarten Couttenier for guidance concerning these recondite matters from 2008 through this book's publication; see Couttenier 2005b.

27. Roelens 1921, 3.

28. Morton 1839; D. Thomas 2000, 42; Mama 1995, 23–32. Thanks to Lucian Gomoll for bringing Mama's work to my attention (pers. comm. 2010).

29. Cf. Stewart 1993, 125; Fabian 2007, 52. On "profanation," see Agamben 2007; on "typological traditions," see Poole 1997, Chapman 1985.

30. Nys 2008, 7–8. Houzé recalls the German-American anthropologist Franz Boas; see Jacknis 1985.

31. Tagg 1993, 80, 63; Tollebeek 2005, 58; Lombroso 2006; Autin 2005; Couttenier 2005b, 78.

32. Tollebeek 2005, 54.

33. Briggs 2000, 246, 250; Tollebeek 2005, 55–56, 58.

34. De Roover 1952; A. Roberts 1989; Mudimbe 1994, 105–53.

35. Roelens 1948, 199–214; Roelens 1946, 31. African "will"—or the lack thereof in Roelens's reckoning—factored in contemporary debates about evolution and degeneration; see Pick 2005, Crary 2001.

36. Roelens 1921, 3; Bhabha 1997, 153–54; cf. Autin 2005.

37. Maarten Couttenier, pers. comm. 2008; for Flemish rebuttals to Houzé's pronouncements, see Beyers 2003; Tollebeek 2005, 68. Palmié 2002, 43, 45; Arata 1990, 622–23.

38. Cited in Césaire 2000, 50, without reference to source; cf. Matsui 2001.

39. Vacher de Lapouge 1899; Houzé 1906, 3, 6, 35, 102–105; cf. Poncelet 2008, 112.

40. Poncelet 2008, 112.

41. Vincke 1985; Vincke 1986, 232; Vanthemsche 2006, 89–90.

42. Bazenguissa-Ganga 2011, 447; Césaire 2000, 42, cited in Ouédraogo 2008, 21. The subheading is from Premesh Lalu's study (2009, 1) of Xhose King Hintsa's "deaths" as understood through *milandu*-like competing histories.

43. Olalquiaga 1998, 70, 81, citing Walter Benjamin.

44. Sagan 1979, 4, emphasis added.

45. Cf. Lalu 2009, 74.

46. Fabian 1996, 43–44; Fabian 1998a; Legros 1996, 23, 146. The decapitation is reported in sources reviewed by Legros, but the disposition of the head is unknown, as it was not buried with the body; Verbeken 1956, 241.

47. Winans 1994, Baer and Schroefer 2001; Lalu 2000, 2009; Ranger 1988; Bazenguissa-Ganga 2011; RFI 2011; Ghanaweb 2009.

48. L. White 1997, 326; Crais and Scully 2008. For a profoundly disquieting case of the loss and recovery of body parts of famous "Others" in the United States, see Orin Starn's *Ishi's Brain,* 2005.

49. Johnson 1988, 322, 320. The name is sometimes written Kiwelewele, leading to other associations.

50. Hollier 1989, xii, 64.

7. *Art Évo* on the Chaussée d'Ixelles

The epigraph paraphrases Trouillot 1995, 110, changing "America" to "Africa." The original phrase is not in Trouillot's voice, as he alludes to Alain Renais's film "Mon oncle d'Amérique" (1980) and suggests that the uncle's character might have said this but apparently did not.

1. Properties of the figure are considered from Tabwa perspectives in the next chapter.

2. Dillon 2001, 111.

3. See Fuji Travel, www.fujitravel.be. Thanks to the proprietor and tenant for permitting Kathleen Louw to photograph the interior of the building in 2010; and to Kathleen Louw and Christian Ost for contacting the Hôtel communal d'Ixelles concerning the house's history and the Stormses' lack of descendants (pers. comm. 2010).

4. De Boeck and Plissart 2005, 46. The RMCA's 2010 photographic exhibition "Kinshasa—Brussels: From Matonge to Matonge" compared the neighborhoods.

5. The subheading is from Benjamin 1986, 154. Asendorf 1993, 119–20. Walter Benjamin's (1986, 1999) discussions of interior decoration haunt Asendorf's discussion yet are hardly cited. Thanks to Prita Meier for bringing Asendorf's work to my attention (pers. comm. 2009).

6. Vogel 1988, 11.

7. Quotation marks around "Lusinga" indicate that although Storms understood this to be the identity of the figure, Lusinga himself and those about him would have recognized the inherences to be both specific to the Lusinga of the day (given positional succession) and more broadly to those of the chief's matrilineage, as discussed in the next chapter. On Storms's eventual promotion to lieutenant general and his military career more generally, see appendix A.

8. Wastiau 2005, 101–105, writing of two figures associated with Chief Kansabala and collected by Storms (as discussed in the next chapter), that are now in the RMCA. Ouédraogo 2008, 20.

9. Benjamin 1999, 537; Melchior-Bonnet 2001, 81–82.

10. "Obdurate sentinels" is from Bravmann 1983, 44. The sculptures are RMCA nos. 31669 and 31670.

11. Paraphrasing Certeau 1988, xxv, as cited in D. Taylor 2007, 13.

12. Asendorf 1993, 134, citing Huysmans 1959; Benjamin 1999, 538, sounding like Edgar Allan Poe 1840.

13. Colomina 1992, 86, citing Le Corbusier 1925, 174, on Loos.

14. See Brussels Remembers, www.brusselsremembers.irisnet.be/memorial/?id=243, and eBru, www.ebru.be/people/people-bruxelles-cimetiere-de-laeken.html. The original bronze bust was stolen from the Square de Meeûs in 1943 during German occupation of Brussels and replaced with a marble reproduction in 1948 as funded by the Widow Storms's family; see François 1990, 40.

15. Paraphrasing Asendorf 1993, 135; cf. Benjamin 1999, 215; Poe 1840.

16. Asendorf 1993, 126, 129, 127.

17. Tanizaki 1977; for contrary views of the "perfect farrago of discordant and displeasing effects" produced by gaslight reflected in the mirrors of period bourgeois homes, see Poe 1840.

18. "Staccato frenzies" is from Christopher French's (2008) discussion of Lee Krasner's work; Asendorf 1993, 130.

19. Gunning 1997, 32; Crary 1992, 116.

20. Crary 1992, 112, with a nod to Foucault 1995, 112, and citing Benjamin 1997, 126; Crary 2001, 7.

21. *L'Illustration congolaise: Journal bimensuel de propagande coloniale* was published from 1924 to 1940, so Madame Storms must have placed the magazine on the pool table after the general's death in 1918. The review was meant to stimulate interest in the colony so that "the Congo should become an extension of Belgium providing employment for Belgian professionals and workers"; Geary 2002, 43–44. Its display by Madame Storms bore political nuance, in other words.

22. G. Hotz's archive of negatives appears to have been destroyed in 2009. Thanks to Marc Pirmez of Hotz nv/sa—a photography business in Brussels not related to the G. Hotz of 1929—for investigating this matter on my behalf via email, 2009. Internet searches for "G. Hotz photographe" have produced no information.

23. "Stilled lives" is from Linker 1998.

24. Tertullian 1931, chapter 33.

25. Barthes 1977b, 22. "Visual oxymoron" is from discussion of Magritte's work in Spitz 1994, 43. Sunburst display of arrows was an African explorer's trope; see Arnoldi 1998, 206.

26. Benjamin 1999, 211; D. Taylor 2007, 64; cf. Corbey 1993, 360; Coombes 1994, 73–74.

27. Jacques and Storms 1886, 108, 111; Storms 1888–1889c. On Tabwa high-backed stools, see Neyt 1985, 80–81; Maurer 1985, 261–62; A. Roberts 1985, 16. The three collected by Storms are RMCA nos. 31654, 31655, and 31656.

28. Stocking 1985, 6. On the development of Belgian taste for Congolese arts during the colonial period, see Salmon 1992; cf. Mudimbe 1986; Fabian 2007; MacGaffey 1998, 224; Corbey 2000, Schildkraut and Keim 1998 and 1990, among others.

29. Coombes 1994, 69; Melchior-Bonnet 2001, 147.

30. Petit 1996a, 355; Van Avermaet and Mbuya 1954, 389; cf. Mabille 1998.

31. Debray 1992, 373; Crary 1992, 118, 124, 126. Debray refers to Benjamin's (1988) "optical unconscious" without mentioning this perhaps-too-obvious source; on stereographic photography in and about Africa, see Murikuki and Sobania 2007; Vanderknyff 2007; Nys 2008, 7, 10.

32. Crary 1992, 124–25.

33. François 1990, 47, is the only source discovered that mentions Madame Storms; thanks to Kathleen Louw for bringing it to my attention. Edholm 1995, 153; cf. McClintock 1995; Lagae 2004, 2009.

34. Benjamin 1986, 154–55, emphasis added; Barthes 1965, 16–17.

35. Asendorf 1993, 49, 133, 137.

36. Stewart 1993, 136, 140, 151; Canclini 1993, viii; T. Mitchell 1992, 289; Chakrabarty 2008; cf. Jules-Rosette 1992; Schor 1994, 256.

37. Shelton 1994, 185; Breckenridge 1989, 210–12.

38. LaGamma 2007, 5–6; Coombes 1994, 63–84; Wynants 1997, 51–57; cf. Cornelis 2005, 160, 162–63; Terryn 1993; Van de Velde 1898, 40.

39. Masui 1897, ix, 159.

40. Colt de Wolf 1897; Wynants 1997, 119–30; Luwel 1954; De Boeck 1998, 23. Francis Dujardin's made-for-TV film *Boma—Tervuren. Le voyage* of 1999 (ArtMattan Productions) concerns the 1897 fair's "African village" and ritual reburial of the Congolese who perished there.

41. T. Mitchell 1992, 290, 295; T. Bennett 1995, 66.

42. DMS 2008.

43. Breckenridge 1989, 212; Crary 1992, 112; Bataille 1991a, 54, cf. A. Roberts 1996e, 84–85; Jay 1988.

44. Roberts-Jones 1999, 178; Silverman 2011, 144, 146, 164–70.

45. Asendorf 1993, 128.

46. To my knowledge, the usage of the phrase *Art Évo* is original to the present writing, although a 2009 browse on Google suggests that the phrase has been the name for institutions ranging from a gallery in Calgary to a British auto rally and a Turkish jazz trio.

47. Becker 1887, 2: 365; cf. C.K.R. 1896, 279; Fanon 1991, 250; cf. Coombes 1994, 122, that turn-of-the-century ethnographic displays "reinforced certain aspects of eugenic philosophy."

48. Saunders 2005, 91.

49. Burdo 2008.

50. Even now, at least some "former [Belgian] colonials construct their own subalternity in contemporary society" given to dismissing or criticizing their contributions; Arnaut 1999, 14; cf. G. Jacques 1995, Dembour 2000, Butcher 2007, Weyn 2010. Some address their nostalgia through admirable philanthropy in the DRC; see Albertville, Kalemie, www .kalemie.be.

51. Pratt 2008, 200.

52. Foucault 2004, 38. On "culture-building" from Robert Blauner via Caulfield 1972, 202, see A. Roberts 1996e, 85–86.

8. Lusinga's Lasting Laughs

1. Storms ca. 1884; Colle 1913, 1: 6; Kaoze 1910–1911, 418.

2. Vansina 1996, 13; Verhulpen 1936; Hobsbawm 1983, 1, emphasis added.

3. Benedict 1932, 26, cited in Babcock 1993, 71.

4. Kristeva 2012, 51; Colle 1913, 1: 53. A caveat: because of positional succession and manipulation of king lists for political purposes, one cannot be certain that the Lusinga in question was the one assassinated by Storms.

5. Kaoze 1950; cf. Grunne 1985, 92–93. On the Seattle figure no. 81-17-790, see Maurer and Roberts 1985, 100–101; cf. Maurer 1985, 225. On the Tumbwe chiefship, see Colle 1913, Nagant 1976.

6. Colle 1913, 1: 6; A. Roberts 1985, 10–16. The same tactic was deployed by Chief Manda; see Maurer and Roberts 1885, 124–25. On figures collected by Storms that are now at the RMCA, see Maurer 1985. On relevant regional sculptural styles, see Agthe 1983; Bassani 1990; Blakely and Blakely 1987; Gossiaux 1990; LaGamma 2011; Neyt 1977, 1985; and Roberts and Roberts 1996, 221–30; cf. Vansina 1984, 176.

7. Krieger 1990, 22–23, plates 105–107; Berlin Museum für Völkerkunde nos. III E 8987–8989; Maurer 1985, 224. Alternatively, the figures may have been commissioned by Bischoff; their records in the Berlin museum were destroyed during World War II.

8. Weiss 1997, 165, first emphasis added; Weiner 1985, 210; cf. N. Thomas 1991, 23.

9. An exception is the Seattle Art Museum's "Tumbwe" figure that is 86 centimeters tall despite damage to its legs. Large figures were common among Hemba and related groups westward along the Lukuga; see LaGamma 2011, Neyt 1977, A. Roberts 1996a.

10. Wolf 1971, 145; Cotter 2010, C22, changed from plural to singular; R. Thompson 1974, 5–6.

11. R. Thompson 1981, 132, 118.

12. A. Roberts 1980, 150–55.

13. See Willis 1967 for similar symbolism among Fipa living on the southeastern shores of Lake Tanganyika and who are culturally related to Tabwa; cf. Fernandez 1986, 55; R. Thompson 1974.

14. The figure is shown without the necklace in a plate in Jacques and Storms 1886, and as a consequence, one cannot be certain it was original to the object.

15. Kaoze 1942, 98; also see A. Roberts 1995b, 58–59. "Singular" is a fifteenth-century English term of venery for groups of wild boars—*Singularis porcus*; see Lipton 1977, 45.

16. On Tabwa lunar symbolism, see A. Roberts 1985, 2005; on the "tactile engagements" of Luba arts, see M. Roberts 2009.

17. See M. Roberts 1994a; A. Roberts 1994c; Roberts and Roberts 1996, chapter 5.

18. The beads are no longer associated with the figure, nor do they appear in Jacques and Storms 1886, plate 12. "Kansabala's wife" (RMCA 31664) has nothing about the brow in the same photo.

19. Colle 1913, 2: 603. A Kusu male figure bears a similar necklace of *mpiki* seeds; A. Roberts 1996a, 213. On Bugabo among Tabwa, see A. Roberts 2010; Bugabo adepts are *bagabo, mugabo* singular.

20. Storms 1883–1885, 2 December 1884; Schmidt 1912, 276.

21. White Fathers 1885–1889, 14 February 1885 and 12 March 1886; A. Roberts 1983, 1986a.

22. Douglas 1975, 31; Van Avermaet and Mbuya 1954, 662; Jacques and Storms 1886, plate 12.

23. Jacques and Storms 1886, 85.

24. Gell 1998, 223–24; Küchler 1994; Weiner 1985, 223; N. Thomas 1991, 23.

25. Jacques and Storms 1886, 85.

26. Pinney 2004, 8, of Melanesian imagery.

27. A. Roberts 1985, 11; cf. Roelens 1948; cf. A. Roberts 1989. I did not have photos of Tabwa objects to show people during my research, and because conflict prevented my return, I have not been able to determine which figures illustrated in Maurer 1985 might be those in question; such "image repatriation" remains to be undertaken.

28. Colle 1913, 1: 435; cf. Jordàn 2006; A. Roberts 1994a, 1995a; MacGaffey 1988, 1991, 1993, 2000; Martinez-Ruiz 2010.

29. E.g., Cosentino 1995, Janzen 1982, Palmié 2002. The subheading is from Pinney 2008, 7.

30. Mulinda 1985, 202; MacGaffey 1991, 4.

31. A. Roberts 1985, 11–12; A. Roberts, 1993c; Gell 1998, 227, of malangan sculptures of New Ireland; Morgan 1998, 31, emphasis added, of popular images of Christ as understood by many American Evangelicals.

32. See A. Roberts 1990; cf. Johnson 1988, 338, 530; B. Thompson 1999.

33. Roberts and Roberts 1996, 2007.

34. See M. Roberts 1996 and Reefe 1977. No plural of *lukasa* is used by Luba, and an anglicized plural will be adopted here.

35. Roberts and Roberts 1996, 171; M. Roberts 1994a, 31; A. Roberts 1986d, 32.

36. Cf. the extended case study of A. Roberts 1996b. As opposed to the Luba-centric Mbudye Society, Tabwa participated in trans-ethnic sodalities such a Bugabo and Butwa that provided esoteric knowledge and capacities; see A, Roberts 2010, 1986b.

37. Melion and Küchler 1991, 30.

38. MacGaffey 2000, 43; MacGaffey 1998, 229; Devisch 1998, 130; Gell 1998, 62.

39. E.g., Marriott 1976; MacGaffey 1988, 2000a; Fowler 2004. Steiner 2001, 209–11. Latour 1993, 13 and passim; Pinney 2008, 7, on Indian photography.

40. Gell 1998, 17–18, emphasis added; cf. Fowler 2004, 6 and passim.

41. Agamben 2007, 83–84.

42. Palmié 2002, 247; Saunders 2005, 91; cf. Jong and Rowlands 2007. On *vizwa*, see A. Roberts 2000, Davis 2000, 133–62. Sammy Baloji's recent photographic collages demonstrate renewed Congolese attention to colonial memories; see Arndt 2013; Baloji and Couttenier 2013.

43. See Wastiau 2000.

44. Davis 2000, 141, 143; cf. Luba *mazyende,* Van Avermaet and Mbuya 1954, 817–18. Theuws 1961, 39; Van Acker 1907, 83; Anon. n.d.3.

45. On Mobutu's "kleptocracy," see T. Turner 1979; A. Roberts 1986c.

46. Drewal 2008; Jewsiewicki 2008; Fabian 1996, 197–98; Ceyssens 1975; L. White 2000.

47. See Roelens 1948 for such thoughts and Mudimbe 1994 for a riposte.

48. Crapanzano 2004, 4; cf. Chakrabarty 2000.

49. Palmié 2002, 11; cf. L. White 2000.

50. Gell 1998, 223; Hegel 1977, 202, 205; Barth 1993, 3; Metcalf and Huntington 1999, 25; Fabian 1972, 567.

51. Storms 1883–1885, 15 December 1884, on *suzerainété;* cf. Anon. n.d.1, 4. Heremans 1966, plate 5; Reichard 1884b; cf. Luffin 2007, 19–20. Johnson 1988, 16, 141.

52. For an "archaeology of Swahili" as spoken by early central African explorers, see Fabian 1986; Mudekereza 2011 is an artistic response to "mistreated treaties" of the colonial period, and the subheading of this section is drawn from his work.

53. Storms n.d.1.

54. Palmeirim 2006, 57–58; Cunnison 1959; Cunnison 1970, 38; Richards 1940, 1950; cf. Kaoze ca.1930; Nagant 1976.

9. Composing Decomposition

1. Early Luba burial of chiefs was not described in exegetical detail. See Cameron 1877, 2: 110; W. Burton 1939, 256–59; W. Burton 1961, 34–49; De Muelenaere 1902, Ceyssens 2011, 42; Verhulpen 1936, 94, 333; A. Roberts 1996c; and especially Noret and Petit 2011.

2. Childs and de Maret 1996; Storms n.d.4; Storms 1883–1885, 2 May 1885; Jacques and Storms 1886, 92; Van Acker 1903. I gathered exegeses on these matters from chiefs Mpala, Zongwe, and Kapampa, and about chiefs Kansabala and Tumbwe.

3. Roach 1996, 25, 39; V. Turner 1969, 3, V. Turner 1968.

4. Storms 1883–1885, 7–8 March 1885; cf. Giraud 1890, 476; Becker 1887.

5. Storms 1883–1885, 18 March 1885; cf. Smith 1968, 280.

6. Shorter 1968, 241, citing Burdo 1886, 420; cf. Fair 1998.

7. Storms 1883–1885, 19 March 1885.

8. Ibid., 22–23 March, 2 April 1885; Storms n.d.7.

9. Storms 1883–1885, 3 April 1885; Desch Obi 2008, 359n23.

10. Storms 1883–1885, 27 March 1885; Jacques and Storms 1886, 85. The figures are RMCA nos. 31663 and 31664. See Maurer and Roberts 1985, 108–11; Verswijver et al. 1995, 228; A. Roberts 1995c, 1996f; Wastiau 2005.

11. See Wolf 1971, 96; Colle 1904, 335, and Colle 1905, 79; Neyt 1981, 280–89, 307–16; Neyt and de Strycker 1979.

12. Wood identification from RMCA photo-fiche; A. Roberts 1995c, 54, 56.

13. See Gapangwa 1983, Heremans 1966, Mudimbe 1994, and A. Roberts 1987 and 1989.

14. Moinet 1885–1888, 12 September 1885.

15. Ibid., 1 February 1886; mentioned in a letter to Storms, Moinet 1886d; cf. Jacques and Storms 1886, 91–92, IAAPB 1892, 79. A. Roberts 1996c is a preliminary discussion of this event.

16. Because Tabwa observe matrilineal descent, children of Kansabala's sisters' daughters would be of his own lineage and clan, and his closest confidants and staunchest supporters. Ideally, they would wed children of the chief's sons through cross-cousin marriage to keep the inner family closely bound.

17. Van Acker 1907, 43; IAAPB 1892, 31.

18. Cf. Davis 2000, 49; Kaoze 1950, 10.

19. IAAPB 1892, 79; Jacques and Storms 1886, 92; cf. Verhulpen 1936, 79; Van Avermaet and Mbuya 1954, 310, 397; Verbeek 1990; Siegel 1985.

20. Jacques and Storms 1886, 92; Storms 1888–1889, 16; cf. Cameron 1877, 2: 110; Colle 1: 1913, 407–409; Becker 1887, 2: 304. Zongwe's lakeside chiefdom south of Moba was among the farthest from Lubanda to submit to Storms; Storms n.d.1.

21. Delhaise 1908a, 210, writing of "Wabemba" as Bemba-speaking southern Tabwa; his treatise on "Wahorohoro" (1908b) concerned Luba-ized Tabwa around Kalemie. With regard to the apparent discrepancy about watery sites of burial, flowing streams become swampy pools depending on rainfall, and vice-versa.

22. Delhaise 1908a, 210; IAAPB 1892, 31; cf. W. Burton 1961, 43; Theuws 1960, 163; Ceyssens 1998, 125.

23. IAAPB 1892, 3; W. Burton 1961, 43.

24. Schmidt 1912, 277; A. Roberts 1986b, 23–24, A. Roberts 2010, 26; cf. Gossiaux 2000, 81–84.

25. From the twelfth-century *Bestiary* in T. White 1960, 3; A. Roberts 1995b, 75–76. Female spotted hyenas have a sham scrotum and elongated clitoris that closely resemble male anatomy; see Kruuk 1974, 210–11.

26. Van Acker 1907, 65; Morris 1969, 1079; A. Roberts 1986a, A. Roberts 1995b, 75–76.

27. Storms n.d.4.

28. Johnson 1988, 99; cf. Verbeke 1937, 54; Theuws 1960, 169; Vansina 1964, 102; Heusch 1958 and 1985, 100; Dewey and Childs 1996, 62–66; A. Roberts 2011.

29. Liberski 1989, vii; cf. Duffy 2005, 316.

30. See, for example, Schechner 2003, 296–301.

31. P. Brown 1982, 78.

32. Douglas 1985, 176–79; Heusch 1971, 15–16; cf. Hertz 1960, 76, in Metcalf and Huntington 1999, 74; but see Gorman 2012; Jones 2000.

33. Bloch and Parry 1982, 11, 15, 26; Gell 1998, 104. On the production and use of *vizimba* activating agents, see A. Roberts 1996b; Davis 2000.

34. Iliffe 2005, 100 and passim.

35. Roach 1996, 41, referring to Bataille 1991b and citing Hyde 1979.

36. Cooper 1979, 105, 107.

37. Bataille 1991b, 59, cited in Roach 1996, 124; Weiner 1985, 210.

38. Roach 1996, 30 and passim.

39. Ota 2009, 198.

40. Metcalf and Huntington 1999, 43.

41. Heusch 1985, 121; Iliffe 2005, 114 and passim.

42. Roach 1996, 124, citing Bataille 1991b, 59; Douglas 1985, 178; cf. Leinhardt 2003, 316; Dumas-Champion 1989.

43. Bloch and Parry 1982, 7–8, 18; cf. Noret and Petit 2011, 15–18.

44. A. Roberts 1984, 1986c.

45. Hubert and Mauss 1964, as discussed in Heusch 1985, 3 and passim; cf. Colleyn 1976.

46. On "continuance" as a religious goal, see Duffy 2005, 333.

47. Davis 2000, 108; cf. Colle 1913, 2: 617–20. In performance and herbal medicines, Bulindu members engaged the symbolism of bushpigs, emblem of Lusinga's clan; Nagant 1972, annex 2, 22.

48. Kristeva 2012, 121, and ibid., the subheading, p. 6; Davis 2000, 40 and passim; Willis 1991 and 1967.

49. Delhaise 1908a, 209–210; Anon. n.d.3; cf. Davis 2000, 41; cf. W. Burton 1961; Noret and Petit 2011; Theuws 1960.

50. R. Thompson 1981, 95; on Kibawa, see A. Roberts 1980, 1985, 1986d, 1988b, 1991, 2012.

51. Kristeva 2012, 57.

52. R. Thompson 1981, 54.

53. A. Roberts 1993b; V. Turner 1970, 93–111; Fernandez 1986, 63 and passim.

54. Van Avermaet and Mbuya 1954, 387–90; cf. Ceyssens 1998.

55. See A. Roberts 2000; cf. Tonda 2005, 78–79.

56. Heraclitus's Fragment 41, as cited by Plato in the *Cratylus*, 1998; cf. Ingold 2006, 15.

57. Kaoze and Nagant 1973, 748–49.

58. From Plato's *Timaeus* 2009. Alfred North Whitehead's use of the phrase in his ruminations about "subjective immortality" offers intriguing parallels to Tabwa funereal philosophy; see Ford and Suchocki 1977.

59. Womersley 1984, 67–68; Petit 1995, 116–17.

60. Jacques and Storms 1886, 26; A. Roberts 1990; cf. Simbao 2010, Ceyssens 1998, Wright 1993, Harding 1961, Hatchell 1928; Safer and Gill 1982, 97–98. Storms left over two hundred *mpande* disks to the White Fathers for political manipulation as well as trade; Moinet 1885c.

61. Hubert 1905. On Tabwa senses of time, calendrics, and temporal processes, see A. Roberts 1980.

62. MacGaffey 1983, 128–29; MacGaffey 1986, 6; A. Roberts 1980, 35–68; cf. Palmeirim 2006, 49; Cartry 1984; V. Thompson 1981, 44.

63. A. Roberts 1996d; Van Acker 1903, 260; cf. Ceyssens 2011, 118–20.

64. Gell 1998, 140, citing Wagner 1991, 163; cf. Fowler 2004.

65. A. Roberts 1980, 377–79, 417–28; A. Roberts 1988b, 1988c, 1990; M. Roberts 2000; Roberts and Roberts 1996; Kalunga Mwela-Ubi, pers. comm. 1986; cf. Simbao 2010, 78–79.

66. Wagner 1991, 163.

67. Kristeva 2012, 4–5.

68. Ibid., 55.

10. Defiances of the Dead

1. Wastiau 2005, 101, 103; on the social lives of things through African examples, see M. Roberts 1994b. Couttenier 2010, 124–26; Couttenier 2005a. On violence in the Congo Free State, see Vellut 1984.

2. Couttenier 2010, 124–26, 142, citing F. Cornet 1946, 6–7.

3. Couttenier 2010, 136, 138–39, citing Schouteden 1946, 44.

4. RMCA inventory sheet A.424 does not identify the artist, but Marnix d'Haveloose created the bust of Storms in the Square de Meeûs in Brussels, and the RMCB sculpture appears to be by the same hand.

5. Couttenier 2010, 139.

6. The RMCA will be closed for renovation in 2013, and these observations from 2010 may no longer obtain once the museum reopens to the public

7. L. Thornton 1990, 330; "The Belgian Uniforms by James Thiriar," Doctors of the Great War, www.1914-1918.be/james_thiriar.php. None of the uniforms or less formal dress in Thiriar n.d. or 1930, or in his other illustrations, such as those accompanying Gendarme 1942, corresponds to Storms's attire in the portrait (RMCA no. HO.0.1.641) that seems of Bwana Boma's own device.

8. Thanks to David Bichrest, executive secretary of the Winchester Arms Collectors Association, for tentatively identifying the carbine in Thiriar's portrait via email, 2008; cf. The Winchester Collector, www.WinchesterCollector.org.

9. Convents 1993, 243.

10. The cast of Storms's face seems derived from a sketch by G. Vanaise in Becker 1887, 2: 385, as adapted slightly in Burdo 1886, 509 (illustrator's signature illegible); for an example of Thiriar's heroic portraits, see Ceyssens 2011, cover and plate 5.

11. Jeal 2007, 242.

12. Thanks to Evan Maurer, Ernest Wolfe III, and an anonymous curator of the National Rifle Association's National Firearms Museum for identifying and explaining these arms. See the cover of Jeal 2007 for another of the same series of *cartes de visite*.

13. Berenson 2011, 56–59, 67, 72–74; Ewans 2002, 68–69. On recent events, see Bazenguissa-Ganga 2011, Bernault 2010, www.culture.fr/fr/legende/conquerantpacifique1.htm., viewed April 2012. I disagree with Jeal's portrayal of Stanley as kinder and gentler than evidence suggests; see Hochschild 1998, 31, 49, and passim; Berenson 2011, 10–15, 37; Jewsiewicki 1986, 217.

14. Berenson 2011, 10–15.

15. Thanks to Kathleen Louw and Christian Ost for photographing the spatial relationship between the Ward sculpture and the bust of Storms at the RMCA in January 2010.

16. Marles 1996, 18. On Ward's oeuvre, see Arnoldi 1998, 2005.

17. Jacquemin 2003, 72.

18. Saunders 2005, 89; González 2008, 10; Fanon 1995, 89; cf. Bhabha 1997, 159.

19. Nys 2008, 7–8, as discussed in chapter 6.

20. Thanks to Sabine Cornelis and Mary Jo Arnoldi for this information via emails, 2010.

21. The photo accompanies both Vellut 2003, 34, and Couttenier 2010, 138; neither author mentions the sculpture of the African man; Arnoldi, pers. comm. 2010.

22. Cf. Spivak 1999, 269 and passim; Goldblatt 2005; W. Mitchell 2006. Wilson cited in Gonzáles 2008, 68–69, emphasis added; Gonzáles 2001, 25–26. Mudekereza cited in Mudekereza and Cornelis 2011, 7; Cornelis and Lagae 2011, 5. The phrase "cries and whispers" in this paragraph and the section subheading are an obvious nod to Ingmar Bergman's splendid film of 1972 in which two sisters "watch over a third sister on her deathbed, torn between

fearing she might die and hoping she will." Wikipedia, http//en.wikipedia.org/wiki/Cries_ and_Whispers, viewed in August 2011. Such ambivalence informs colonial relations as well.

23. Verswijver et al. 1995, 229; A. Roberts 1995b; Maurer and Roberts 1985; Van Geluwe 1986. Benjamin 1969, 256. On museum silences, see Karp and Kratz 2000, 198 and passim.

24. Cf. Bouttiaux 1999, 2003; Gryseels 2003.

25. Stewart 1993, 151; Stewart 1994, 204.

26. Roussel 1995; Ford 2000, 1–2; Foucault 2004, 16, 38; Trouillot 1995, 110.

Appendixes

1. Colle 1913, 1: 3–8, and passim; on heartland Luba, see Roberts and Roberts 1996.

2. On "Ng'ombe," see Reefe 1981, 129–44; Van Avermaet and Mbuya 1954, 435; Ceyssens 1998, 125; Roberts and Roberts 2007, 26, 4. Cf. Gossiaux 1973, 1983; Heusch 1982b, 1985; Legros 1996.

3. Colle 1913, 1: 53; Verhulpen 1936, 374.

4. See Boone 1961, 56–57 with the caveat that this source is very problematic due to its peculiar stratigraphic model used to determine "primacy," and its colonial conflation of "tribe," "race," language, clan, chiefdom, and profession.

5. Schmidt 1909; cf. Womersley 1984, 1; Mudimbe 1991, 90; Van Avermaet and Mbuya 1954, 222; Ceyssens 1998, 149–51.

6. Schmidt (Schmitz) 1912; Boone 1961, 240–43. On Tusanga clan histories, see Kaoze ca. 1930; Nagant 1972, 1976; Kimpinde 1982. On the politics of Tabwa ethnic identity as expounded by Stefano Kaoze, see Kimpinde 1982; Nagant 1972, 1976; A. Roberts 1987, 1989. On matrilineal descent among Tabwa, see A. Roberts 1980.

7. Anon. n.d.1; Coosemans 1948, 899–903; cf. François 1990, 44. See www.ebru. be/people/people-bruxelles-cimetiere-de-laeken.html. Thanks to Kathleen Louw for visiting and photographing Storms's tomb on my behalf in 2010.

8. Data are taken from these files obtained on my behalf by Kathleen Louw; see also www.klm-mra.be; http://users.skynet.be/dodeluc/1870_9.html.

9. Wahis 1927, 43.

10. François 1990, 47, based upon information from Madame Storms's relatives. Thanks to Kathleen Louw for discovering this precious document.

11. Cf. Ceyssens 2011, 102.

12. Couttenier 2010, 141. André Leguebe, pers. comm. 1982.

13. But see Gauthier 2008, Koivunun 2006, Steiner 1995.

14. Baridon 2005, 144.

15. Burdo 1886, 517, 535—the point being that this was not meant to be the same person, nor her sister!

16. Giraud 1887, 390–91; Livingstone as discussed in Koivunen 2006, 19–20, 262.

17. Legros 1996, 147–50.

18. Reichard cited in Verbeken 1956, 143–44, who suggests that Reichard's description was influenced by the hostility Msiri had shown him.

19. Sizer and Drayton 1887. Cf. Corman 1985; Stern 1971, 225.

20. Sizer and Drayton 1887, 8, and cover; Cowan 1875, 32; Koivunen 2006, 129.

21. Lombroso 2006; Autin 2005, 213–14; Stern 1971, 225.

22. Evans 1998, 241, 247, citing Georges Borgeaud, 250, citing Edmondo Marcucci. Thanks to Susan Gagliardi for bringing this source to my attention. Stanley 1891, 1: 246; Koivunen 2006, 223.

Bibliography

Abbreviations:

AK-KD Archives of the Kalemie-Kirungu Diocese of the Roman Catholic Church, located in Kalemie, DRC.
CAWFR Central Archives of the White Fathers (Missionaries of Our Lady of Africa), Rome.
FS *Fonds Storms,* RMCA.
RMCA Royal Museum of Central Africa, Tervuren, Belgium.

Abu-Lughod, L. 1991. "Writing against Culture." In *Recapturing Anthropology,* ed. R. Fox, 137–62. Santa Fe, NM: School for Advanced Research.
Achebe, C. 1990. "An Image of Africa." In *Joseph Conrad: Third World Perspectives,* ed. R. Hamner, 119–29. Washington, DC: Three Continents.
Ackroyd, P. 1999. *The Life of Thomas More.* New York: Anchor.
Agamben, G. 2007. *Profanations.* Cambridge: MIT Press.
Agthe, J. 1983. *Luba-Hemba, Afrika-Sammlung 1.* Frankfurt: Museum für Völkerkunde.
Alpers, E. 1968. "The Nineteenth Century: Prelude to Colonialism." In *Zamani: A Survey of East African History,* ed. B. Ogot and J. Kieran, 238–54. Nairobi: Longman.
———. 1975. *Ivory and Slaves in East Central Africa.* Berkeley: University of California Press.
———. 2001. "Becoming Mozambique: Diaspora and Identity in Mozambique." In *History, Memory, and Identity,* ed. V. Teelock and E. Alpers, 117–56. Port Louis: University of Mauritius.
———. 2003. "The African Diaspora in the Indian Ocean." In *The African Diaspora in the Indian Ocean,* ed. S. de Silva Jayasuriya and R. Pankhurst, 19–50. Trenton, NJ: Africa World Press.
Anderson, B. 1993. *Imagined Communities: Reflections on the Origin and Spread of Nationalism.* London: Verso.
Annaert-Bruder, A. ca.1965. "Carte de la localisation par points de la population,

République du Zaïre, Province du Katanga." *Centre Scientifique et Médical de l'Université Libre de Bruxelles en Afrique Centrale.*

Anonymous. n.d.1. "Notice sur Storms." *FS*, no. 6, F-III, RMCA.

———. n.d.2. "Croyances et pratiques religieuses de nos populations indigènes," file "Abbé Kaoze," AK-KD.

———. n.d.3. Partial notebook in French and Kitabwa, perhaps written by J. Weghsteen or S. Kaoze, 42–53 and 117–70. 803/121/A, CAWFR.

———. 1881. "To Tanganyika's Shore: Young Joseph Thomson's African Expedition." *New York Times* 3 July, 10.

———. 1883. *The Congo: The White Line across the Dark Continent with Map. The Operations of the* Association Internationale Africaine *and of the* Comité d'Étude du Haut Congo *from December 1877 to October 1882, by a Participant in the Enterprise.* London: E. and F. N. Spon.

———. 1885a. Untitled article, *Mouvement géographique* 2 (16): 9 August, 65.

———. 1885b. "Local and General," *Star* (New Zealand), 23 October.

———. 1885c. Untitled article. *Mouvement géographique* 2 (17): 69.

———. 1885d. "Stanley à Storms." *Mouvement géographique* 2 (3): 11.

———. 1894. "L'Échange du sang." *Le Congo illustré* 3 (8): 22 April, 57–58.

———. 1896a. "Les bomas arabes." *La Belgique coloniale* 2 (20): 234–35.

———. 1896b. "L'Esclavage en Afrique." *La Belgique coloniale* 2 (22): 253–55.

———. 1929. "Documentation. Crimes et superstitions indigènes: vols et magie." *Revue juridique du Congo Belge* 5 (10): 291.

Arata, S. 1990. "The Occidental Tourist: 'Dracula' and the Anxiety of Reverse Colonization,"*Victorian Studies* 33 (4): 621–45.

Arens, W. 1980. *The Man-Eating Myth: Anthropology and Anthropophagy.* New York: Oxford University Press.

Arnaut, K. 1999. "Belgian Memories, African Objects: Colonial Re-Collection at the Musée Africain de Namur." Working paper, http://www.africana.ugent.be/file/7.

Arndt, L. 2013. "Vestiges of Oblivion—Sammy Baloji's Works on Skulls in European Museum Collections." www.darkmatter101.org.

Arnoldi, M. J. 1998. "Where Art and Ethnology Met: The Ward African Collection at the Smithsonian." In *The Scramble for Art in Central Africa*, ed. E. Schildkraut and C. Keim, 193–216. New York: Cambridge University Press.

———. 2005. "Les sculptures de la rotonde du Musée royal de l'Afrique centrale (1910–2005)." In *La mémoire du Congo: Le temps colonial*, ed. J.-L. Vellut, 180–84. Gand, Belgium: Snoeck.

Asad, T. 1991. "From the History of Colonial Anthropology to the Anthropology of Western Hegemony." In *Colonial Situations: Essays on the Contextualization of Ethnographic Knowledge*, ed. G. Stocking, 314–24. Madison: University of Wisconsin Press.

Asendorf, C. 1993. *Batteries of Life: On the History of Things and Their Perception in Modernity.* Berkeley: University of California Press.

Ash, T. G. 2009. "1989!" *New York Review of Books.* 5 November, 4, 6, 8.

Asim, J. 2007. *The N Word: Who Can Say It, Who Shouldn't, and Why.* New York: Houghton Mifflin Harcourt.

Auden. W. H. 2007. "Another Time." In *Another Time*, no pagination. 1st ed. 1940. London: Faber and Faber.

Autin, G. 2005. "Le Type criminel: La controverse Tarde-Lombroso." In *La Physiognomie: Problèmes d'une pseudo-science*, ed. C. Bouton et al., 211–32. Paris: Éds. KIMÉ.

Avon, T. 1915–1916. "Vie sociale des Wabende du Tanganika." *Anthropos* 10–11 (1–2): 98–113.

Babcock, B. 1993. "At Home, No Women Are Storytellers: Ceramic Creativity and the Politics of Discourse in Cochiti Pueblo." In *Creativity/Anthropology,* ed. S. Lavie et al., 70–99. Ithaca, NY: Cornell University Press.

Baer, M., and O. Schroefer. 2001. *Eine Kopsjagd: Deutsch in Ostafrica.* Berlin: Christof Links.

Ballard, R. 1983. *Exploring Our Living Planet.* Washington, DC: National Geographic.

Baloji, S. 2010. "Aller et Retour." In *A Useful Dream: African Photography, 1960–2010,* ed. F. Vanhaecke and S. Ajami, 156. Milan: Silvana.

Baloji, S., and M. Couttenier. 2013. "The Charles Lemaire Expedition Revisited: Social Memory in Oral History, Landscape, Writings, and Photos." *African Arts* 46.

Baridon, L. 2005. "Du portrait comme une science: Phrénologie et arts visuels en France au XIXe siècle." In *La Physiognomie: Problèmes d'une pseudo-science,* ed. C. Bouton et al. 142–70. Paris: Éds. KIMÉ.

Barth, F. 1993. *Cosmologies in the Making: A Generative Approach to Cultural Variation in Inner New Guinea.* Cambridge, UK: Cambridge University Press.

Barthes, R. 1965. "Objective Literature: Alain Robbe-Grillet." In *Two Novels by Robbe-Grillet:* Jealousy *and* In the Labyrinth, 11–25. New York: Grove.

———. 1977a. "Introduction to the Structual Study of Narratives." In *Image—Music—Text: Essays by Roland Barthes, selected and translated by Stephen Heath,* 79–124. New York: Noonday.

———. 1977b. "The Photographic Message." In *Image—Music—Text: Essays by Roland Barthes, selected and translated by Stephen Heath,* 15–31. New York: Noonday.

Bassani, E. 1990. "Il Maestro del Warua/The Warua Master," *Quaderni Poro* 6. Milan: Carlo Monzino.

Basso, K. 1996. *Wisdom Sits in Places: Landscape and Language among the Western Apache.* Albuquerque: University of New Mexico Press.

Bataille, G. 1991a. *Visions of Excess: Selected Writings, 1927–1939.* Minneapolis: University of Minnesota Press.

———. 1991b. *The Accursed Share.* Vol. 1: *Consumption.* Trans. Robert Hurley. New York: Zone.

Baudrillard, J. 1981. *For a Critique of the Political Economy of the Sign.* St. Louis: Telos Press.

Bazenguissa-Ganga, R. 2011. "The Bones of the Body Politic: Thoughts on the Savorgnan de Brazza Mausoleum." *International Journal of Urban and Regional Research* 35 (2): 445–52.

Becker, J. 1887. *La vie en Afrique, ou trois ans dans l'Afrique centrale.* 2 vols. Brussels: J. Lebègue.

Beidelman, T. 1963. "The Blood Covenant and the Concept of Blood in Ukaguru." *Africa* 33 (4): 321–42.

Benedict, R. 1932. "Configurations of Culture in North America." *American Anthropologist* 34: 1–27.

Benjamin, W. 1969. *Illuminations.* New York: Schocken.

———. 1986. *Reflections.* New York: Schocken.

———. 1997. *Charles Baudelaire: A Lyric Poet in the Era of High Capitalism.* London: Verso.

———. 1999. *The Arcades Project.* Cambridge, MA: Harvard University Press.

Bennett, N. 1960. "Captain Storms in Tanganyika, 1882–1885." *Tanganyika Notes and Records* 54: 51–63.

Bennett, T. 1995. *The Birth of the Museum: History, Theory, Politics.* New York: Routledge.

———. 2005. "Culture." In *New Key Words: A Revised Vocabulary of Culture and Society,* ed. T. Bennett et al., 63–69. Malden, MA: Blackwell.

Berenson, E. 2011. *Heroes of Empire: Five Charismatic Men and the Conquest of Africa.* Berkeley: University of California Press.

Bernault, F. 2010. "Colonial Bones: The 2006 Burial of Savorgnan de Brazza in the Congo." *African Affairs* 109 (436): 367–90.

Beyers, L. 2003. "Rasdenken tussen geneeskunds en natuurwetenschap: Émile Houzé en de Société d'Anthropologie de Bruxelles, 1882–1921." In *Degeneratie in België 1860–1940: Een geschiedenis van ideeën en Praktijken,* ed. J. Tollebeek, et al., 43–77. Belgium: Leuven University Press.

Bhabha, H. 1994. *The Location of Culture.* New York: Routledge.

———. 1997. "Of Mimicry and Man: The Ambivalence of Colonial Discourse." In *Tensions of Empire,* ed. F. Cooper and A. L. Stoler, 152–60. Berkeley: University of California Press.

Biaya, T. K. 1995. "Ethnopsychologie de quelques anthroponyms africains des missionnaires catholiques du Kasai colonial." *Annales Aequatoria* 16: 184.

Blakely, P., and T. Blakely. 1994. "Ancestors, 'Witchcraft,' and Foregrounding the Poetic: Men's Oratory and Women's Song-Dance in Hêmbá Funerary Performance." In *Religion in Africa,* ed. T. Blakely et al., 398–442. Portsmouth, NH: Heinemann.

Blakely, T., and P. Blakely. 1987. "So'o Masks and Hemba Funerary Festival." *African Arts* 21 (1): 30–37, 84–86.

Bloch, M., and J. Parry. 1982. "Introduction: Death and the Regeneration of Life." In *Death and the Regeneration of Life,* ed. M. Bloch and J. Parry, 1–44. New York: Cambridge University Press.

Bockie, S. 1993. *Death and the Invisible Powers: The World of Kongo Belief.* Bloomington: Indiana University Press.

Boëtsch, G. 1995. "Anthropologues et 'indigènes': mesurer la diversité, montrer l'altérité." In *L'Autre et nous, "scènes et types,"* ed. P. Blanchard et al., 55–60. Paris: ACHAC.

Bontinck, F. 1974. *L'autobiographie de Hamed ben Mohammed el-Murjebi, Tippo Tipo (ca. 1840–1905).* Brussels: Académie royale des Sciences d'Outre-Mer.

Boone, O. 1961. *Carte ethnique du Congo, quart sud-est.* RMCA, *Annales* 37.

Boulanger, A. 1985. *Société et religion des Zela (Rép. Du Zaïre),* II (82). Bandundu, Zaïre: CEEBA.

Boulger, D. 1898. *The Congo State, or The Growth of Civilization in Central Africa.* London: W. Thacker.

Bouttiaux, A.-M. 1999. "Des mises en scène de curiosités aux chefs-d'oeuvre mis en scène: Le Musée royal de l'Afrique à Tervuren." *Cahiers d'Études Africaines* 39 (155–56): 595–616.

———. 2003. "Périodes coloniales: 'pillage' et création des collections muséales," "La Restitution des biens culturels: Quel rôle pour la Belgique?" www.senate.be/doc/misc/cultuurgoederen-10-1-2003.html.

Bradley, T. E., ed. 1881. *The Lamp.* Vol. 20. London: S. Joseph's.

Bradshaw, R., and I. Ndzesop. 2010. "The Proliferation of Mercenaries in Precolonial and Postcolonial Africa in World Historical Perspective." In *Africanists on Africa: Current Issues,* ed. P. Chabal and P. Skalník, no pagination. Berlin: LIT.

Braeckman, C. 1992. *Le dinosaure: Le Zaïre de Mobutu.* Paris: Fayard.

Bravmann, R. 1983. *African Islam.* Washington, DC: Smithsonian Institution.

Breckenridge, C. 1989. "The Aesthetics and Politics of Colonial Collecting: India at World Fairs." *Comparative Studies in Society and History* 31 (2): 195–216.

Brelsford, V. 1974. "African Dances of Northern Rhodesia." In *Occasional Papers of the*

Rhodes-Livingstone Museum, 21–52. 1st ed. 1948. Manchester, UK: Manchester University Press.

Breton, A. 1972. *Manifestoes of Surrealism.* Ann Arbor: University of Michigan Press.

Briggs, L. 2000. "The Race of Hysteria: 'Overcivilization' and the 'Savage' Woman in Late Nineteenth-Century Obstetrics and Gynecology." *American Quarterly* 52 (2): 246–73.

Broca, P. 1875. "Instructions craniométriques." *Bulletin de la Société d'Anthropologie* (Paris) 10: 337–67.

Brotchie, A. 1995. Introduction to *Encyclopaedia Acephalic,* ed. R. Lebel and I. Waldberg, 8–28. London: Atlas.

Brown, L. 1972. *African Birds of Prey.* Boston: Houghton Mifflin.

Brown, P. 1982. *The Cult of the Saints: Its Rise and Function in Late Christianity.* Chicago: University of Chicago Press.

BSAB [*Bulletin de la Société d'Anthropologie de Bruxelles*]. 1888–1889. "Liste de members." 5–16.

Buakasa, T. 1972. "Le discours de la *kindoki* ou sorcellerie." *Cahiers de religions africaines* 4 (11): 5–67.

Burdo, A. 1885. *Les Arabes dans l'Afrique centrale.* Paris: E. Dentu.

———. 1886. *Les Belges dans l'Afrique centrale. Voyages, Aventures et Découvertes. Le Congo et ses Affluents.* Vol. 1: *De Zanzibar au lac Tanganyika.* 3 vols. Ed. C. de Martrin-Donos. Brussels: P. Maes.

———. 2008. *Stanley: Sa vie, ses aventures, ses voyages.* 1st ed. 1888. Paris: Magellan.

Burton, R. 1860. *The Lake Regions of Central Africa.* 2 vols. London: Longman, Green.

Burton, W. F. P. 1939. *L'Ame Luba.* Elisabethville, DRC: Éds. de la Revue Juridique du Congo Belge.

———. 1961. "Luba Religion and Magic in Custom and Belief." *Annales du Musée royal de l'Afrique centrale* 35. Tervuren, Belgium.

Butcher, T. 2007. *Blood River: A Journey to Africa's Broken Heart.* London: Chatto and Windus.

Cameron, V. L. 1877. *Across Africa.* 5th ed. 2 vols. London: Daldy, Isbister, and Co.

Cancel, R. 1989. *Allegorical Speculation in an Oral Society: The Tabwa Narrative Tradition.* Berkeley: University of California Press.

Canclini, N. G. 1993. *Transforming Modernity: Popular Culture in Mexico.* Austin: University of Texas Press.

Capoeira, N. 2002. *Capoeira: Roots of the Dance-Fight-Game.* Berkeley, CA: North Atlantic.

Cartry, M. ed. 1984. "Calendriers d'Afrique." *Systèmes de Pensée en Afrique Noire* 7.

Casier, J. 1987. "Le royaume chrétien de Mpala: 1887–1893." *Souvenirs historiques* 13. Brussels: Nuntiuncula. Revised 2007 on The Kingdom of Christian Mpala, 1887–1893, www.africamission-mafr.org/mpala.htm.

Caulfield, M. 1972. "Culture and Imperialism: Proposing a New Dialectic." In *Reinventing Anthropology,* ed. D. Hymes, 182–212. New York: Random House.

Centner, T. 1963. *L'Enfant africain et ses jeux.* Elisabethville, DRC: Centre d'études des problèmes sociaux indigènes.

Certeau, M. de. 1988. *The Writing of History.* New York: Columbia University Press.

Césaire, A. 2000. *Discourse on Colonialism.* 1st ed. 1955. New York: Monthly Review.

Ceupens, B. 2006. "Allochtones, Colonizers, and Scroungers: Exclusionary Populism in Belgium." *African Studies Review* 49 (2): 147–86.

Ceyssens, R. 1975. "Mutumbula, mythe de l'opprimé. " *Culture et Développement* 7 (3–4): 483–550.

———. 1998. *Balungu: Constructeurs et destructeurs de l'État en Afrique centrale*. Paris: L'Harmattan.

———. 2011. *De Luulu à Tervuren: La collection Oscar Michaux au Musée royal de l'Afrique centrale*. Tervuren, Belgium: RMCA.

Chakrabarty, D. 2000. *Provincializing Europe: Postcolonial Thought and Historical Difference*. Princeton, NJ: Princeton University Press.

———. 2008. "Belatedness as Opportunity." Keynote address at the conference "(World) Art? Art History and Global Practice," Northwestern University, May 2008.

Chandler, A. 1986. "Heroism in Defeat: The Paris *Exposition Universelle* of 1878." Revised from an article of the same name in *World's Fair* 6 (4), 1986, at http://charon.sfsu.edu/publications/PARISEXPOSITIONS/1878EXPO.html, viewed June 2010.

Chapman, W. 1985. "Arranging Ethnology: A. H. L. F. Pitt Rivers and the Typological Tradition." In *Objects and Others: Essays on Museums and Material Culture*, ed. G. Stocking, 15–48. Madison: University of Wisconsin Press.

Childs, S. T., and P. de Maret. 1996. "Re/Constructing Luba Pasts." In *Memory: Luba Art and the Making of History*, ed. M. N. Roberts and A. Roberts. Munich: Prestel.

C.K.R. 1896. "Comment on fait la connaissance des Nègres." *La Belgique coloniale* 2 (24): 279–80, 291–93.

Clark, J., ed. 2004. *The African Stakes of the Congo War*. New York: Palgrave Macmillan.

Clifford, J. 1986. "Introduction: Partial Truths." In *Writing Culture: The Poetics and Politics of Ethnography*, ed. J. Clifford and G. Marcus, 1–26. Berkeley: University of California.

Colle, P. 1904. "Mission de Lukulu Sacre-Coeur (Urua): Croyances religieuses des Baluba." *Missions d'Afrique des Pères Blancs*, 329–37.

———. 1905. "Croyances religieuses des Baluba. " *Missions d'Afrique des Pères Blancs*, 78–81; abridged in idem 1913, 439–40.

———. 1913. *Les Baluba*. 2 vols. Antwerp, Belgium: Albert Dewit.

———. 1935. "Apropos d'apparitions." *Grands Lacs* 51 (10): 466–68.

Colleyn, J.-P. 1976. "Le sacrifice selon Hubert et Mauss." *Systèmes de pensée en Afrique noire* 2: 23–42.

Colomina, B. 1992. "The Split Wall: Domestic Voyeurism." In *Sexuality and Space*, ed. B. Colomina, 72–128. Princeton, NJ: Princeton University Press.

Colt de Wolf, B. 1897. "The Brussels Exhibition." *New York Times*, 28 March.

Comaroff, J. 1997. "Images of Empire, Contests of Conscience." In *Tensions of Empire*, ed. F. Cooper and A. L. Stoler, 163–97. Berkeley: University of California Press.

Conklin, A. 2008. "Skulls on Display: The Science of Race in Paris's Musée de l'Homme, 1928–1950." In *Museums and Difference*, ed. D. Sherman, 250–88. Bloomington: Indiana University Press.

Conrad, J. 1967. *The Heart of Darkness* (1899). In *Great Short Works of Joseph Conrad*, 209–92. New York: Harper Row.

Convents, G. 1993. "Popular Pleasure for the Middle Classes." In *De Panoramische Droom/The Panoramic Dream. Antwerpen en de Wereldtentoostelligen [Antwerp and the World Expositions], 1885, 1894, 1930*, ed. Mandy Nauwelaerts et al., 243–47. Gand, Belgium: Snoeck.

Coombes, A. 1994. *Reinventing Africa: Museums, Material Culture, and Popular Imagination in Late Victorian and Edwardian England*. New Haven, CT: Yale University Press.

Cooper, F. 1979. "Review Article: The Problem of Slavery in African Studies." *Journal of African History* 20 (1): 103–25.

———. 1992. "Colonizing Time: Work Rhythms and Labor Conflict in Colonial Mombasa." In *Colonialism and Culture,* ed. N. Dirks, 209–45. Ann Arbor: University of Michigan Press.

Coosemans, M. 1948. "Storms (Émile-Pierre-Joseph), Explorateur, Capitaine d'infanterie (Wetteren 2.6.1846—Ixelles. 12.1.1918)." *Biographie coloniale belge* 1: 899–903. Brussels: Falk.

Corbey, R. 1993. "Ethnographic Showcases, 1870–1930." *Cultural Anthropology* 8 (3): 338–69.

———. 2000. *Tribal Art Traffic: A Chronicle of Taste, Trade, and Desire in Colonial and Post-Colonial Times.* Amsterdam: Royal Tropical Institute.

Corman, L. 1985. *Visages et caractères.* Paris: Presses Universitaires Françaises.

Cornelis, S. 1991. "Stanley au service de Léopold II: La fondation de l'État Indépendent du Congo, 1878–1885." In *H. M. Stanley, Explorateur au service du Roi,* ed. S. Cornelis et al., 41–57. RMCA, *Annales Sciences historiques* 15.

———. 1995. "Regards d'artistes belges sur les peuples du Congo (1880–1940)." In *L'Autre et nous, "scènes et types,"* ed. P. Blanchard et al., 191–96. Paris: ACHAC.

———. 2005. "Le colonisateur satisfait, ou le Congo représenté en Belgique (1897– 1958)." In *La mémoire du Congo: Le temps colonial,* ed. J.-L. Vellut, 159–69. Gand, Belgium: Snoeck.

Cornelis, S., and J. Lagae. 2011. "'Congo Far West': Arts, sciences et collections, Quelques réflexions sur un projet experimental au MRAC." In *Congo Far West: Arts, sciences et collections,* 4–5. Milan: SilvanaEditoriale.

Cornet, F. 1946. "La Section Historique du Musée du Congo Belge." *La Revue Coloniale Belge* 1 (9).

Cosentino, D. 1982. "Mende Ribaldry." *African Arts* 15 (2): 64–67, 88.

Cosentino, D., ed. 1995. *Sacred Arts of Haitian Vodou,* Los Angeles: UCLA Fowler Museum.

Cosgrove, D. 1985. *Social Formation and Symbolic Landscape.* Totowa, NJ: Barnes and Noble.

Cotter, H. 2010. "Emerald Deities of Fervor and Flux." *New York Times,* 27 August, C19, C22.

Coupland, R. 1967. *The Exploitation of East Africa, 1856–1890: The Slave Trade and the Scramble.* 1st ed. 1939. Evanston, IL: Northwestern University Press.

Couttenier, M. 2004. "Fysieke antropologie, koloniale etnografie en het museum van Tervuren. Een geschiedenis can de Belgische antropologie (1882–1925)." Unpublished PhD dissertation, Catholic University of Leuven, Belgium.

———. 2005a. "Premières présentations de culture matérielle congolaise au Musée de Tervuren: les scientifiques et leurs orientations (1897–1925)." In *La mémoire du Congo: Le temps colonial,* ed. J.-L. Vellut, 185–89. Gand, Belgium: Snoeck.

———. 2005b. *Congo tentoongesteld: Een geschiedenis van de Belgische antropologie en het museum van Tervuren (1882–1925).* Leuven, Belgium: ACCO.

———. 2009. "Fysieke antropologie in België en Congo 1883–1964." In *De exotische mens. Andere culturen als amusement,* ed. B. Sliggers and P. Allegaert, 96–113. Tielt, Belgium: Lannoo.

———. 2010. "'No Documents, No History': The Moral, Political and Historical Sciences Section of the Museum of the Belgian Congo, Tervuren (1910–1948)." *Museum History Journal* 3 (2): 123–48.

Cowan, John. 1875. *Self-Help in the Attainment of Perfection of Character and Success in Life.* New York: Cowan and Co.

Crais, C., and P. Scully. 2008. *Sara Baartman and the Hottentot Venus: A Ghost Story and a Biography.* Princeton, NJ: Princeton University Press.

Crapanzano, V. 2004. *Imaginative Horizons: An Essay in Literary-Philosophical Anthropology.* Chicago: University of Chicago Press.

Crary, J. 1992. *Techniques of the Observer: On Vision and Modernity in the Nineteenth Century.* Cambridge: MIT Press.

———. 2001. *Suspensions of Perception: Attention, Spectacle, and Modern Culture.* Cambridge: MIT Press.

Cunnison, I. 1959. *The Luapula Peoples of Northern Rhodesia: Custom and History in Tribal Politics.* Manchester, UK: Manchester University Press.

———. 1969. "History on the Luapula." *Rhodes-Livingstone Institute Papers* 21. 1st ed. 1951. Manchester, UK: Manchester University Press.

———. 1970. "Perpetual Kinship: A Political Institution of the Luapula Peoples." *Human Problems in British Central Africa* 20: 28–48. Manchester, UK: Manchester University Press.

Davis, C. 2000. *Death in Abeyance: Illness and Therapy among the Tabwa of Central Africa.* Edinburgh, UK: Edinburgh University Press.

Davis-Roberts, C. 1985. "Consciousness in Extremity: Discourse on Madness among the Tabwa of Zaire." *International Journal of Psychology* 20 (4–5): 569–87.

DeBeerst, G. 1894. "Essai de grammaire tabwa." *Zeitschrift für Afrika und Ocean Sprachen,* vols. 1–2.

De Boeck, F. 1998. "Beyond the Grave: History, Memory, and Death in Postcolonial Congo/ Zaïre." In *Memory and the Postcolony: African Anthropology and the Critique of Power,* ed. R. Werbner, 21–57. New York: Zed.

De Boeck, F., and M.-F. Plissart. 2005. *Kinshasa: Tales of the Invisible City.* Brussels: Ludion.

Debray, R. 1992. *Vie et mort de l'image: Une histoire du regard en Occident.* Paris: Gallimard.

Delhaise, C. 1908a. "Chez les Wabemba." *Bulletin de la Société royale belge de Géographie* 32: 173–227, 261–83.

———. 1908b. "Chez les Warundi et les Wahorohoro." *Bulletin de la Société royale belge de Géographie* 32: 429–50.

Dembour, M.-B. 2000. *Recalling the Belgian Congo: Conversations and Introspection.* New York: Berghahn.

De Muelenaere, F. 1902. "Enterrement d'un chef nègre, Makombo." *Mouvement géographique* 19 (38): 458–60.

Denoël, T., ed. 1992. *Le nouveau dictionnaire des Belges.* Brussels: Le Cri.

De Roover, A. 1952. *Victor Roelens, de Vlaamse Lavigerie.* Antwerp: Nieuw Afrika.

Desch Obi, T. 2008. *Fighting for Honor: The History of African Martial Art Traditions in the Atlantic World.* Columbia: University of South Carolina Press.

Devisch, R. 1998. "Treating the Affect by Remodelling the Body in a Yaka Healing Cult." In *Bodies and Persons: Comparative Perspectives from Africa and Melanesia,* ed. M. Lambek and A. Strathern, 127–57. New York: Cambridge University Press.

Devroey, E.-J., and C. Neuhuys-Nisse. 1965. *Léon Dardenne, 1865–1912.* Tervuren, Belgium: RMCA.

Dewey, W., and S. T. Childs. 1996. "Forging Memory." In *Memory: Luba Arts and the Making of History,* ed. M. Roberts and A. Roberts, 60–83. Munich: Prestel.

Dillon, S. 2001. "Victorian Interior." *Modern Language Quarterly* 62 (2): 83–115.

Dion, I. 2007. *Pierre Savorgnan de Brazza: Au coeur du Congo*. Paris: Éds. Images et Manoeuvres.

DMS [Direction des Monuments et des Sites de la Région de Bruxelles]. 2008. "Les passages de Bruxelles/Les Galeries Royales Saint-Hubert," UNESCO World Heritage Center, http://whc.unesco.org.

Dollo, M. 1886. "Notice sur les reptiles et batraciens receuillis par M. le Capitaine Storms dans la région du Tanganika." *Bulletin du Musée Royal d'Histoire Naturelle de Belgique* 4: 151–60.

Dorst, J., and P. Dandelot. 1969. *A Field Guide to the Larger Mammals of Africa*. Boston: Houghton Mifflin.

Dorward, D. 1974. "Ethnography and Administration: A Study of Anglo-Tiv 'Working Misunderstanding.'" *Journal of African History* 15 (3): 457–77.

Douglas, M. 1975. *Implicit Meanings: Essays in Anthropology*. New York: Routledge.

———. 1985. *Purity and Danger: An Analysis of Concepts of Pollution and Taboo*. 1st ed. 1966. Boston: Ark Paperbacks.

Drewal, H. J., ed. 2008. *Mami Wata: Arts for Water Spirits in Africa and Its Diasporas*. Bloomington: Indiana University Press.

Dubois, M.-M., ed. 1981. *Dictionnaire français-anglais/anglais-français, nouvelle édition*. Paris: Larousse.

Duchesne, A. 1892. "L'esclavage sur le Tanganika." *Mouvement antiesclavagiste* 4: 20–23.

Duffy, E. 2005. *The Stripping of the Altars: Traditional Religion in England, 1400–1580*. 2nd ed. New Haven, CT: Yale University Press.

Dujardin, F. 1999. *Boma-Tervuren, Le Voyage*, made-for-TV film. Charleroi, Belgium: RTBF and Cobra Film.

Dumas-Champion, F. 1989. "'Le mort circoncis': Le culte des crânes dans les populations de la Haute Bénoué (Cameroun/Nigeria). " *Systèmes de pensée en Afrique noire, cahier* 9: 33–73.

Dupré, M.-C. 1991. "Colours in Kidumu Masks of the Teke Tsaayi." In *Body and Space: Symbolic Models of Unity and Division in African Cosmology and Experience*, ed. A. Jacobson-Widding, 217–35. Uppsala Studies in Cultural Anthropology 16.

Durham, D., and J. Fernandez. 1991. "Tropical Dominions: Struggle over Domains of Belonging and Apartness in Africa." In *Beyond Metaphor: The Theory of Tropes in Anthropology*, ed. J. Fernandez, 190–210. Stanford, CA: Stanford University Press.

Edholm, F. 1995. "The View from Below: Paris in the 1880s." In *Landscape Politics and Perspectives*, ed. B. Bender, 139–68. Providence, RI: Berg.

Ellis, H. 2007. *Selected Essays*. London: Pomona.

Elsing, J. 1956. *La saga des Baluba*. Paris: Plon.

ETA [Équipe Tous Ensemble]. ca. 1987. "Mpala-Lubanda, Première communauté chrétienne du Diocèse de Kalemie-Kirungu, 1885–1985." Pamphlet. *Diocèse de Kalemie-Kirungu*, DRC.

Evans, A. 1998. "The Illustrators of Jules Verne's 'Voyages Extraordinaires.'" *Science Fiction Studies* 25 (2): 241–70.

Evans-Pritchard, E. 1928. "The Dance." *Africa* 1 (4): 446–62.

Ewans, M. 2002. *European Atrocity, African Catastrophe: Leopold II, the Congo Free State, and its Aftermath*. New York: RoutledgeCurzon.

Eyenga-Cornelis, S. 2003. "Les peintres naturalistes belges au Congo (1886–1900)." In *Le Congo et l'art belge, 1880–1960*, ed. J. Guisset, 90–109. Brussels: Renaissance du Livre.

Fabian, J. 1972. "How Others Die: Reflections on the Anthropology of Death." *Social Research* 39 (3): 543–67.

———. 1983. "Missions and the Colonization of African Languages: Developments in the Former Belgian Congo." *Canadian Journal of African Studies* 17 (2): 165–87.

———. 1986. *Language and Colonial Power: The Appropriation of Swahili in the Former Belgian Congo, 1880–1938.* Berkeley: University of California Press.

———. 1996. *Remembering the Present: Painting and Popular History in Zaire.* Berkeley: University of California Press.

———. 1998a. *Moments of Freedom: Anthropology and Popular Culture.* Charlottesville: University Press of Virginia.

———. 1998b. "The History of Zaïre as Told and Painted by Tshibumba Kanda Matulu in Conversation with Johannes Fabian." *Archives of Popular Swahili* 2 (2), November. www2.fmg.uva.nl/lpca/aps/tshibumba1a.html.

———. 2000. *Out of Our Minds: Reason and Madness in the Exploration of Central Africa.* Berkeley: University of California Press.

———. 2001. "Time, Narration, and the Exploration of Central Africa." *Narrative* 9 (1): 3–20.

———. 2006. "Forgetting Africa." In *African Anthropologies: History, Critique and Practice,* ed. N. Mwenda et al., 139–53. New York: Zed.

———. 2007. *Memory against Culture: Arguments and Reminders.* Durham, NC: Duke University Press.

Faïk-Nzuji, C. 1992. *Symboles graphiques en Afrique noire.* Paris: Karthala.

———. 2000. *Arts africains: Signes et symboles.* Paris: DeBoeck Université.

Fair, L. 1998. "Dressing Up: Clothing, Class, and Gender in Post-Abolition Zanzibar." *Journal of African History* 39: 63–94.

Fanon, F. 1991. *The Wretched of the Earth.* New York: Grove.

———. 1995. *Peau noire, masques blancs.* Paris: Éds. du Seuil.

Felix, M., and M. Jordán. 1998. *Makishi lya Zambia: Mask Characters of the Upper Zambezi Peoples [Masken-Charaktere der Völker am Oberen Sambesi].* Munich: Fred Jahn.

Fernandez, J. 1982. *Bwiti: An Ethnography of the Religious Imagination in Africa.* Princeton, NJ: Princeton University Press.

———. 1986. *Persuasions and Performances: The Play of Tropes in Culture.* Bloomington: Indiana University Press.

Ford, L., and M. Suchocki. 1977. "A Whiteheadian Reflection on Subjective Immortality." *Process Studies* 7 (1): 1–13.

Ford, M. 2000. *Raymond Roussel and the Republic of Dreams.* Ithaca, NY: Cornell University Press.

Foster, S. L. 1986. *Reading Dancing: Bodies and Subjects in Contemporary American Dance.* Berkeley: University of California Press.

———. 1995. "Choreographing History." In *Choreographing History,* ed. S. L. Foster, 3–21. Bloomington: Indiana University Press.

Foucault, M. 1980. *Power/Knowledge: Selected Interviews and Other Writings, 1972–1977.* New York: Pantheon.

———. 1995. *Discipline and Punish: The Birth of the Prison.* New York: Vintage.

———. 2004. *Death and the Labyrinth: The World of Raymond Roussel.* New York: Continuum.

Fowler, C. 2004. *The Archaeology of Personhood: An Anthropological Approach.* New York: Routledge.

François, J. 1990. "L'Avenue Général Storms." *Florinas* 28: 3–4, 33–47.

French, C. 2008. "Lee Krasner." *ARTnews* (November): 170.

Fu-Kiau Bunseki. 1974. "Man in his World." Excerpt from *N'Kongo ye Nza Yakun zungidila.*

In *An Anthology of Kongo Religion: Primary Texts from Lower Zaïre*. ed. J. Janzen and W. MacGaffey, 34. University of Kansas Publications in Anthropology 5. Lawrence: University of Kansas Press.

———. 2001. *African Cosmology of the Bântu-Kôngo: Tying the Spiritual Knot, Principles of Life and Living*. Brooklyn, NY: Athelia Henrietta.

Gansemans, J. 1980. "Les instruments de musique luba (Shaba, Zaïre)." RMCA, *Annales* 103.

———. 1981. "La musique et son rôle dans la vie sociale et rituelle luba." *Cahiers des Religions Africaines* 16 (31–32): 181–234.

Gapangwa, N. 1983. "Les origins de la Mission du Tanganyika (1878–1914): Les méthodes pastorals." Unpublished doctoral dissertation, Faculty of Ecclesiastical History, Gregorian Pontifical University, Rome.

Gauthier, G. 2008. *Edouard Riou, dessinateur: Entre* le Tour du monde *et Jules Verne*. Paris: L'Harmattan.

Geary, C. 2002. *In and Out of Focus: Images from Central Africa, 1885–1960*. London: Peter Wilson.

Geertz, C. 1973. *The Interpretation of Cultures*. New York: Basic Books.

Gell, A. 1998. *Art and Agency: An Anthropological Theory*. New York: Oxford University Press.

Gendarme, F. 1942. *Croquis congolais*. 3 vols. Brussels: Wellens-Pay.

Geschiere, P. 2004. *The Modernity of Witchcraft: Politics and the Occult in Postcolonial Africa*. Charlottesville: University of Virginia Press.

Ghanaweb. 2009. "General News of Tuesday, 24 March," www.ghanaweb.com, as reported on H-AFRICA@h-net.msu.edu by K. Akurang-Parry, 25 March.

Gil, J. 2006. "Paradoxical Body." *TDR: The Drama Review* 50 (4): 21–35.

Gillis, A. 1981. *Dictionnaire français-kiluba*. Gent, Belgium: Henri Dunantlaan.

Giraud, V. 1887. "Les lacs de l'Afrique Équatoriale." *Le Tour du Monde*, 337–400.

———. 1890. *Les lacs de l'Afrique Centrale, Voyage d'exploration exécuté de 1883 à 1885*. Paris: Hachette.

Gogol, N. 1985. "The Nose" (ca. 1836). In *The Complete Tales of Nikolai Gogol*. Chicago: University of Chicago Press.

Goldblatt, D. 2005. *Art and Ventriloquism*. New York: Routledge.

González, J. 2001. "Against the Grain: The Artist as Conceptual Materialist." In *Fred Wilson: Objects and Installations, 1979–2000*, ed. M. Berger, 22–31. New York: Distributed Art Publishers.

———. 2008. *Subject to Display: Reframing Race in Contemporary Installation Art*. Cambridge: MIT Press.

Gorceix, P. 1997. *La Belgique fin de siècle . . . Romans—Nouvelles—Théâtre*. Brussels: Éds. Complexe.

Gordon, D. 2004. "The Cultural Politics of a Traditional Ceremony: Mutomboko and the Performance of History on the Luapula (Zambia)." *Comparative Studies in Society and History* 46 (1): 63–83.

———. 2006a. *Nachituta's Gift: Economy, Society, and Environment in Central Africa*. Madison: University of Wisconsin Press.

———. 2006b. "History on the Luapula Retold: Landscape, Memory, and Identity in the Kazembe Kingdom." *Journal of African History* 47: 21–42.

Gorman, J. 2012. "Survival's Ick Factor." *New York Times* 24 January, D1, D4.

Gossiaux, P. P. 1973. "Mythologie et culte de Lyangombe chez les Bashi selon Père Colle." *Revue Universitaire du Burundi* 1 (3-4): 141–202.

———. 1983. "Mythe et pouvoir: Le culte de Ryangombe-Kiranga (Afrique équatoriale de l'Est)." *Actes du Colloque de Liège et Louvain-la-Neuve, 1981. Homo religiosus* 9: 337–72.

———. 1990. "Les Maîtres de Buli: Esthétique et Ethno-histoire (avec deux inédits)." *Art et exotisme, Revue des historiens de l'art, des archéologues, des musicologues, et des orientalistes de l'Université de Liège* 9: 38–49.

———. 2000. "Le Bwame du Léopard des Babembe (Kivu-Congo)." In *Animaux que l'homme choisit d'inhumer,* ed. L. Bodson, 169–269. Liège, Belgium: Université de Liège. Revised at Anthroposys, www.anthroposys.be.

Gottlieb, A. 1997. "Blood (symbolic)." In *The Blackwell Dictionary of Anthropology,* ed. T. Banfield. Oxford: Blackwell.

Gould, S. J. 1981. *The Mismeasure of Man.* New York: Norton.

———. 2002. *The Structure of Evolutionary Theory.* Cambridge, MA: Belknap Press.

Grévisse, F. 1956. "Notes ethnographiques relatives à quelques populations authochtones du Haut-Katanga industriel." *Bulletin du Centre d'études des problèmes sociaux indigènes* 32: 65–207.

Grunne, B. de. 1985. "A Note on 'Prime Objects' and Variation in Tabwa Figural Sculpture." In *The Rising of a New Moon: A Century of Tabwa Art,* ed. E. Maurer and A. Roberts, 91–96. Seattle: University of Washington Press.

Gryseels, G. 2003. Untitled contribution. "La Restitution des biens culturels: Quel rôle pour la Belgique?" Belgian Senate. www.senate.be/doc/misc/cultuurgoederen-10-1-2003 .html.

Guillemé, R. P. 1892. "Lettre à Émile Storms de Mpala, janvier." *Mouvement antiesclavagiste* 4: 20–22.

Guisset, J. 2003. "L'Afrique dans la peinture en Belgique (1880–1914)." In *Le Congo et l'art belge, 1880–1960,* ed. J. Guisset, 110–39. Brussels: Renaissance du Livre.

Gunning, T. 1997. "From the Kaleidoscope to the X-Ray: Urban Spectatorship, Poe, Benjamin, and *Traffic in Souls* (1913)." *Wide Angle* 19 (4): 25–61.

Hagerfors, L. 1985. *The Whales in Lake Tanganyika.* New York: Grove.

Halen, P. 1992. "Exotisme et Antiexotisme: Notes sur les écrivains antiesclavagistes en Belgique francophone (1856–1894)." In *Papier blanc, encre noire: Cent ans de culture francophone en Afrique centrale (Zaïre, Rwanda et Burundi),* ed. M. Quaghebeur et al. 2 vols. 35–53. Brussels: Éds. Labor.

Harding, J. R. 1961. "Conus Shell Disk Ornaments (Vibangwa) in Africa." *Journal of the Royal Anthropological Institute of Great Britain and Ireland* 91 (1): 52–66.

Harries, P. 2001. "Missionaries, Marxists, and Magic: Power and the Politics of Literacy in South-East Africa." *Journal of Southern African Studies* 27 (3): 405–27.

Hartlaub, G. 1886. "Description de trois nouvelles espèces d'oiseaux rapportées des environs du lac Tanganyka (Afrique Centrale) par M. le Capitaine Ém. Storms," with appendix by Alph. Dubois, "Liste des oiseaux recueillis par M. le Capitaine Ém. Storms dans la région du lac Tanganyka (1882–1884)." *Bulletin du Musée Royal d'Histoire Naturelle de Belgique* 4: 143–50.

Hartley, L. 2006. *Physiognomy and the Meaning of Expression in Nineteenth-Century Literature and Culture.* Cambridge, UK: Cambridge University Press.

Hatchell, G. 1928. "Vibangwa: A Form of Insignia Used in the Eastern Hinterland of Lake Tanganyika." *Man* 19: 27–30.

———. 1940. "Some Account of the People Living under the Protection of Mount Mkungwe." *Tanganyika Notes and Records* 9: 41–46.

Headrick, D. 1981. *The Tools of Empire: Technology and European Imperialism in the Nineteenth Century.* New York: Oxford University Press.

Hegel, G. 1977. *Phenomenology of Spirit*. 1st ed. 1807. New York: Oxford University Press.

Heller, J. 2004. *Catch-22*. 1st ed. 1955. New York: Simon and Schuster.

Henige, D. 1974. *The Chronology of Oral Tradition*. Oxford: Clarendon.

Heremans, R. 1966. *Les établissements de l'Association internationale africaine au lac Tanganika et les Pères Blancs: Mpala et Karéma, 1877–1885*. RMCA, Annales 3.

Hertz, R. 1960. *Death and the Right Hand*. New York: Free Press.

Heusch, L. de. 1958. *Essais sur le symbolisme de l'inceste royal*. Brussels: Institut de Sociologie Solvey, Université Libre de Bruxelles.

———. 1971. Preface to *De la souillure: Essai sue les notions de pollution et de tabou* by Mary Douglas. Paris: Maspero.

———. 1972. *Le roi ivre ou l'origine de l'État*. Paris: Gallimard.

———. 1982a. *The Drunken King; or, The Origin of the State*. Bloomington: Indiana University Press.

———. 1982b. *Rois nés d'un coeur de vache*. Paris: Gallimard.

———. 1985. *Sacrifice in Africa: A Structuralist Approach*. Manchester, UK: Manchester University Press.

———. 1991. "Le roi vient d'ailleurs." In *Body and Space: Symbolic Models of Unity and Division in African Cosmology and Experience*, ed. A. Jacobson-Widding, 109–17. Uppsala Studies in Cultural Anthropology 16.

Hobsbawm, E. 1983. Introduction to *The Invention of Tradition*, ed. E. Hobsbawm and T. Ranger, 1–14. Cambridge, UK: Cambridge University Press.

Hocart, A. 1935. "Blood-Brotherhood." *Man* 35 (127): 113–15.

Hochschild, A. 1998. *King Leopold's Ghost*. Boston: Houghton Mifflin.

Hollier, D. 1989. *Against Architecture: The Writings of Georges Bataille*. Cambridge: MIT Press.

Hore, A. 1886. *To Lake Tanganyika in a Bath Chair*. London: Sampson Low.

Hoskins, J. 2010. "Seeing Syncretism as Visual Blasphemy: Critical Eyes on Caodai Religious Architecture." *Material Religion* 6 (1): 30–59.

Houzé, É. 1885. "Communication de M. Houzé: Les nègres du Haut Congo, tribu baroumbé." *Bulletin de la Société d'Anthropologie de Bruxelles* 4: 67–83.

———. 1886. "Les tribus occidentales du lac Tanganika." *Bulletin de la Société d'Anthropologie de Bruxelles* 5: 43–64, Plate I.

———. 1906. "L'Aryen et l'anthroposociologie: Étude critique." *Instituts Solvay, Institut de Sociologie, Notes et mémoires* 5.

Hubert, H., and M. Mauss. 1964. *Sacrifice: Its Nature and Function*. 1st ed. 1899. Chicago: University of Chicago Press.

Huff, K. 2009. Review of Gérard Prunier's *Africa's World War* (2008). Amazon.com. Posted 29 May.

Hunt, N. R. 1999. *A Colonial Lexicon of Birth Ritual, Medicalization, and Mobility in the Congo*. Durham, NC: Duke University Press.

Huysmans, J.-K. 1959. *Against Nature*. 1st ed. 1884. Harmondsworth, UK: Penguin Books.

Hyde, L. 1979. *The Gift: Imagination and the Erotic Life of Property*. New York: Vintage.

IAAPB [Institut apostolique africain des Pères Blancs]. 1892. *Près du Tanganika par les Missionnaires de Son Éminence le Cardinal Lavigerie*. Antwerp, Belgium: H. Majoor.

Iliffe, J. 2005. *Honour in African History*. New York: Cambridge University Press.

Ingold, T. 2006. "Rethinking the Animate, Re-Animating Thought." *Ethnos* 71 (1): 9–20.

Inomata, T., and L. Coben, eds. 2006. *Archaeology of Performance: Theaters of Power, Community, and Politics*. Lanham, MD: Altamira.

Jacknis, I. 1985. "Franz Boas and Exhibits." In *Objects and Others: Essays on Museums and Material Culture*, ed. G. Stocking, 75–111. Madison: University of Wisconsin Press.

Jackson, M. 1998. *Minima Ethnographica: Intersubjectivity and the Anthropological Project.* Chicago: University of Chicago Press.

———. 2005. *Existential Anthropology: Events, Exigencies, and Effects.* New York: Berghahn.

Jacobson-Widding, A. 1979. *Red-White-Black as a Mode of Thought.* Uppsala Studies in Cultural Anthropology 1.

———. 1988. "Death Rituals as Inversions of Life Structures: A Comparison of Swedish and African Funerals." Uppsala Studies in Cultural Anthropology 8: 137–53.

———. 1990. "The Fertility of Incest." Uppsala Studies in Cultural Anthropology 15: 47–73.

———. 2000. *Chapungu: The Bird That Never Drops a Feather. Male and Female Identities in an African Society.* Uppsala Studies in Cultural Anthropology 28.

Jacquemin, J.-P. 2003. "L'Art colonial à pile ou face: Exotisme et propagande." In *Le Congo et l'art belge, 1880–1960,* ed. J. Guisset, 66–73. Brussels: Renaissance du Livre.

Jacques, G. 1995. *Lualaba: Histoires de l'Afrique profonde.* 2nd ed. Brussels: Racine.

Jacques, V., and É. Storms. 1886. *Notes sur l'ethnographie de la partie orientale de l'Afrique Équatoriale.* Brussels: F. Hayez, as an offprint of *Bulletin de la Société d'Anthropologie de Bruxelles* 5 (1886): 91–223.

Janssens, U. 2007. *Ces Belges les plus braves: Histoire de la Belgique gauloise.* Tielt, Belgium: Lannoo.

Janzen, J. 1982. *Lemba, 1650–1930: A Drum of Affliction in Africa and the New World.* New York: Garland.

———. 1992. *Ngoma: Discourses of Healing in Central and Southern Africa.* Berkeley: University of California Press.

Jay, M. 1988. "Scopic Regimes of Modernity." In *Vision and Visuality,* ed. H. Foster, 3–28. New York: New Press.

Jeal, T. 2007. *Stanley: The Impossible Life of Africa's Greatest Explorer.* New Haven, CT: Yale University Press.

Jeurissen, L. 2006. "Histoire coloniale et nomadisme heuristique: Du 'Congo de Papa' au 'Bled.'" *Civilisations* 54 (1–2): 33–43.

Jewsiewicki, B. 1986. "Collective Memory and the Stakes of Power: A Reading of Popular Zairian Historical Discourses." *History in Africa* 13: 195–223.

———. 1987. "Vers une anthropo-sociologique historique des populations: Une proposition de macro-analyse des processus démographiques contemporains au Zaïre." *Cahiers d'Études Africaines* 27 (105–106): 107–21.

———. 2008. "Mami Wata/Mamba Muntu Paintings in the Democratic Republic of the Congo." In *Mami Wata: Arts for Water Spirits in Africa and Its Diasporas,* ed. H. Drewal, 126–33. Los Angeles: UCLA Fowler Museum.

Johnson, F. 1988. *A Standard Swahili-English Dictionary.* 1st ed. 1939. New York: Oxford University Press.

Jones, M. O. 2000. "What's Disgusting, Why, and What Does It Matter?" *Journal of Folklore Research* 37 (1): 53–71.

Jong, F. de, and M. Rowlands, eds. 2007. *Reclaiming Heritage: Alternative Imaginaries of Memory in West Africa.* Walnut Creek, CA: Left Coast.

Jordán, M. 2006. *Makishi: Mask Characters of Northwestern Zambia.* Los Angeles: UCLA Fowler Museum.

Joubert, L.-L. 1889. "Ce que les blancs peuvent faire en Afrique." *Mouvement antiesclavagiste* 1: 56–59.

Jules-Rosette, B. 1992. "What Is 'Popular'? The Relationship between Zaïrian Popular and

Tourist Paintings." In *Art pictoral zaïrois*, ed. B. Jewsiewicki, 134–43. Sillery, Québec: Septentrion.

Kaeppler, A. 1991. "Memory and Knowledge in the Production of Dance." In *Images of Memory*, ed. S. Küchler and W. Melion, 109–20. Washington, DC: Smithsonian Institution.

Kaoze, S. 1910–1911. "Le psychologie des Bantu." *La Revue Congolaise* 1: 410–37, 2: 55–63.

———. ca. 1930. "Le mukowa ou clan." Typescript, AK-KD.

———. 1942. "Culte et superstitions des Batabwa." Unpublished notebooks, AK-KD.

———. 1950. "Histoire des Bena-Kilunga." Manuscript in Nagant 1976.

Kaoze, S., and G. Nagant. 1973. "Proverbes tabwa." *Cahiers d'Études africaines* 13 (52): 744–68.

Karp, I., and C. Kratz. 2000. "Reflections on the Fate of Tippoo's Tiger: Defining Cultures through Public Display." In *Cultural Encounters: Representing Otherness*," ed. E. Hallam and B. Street, 194–228. New York: Routledge.

Karp, I., et al. eds. 2006. *Museum Frictions: Public Cultures/Global Transformations*. Durham, NC: Duke University Press.

Karp, I., and D. Lavine, eds. 1991. *Exhibiting Cultures: The Poetics and Politics of Museum Display*. Washington, DC: Smithsonian Institution.

Kasfir, S. 2007. *African Art and the Colonial Encounter: Inventing a Global Commodity*. Bloomington: Indiana University Press.

Kestergat, J. 1985. *Quand le Zaïre s'appelait Congo*. Brussels: La Libre Belgique.

Kimpinde. 1982. *Stefano Kaoze, prêtre d'hier et d'aujourd'hui*. Kinshasa, DRC: St. Paul Afrique.

Koivunen, L. 2006. *Visualizing the "Dark Continent": The Process of Illustrating Nineteenth-Century British Travel Accounts of Africa*. Turku, Finland: University of Turku Press.

Krieger, K. 1990. *Ostafrikanische plastic*. Berlin: Museum für Völkerkunde.

Kristeva, J. 2012. *The Severed Head: Capital Visions*. New York: Columbia University Press.

Kruuk, H. 1974. *The Spotted Hyena: A Study of Predation and Social Behavior*. Chicago: University of Chicago Press.

Küchler, S. 1994. "Making Skins: Malangan and the Idiom of Kinship in Northern New Ireland." In *Anthropology, Art and Aesthetics*, ed. J. Coote and A. Shelton, 94–112. New York: Oxford University Press.

Lagae, J. 2004. "Colonial Encounters and Conflicting Memories: Shared Colonial Heritage in the Former Belgian Congo." *Journal of Architecture* 9 (2): 173–97.

———. 2005. "Sur la production du savoir et le rôle de la science dans le contexte colonial belge." In *La mémoire du Congo, le temps colonial*, J.-L. Vellut et al., 130–38. Gand, Belgium: Snoeck.

———. 2009. "Wonen in de belgische kolonie: 'Il faut donner à l'agent congolais un home.'" Available at http://www.congoforum.be/upldocs/LAGAE+Johan_DWR+116_2005.pdf.

LaGamma, A. 2007. *Eternal Ancestors: The Art of the Central African Reliquary*. New Haven, CT: Yale University Press.

———. 2011. *Heroic Africans: Legendary Leaders, Iconic Sculptures*. New York: Metropolitan Museum of Art.

Lalu, P. 2000. "The Grammar of Domination and the Subjection of Agency: Colonial Texts and Modes of Evidence." *History and Theory* 39 (4): 45–68.

———. 2009. *The Deaths of Hintsa: Postapartheid South Africa and the Shape of Recurring Pasts*. Cape Town: Human Sciences Research Council.

Lamp, F. 2004. *See the Music, Hear the Dance: Rethinking African Art at the Baltimore Museum of Art*. Munich: Prestel.

Latour, B. 1993. *We Have Never Been Modern*. Cambridge, MA: Harvard University Press.

Lazreg, M. 2008. *Torture and the Twilight of Empire: From Algiers to Baghdad*. Princeton, NJ: Princeton University Press.

Lechaptois, A. 1913. *Aux Rives du Tanganika*. Maison-Carrée, Algeria: Missionnaires d'Afrique.

Le Corbusier [Charles-Édouard Jeanneret-Gris]. 1925. *Urbanisme*. Paris: Éds. G. Crès.

Leduc, M. 2006. "Les sociétés savants et les images rapportées par les explorateurs du bassin du Congo 1870–1899." *La Ricerca Folklorica* 54: 57–66.

Legros, H. 1996. *Chasseurs d'ivoire: Une histoire du royaume Yeke du Shaba (Zaïre)*. Brussels: l'Université de Bruxelles.

Lewis, J. 1992. *Ring of Liberation: Deceptive Discourse in Brazilian Capoiera*. Chicago: University of Chicago Press.

Liberski, D. 1989. "Presentation." *Systèmes de pensée en Afrique noire, 9, Le deuil et ses rites*, vii–xiii.

Lienhardt, G. 2003. *Divinity and Experience: The Religion of the Dinka*. 1st ed. 1961. New York: Oxford University Press.

Likaka, O. 2009. *Naming Colonialism: History and Collective Memory in the Congo, 1870–1960*. Madison: University of Wisconsin Press.

Linker, K. 1998. "Artifacts of Artifice." *Art in America* (July): 74–79, 106.

Lipton, J. 1977. *An Exaltation of Larks, or, The Venereal Game*. New York: Penguin.

Livingstone, D. N. 1992. *The Geographical Tradition*. Oxford, UK: Blackwell.

Lombroso, C. 2006. *Criminal Man*. Translated and with new introduction by M. Gibson and N. Hahn Rafter. 1st ed. 1876. Durham, NC: Duke University Press.

Luffin, X. 2007. "On the Swahili Documents in Arabic Script from the Congo (19th Century)." *Swahili Forum* 14: 17–26.

Luwel, M. 1954. "De Congolezen op de Tentoonstelling van 1897." *Revue Congolaise Illustrée* 26: 41–44; 27: 42–47.

Mabille, P. 1998. *Mirror of the Marvelous*. 1st ed. 1962. Rochester, VT: Inner Traditions.

MacGaffey, W. 1972. "The West in Congolese Experience." In *Africa and the West: Intellectual Responses to European Culture*, ed. P. Curtin, 49–74. Madison: University of Wisconsin Press.

———. 1983. *Modern Kongo Prophets*. Bloomington: Indiana University Press.

———. 1986. *Religion and Society in Central Africa: The BaKongo of Lower Zaïre*. Chicago: University of Chicago Press.

———. 1988. "Complexity, Astonishment, Power: The Visual Vocabulary of Kongo Minkisi." *Journal of Southern African Studies* 14: 188–203.

———. 1991. *Art and Healing of the Bakongo Commented by Themselves: Minkisi from the Laman Collection*. Bloomington: Indiana University Press.

———. 1993. "The Eyes of Understanding: Kongo Minkisi." In *Astonishment and Power* by W. MacGaffey and M. Harris, 18–103. Washington, DC: Smithsonian Institution.

———. 1998. "Magic, or as We Usually Say, Art." In *The Scramble for Art in Central Africa*, ed. E. Schildkraut and C. Keim, 217–35. Cambridge: Cambridge University Press.

———. 2000. *Kongo Political Power: The Conceptual Challenge of the Particular*. Bloomington: Indiana University Press.

Malaquais, D. 2002. *Architecture, pouvoir, et dissidence au Cameroun*. Paris: Karthala.

Mama, A. 1995. *Beyond the Masks: Race, Gender, and Subjectivity*. New York: Routledge.

Marechal, P. 2005. "Le controverse sur Léopold II et le Congo dans la littérature et les médias: Réflexions critiques." In *La mémoire du Congo, le temps colonial*, ed. J.-L. Vellut et al., 43–49. Gand, Belgium: Snoeck.

Maret, P. de. 1995. "Croisette Histories." In *Objects, Signs of Africa,* ed. L. de Heusch. RMCA, *Annales* 145: 133–45.

Marks, S. 1984. *Imperial Lion: Human Dimensions of Wildlife Management in Central Africa.* Boulder, CO: Westview.

Marles, H. 1996. "Arrested Development: Race and Evolution in the Sculpture of Herbert Ward." *Oxford Art Journal* 19 (1): 16–28.

Marriott, McK. 1976. "Hindu Transactions: Diversity without Dualism." In *Transactions and Meaning: Directions in the Anthropology of Exchange and Symbolic Behaviour,* ed. B. Kapferer, 109–37. Philadelphia: Institute for the Study of Human Issues.

Martinez-Ruiz, B. 2010. "*Ma kisi nsi:* L'art des habitants de la région de Mbanza Kongo." In *Angola figures du pouvoir,* ed. C. Falgayrettes-Leveau, 178–213. Paris: Éds. Dapper.

Masui, T. 1897. *Guide de la Section du Congo à l'Exposition de Bruxelles-Tervueren en 1897.* Brussels: Veuve Monnom.

Matsui, T. 2001. "L'Anthropologie de Georges Vacher de Lapouge: Race, classe, et eugénisme." *Études de langue et littérature françaises* 79: 47–57.

Maurer, E. 1985. "Catalogue Raisonné." In *The Rising of a New Moon: A Century of Tabwa Art,* ed. E. Maurer and A. Roberts, 219–78. Seattle: University of Washington Press.

Maurer, E., and A. Roberts, eds. 1985. *The Rising of a New Moon: A Century of Tabwa Art.* Seattle: University of Washington Press.

Maurice, A., ed. 1955. *Unpublished Letters of Henry Morton Stanley.* London: W. and R. Chambers.

Mauss, M. 1954. *The Gift.* Glencoe, IL: Free Press.

———. 1979. *Sociology and Psychology.* London: Routledge.

McClintock, A. 1995. *Imperial Leather: Race, Gender, and Sexuality in the Colonial Contest.* New York: Routledge.

Meier, P. 2009. "Objects on the Edge: Swahili Coast Logics of Display." *African Arts* 42 (4): 8–23.

Melchior-Bonnet, S. 2001. *The Mirror: A History.* New York: Routledge.

Melion, W., and S. Küchler. 1991. Introduction to *Images of Memory: On Remembering and Representation,* ed. S. Küchler and W. Melion, 1–46. Washington, DC: Smithsonian Institution.

Metcalf, P., and R. Huntington. 1999. *Celebrations of Death: The Anthropology of Mortuary Ritual.* 2nd ed. New York: Cambridge University Press.

Mihesuah, D., ed. 2000. *Repatriation Reader: Who Owns American Indian Remains?* Lincoln: University of Nebraska Press.

Milbourne, K. 2003. "Diplomacy in Motion: Art, Pageantry, and the Politics of Creativity in Barotseland (Western Zambia)." Unpublished PhD dissertation, Department of Art and Art History, University of Iowa.

Miller, J. 2002. "Central Africa during the Era of the Slave Trade, c.1490s–1850s." In *Central Africans and Cultural Transformations in the American Diaspora,* ed. L. Heywood, 21–69. New York: Cambridge University Press.

Mitchell, T. 1992. "Orientalism and the Exhibitionary Other." In *Colonialism and Culture,* ed. N. Dirks, 289–317. Ann Arbor: University of Michigan Press.

Mitchell, W. J. T. 2006. *What Do Pictures Want? The Lives and Loves of Images.* Chicago: University of Chicago Press.

Moinet, I. 1885–1888. "Diaire de Mpala." Vol. 1. Typescript (missing first notebook), AK-KD. In entirety with new pagination, CAWFR.

———. 1885a. Letter to *Très Révérend Père* from Kapakwe, 25 March. CAWFR, C.19-243.

———. 1885b. Letter to *Éminence et Très Révérend Père* from Mpala, 25 Oct. CAWFR, C.19.250.

———. 1885c. Letter to *Éminence et Très Révérend Père* from Mpala, 2 Aug. CAWFR, C.19.245.

———. 1885d. Letter to Émile Storms from Mpala, 26–28 Aug. RMCA *FS*, 38, F-X, B-II.

———. 1886a. Letter to "Sa Magesté [*sic*] Emile 1er, Roi du Tanganyka [*sic*]" (Émile Storms) from Mpala, 10 Feb. RMCA *FS*, 38, F-X, B-II.

———. 1886b. Letter to Émile Storms from Mpala, 1 May, RMCA *FS*, 38, F-X, B-II.

———. 1886c. Letter to Père Debbaudt from Mpala, 10 Jan. CAWFR, C.19.446.

———. 1886d. Letter to Émile Storms from Mpala, 21 March. RMCA *FS*, 38, F-X, B-II.

———. 1887. Letter to Émile Storms from Mpala, 8 Oct. RMCA *FS*, 38, F-X, B-II.

Moncet, A. 1885a. Letter to "Eminentissisme Seigneur" from Mpala, 26 Sept. CAWFR, C.19-210.

———. 1885b. Letter to "Très Révérend et Très Vénéré Père" from Mpala, 28 Sept. CAWFR, C.19-211.

———. 1885c. Letter to "Très Révérend et Très Vénéré Père" from Mpala, 31 Oct. CAWFR, C.19-212.

———. 1885d. Letter to Mgr. Bridoux from Mpala, 2 Aug. CAWFR, C.19-298.

———. 1886. Letter to "Eminentissisme Seigneur" from Mpala, 2 Jan. CAWFR, C.19-214.

———. 1887. Letter to unknown person from Mpala, Aug. CAWFR, C.19-200.

Moore, R. 1940. "*Bwanga* among the Bemba." *Africa* 13 (3): 211–33.

Morgan, D. 1998. *Visual Piety: A History and Theory of Popular Religious Images.* Berkeley: University of California Press.

Morisseau, J. 1910. *Sur le lac Moero (Encore le Katanga).* Brussels: Charles Bulens.

Morris, W., ed. 1969. *The American Heritage Dictionary of the English Language.* Boston: Houghton Mifflin.

Morton, S. 1839. *Crania Americana.* Philadelphia: J. Dobson.

Mudekereza, P. 2011. "Congo Far West: Traités (mal)traités." In *Congo Far West: Arts, sciences et collections,* 100–107. Milan: SilvanaEditoriale.

Mudekereza, P., and S. Cornelis. 2011. "Le choix de l'artiste: briser l'anonymat de *L'Art au Congo.*" In *Congo Far West: Arts, sciences, et collections,* 4–5. Milan: SilvanaEditoriale.

Mudimbe, V. Y. 1986. "African Art as a Question Mark." *African Studies Review* 29 (1): 3–4.

———. 1988. *The Invention of Africa: Gnosis, Philosophy, and the Order of Knowledge.* Bloomington: Indiana University Press.

———. 1991. *Parables and Fables: Exegesis, Textuality, and Politics in Central Africa.* Madison: University of Wisconsin Press.

———. 1994. *The Idea of Africa.* Bloomington: Indiana University Press.

———. 1997. *Tales of Faith: Religion as Political Performance in Central Africa.* London: Athlone.

Muhindo, V. M. 2003. *Le Congo-Zaïre d'une guerre à l'autre, de libération en occupation.* Paris: L'Harmattan.

Mulambu-Mvuluya, F. 1974. "Cultures obligatoires et colonisation dans l'ex-Congo Belge." *Cahiers du CEDAF* 6–7: 1–99.

Mulinda, H. B. 1985. "Le nkisi dans la tradition woyo du Bas-Zaïre." In *Systèmes de Pensée en Afrique Noire 8:* 201–20.

Munongo, A. n.d. *Pages d'histoire yeke.* Elisabethville, DRC: Imbelco.

Muriuki, G., and N. Sobania. 2007. "The Truth Be Told: Stereoscopic Photographs, Interviews, and Oral Traditions from Mount Kenya." *Journal of East African Studies* 1 (1): 1–15.

Nabokov, V. 1989. *Invitation to a Beheading.* 1st ed. 1959. New York: Vintage.

Nagant, G. 1972. "Une société de l'Est du Zaïre: Les Tusanga depeints par eux-mêmes." Unpublished *mémoire de licence.* École Pratique des Hautes Études, Paris.

———. 1976. "Famille, histoire, religion chez les Tumbwe du Zaïre." Unpublished *thèse du troisième cycle*, 2 vols. École Pratique des Hautes Études, Paris.

Nandy, A. 1983. *The Intimate Enemy*. New Delhi: Oxford University Press.

Ndaywel è Nziem, I. 1998. *Histoire générale du Congo: De l'héritage ancien à la République Démocratique*. Brussels: De Boeck and Larcier.

———. 2005. "Le Congo et le bon usage de son histoire." In *La mémoire du Congo, le temps colonial*, ed. J.-L. Vellut et al., 28–35. Gand, Belgium: Snoeck.

Neyt, F. 1977. *La grande statuaire hemba du Zaïre*. Louvain-la-Neuve, Belgium: Institut Supérieur d'Archéologie et d'Histoire de l'Art.

———. 1981. *Arts traditionnels et histoire au Zaïre* [*Traditional Art and History of Zaïre*]. Louvain-la-Neuve, Belgium: Institut Supérieur d'Archéologie et d'Histoire de l'Art.

———. 1985. "Tabwa Sculpture and the Great Traditions of East-Central Africa." In *The Rising of a New Moon: A Century of Tabwa Art*, ed. E. Maurer and A. Roberts, 65–89. Seattle: University of Washington Press.

Neyt, F., and L. de Strycker. 1979. "À propos de quelques lagalla." *Africa-Tervuren* 25 (3): 69–75.

Ngahuia Te Awekotuku. 2006. "*Mata Ora*: Chiseling the Living Face; Dimensions of Maori Tattoo." In *Sensible Objects: Colonialism, Museums, and Material Culture*, ed. E. Edwards et al., 121–40. London: Berg.

Nooter, M. 1991. "Luba Art and Polity: Creating Power in a Central African Kingdom." Unpublished PhD dissertation, Department of Art History and Archaeology, Columbia University.

Nooter, M., ed. 1993. *Secrecy: African Art and Conceals and Reveals*. Munich: Prestel.

Nora, P. 1989. "Between Memory and History." *Representations* 26: 7–25.

Noret, J., and P. Petit. 2011. "Mort et dynamiques sociales au Katanga. "*Cahiers africains— Afrika Studies* 78. Paris: L'Harmattan.

Nys, L. 2008. "Aspirations to Life: Pleas for New Forms of Display in Belgian Museums around 1900." *Journal of the History of Collections* 20 (1): 113–26.

OED [*Oxford English Dictionary*]. 1982. *The Compact Edition of the Oxford English Dictionary*, 2 vols. New York: Oxford University Press.

Olalquiaga, C. 1998. *The Artificial Kingdom: A Treasury of the Kitsch Experience*. New York: Pantheon.

Oliver, R. 1968. "Discernable Developments in the Interior, c. 1500–1840." In *History of East Africa*, 2 vols, ed. R. Oliver and G. Mathew, 169–211. London: Oxford University Press.

O'Shea, J. 2007. *At Home in the World: Bharata Natyam on the Global Stage*. Middletown, CT: Wesleyan University Press.

Ota, Y. 2009. "Strange Tales from the Road: A Lesson in an Epistemology for Anthropology." *Social Analysis* 53 (2): 191–206.

Ouédraogo, J.-B. 2002. *Arts photographiques en Afrique*. Paris: L'Harmattan.

———. 2008. *Identités visuelles en Afrique*. Nantes, France: Amalthée.

Palmeirim, M. 2006. *Of Alien Kings and Perpetual Kin: Contradiction and Ambiguity in Ruwund Symbolic Thought*. Wantage, UK: Sean Kingston.

Palmié, S. 2002. *Wizards and Scientists: Explorations in Afro-Cuban Modernity and Tradition*. Durham, NC: Duke University Press.

Papastergiadis, N. 2002. "Restless Hybrids." In *The Third Text Reader on Art, Culture, and Theory*, ed. R. Araeen et al., 166–75. New York: Continuum.

Pas, P. S. van der. 2010. *A History of the White Fathers in Western Tanzania: Their Work in the Vicariate of Tanganyika with Special Emphasis on Today's Dioceses of Sumbawanga and Mpanda (1878–2002)*. Dar es Salaam, Tanzania: Fr. P. Simchile.

Pelseneer, P. 1886. "Notice sur les mollusques recuellis par M. le Capitaine Storms dans la région du Tanganika." *Bulletin du Musée Royal d'Histoire Naturelle de Belgique* 4: 103–28.

Petit, P. 1995. "The Sacred Kaolin and the Bowl-Bearers (Luba of Shaba)." In *Objects: Signs of Africa*, ed. L. de Heusch, 111–32. RMCA, *Annales* 145.

———. 1996a. "'Les charmes du roi sont les esprits des morts': Les fondements religieux de la royauté sacrée chez les Luba du Zaïre." *Africa* 66 (3): 349–66.

———. 1996b. "Bwile Myopia: A Note from Recent Research." In *Memory: Luba Art and the Making of History*, ed. M. Roberts and A. Roberts, 236–38. Munich: Prestel.

Pick, D. 2005. "Body and Will: Problems of Victorian Identity." In *The Many Faces of Evolution in Europe, c. 1860–1914*, ed. P. Dassen and M. Kemperink, 17–39. Dudley, MA: Peeters.

Pinney, C. 2004. *"Photos of the Gods": The Printed Image and Political Struggle in India*. London: Reaktion.

———. 2008. *The Coming of Photography in India*. London: British Library.

Plato. 1998. *Cratylus/Plato*. 1st ed. ca. 375 BCE. Indianapolis: Hackett.

———. 2009. *Timaeus and Critias*. New York: Oxford University Press.

Poe, E. A. 1840. "The Philosophy of Furniture." *Burton's Gentleman's Magazine*, May, 243–45.

Poncelet, M. 2008. *L'Invention des sciences coloniales belges*. Paris: Karthala.

Poole, D. 1997. *Vision, Race, and Modernity: A Visual Economy of the Andean Image World*. Princeton, NJ: Princeton University Press.

Portelli, A. 1981. "The Time of My Life: Functions of Time in Oral History." *International Journal of Oral History* 2 (3): 162–80.

Pratt, M. L. 2008. *Imperial Eyes: Travel Writing and Transculturation*. 2nd ed. New York: Routledge.

Pratten, D. 2007. *The Man-Leopard Murders: History and Society in Colonial Nigeria*. Bloomington: Indiana University Press.

Prins, G. 1992. "The Battle for Control of the Camera in Late Nineteenth-Century Western Zambia." In *Anthropology and Photography, 1860–1920*, ed. E. Edwards, 218–24. New Haven, CT: Yale University Press.

Prunier, G. 2008. *Africa's World War: Congo, the Rwandan Genocide, and the Making of a Continental Catastrophe*. New York: Oxford University Press.

Rabaud, A. 1880a. "L'Abbé Debaize." *Bulletin de la Société de géographie de Marseille* 4: 141–91.

———. 1880b. *L'Abbé Debaize et sa mission géographique et scientifique dans l'Afrique Centrale*. Offprint, *Bulletin de la Société de Géographie de Marseille*, April, May, June. Marseille: Barlatier-Feissat.

Rahier, J. 2003. "The Ghost of Leopold II: The Belgian Royal Museum of Central Africa and Its Dusty Colonialist Exhibition." *Research in African Literatures* 34 (1): 58–84.

Ramaeckers, J. 1882. Letter to Colonel Strauch from Karema, 18 January. RMCA, FS No. 7, F-III.

Ranger, T. 1975. *Dance and Society in Eastern Africa, 1890–1970: The Beni Ngoma*. Berkeley: University of California Press.

———. 1988. "Chingaira Makoni's Head: Myth, History, and the Colonial Experience." Indiana University African Studies Program Occasional Papers.

Reefe, T. 1975. "A History of the Luba Empire to c.1885." Unpublished PhD dissertation, Department of History, University of California, Berkeley.

———. 1977. *"Lukasa: A Luba Memory Device." African Arts* 10 (4): 48–50, 88.

———. 1981. *The Rainbow and the Kings: A History of the Luba Empire to 1891.* Berkeley: University of California Press.

Reichard, P. 1884a. Entries in *Mittheilungen der Afrikanischen Gesellschaft in Deutschland,* Berlin.

———. 1884b. "Kansawara." Photocopy of original with marginal notes. RMCA, *FS,* F-VI, B-II, *dossier Reichard* doc. C.

———. 1886. "Aux sources du Congo: Le Marungu." *Mouvement géographique* 3: 57–58.

Renton, D., et al. 2007. *The Congo: Plunder and Resistance.* London: Zed.

RFI [Radio France International]. 2011. "Un siècle après leur extermination, l'Allegmagne restitue des crânes aux Héréros et Namas,"1 October. Received via AFRICOM listserve.

Richards, A. 1940. "The Political System of the Bemba Tribe." In *African Political Systems,* ed. M. Fortes and E. E. Evans-Pritchard, 83–120. London: Oxford University Press.

———. 1950. "Some Types of Family Structure amongst the Central Bantu." In *African Systems of Kinship and Marriage,* ed. A. Radcliffe-Brown and D. Forde, 207–51. London: Oxford University Press.

Roach, J. 1996. *Cities of the Dead: Circum-Atlantic Performance.* New York: Columbia University Press.

Roberts, A. 1979. "'The Ransom of Ill-Starred Zaire': Plunder, Politics, and Poverty in the OTRAG Concession." In *Zaire: The Political Economy of Underdevelopment,* ed. G. Gran, 211–36. New York: Praeger.

———. 1980. "Heroic Beasts, Beastly Heroes: Principles of Cosmology and Chiefship among the Lakeside BaTabwa of Zaïre." Unpublished PhD dissertation, Department of Anthropology, University of Chicago.

———. 1981. "Passage Stellified: Speculation upon Archaeoastronomy in Southeastern Zaïre." *Archaeoastronomy* 4 (4): 27–37.

———. 1982. "'Comets Importing Change of Times and States': Ephemerae and Process among the Tabwa of Zaïre." *American Ethnologist* 9 (4): 712–29.

———. 1983. "'Perfect' Lions, 'Perfect' Leaders: A Metaphor for Tabwa Chiefship." *Journal de la Société des Africanistes* 53 (1–2): 93–105.

———. 1984. "'Fishers of Men': Religion and Political Economy among Colonized Tabwa." *Africa: Journal of the International African Institute* 54 (2): 49–70.

———. 1985. "Social and Historical Contexts of Tabwa Art." In *The Rising of a New Moon: A Century of Tabwa Art,* ed. E. Maurer and A. Roberts, 1–48. Seattle: University of Washington Press.

———. 1986a. "'Like a Roaring Lion': Late 19th-Century Tabwa Terrorism." In *Banditry, Rebellion, and Social Protest in Africa,* ed. D. Crummey, 65–86. Portsmouth, NH: Heinemann.

———. 1986b. "Les arts du corps chez les Tabwa." *Arts d'Afrique noire* 59: 15–20.

———. 1986c. "The Comeuppance of 'Mr. Snake' and Other Tales of Survival from Contemporary Rural Zaïre." In *The Crisis in Zaïre: Myths and Realities,* ed. Nzongola-Ntalaja, 113–21. Trenton, NJ: Africa World Press.

———. 1986d. "Duality in Tabwa Art." *African Arts* 19 (4): 26–35, 86–87.

———. 1987. "'Insidious Conquests': War-Time Politics along the Southwestern Shore of Lake Tanganyika." In *Africa and the First World War,* ed. M. Page, 186–213. London: MacMillan.

———. 1988a. "'L'Authenticité,' 'l'alienation' et l'homicide: une étude sur le processus social dans les zones rurales du Zaïre." In *Dialoguer avec le léopard? Pratiques, savoirs et actes du peuple face au politique en Afrique noire contemporaine,* ed. B. Jewsiewicki and H. Moniot, 327–51. Paris: L'Harmattan.

———. 1988b. "Through the Bamboo Thicket: The Social Process of Tabwa Ritual Perfor-
mance." *TDR, The Drama Review* 32 (2): 123–38.

———. 1988c. "Tabwa Tegumentary Inscription." In *Marks of Civilization: Artistic Trans-
formation of the Human Body,* ed. A. Rubin, 41–56 . Los Angeles: UCLA Museum of
Cultural History.

———. 1989. "History, Ethnicity and Change in the 'Christian Kingdom' of Southeastern
Zaire." In *The Creation of Tribalism in South and Central Africa: Studies in the Political
Economy of Ideology,* ed. L. Vail, 193–214. Berkeley: University of California Press.

———. 1990. "Tabwa Masks: 'An Old Trick of the Human Race.'" *African Arts* 23 (2): cover,
36–47, 101–103.

———. 1991. "Where the King Is Coming From." Uppsala Studies in Cultural Anthropology
16: 249–69.

———. 1993a. "Insight, or, NOT Seeing Is Believing." In *Secrecy: African Art that Conceals
and Reveals,* ed. M. Nooter, 64–79. New York: Museum for African Art.

———. 1993b. "Neither Here Nor There." In *Threshold States/Sprach-Schwellen,* ed. H.
Breder, 106–109. Münster: Hackmeister.

———. 1993c. "Smelting Ironies: The Performance of a Tabwa Technology." Paper for "'Iron,
Master of Them All.'" 5th Stanley Conference on African Art, University of Iowa.

———. 1994a. "Formenverwandtschaft: Ästhetische Berührungspunkte Zwischen Völkern
West-Tanzanias und Südost-Zaire/Usanifu sawa kati ya watu wa Tanzania magharibi
na watu wa kusini mashariki ya Zaïre." In *Tanzania: Meisterwerke Afrikanischer Skulp-
tur/Sanaa za Mabingwa wa Kiafrika,* ed. J. Jahn, 350–70. Munich: Fred Jahn.

———. 1994b. "'Authenticity' and Ritual Gone Awry in Mobutu's Zaïre: Looking beyond
Turnerian Models." *Journal of Religion in Africa* 24 (2): 134–57.

———. 1994c. "'Swing the Ramrod Pivot': Staffs of Tabwa Shamans, Herbalists, Hunters, and
Chiefs." In *Staffs of Life: Rods, Staffs, Scepters, and Wands from the Coudron Collection of
African Art,* ed. A. Roberts, 33–38. Iowa City: University of Iowa Museum of Art.

———. 1995a. "Lusinga, Ancestor Figure." In *Treasures from the Africa Museum Tervuren,*
ed. G. Verswijver et al., 370–71. Tervuren, Belgium: RMCA.

———. 1995b. *Animals in African Art: From the Familiar to the Marvelous.* Munich: Prestel.

———. 1995c. "Figure Masculine, Figure Féminine." In *Trésors d'Afrique, Musée de Tervu-
ren,* ed. G. Verswijver et al, 368–69. Tervuren, Belgium: RMCA.

———. 1996a. "Peripheral Visions." In *Memory: Luba Arts and the Making of History,* ed.
M. Roberts and A. Roberts, 210–43. Munich: Prestel.

———. 1996b. "Anarchy, Abjection, and Absurdity: A Case of Metaphoric Medicine among
the Tabwa of Zaire." In *The Anthropology of Medicine: From Theory to Method,* ed. L.
Romanucci-Ross et al., 224–39. 3rd ed. New York: Bergin.

———. 1996c. "Le dernier carrefour d'un chef tabwa." In *Mort et vie: Hommages au profes-
seur Dominique Zahan (1915–1991),* ed. P. Erny et al., 93–121. Paris: L'Harmattan.

———. 1996d. "Precolonial Tabwa Textiles." *Museum Anthropology* 20 (1): 47–59.

———. 1996e. "The Ironies of 'System D.'" In *Recycled, Reseen: Folk Art from the Global
Scrap Heap,* ed. C. Cerny and S. Seriff, 82–101. New York: Harry Abrams.

———. 1996f. "Male Figure, Female Figure." In *Masterpieces from Central Africa: The Ter-
vuren Museum,* ed. G. Verswijver et al., 183–84. RMCA, *Annales* 155.

———. 2000. "Difficult Decisions, Perilous Acts: Producing Potent Histories with the Tabwa
Boiling Water Oracle." In *Insight and Artistry: A Crosscultural Study of Divination in
Central and West Africa,* ed. J. Pemberton III, 83–98. Washington, DC: Smithsonian
Institution.

———. 2005. "Monotony and Surprise in Tabwa Cosmology." In *Songs from the Sky:*

Indigenous Astronomical and Cosmological Traditions of the World, ed. V. D. Chamberlain et al., 281–92. College Park, MD: Center for Archaeoastronomy.

———. 2009. "Tempering 'the Tyranny of *Already*': Re-signification and the Migration of Images." In *Religion and Material Culture: The Matter of Belief*, ed. D. Morgan, 115–34. New York: Routledge.

———. 2010. "Bugabo: Arts, Ambiguity, and Transformation in Southeastern Congo." Anthroposys, www.anthroposys.be.

———. 2011. "Embodied Dilemma: Tabwa Twinship in Thought and Performance." In *Double Trouble or Twice Blessed? Twins in African and Diaspora Cultures*, ed. P. Peek, 232–50. Bloomington: Indiana University Press.

———. 2012. "Performing Cosmology: Harmonies of Land, Lake, Body, and Sky." In *African Cosmos: Performing the Moral Universe*, ed. C. Kreamer, 1–20. Washington, DC: National Museum of African Art.

Roberts, M. N. 1994a. "The Sculpted Narratives of Luba Staffs of Office." In *Staffs of Life: Rods, Staffs, Scepters, and Wands from the Coudron Collection of African Art*, ed. A. Roberts, 24–32. Iowa City: University of Iowa Museum of Art.

———. 1994b. "Does an Object Have a Life?" In *Exhibition-ism: Museums and African Art*, ed. M. Roberts and S. Vogel, 36–55. New York: Museum for African Art.

———. 1996. "Luba Memory Theater." In *Memory: Luba Art and the Making of History*, ed. M. Roberts and A. Roberts, 116–49. Munich: Prestel.

———. 2000. "Proofs and Promises: Setting Meaning before the Eyes." In *Insight and Artistry in African Divination*, ed. J. Pemberton III, 63–82. Washington, DC: Smithsonian Institution.

———. 2007a. "Inscribing Identity: The Body." In *Inscribing Meaning: Writing and Graphic Systems in African Art*, ed. C. Kreamer et al., 54–69. Milan: 5continents.

———. 2007b. "Sacred Scripts." In *Inscribing Meaning: Writing and Graphic Systems in African Art*, ed. C. Kreamer et al., 88–106. Milan: 5continents.

———. 2009. "Tactility and Transcendence: Epistemologies of Touch in African Arts and Spiritualities." In *Religion and Material Culture: The Matter of Belief*, ed. D. Morgan, 77–96. New York: Routledge.

———. 2011. "Children of the Moon: Twins in Luba Art and Ontology." In *Double Trouble or Twice Blessed? Twins in African and Diaspora Cultures*, ed. P. Peek, 251–68. Bloomington: Indiana University Press.

Roberts, M., and A. Roberts. 2007. *Visions of Africa: Luba*. Milan: 5Continents.

Roberts, M., and A. Roberts, eds. 1996. *Memory: Luba Art and the Making of History*. Munich: Prestel.

Roberts-Jones, P., ed. 1999. *Brussels, Fin de Siècle*. Cologne: Evergreen.

Rockel, S. 2009. "Slavery and Freedom in Nineteenth-Century East Africa: The Case of Waungwana Caravan Porters." *African Studies* 68 (1): 87–109.

Roelens, V. 1921. "Le Respect de la coutume indigène." *Revue générale de la Colonie belge*, Nov. Brussels: Goemaere.

———. 1946. "Les rayons et les ombres de l'Apostolat au Haut Congo." *Grands Lacs* 61: 4–6 n.s.

———. 1948. *Notre vieux Congo, 1891–1917: Souvenirs du premier Evèque du Congo Belge*. Namur, Belgium: Grands Lacs.

Róheim, G. 1992. *Fire in the Dragon and Other Psychoanalytic Essays on Folklore*. Princeton, NJ: Princeton University Press.

Rosaldo, R. 1980. *Ilongot Headhunting, 1883–1974: A Study in Society and History*. Stanford, CA: Stanford University Press.

Ross, Doran, ed. 1992. *Elephant: The Animal and Its Ivory in African Culture*. Los Angeles: UCLA Fowler Museum.

Rotberg, R. 1971. *Joseph Thomson and the Exploration of Africa*. London: Chatto and Windus.

Roussel, R. 1995. *How I Wrote Certain of My Books*. Cambridge, MA: Exact Change.

Rubbers, B. 2004. "Conversation sur la couleur des hommes." *Revue politique. Revue des debats*, June (35): 43–45.

Rubin, A., ed. 1988. *Marks of Civilization: Artistic Transformation of the Human Body*. Los Angeles: UCLA Fowler Museum.

Safer, J., and F. Gill. 1982. *Spirals from the Sea: An Anthropological Look at Shells*. New York: Clarkson Potter.

Sagan, C. 1979. *Broca's Brain: Reflections on the Romance of Science*. New York: Ballantine.

Sahlins, M. 1995. *How "Natives" Think—About Captain Cook, For Example*. Chicago: University of Chicago Press.

Said, E. 1994. *Culture and Imperialism*. New York: Vintage.

Salmon, P. 1992. "Réflexions à propos du goût des arts zairois en Belgique durant la période coloniale (1885–1960)." In *Papier blanc, encre noire: Cent ans de culture francophone en Afrique centrale (Zaïre, Rwanda et Burundi)*, ed. M. Quaghebeur et al., 179–201. 2 vols. Brussels: Éds. Labor.

Saunders, B. 2005. "Congo-Vision." In *Science, Magic, and Religion: The Ritual Processes of Museum Magic*, ed. M. Bouquet and N. Porto, 75–94. New York: Bergahn.

Schalow, Herman, ed. 1888. *Von Zanzibar zum Tanganjika: Briefs aus Ostafrika von Dr. Richard Böhm*. Leipzig: Brodhaus.

Schechner, R. 2003. *Performance Theory*. New York: Routledge.

Schildkraut, E., and C. Keim. 1990. *African Reflections: Art from Northeastern Zaïre*. New York: American Museum of Natural History.

Schildkraut, E., and C. Keim, eds. 1998. *The Scramble for Art in Central Africa*. New York: Cambridge University Press.

Schmidt [Schmitz], R. 1909. "Chefferie de Kirungu: Historique." Report from Baudouinville. Archives of the Bureau des Affaires coutumières. Division régionale des affaires politiques (Lubumbashi). Dossier "Territoire Bazimba."

———. 1912. *Les Baholoholo*. Brussels: Albert Dewit.

Schmitz, B. 1903a. "Une dame celeste." *Missions d'Afrique (Pères Blancs)*, 315–20.

———. 1903b. "Les minérais de fer du Haut-Congo." *La Belgique coloniale* 8: 40.

Schor, N. 1994. "Collecting Paris." In *The Cultures of Collecting*, ed. J. Elsner and R. Cardinal, 252–74. Cambridge, MA: Harvard University Press.

Schouteden, H. 1946. *Geïllustreerde Gids van het Museum van Belgisch Congo*. Tervuren, Belgium: Royal Museum of the Belgian Congo.

Shelton, A. 1994. "Cabinets of Transgression: Renaissance Collections and the Incorporation of the New World." In *The Cultures of Collecting*, ed. J. Elsner and R. Cardinal, 177–203. Cambridge, MA: Harvard University Press.

Sheriff, A. 1987. *Slaves, Spices, and Ivory in Zanzibar: Integration of an East African Commercial Empire into the World Economy, 1770–1873*. Athens: Ohio University Press.

Shorter, A. 1968. "Nyungu-ya-Mawe and the Empire of the Ruga-Rugas." *Journal of African History* 9 (2): 235–59.

———. 1972. *Chiefship in Western Tanzania: A Political History of the Kimbu*. London: Oxford University Press.

Shorter, D. 2009. *We Will Dance Our Truth: Yaqui History in Yoeme Performances*. Lincoln: University of Nebraska Press.

Shorto, R. 2008. *Descartes' Bones: A Skeletal History of the Conflict between Faith and Reason*. New York: Doubleday.

Showalter, E., et al. 1993. *Hysteria beyond Freud*. Berkeley: University of California Press.

Siegel, B. 1985. "The Binary Mind and the Immortal Head: A Structural Analysis of the Myth of Chief Chipimpi." *Furman Studies* 31 (December): 36–55.

Silverman, D. 2011. "Art Nouveau, Art of Darkness: African Lineages of Belgian Modernism, Part I." *West 86th* 18 (2): 139–81.

Simbao, R. 2010. "Dialectics of Dance and Dress: The Performative Negotiation of Soli Girl Initiates (Moye) in Zambia." *African Arts* 43 (3): 64–85.

Singleton, M. 1989. "L'Homme-lion: De la métamorphose magique à la manipulation génétique." *Cahiers du CIDEP* 2: 5–86.

Sizer, N., and H. Drayton. 1887. *Heads and Faces: How to Study Them; A Manual of Phrenology and Physiognomy for the People*. New York: Fowler and Wells.

Sklar, D. 2001. *Dancing with the Virgin: Body and Faith in the Fiesta of Tortugas, New Mexico*. Berkeley: University of California Press.

Smith, A. 1968. "The Southern Section of the Interior, 1840–84." In *History of East Africa*, ed. R. Oliver and G. Mathew. 2 vols., 252–74. London: Oxford University Press.

Smythe, K. 2006. *Fipa Families: Reproduction and Catholic Evangelization in Nkansi, Ufipa, 1880–1960*. Athens: Ohio University Press.

———. 2007. "African Women and White Sisters at the Karema Mission Station." *Journal of Women's History* 19 (2): 59–84.

Spear, T. 2000. "Swahili History and Society to 1900: A Classified Bibliography." *History in Africa* 27: 339–73.

Spitz, E. 1994. *Museums of the Mind: Magritte's Labyrinth and Other Essays in the Arts*. New Haven, CT: Yale University Press.

Spivak, G. 1999. *A Critique of Postcolonial Reason: Toward a History of the Vanishing Present*. Cambridge, MA: Harvard University Press.

Stahl, P.-H. 1986. *Histoire de la décapitation*. Paris: Presses Universitaires Françaises.

Stanley, H. M. 1872. *How I Found Livingstone. Travels. Adventures and Discoveries in Central Africa; Including Four Months' Residence with Dr. Livingstone*. New York: Scribner, Armstrong.

———. 1879. *Through the Dark Continent*. 2 vols. London: Sampson and Low.

———. 1885. *The Congo and the Founding of Its Free State*. New York: Harper and Bros.

———. 1909. *The Autobiography of Sir Henry Morton Stanley*. Boston: Houghton Mifflin.

Starn, O. 2005. *Ishi's Brain: In Search of America's Last 'Wild' Indian*. New York: Norton.

Steiner, C. 1995. "Travel Engravings and the Construction of the Primitive." In *Prehistories of the Future: The Primitivist Project and the Culture of Modernism*, ed. E. Barkan and R. Bush, 202–25. Stanford, CA: Stanford University Press.

———. 2001. "Rights of Passage: On the Liminal Identity of Art in the Border Zone." In *The Empire of Things: Regimes of Value and Material Culture*, ed. F. Myers, 207–31. Santa Fe, NM: School for Advanced Research.

Stengers, J. 1989. *Congo mythes et réalités: 100 ans d'histoire*. Louvain-la-Neuve, Belgium: Duculot.

Stern, M. 1971. *Heads and Headlines*. Norman: University of Oklahoma Press.

Stevens, W. 1995. *The Collected Poems*. New York: Vintage.

Stewart, S. 1993. *On Longing: Narratives of the Miniature, the Gigantic, the Souvenir, the Collection*. Durham, NC: Duke University Press.

———. 1994. "Death and Life, in that Order, in the Works of Charles Wilson Peale." In *The*

Cultures of Collecting, ed. J. Elsner and R. Cardinal, 204–23. Cambridge, MA: Harvard University Press.

Stocking, G. 1985. "Essays on Museums and Material Culture." In *Objects and Others: Essays on Museums and Material Culture*, ed. G. Stocking, 3–14. Madison: University of Wisconsin Press.

Stoler, A. L. 1992. "Rethinking Colonial Categories: European Communities and the Boundaries of Rule." In *Colonialism and Culture*, ed. N. Dirks, 319–52. Ann Arbor: University of Michigan Press.

———. 2002. *Carnal Knowledge and Imperial Power: Race and the Intimate in Colonial Rule.* Berkeley: University of California Press.

Storms, É. n.d.1. Untitled list of submitting chiefs. RMCA, *FS* F-VI, B-II.

———. n.d.2. "L'esclavage" (draft paper). RMCA, *FS*, No.14, F-IV, B-II.

———. n.d.3. "Projets de lettres à Bruxelles." RMCA, *FS*, No.16, F-IV, B-II.

———. n.d.4. "Moeurs - toilette" (folder of texts). RMCA, *FS*, No.22, F-VI,B-II.

———. n.d.5. "Description de Zanzibar" (partially burned pages). RMCA, *FS*, No. 5, F- III.

———. n.d.6. "Examiner l'emploi de la force de la part des gouvernements et de la part des particuliers en vue de la suppression de la traite" Manuscript. RMCA, *FS*, No. 5, F-III.

———. n.d.7. Unidentified documents (some partially burned). RMCA, *FS*, No.14, F-IV, B-II.

———. n.d.8. "Accueil des Noirs à une arrivée à Karema venant de Mpala." Typescript attached to "LES DAWA: Ce qu'ils contiennent, et destination." RMCA, *FS*, No. 33 *carnet gris*, F-IX, B-II.

———. 1883–1885. *"Journal de la Station de Mpala fondée le 4 mai 1883 par Lieutenant Storms, Adjoint d'État-Major, Commandant de la 4e expedition africaine."* Typescript from 25 October 1884 to 21 July 1885. RMCA *FS*, 1, F-I.

———. 1883a. Letter to unnamed person, May. RMCA *FS*, No. 22, F-VI, B-II.

———. 1883b. Letter to *Secrétaire général de l'Association internationale africaine* from Mpala, 15 Nov. RMCA, *FS*, No. 12, F-III, B-I.

———. 1883c. Unidentified pages, unmarked folder. RMCA, *FS*, F-VI, B-II.

———. ca. 1884. "Voyage à Oudjidji. " RMCA ,*FS*, No. 11, F-III.

———. 1884a. Unidentified notes. RMCA, *FS*, No. 22, F-VI, B-II.

———. 1884b. Letter to Strauch, March. RMCA, *FS*, No. 22, F-VI, B-II.

———. 1884c. "Établissement de la Station de Mommpara sur le lac Tanganika." *Mouvement géographique* 1 (6): 22–23.

———. 1884d. Letter to IAA, Sept. RMCA, *FS*, No. 22, F-III, B-I.

———. 1885a. "Agenda 1885," RMCA, *FS*, No.31, F-VIII, B-II.

———. 1885b. Letter to *M. le Secretaire*. Mpala, June, RMCA, *FS*, "divers."

———. 1885c. Letter fragment. RMCA, *FS*, "divers."

———. 1885d. "'L'Échange du sang,' Moeurs africaines." *Le Mouvement géographique* 2 (1): 3–4.

———. 1885e. "Une séance de féticheur." *Le Mouvement géographique* 2 (2): 7.

———. ca. 1885. Loose pages partially destroyed by fire. RMCA, *FS*, No. 20, F-IV, B-II.

———. 1886a. "Le Tanganika: Quelques particularités sur les moeurs africaines." *Bulletin de la Société royale belge de géographie* 10: 169–99.

———. 1886b. "Notes pour une conférence." RMCA, *FS*, No. 15, F-IV, B-II.

———. 1888–1889a. "L'Esclavage entre le lac Tanganika et la côte Est." *Mouvement antiesclavagiste* 1: 14–18.

———. 1888–1889b. "Idées d'un pionnier de la Civilisation." *Mouvement antiesclavagiste* 1: 348–49.

———. 1888–1889c. Untitled intervention. *Bulletin de la Société d'Anthropologie de Bruxelles* 7: 166–67.

Strauch, M. ca. 1882. Letter to Émile Storms from Brussels (no date but seemingly prior to Storms's departure for Africa). RMCA, *FS*, No. 21, F-V, B-II.

———. 1883a. Letter to Émile Storms from Brussels, 16 March. RMCA, *FS*, No. 21, F-V, B-II.

———. 1883b. Letter to Émile Storms from Brussels, 20 June. RMCA, *FS*, No. 21, F-V, B-II.

———. 1883c. Letter to Émile Storms from Brussels, 8 December. RMCA, *FS*, F-V, B- II.

———. 1883d. Letter to Émile Storms from Brussels, 30 March. RMCA, *FS*, No. 21, F-V, B-II.

———. 1884a. Letter to Émile Storms from Brussels, 28 March. RMCA, *FS*, No. 21, F-V, B-II.

———. 1884b. Letter to Émile Storms from Brussels, 7 November. RMCA, *FS*, No. 21, F-V, B-II.

———. 1884c. Letter to Émile Storms from Brussels, 25 April. RMCA, *FS*, No. 21, F-V, B-II.

Strother, Z. S. 1998. *Inventing Masks: Agency and History in the Art of Central Pende*. Chicago: University of Chicago Press.

Stuckey, P. S. 1995. "Christian Conversion and the Challenge of Dance." In *Choreographing History*, ed. S. L. Foster, 54–66. Bloomington: Indiana University Press.

Studstill, J. 1984. *Les desseins d'arc-en-ciel: Épopée et pensée chez les Luba du Zaïre*. Paris: Centre National de Recherche Scientifique.

Tagg, J. 1993. *Burden of Representation: Essays on Photographies and Histories*. Minneapolis: University of Minnesota Press.

Tanizaki, J. 1977. *In Praise of Shadows*. Sedgwick, ME: Leete's Island Books.

Taussig, M. 1992. "Culture of Terror—Space of Death: Roger Casement's Putumayo Report and the Explanation of Torture." In *Colonialism and Culture*, ed. N. Dirks, 135–73. Ann Arbor: University of Michigan Press.

Taylor, D. 2007. *The Archive and the Repertoire: Performing Cultural Memory in the Americas*. Durham, NC: Duke University Press.

Taylor, G. 2005. *Capoeira: The Jogo de Angola from Luanda to Cyberspace*. Berkeley: North Atlantic.

Terashima, H. 1980. "Hunting Life of the Bambote: An Anthropological Study of Hunter-Gatherers in a Wooded Savanna." *Africa* 2, SENRI Ethnological Studies 6: 223–68.

Terryn, C. 1993. "From Elite Fair to Mass Medium. Exhibitions and Visitors at the Antwerp World Exhibitions." In *De Panoramische Droom/The Panoramic Dream. Antwerpen en de Wereldtentoostelligen/Antwerp and the World Expositions. 1885, 1894, 1930*, ed. M. Nauwelaerts et al., 77–81. Gand, Belgium: Snoeck.

Tertullian. 1931. *Tertullian: Apology and* De Spectaculis, *Minucius Felix*. Cambridge, UK: Loeb Classical Library.

Theunissen, B. 1990. *Eugène Dubois and the Ape-Man from Java: The History of the First "Missing Link" and Its Discoverer*. Dordrecht, Holland: Springer.

Theuws, T. 1960. "Naître et mourir dans le rituel luba." *Zaïre* 14 (2–3): 115–73.

———. 1961. "Le réel dans la conception luba." *Zaïre* 15 (1): 3–44.

———. 1968. "Le Styx ambigu." *Problèmes sociaux congolais* 81:, 5–33.

Thiriar, J. n.d. *Uniformes belges*. 3 vols. Brussels: Historia.

———. 1930. *Les uniformes de notre armée, 1830–1930*. Brussels: n.p.

Thomas, D. 2000. *Skull Wars: Kennewick Man, Archeology, and the Battle for Native American Identity*. New York: Basic Books.

Thomas, N. 1991. *Entangled Objects: Exchange, Material Culture, and Colonialism in the Pacific*. Cambridge, MA: Harvard University Press.

Thompson, B. 1999. "Kiuza Mpheho (Return of the Winds): The Arts of Healing among the

Shambaa Peoples of Tanzania." Unpublished PhD dissertation, Department of Art and Art History, University of Iowa.

Thompson, R. F. 1974. *African Art in Motion: Icon and Act in the Collection of Katherine Coryton White*. Berkeley: University of California Press.

———. 1981. *The Four Moments of the Sun: Kongo Art in Two Worlds*. Washington, DC: National Gallery of Art.

———. 2005. *Tango: The Art History of Love*. New York: Pantheon.

Thomson, J. 1968. *To the Central African Lakes and Back: The Narrative of the Royal Geographical Society's East Central African Expedition, 1878–1880*. 1st ed. 1881. 2 vols. London: Frank Cass.

Thornton, J. 1998. *Africa and Africans in the Making of the Atlantic World, 1400–1800*. New York: Cambridge University Press.

Thornton, L. 1990. *Les Africanistes, peintres voyageurs, 1860–1960*. Paris: ACR.

Thys, A. 1885a. Letter "p.o. Secrétaire Général de l'AIA" to Storms from Brussels, 30 January. RMCA, FS, No. 21, F-V, B-II.

———. 1885b. Letter "p.o. Secrétaire Général de l'AIA" to Storms from Brussels, 27 February. RMCA, FS, No. 21, F-V, B-II.

Tillotson, J. 1685. *A Discourse against Transubstantiation*, 5th ed. London: Three Pigeons.

Tilsey, G. 1929. *Dan Crawford, Missionary and Pioneer in Central Africa*. London: Oliphants.

Tollebeek, J. 2005. "Degeneration, Modernity and Cultural Change: A Belgian Perspective, 1860–1940." In *The Many Faces of Evolution in Europe, c. 1860–1914*, ed. P. Dassen and M. Kemperink, 53–71. Dudley, MA: Peeters.

Tonda, J. 2005. *Le Souverain moderne: Le corps du pouvoir en Afrique centrale (Congo, Gabon)*. Paris: Karthala.

Tonkin, E. 1995. *Narrating Our Pasts: The Social Construction of Oral History*. Cambridge, UK: Cambridge University Press.

Trouillot, M.-R. 1991. "Anthropology and the Savage Slot: The Poetics and Politics of Otherness." In *Recapturing Anthropology: Working in the Present*, ed. R. Fox, 17–44. Santa Fe, NM: School for Advanced Research.

———. 1995. *Silencing the Past: Power and the Production of History*. Boston: Beacon.

Turner, T. 1979. "Clouds of Smoke: Cultural and Psychological Modernization in Zaïre." In *Zaïre: The Political Economy of Underdevelopment*, ed. G. Gran, 69–84. New York: Praeger.

———. 2007. *Congo Wars: Conflict, Myth, Reality*. New York: Zed.

Turner, V. 1964. *Schism and Continuity in African Society: A Study of Ndembu Village Life*. Manchester, UK: Manchester University Press.

———. 1966. "Colour Classification in Ndembu Ritual." In *Anthropological Approaches to the Study of Religion*, ASA Monograph 3, 47–84.

———. 1968. "Mukanda: The Politics of a Non-Political Ritual." In *Local-Level Politics: Social and Cultural Perspectives*, ed. M. Swartz, 135–50. Chicago: Aldine.

———. 1969. "Chihamba, the White Spirit: A Ritual Drama of the Ndembu." *Rhodes- Livingstone Papers* 33.

———. 1970. *The Forest of Symbols: Aspects of Ndembu Ritual*. Ithaca, NY: Cornell University Press.

———. 1980. "Social Dramas and Stories about Them." *Critical Inquiry* 7 (1): 141–68.

———. 1981. *Drums of Affliction: A Study of Religious Processes among the Ndembu of Zambia*. Ithaca, NY: Cornell University Press.

Twain, M. 1971. *King Leopold's Soliloquy*. New York: International Publications.

Untermeyer, Louis. 1959. *A Treasury of Ribaldry*. Garden City, NY: Hanover House.

Vacher de Lapouge, G. 1899. *L'Aryen et son rôle social*. Paris: A. Fontemoing.

Van Acker, A. 1903. "Allons rendre visite à des sauvages." *Missions d'Afrique des Pères Blancs,* 258–65.

———. 1907. *Dictionnaire Kitabwa/Français/Kitabwa*. Royal Museum of the Belgian Congo, Tervuren, Belgium, *Annales* 5.

Van Avermaet, E., and B. Mbuya. 1954. *Dictionnaire kiluba-français*. Royal Museum of the Belgian Congo, Tervuren, Belgium, *Annales* 7.

Vanderknyff, R. 2007. "Parlor Illusions: Stereoscopic Views of Sub-Saharan Africa." *African Arts* 40 (3): 50–63.

Van de Velde, H. 1898. "Die Kolonial-Ausstellung Tervueren." *Dekorative Kunst: illustrierte Zeitschrift für angewandte Kunst* (October): 38–41.

Van Geluwe, H. 1986. *Tabwa Tervuren, 1986*. Tervuren, Belgium: RMCA.

Van Overbergh, C. 1913. "Le musée modern." In *Trésors de l'art belge au XVIIe siècle: Mémorial de l'Exposition d'Art ancien à Bruxelles en 1910*. Tome II: *Beaux-Arts—Arts appliqués—Milieu social*, 97–101. Brussels: Van Oest.

Vansina, J. 1964. *Le royaume kuba*. Tervuren, Belgium: RMCA.

———. 1968. *Kingdoms of the Savanna: A History of Central African States until European Occupation*. Madison: University of Wisconsin Press.

———. 1984. *Art History in Africa: An Introduction to Method*. New York: Longman.

———. 1985. *Oral Tradition as History*. Madison: University of Wisconsin Press.

———. 1996. "From Memory to History: Processes of Luba Historical Consciousness." Foreword to *Memory: Luba Art and the Making of History*, ed. M. Roberts and A. Roberts, 12–14. Munich: Prestel.

———. 2010. *Being Colonized: The Kuba Experience in Rural Congo, 1880–1960*. Madison: University of Wisconsin Press.

Vanthemsche, G. 2006. "The Historiography of Belgian Colonialism in the Congo." In *Europe and the World in European Historiography*, ed. Csaba Lévai, 89–119. Pisa, Italy: Pisa University Press.

———. 2007. *La Belgique et le Congo: Empreintes d'une colonie, 1885–1980. Nouvelle Histoire de Belgique* 4. Brussels: Éds Complexe.

Vauthier, R., ed. 1896. "L'Esclavage en Afrique." *La Belgique Coloniale* 2 (22): 253–55.

Vellut, J.-L. 1984. "La violence armée de l'État Indépendant du Congo." *Revue internationale des sciences du développement* 16: 671–707.

———. 1998. "The Congo Basin and Angola." In *General History of Africa VI: Africa in the Nineteenth Century until the 1880s*, ed. J. Ade Ajayi, 294–324. Berkeley: University of Calfornia Press.

———. 2003. "Aperçu des relations Belgique-Congo (1885–1960)." In *Le Congo et l'art belge, 1880–1960*, ed. J. Guisset, 20–35. Brussels: Renaissance du Livre.

Verbeek, L. 1990. *Le monde des esprits au sud-est du Shaba et au nord de la Zambie*. Rome: Ateneo Salesiano.

Verbeke, F. 1937. "Le bulopwe et le kutomboka par le sang humain chez les Baluba- Shankaji." *Bulletin des Juridictions indigènes et du Droit coutumier congolais* 5 (2): 52–61.

Verbeken, A. 1956. *Msiri, roi du Garenganze: "l'homme rouge" du Katanga*. Brussels: L. Cuypers.

Verhoeven, J. 1929. *Jacques de Dixmude, l'Africain: Contribution à l'histoire de la Société antiesclavagiste belge, 1888–1894*. Brussels: Librairie Coloniale.

Verhulpen, E. 1936. *Baluba et Balubaïsés du Katanga*. Antwerp: Éds de l'Avenir Belge.

Verswijver, G., et al., eds. 1995. *Treasures from the Africa Museum Tervuren*. Tervuren, Belgium: RMCA.

Vincke, É. 1985. *Géographie et hommes d'ailleurs: Analyse critique de manuels scolaires.* Centre Bruxellois de Recherche et de Documentation pédagogiques, 28.

———. 1986. "L'Homme exotique dans les manuels belges de géographie édités en français." *Afrika Focus* 2 (3–4): 221–49.

Vogel, S. 1988. Introduction to *ART/artifact: African Art in Anthropology Collections,* ed. S. Vogel, 11–17. Munich: Prestel.

Wack, H. 1905. *The Story of the Congo Free State.* New York: G. P. Putnam's Sons.

Wagner, R. 1981. *The Invention of Culture.* Chicago: University of Chicago Press.

———. 1991. "The Fractal Person." In *Big Men and Great Men: Personifications of Power in Melanesia,* ed. M. Strathern and M. Godelier, 159–73. New York: Cambridge University Press.

Wahis, T. 1927. "Storms: Le fondateur de la station de M'Pala." In *Les pionniers belges au Congo,* ed. H. Depester, 43–45. Tamines, Belgium: Duculot-Roulin.

Waller, H., ed. n.d. *The Last Journals of David Livingstone, in Central Africa from Eighteen Hundred and Sixty-Five to His Death.* 1st ed. 1875. Detroit: Negro History Press.

Wastiau, B. 2000. *Congo-Tervuren/Aller-Retour: Le transfert de pièces ethnographiques du Musée royal de l'Afrique centrale à l'Institut des Musées nationaux du Zaïre 1976–1982.* Tervuren, Belgium: RMCA.

———. 2005. "The Scourge of Chief Kansabala: The Ritual Life of Two Congolese Master-pieces at the Royal Museum for Central Africa (1884–2001)." In *Science, Magic, and Religion: The Ritual Processes of Museum Magic,* ed. M. Bouquet and N. Porto, 95–115. New York: Bergahn.

———. 2009. "The Violence of Collecting: Objects, Images, and People from the Colonial Congo." Unpublished conference paper, American Historical Association annual meetings, New York.

Wauthion, R. 1939a. Letter to *Administrateur territorial* about incidents of 4 February 1939. Unpublished report from Albertville, 7 April. Archives of the Sous-Région du Tanganyika, cl. 343.

———. 1939b. Letter to *Chef de Province du Katanga,* annex to PVA. Unpublished report from Albertville, 27 April. Archives of the Sous-Région du Tanganyika, cl. 343.

Weghsteen, J. 1964. "La musique et les instruments de la musique des Noirs de la région de Baudouinville (Congo)." *Annali del Pontifico Museo Missionario Etnologico Lateranensi* 28: 85–111.

Weiner, A. 1985. "Inalienable Wealth." *American Ethnologist* 12 (2): 210–27.

Weiss, B. 1997. "Forgetting Your Dead: Alienable and Inalienable Objects in Northwestern Tanzania." *Anthropological Quarterly* 70 (4): 164–72.

West, H. 2005. *Kupilikula: Governance and the Invisible Realm in Mozambique.* Chicago: University of Chicago Press.

Weyn, G. 2010. *Albertville/Kalemie: La ville et son territoire des origines à 1965.* Brussels: Masoin.

White, L. 1994. "Blood Brotherhood Revisited: Kinship, Relationship, and the Body in East and Central Africa." *Africa* 64 (3): 359–72.

———. 1997. "The Traffic in Heads: Bodies, Borders and the Articulation of Regional Histories." *Journal of Southern African Studies* 23 (2): 325–38.

———. 2000. *Speaking with Vampires: Rumor and History in Colonial Africa.* Berkeley: University of California Press.

White, T. 1960. *The Bestiary.* New York: Putnam.

White Fathers. 1885–1889. "Diaire de Mpala." Unpublished typescript, new pagination, CAWFR.

Williams, J. 1964. *A Field Guide to the Birds of East and Central Africa.* Boston: Houghton Mifflin.

Willis, Roy. 1967. "The Head and the Loins: Lévi-Strauss and Beyond." *Man* (n.s.) 2 (4): 519–34.

———. 1981. *A State in the Making: Myth, History, and Social Transformation in Pre- Colonial Ufipa.* Bloomington: Indiana University Press.

———. 1991. "The Body as Metaphor: Synthetic Observations on an African Artwork." Uppsala Studies in Cultural Anthropology 16: 271–81.

Winans, E. 1994. "The Head of the King: Museums and the Path to Resistance." *Comparative Studies in Society and History* 36 (2): 221–41.

Wissmann, H. von. 1891. *My Second Journey through Equatorial Africa: From the Congo to the Zambesi in the Years 1886 and 1887.* London: Chatto and Windus.

Wolf, J., ed. 1971. *Missionary to Tanganyika, 1877–1888: The Writings of Edward Coode Hore, Master Mariner.* London: Frank Cass.

———. 1976. *The Central African Diaries of Walter Hutley, 1877 to 1881.* African Historical Documents, Series IV, African Studies Center, Boston University.

Womersley, H. 1984. *Legends and History of the Luba.* Los Angeles: Crossroads.

Wood, D. 1992. *The Power of Maps.* New York: Guilford.

Wright, M. 1993. *Strategies of Slaves and Women: Life-Stories from East/Central Africa.* New York: Lilian Barber.

Wright, M., and P. Lary. 1971. "Swahili Settlements in Northern Zambia and Malawi." *African Historical Review* 4 (3): 547–73.

Wynants, M. 1997. *Des Ducs de Brabant aux villages congolais: Tervuren et l'Exposition Coloniale 1897.* Tervuren, Belgium: RMCA.

———. 2005. "'His Majesty is out of town': Les relations tendues entre Léopold II et Stanley après la conférence de Berlin." In *La mémoire du Congo, le temps colonial,* ed. J.-L. Vellut et al., 69–73. Gand, Belgium: Snoeck.

Zarrilli, P. 2008. *When the Body Becomes All Eyes: Paradigms, Discourses and Practices of Power in Kalarippayattu, a South Indian Martial Art.* Delhi: Oxford University Press.

Index

Allen F. Roberts is Professor of World Arts and Cultures at the University of California, Los Angeles. He and Mary Nooter Roberts are co-authors of *Memory: Luba Art and the Making of History* (1996), winner of the College Art Association's Alfred H. Barr Award for outstanding museum scholarship, and *A Saint in the City: Sufi Arts of Urban Senegal* (2003), accorded the African Studies Association's Herskovits Prize as the best volume of its year and the Arts Council of the African Studies Association's Arnold Rubin Outstanding Publication Award for 2001–2003.